XEROPHILE

Revised Edition

Edited by Cactus Store

XEROPHILE

Revised Edition

Cactus Photographs from Expeditions of the Obsessed

TEN SPEED PRESS
California | New York

March 30, 1930

La Paz, Baja California, Mexico

I have seen the creeping devil cactus creep on the shores of Magdalena Bay, gathered the casa de rata, been struck by the jumping cholla of Comondu and rode by towering cardons until I see spines in my sleep. I have been down to the axel a dozen times in mud, stuck in sand, had to carry my load up grades, bumped over rocks, broke a universal joint in El Arenoso and again on a hill, been through El Purgatorio and down the grade into El Inferno, turned the truck flat on its side, been in perils on the seashore and mountain tops, under overhanging rocks and leaning cardons, between the living rock and deep pits. I have cut off tree limbs and filled up chuck holes and drank water out of ruts in the road, forgotten what a bridge looks like and been sick in the Mulege but near the end of the road is La Paz and the trip has been wonderful.

—Edward E. Gates, letter to Mr. Scott Hazelton

Contents

Xerophile *adj.* (from Greek *xeros*, meaning "dry," and *philos*, "loving")—
thriving in or tolerant or characteristic of an environment with a
limited water supply.

Since the 1930s, Southern California has been home to a rich network of cactus and succulent clubs, societies, and shows. Evidence of this history is stored away all over the Southland—go to a longtime cactus collector's garage, and you'll likely find shoe boxes stuffed full of old succulent newsletters and magazines, stacked up next to the Christmas decorations and boogie boards. Bargain bins at cactus shows in the Valley can yield issues of the Czech journal *Kaktusy* from the 1980s, out-of-print books on the euphorbias of Africa, or a hand-typed field guide to the cactus of Baja. To us—members of a younger generation of collectors accustomed to relying on the resources available online—this printed ephemera was a fascinating relic, a view into a past world.

After opening the Cactus Store in 2014, we became increasingly captivated by this material. We acquired what we could, and as our library expanded we were continually struck by a certain type of photography that we weren't accustomed to seeing. These weren't the usual photos of perfect show plants in a greenhouse, a saguaro lit by a blazing sunset, or a slick studio shot of an obscenely flowering *Echinopsis*. What we became captivated by, and what we found to be far more beautiful and true, were documentary photographs of cactus in their native environments, the often improbable landscapes where these plants grow wild. Seeing an image of a 15-foot-tall (4.6 m) *Browningia candelaris* (page 138) living in a habitat that is Earth's closest equivalent to Mars, its trunk thickly covered in spines, topped with a crown of twisted, rust-red branches, will quickly make you realize that the 6-inch (15 cm) green juvenile you've

been caring for—and watching grow at a glacially slow pace—is a long, long way from home.

Xerophile is made up of these images, hundreds of them, which we have spent the past two years tracking down. They are drawn from the archives of twenty-five explorers and span eighty years, from the early days of Kodachrome to the bottomless memory cards of today's digital SLRs. These pictures were never meant to be art, and most of them have barely, if ever, been seen by the public. They were taken as a form of evidence—this plant exists here now—and stored away by the thousands in slide carousels and on hard drives, perhaps appearing on occasion as supporting characters in a PowerPoint presentation before a small audience of collectors, or by way of reproduction at thumbnail size in an obscure journal. We believe that they are worthy of examination in their own right though, and in bringing them together here we have chosen to organize them in an unorthodox way. Not by type or geography, but instead through a visual narrative that emphasizes both the breadth of variation and the surprising connections that exist among this far-flung world of desert-dwelling plants. You'll also notice that we've added to this edition a section called "Notes on the Photographs" (page 321), both to provide context and to highlight some of what makes these plants like catnip for the xeric phytophile.

Today's cactus explorers come from a line of xerophilic obsessives that stretches back to the late 1500s. They are willing to spend months planning a trip across the globe, weeks driving down dirt roads, hiking across mountaintops, and riding on muleback, all in the hope of finding that one habitat, that one plant, that they are seeking. Often, they don't find it. So they keep looking, or return the next year, or never leave. The insatiable drive to examine and document these plants in nature instead of the greenhouse has created a global cadre of enthusiasts,

collectors, botanists, and adventurers. Like the flower salesman Howard Gates, driving alone in Baja in 1930, crawling slowly up the Sierras with extra carburetors strapped to his vehicle in order to be face-to-face with a *Ferocactus* perched above the Sea of Cortez. Or the banker–turned–world traveler Joël Lodé, riding a donkey through the desert for days on end in order to sleep next to the *Uebelmannia* he had been dreaming of back home in France. Not only is the fieldwork undertaken by these explorers responsible for our current, and ever-expanding, scientific understanding of cactus—the specimens that they have collected are the source of almost all the cactus sold and displayed around the world today.

In our store, we try to guide the uninitiated beyond a purely aesthetic appreciation of each cactus in its pot, to reframe the plants in a broader and more complex context. Yes, you are in Los Angeles, but this *Oreocereus celsianus* in front of you comes from the high reaches of the Andes, in Peru; its dense white hair has evolved to defend it from the sun and the snow. Evoking the places these xerophytes come from is an essential part of the store's mission. But it is mostly impossible for our descriptions, no matter how vivid, to do justice to the remote landscapes that have birthed some of the most striking and surreal plants in the natural world. Hopefully this book will help with that. As a good friend once said, everything after this is just plants . . .

Love and luck,

Cactus Store
(C. Cummings, Max Martin, and Carlos Morera)

Contributor Biographies

Giovanna Anceschi
b. Milan, Italy, 1963

Alberto Magli
b. Bologna, Italy, 1960

Giovanna Anceschi and Alberto Magli decided to dedicate their lives to cactus in 2004. The couple, who are based in Italy, have been traveling and researching nonstop ever since, with a focus on field-based taxonomy. They run the comprehensive online archive cactusinhabitat.org, which is dedicated to the documentation and classification of cactus populations in Argentina, Bolivia, Brazil, Chile, Paraguay, Peru, and Uruguay.

Their extended travels have produced notes and photography on more than two hundred and fifty species in the wild. They have contributed studies on *Echinopsis* and Cactaceae systematics initiatives to *The Cactus Explorer*, as well as pieces on *Parodia*, one of their preferred genera.

Peter Berresford
b. Manchester, UK, 1956

Peter Berresford met both his life-long girlfriend and his first cactus, a *Mammillaria prolifera*, which he still owns, fifty years ago. Berresford specializes in *Echinocereus*, and his extensive collection includes thousands of specimens. Though he relished the days when cactus explor-ing involved poring over maps and plotting expeditions in precise detail on paper, he still takes regular trips to what he calls Cactusland. "Nothing's better than habitat," he says. "It's a bit disappointing when you get home and look at the specimens in your greenhouse. You can't beat nature."

Graham Charles
b. Birmingham, UK, 1950

Graham Charles's bibliography includes many books about cactus and succulents. He has lectured all over the world, and has taken more than twenty trips to South America to study plants in their natural habitat, naming a number of new species in the process. He is also the founder and editor of the online journal *The Cactus Explorer* and the editor of *Bradleya*, the yearbook of the British Cactus & Succulent Society.

Based in England, Charles gradu-ated from Birmingham University with a degree in physics, and went on to a career in marketing technical products. He has long since retired to spend more time on his plant life. He met his wife, Elisabeth, at a cactus meeting, and for more than thirty years their plant collections have shared a large greenhouse at their home, in Rutland, near Stamford, England.

Rick Gillman
b. Hornchurch, Essex, UK, 1955

Rick Gillman is a British explorer and succulent collector, having inherited his father's plant collection at a very young age. He has been a member of the British Cactus & Succulent Society for fifty years, and has explored South Africa, the Caribbean, Brazil, Madagascar, Argentina, the US, Mexico, and Ecuador, where he has photographed the endemic species of Cactaceae in extensive detail. His collection of more than three thousand cactus and succulents reflects his background in mathematics. As he says, "I love the marvelous approximate symmetry of the plants." Gillman also has a collection of ukuleles, seven of which feature cactus designs.

Héctor M. Hernández
b. San Luis Potosí, Mexico, 1954

Aside from a few plants that have found their way into his possession, Héctor M. Hernández doesn't have a cactus collection. His knowledge of plants comes from his extensive fieldwork across Mexico, especially in the northern and central regions of the country, and in Oaxaca, Chiapas, and the Yucatán Peninsula. Hernán-dez studied biology at the School of Sciences at the National University of Mexico, and later received his PhD in plant systematics from Saint Louis University. He works as a research botanist at the Institute of Biology at the National University of Mexico, where he has gone on to hold the positions of director, curator of the National Herbarium, and head of the botany department. He is the author of more than a hundred papers on topics ranging from biodiversity

and conservation biology to plant systematics and biogeography. His most recent books, Volumes I and II of *Mapping the Cacti of Mexico*, are part of an ongoing project to document the distribution ranges of Mexican cactus.

Paul Hoxey
b. Bedford, UK, 1971

Paul Hoxey first became interested in cactus as a teenager, and, after mastering the art of growing from seed, he assembled a large collection of Mexican cactus. After university, he built two greenhouses in Cambridge, England—where he'd moved for a job as a silicon-chip designer—which he quickly filled with show specimens. His first trip to habitat, in 1996, got him hooked on cactus exploring, and he eventually shifted his focus from the cactus of Mexico to those of South America, specifically Peru. "The adven-ture of searching for cactus in habitat and trying to visit interesting places has always been of far more interest to me than 'cactus tourism'—follow-ing GPS data to well-known habitats," Hoxey says. "It's the search and finding the unexpected that gives me the greatest pleasure."

John Jacob Lavranos
b. Corfu, Greece, 1926
d. Loulé, Portugal, 2018

John Jacob Lavranos served in the Greek Navy during the Second World War, and went on to earn degrees in law and economics from Athens University. In 1952, after moving to South Africa, where he worked as an insurance broker, Lavranos's passion for botany led him to attend natural-science classes at Witwatersrand University, where he registered for a doctoral degree in science.

Lavranos, who later lived in Portugal, spent years exploring areas that have historically been difficult for Westerners to access, including Somalia, southern Arabia, and the small Yemini islands of Socotra. Most of the *Euphorbia abdelkuri* seen in private collections today originated from samples that Lavranos brought back from the Socotra archipelago in 1967.

Lavranos discovered close to a hundred and fifty succulent species since then, and wrote extensively on Asclepiadaceae and *Aloe*.

George Lindsay
b. Pomona, California, USA, 1916
d. Tiburon, California, USA, 2002

George Edmund Lindsay, the son of citrus orchardists, was a cactophile by the time he reached high school; as a teenager, his desert garden won first prize at the Los Angeles County Fair. By the age of eighteen, Lindsay was exploring Baja on mule, armed with a USDA plant-importation permit. In 1939, before graduating from college, he became the director of the Desert Botanical Garden in Phoenix.

A combat cameraman with the Air Force during the Second World War, Lindsay served in the famed First Motion Picture Unit captained by Ronald Reagan. After the war, he completed both undergraduate and doctoral degrees at Stanford University, with a dissertation on *Ferocactus*.

From 1956 to 1963, Lindsay was the director of the San Diego Natural History Museum, where he invited Reid Moran to be the curator of botany. He went on to direct the California Academy of Sciences, in San Francisco, until 1982. During this time, Lindsay continued his practice of leading expeditions in the Gulf of California, bringing along both biologists and high-profile trustees. A 1973 trip with the celebrity aviator-hero Charles Lindbergh ultimately brought attention to Lindsay's long-fought conservation efforts.

In his later years, Lindsay married Geraldine Kendrick Morris, a widow with five children, and his cactus obsessions turned to South Africa, where he traveled frequently until his death, in 2002, at the age of eighty-five.

Joël Lodé
b. Nantes, France, 1952

Joël Lodé became a member of the Nantes Museum of Natural History Association when he was ten years old. At twenty-two, he began taking long trips on his bicycle, and in August, 1976, he set a world record by crossing Death Valley on bike. Lodé has worked in a wide array of professions, including magician, bank

teller, and actor. His travels include stretches of time spent in El Salvador and Yemen during their respective civil wars, a stint in Australia as a gold prospector, solo expeditions in Kenya, and a trip to Jordan that led to the discovery of *Aloe porphyrostachys* fifteen years before it was scientifically classified.

A prolific writer and photographer, Lodé's *Encyclopedia of Cacti and Other Succulents* is the largest such French database of its kind, and his *Taxonomy of the Cactaceae* features pioneering work in DNA testing of cactus for classification. He is currently based in Spain.

Martin Lowry
b. Preston, Lancashire, UK, 1955

Martin Lowry is a retired biochemist and cancer researcher. He has had his first cactus, a *Cleistocactus hyalacanthus*, since 1962, when he was seven years old. By 1982, he had accumulated a few hundred plants, which filled the windowsills of his family's small apartment before expanding into a large greenhouse. He has taken many trips across South America, but returns most consistently to Bolivia, his primary area of focus. Lowry was part of the team that worked with David Hunt to produce *The New Cactus Lexicon*, for which he was one of the main photographers.

Lowry served as the British Cactus & Succulent Society librarian for many years. He is now retired.

Woody Minnich
b. Columbus, Ohio, USA, 1947

Wendell "Woody" Minnich was born in Ohio, but has lived most of his life in the Mojave Desert. Minnich's desert photography has been widely reprinted, and he is the author of many articles about cactus and succulents; he has also lectured extensively on these subjects. This output is the result of Minnich's forty-five years of fieldwork in regions including Africa, Argentina, Australia, Bolivia, Brazil, Chile, Madagascar, Mexico, Namibia, New Zealand, Peru, Socotra, the United States, and Yemen. His expeditions to these areas, which generally focus on the remote and the unexplored, have paved the way for the discoveries of many new taxa.

Minnich was also a secondary school teacher for thirty-two years, teaching

art, graphic design, and architecture. He has run his nursery, Cactus Data Plants, now based in New Mexico, since 1975. Using his name at any cactus club in the United States will almost surely guarantee an enthusiastic greeting and an open door.

Reid Moran
b. Los Angeles, California, USA, 1916
d. Clearlake, California, USA, 2010

Reid Venable Moran was a trailblazer in Baja California in the 1950s. His visits to Guadalupe Island, off the western coast of the peninsula, from 1948 to 1981, made him the world authority on the Crassulaceae, and served as the foundation for his book, *The Flora of Guadalupe Island, Mexico*. Thanks to his documentation of the near-destruction of the island's plant life by feral goats, it is now a UNESCO biosphere reserve, and vegetation is making a comeback following a state-sponsored goat extermination. During his time as the curator of botany at the San Diego Natural History Museum, from 1957 to 1982, Moran added some sixty-four thousand species to the botanical collection, making the museum a leader in the floristics of Baja California. He named upward of eighteen new plants, and many more have since been named after him.

Moran earned a degree in biology from Stanford University in 1939, and a master's degree in botany from Cornell University in 1942. He served in the Air Force as a flight navigator during the Second World War, and was awarded a Distinguished Flying Cross after his aircraft was shot down over Yugoslavia. After the war, Moran received his doctorate from Berkeley, in 1951, with a dissertation on *Dudleya crassulaceae*.

Moran died in 2010, at the age of ninety-three. He is remembered in his obituary as "a big, vigorous man, ready to climb to the highest peak . . . who knew every word of every Australian folk song."

Jon Rebman
b. Rushville, Illinois, USA, 1965

Jon Rebman is the curator of botany at the San Diego Natural History Museum, following in the footsteps of some highly influential Baja explorers. (George Lindsay gave him a three-hundred-year-old map of the peninsula, recognizing that Rebman's heart lay somewhere in those cholla

patches.) His academic career includes a Fulbright Fellowship to Mexico and the publication of many articles and books on the land and the flora of Baja California, with a focus on Opuntioids. He has collected more than thirty-two thousand specimens, discovering and naming many plants in the process.

A longtime educator, Rebman trains both museum docents and canyoneers. He also conducts extensive fieldwork in Baja, which he has explored in great depth for the past twenty-five years, a practice that he plans to continue until he can no longer ride a donkey.

Jim Weedin
b. Texas, USA, 1949

Jim Weedin has spent most of his life studying cactus in Texas and throughout the Southwest. A career botanist, Weedin enjoys photographing *Echinocereus* and *Opuntia*, and on his regular trips to Big Bend National Park he continues to search for new species of cactus. (*Echinocereus viridiflorus* var. *weedinii* bears his name.) In addition to cactus, Weedin collects fossilized plants. Once, while on an expedition, he backed into the spines of an *Opuntia chisosensis*; legend has it that a photo of that moment is preserved on a friend's hard drive.

Mats Winberg
b. Eskilstuna, Sweden, 1964

Mats Winberg has been collecting cactus since the 1970s. Today he works in sales by day and runs his own seed business by night (succseed.com). He takes regular trips to Argentina and Bolivia, in pursuit of *Rebutia* and *Lobivia*.

Winberg says of these expeditions, "You always remember the parts of trips that didn't go so well—when your camping stove didn't work, when your car didn't start, when you were struggling with a bad stomach, or when roads were inaccessible because of heavy rain—and that is a part of it—but none of that matters when you open your tent and look out and see the clouds in the valleys below you, the sun shining, and the cactus flowers starting to open."

David Yetman
b. New Jersey, USA, 1941

You may recognize this desert rat from PBS: for nine years, David Yetman hosted the nationally syndicated show "The Desert Speaks," and he currently co-produces and hosts his own series, "In the Americas with David Yetman," which is available online.

Of course, Yetman's career amounts to much more than being a television host with a signature rabbit-fur Akubra hat. An ethnobotanist with a focus on the northwestern Mexican state of Sonora, Yetman leads the research and literature on the region's plants and indigenous peoples, and on the use of native resources in largely forgotten societies—those of the Ópatas, the Guarijios, and the Mayos, to name a few.

Born on the East Coast, Yetman has called the Southwest home ever since his childhood asthma prompted the family's relocation to the dry climate of Arizona. He received his PhD in philosophy from the University of Arizona, where he currently works as a research social scientist at the Southwest Center.

Photographers

Giovanna Anceschi (GA)
Peter Berresford (PB)
Bob Bobrow (BB)
Graham Charles (GC)
Kenneth Fink (KF)
Rick Gillman (RG)
Héctor Hernández (HH)
Paul Hoxey (PH)
John Jacob Lavranos (JJL)
George Lindsay (GL)
Joël Lodé (JL)
Martin Lowry (ML)
Alberto Magli (AM)
James D. Mauseth (JM)
Tim Means (TM)
Woody Minnich (WM)
Reid Moran (RM)
Jon Rebman (JR)
Laurie Roberts (LR)
Norman Roberts (NR)
Nigel Taylor (NT)
Martin Tvrdík (MT)
Jim Weedin (JW)
Mats Winberg (MW)
David Yetman (DY)

We have endeavored to provide accurate plant names for the photographs; however, many plant names have changed multiple times in the past century as taxonomy and classification have evolved. In cases where the "correct" name for a plant is unclear or divisive, we have used the plant names as supplied by their respective photographers and mention these discrepancies in the "Notes on the Photographs" section.

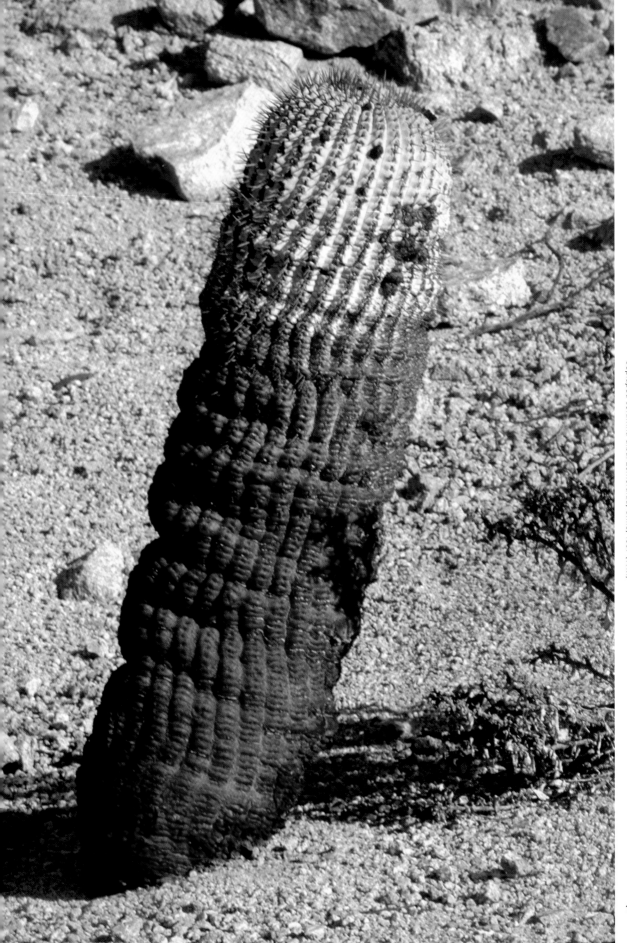

Copiapoa columna-alba. Esmeralda, Chile, 1997 (WM)

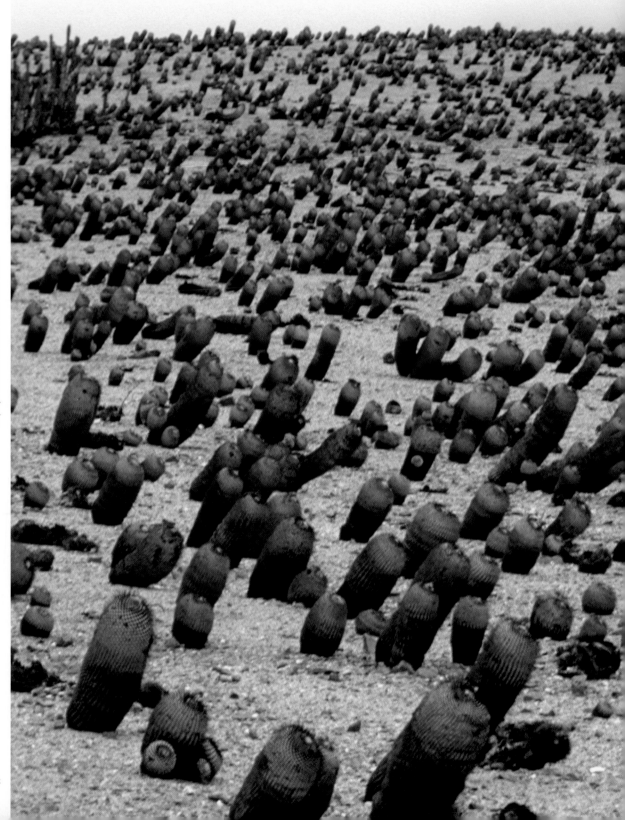

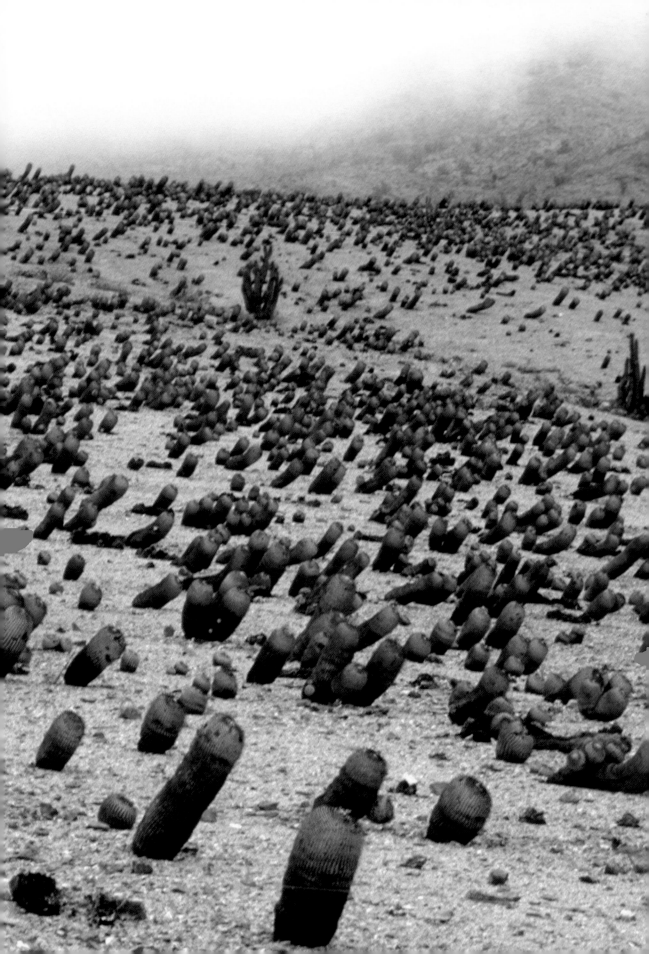

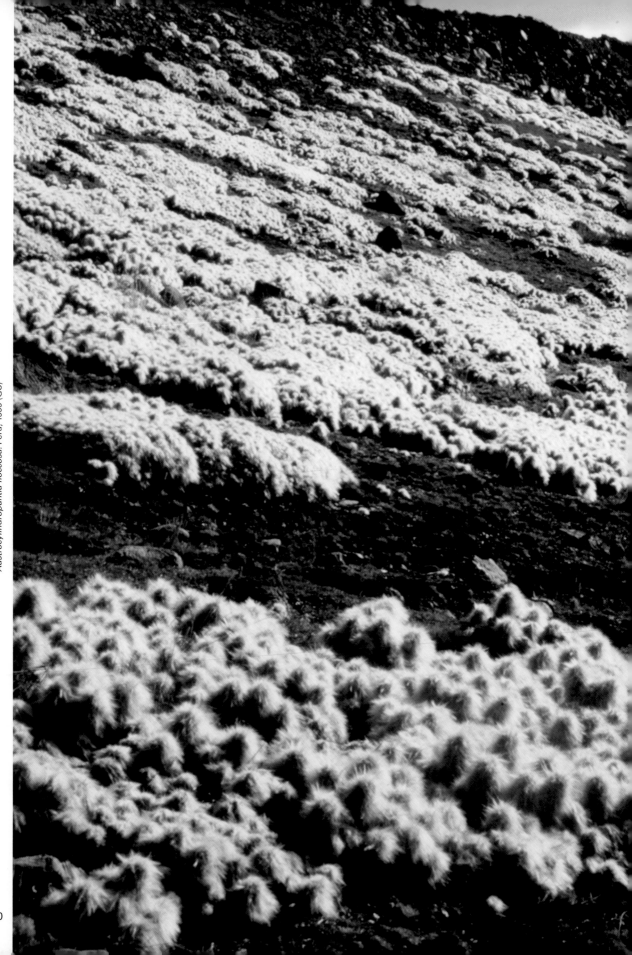

Austrocylindropuntia floccosa. Peru, 1999 (GC)

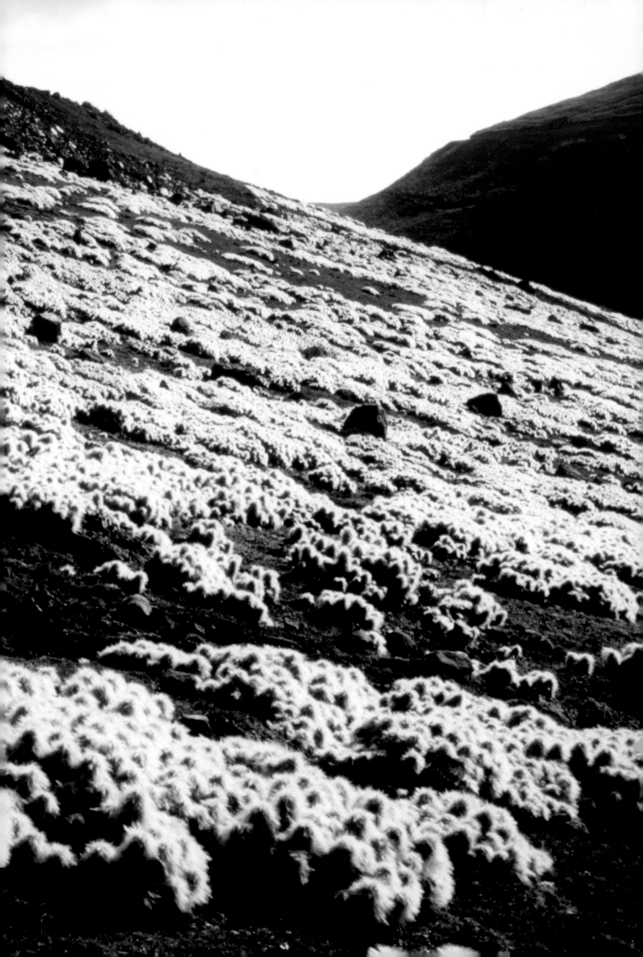

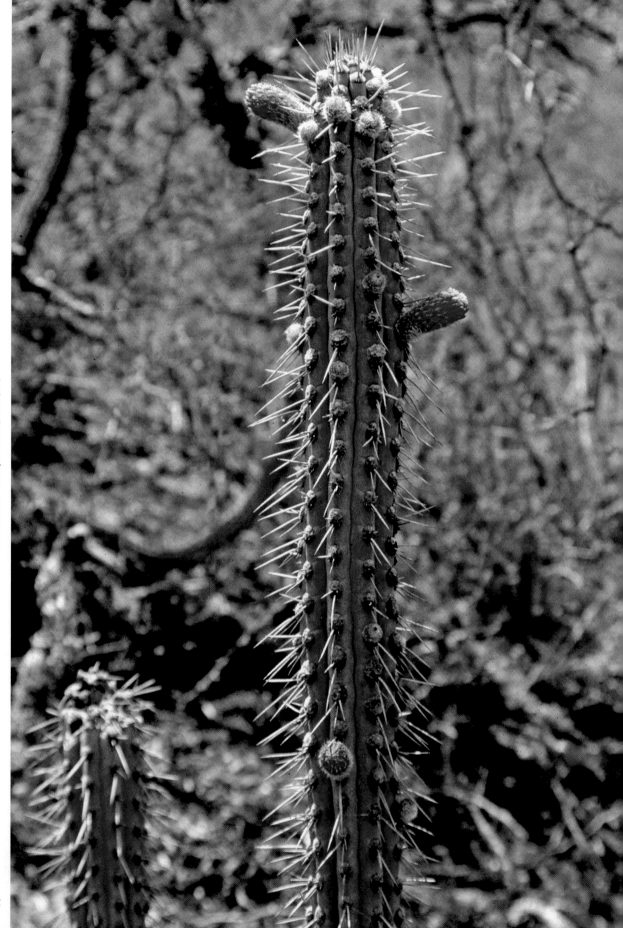

Cleistocactus laniceps. Bolivia, 2003 (ML)

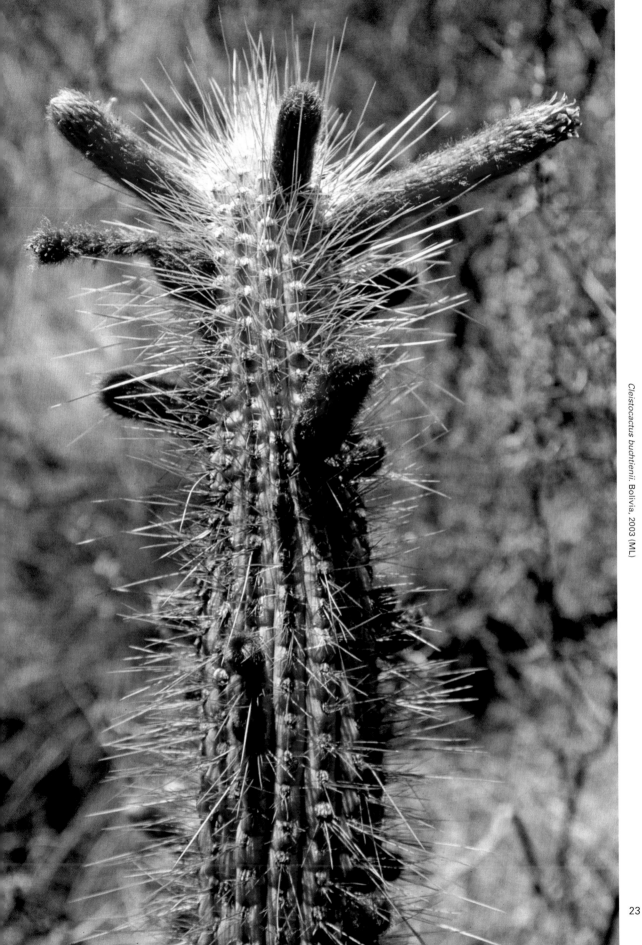

Cleistocactus buchtienii, Bolivia, 2003 (ML)

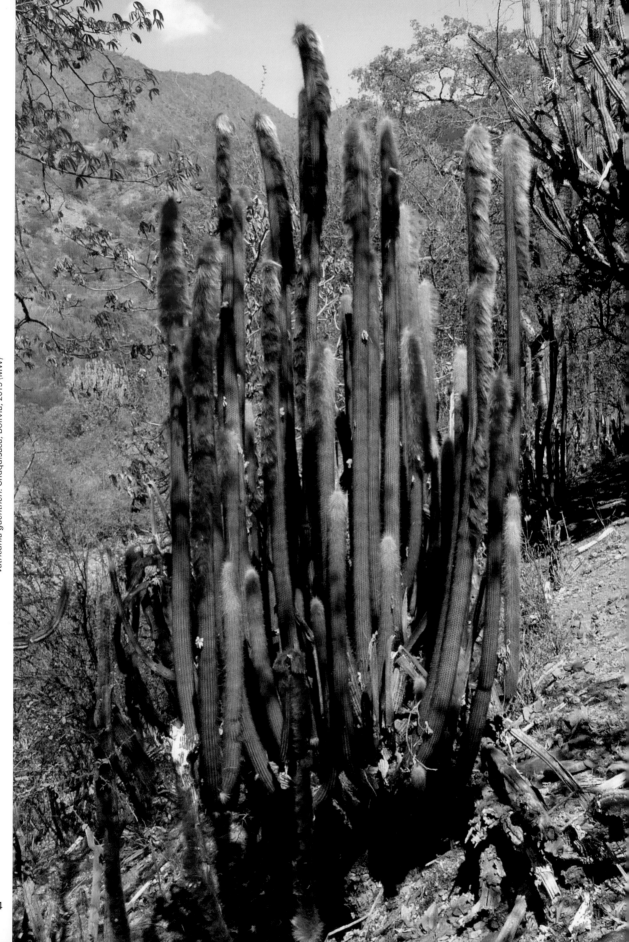

Vatricania guentheri. Chuquisaca, Bolivia, 2015 (MW)

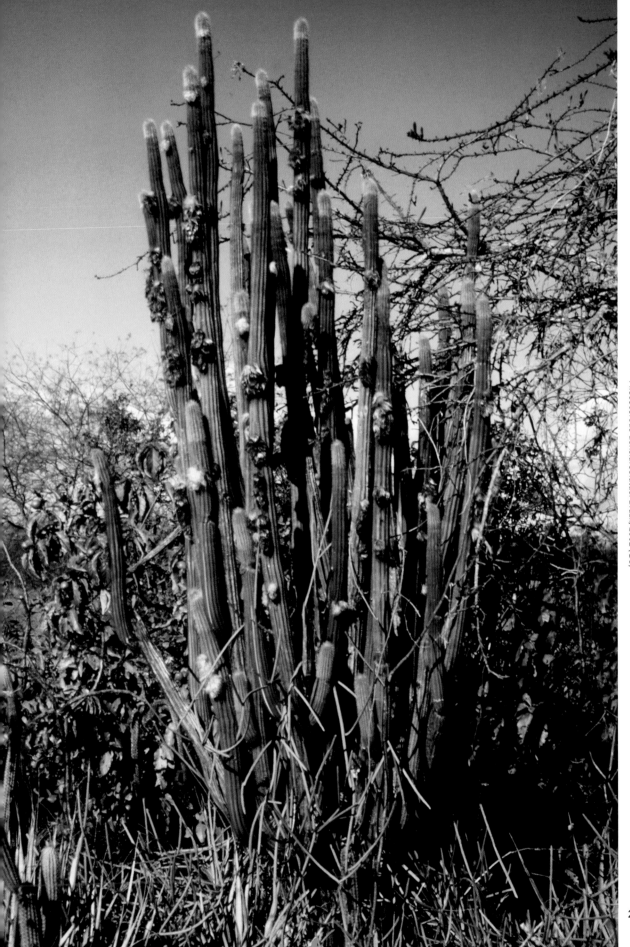

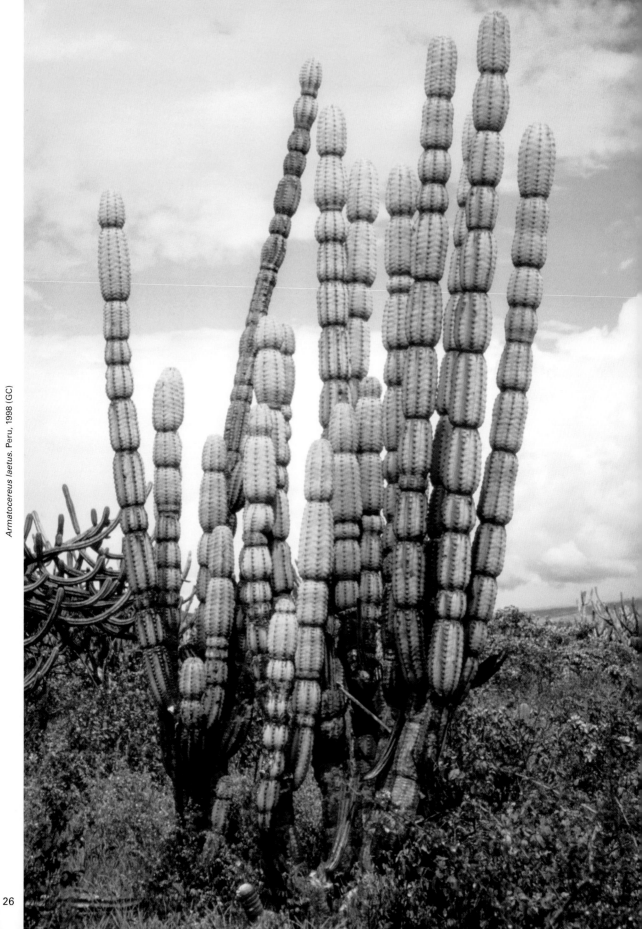

Armatocereus laetus. Peru, 1998 (GC)

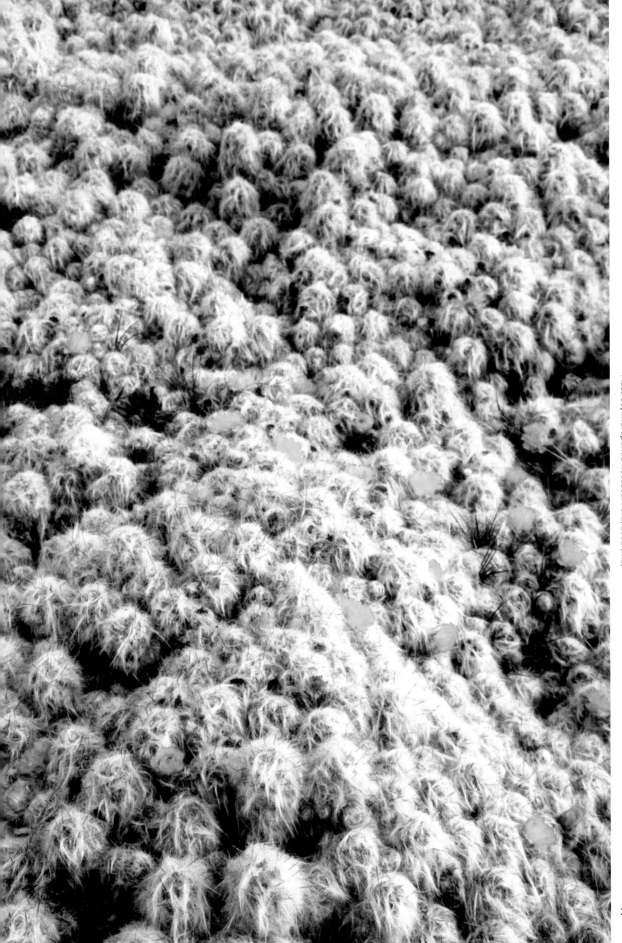

Austrocylindropuntia floccosa. Peru, 2002 (ML)

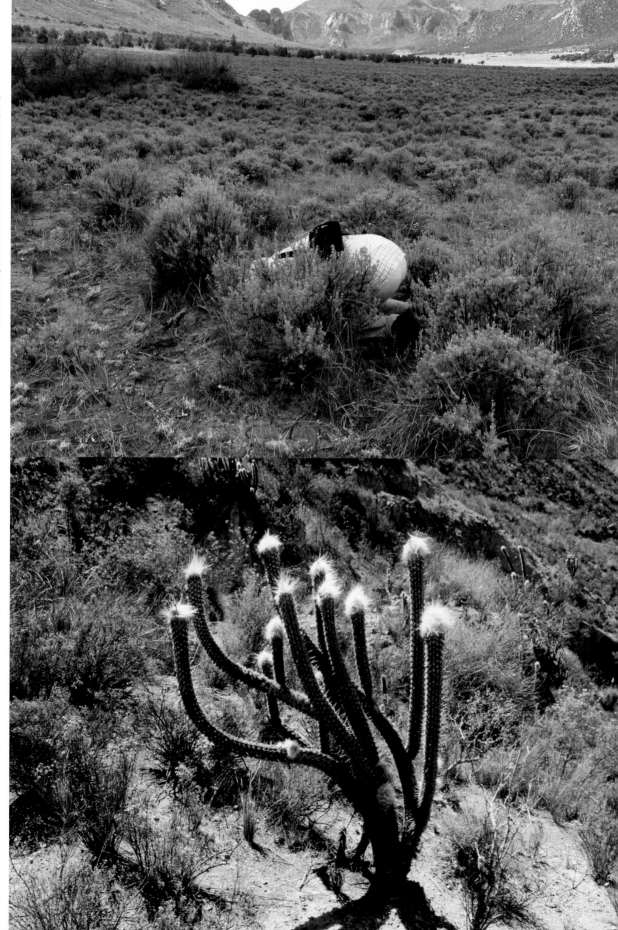

Pediocactus simpsonii (hidden). Colorado, USA, 2015 (MW)

Oreocereus pseudofossulatus. Bolivia, 2003 (ML)

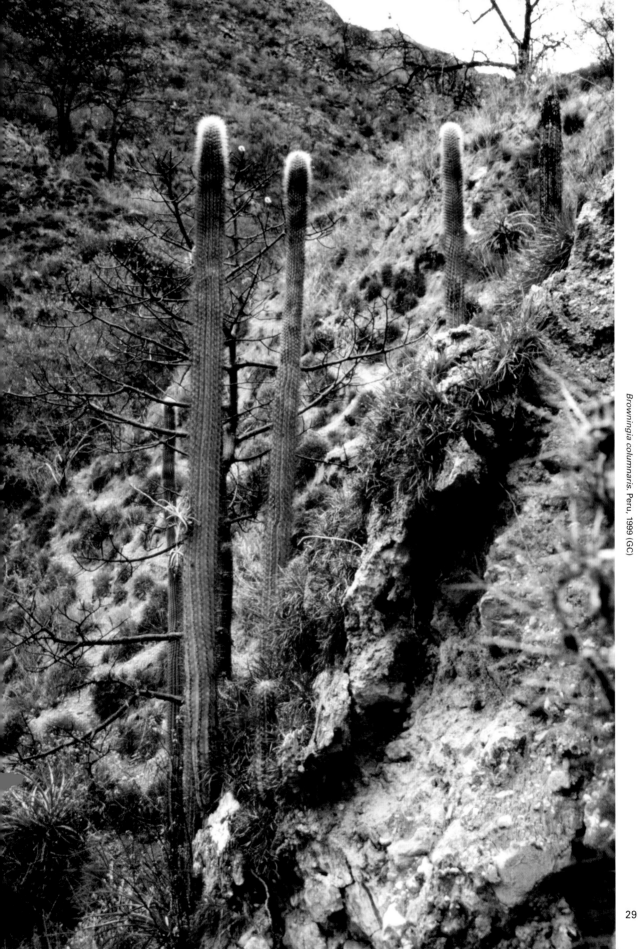

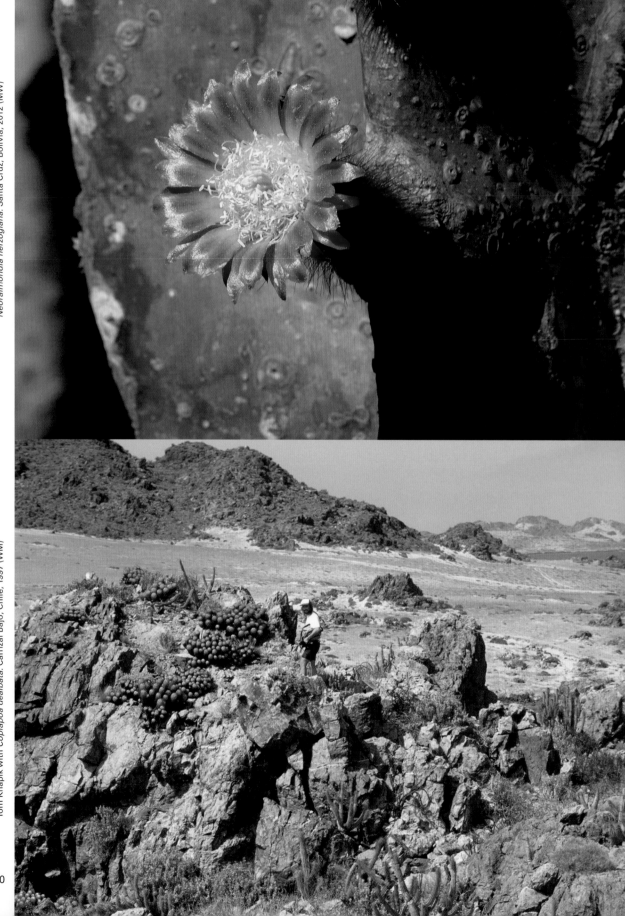

Neoraimondia herzogiana. Santa Cruz, Bolivia, 2012 (MW)

Tom Knapik with *Copiapoa dealbata.* Carrizal Bajo, Chile, 1997 (WM)

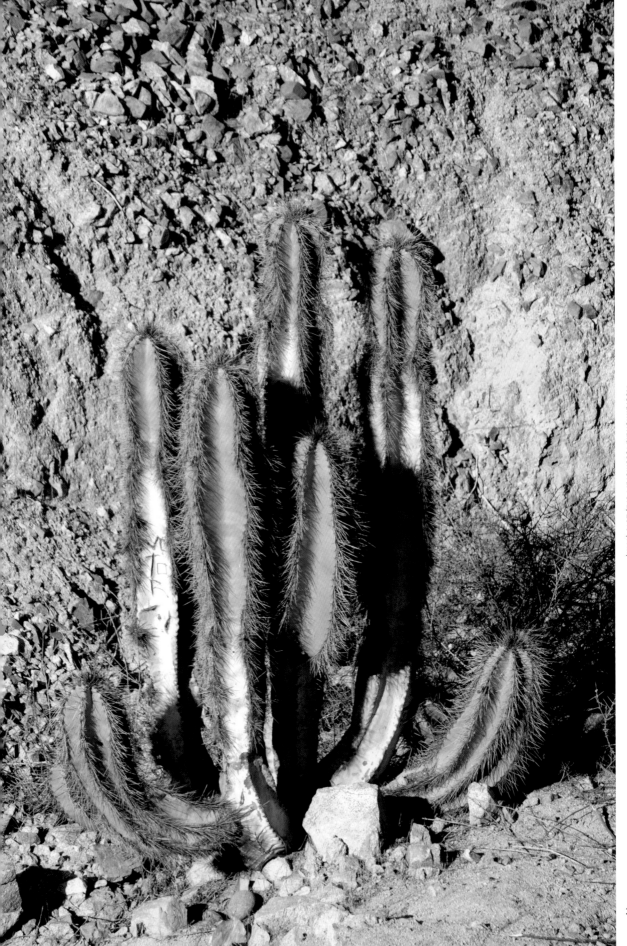

31

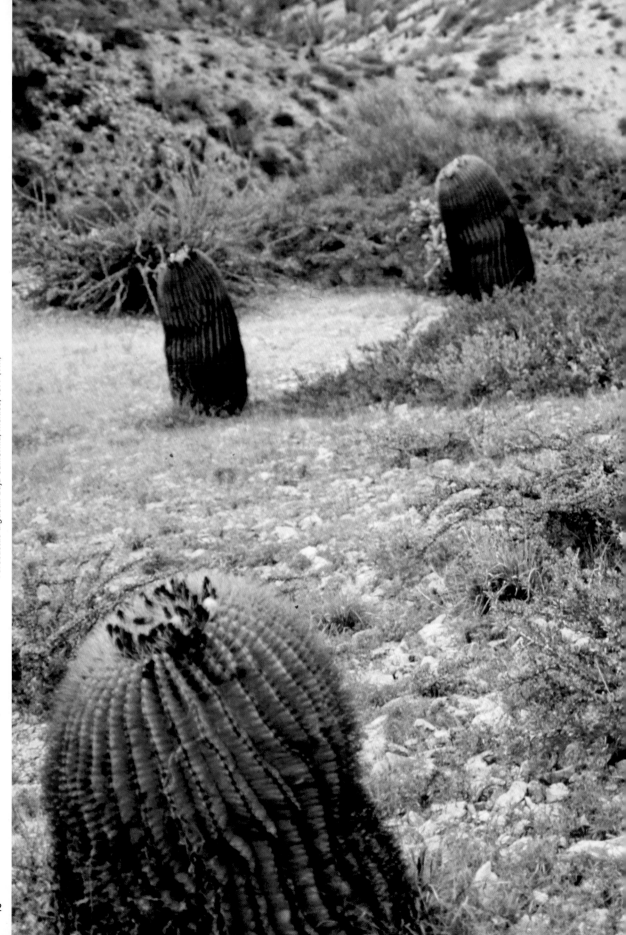

Ferocactus diguetii. Baja California, Mexico, 1977 (TM)

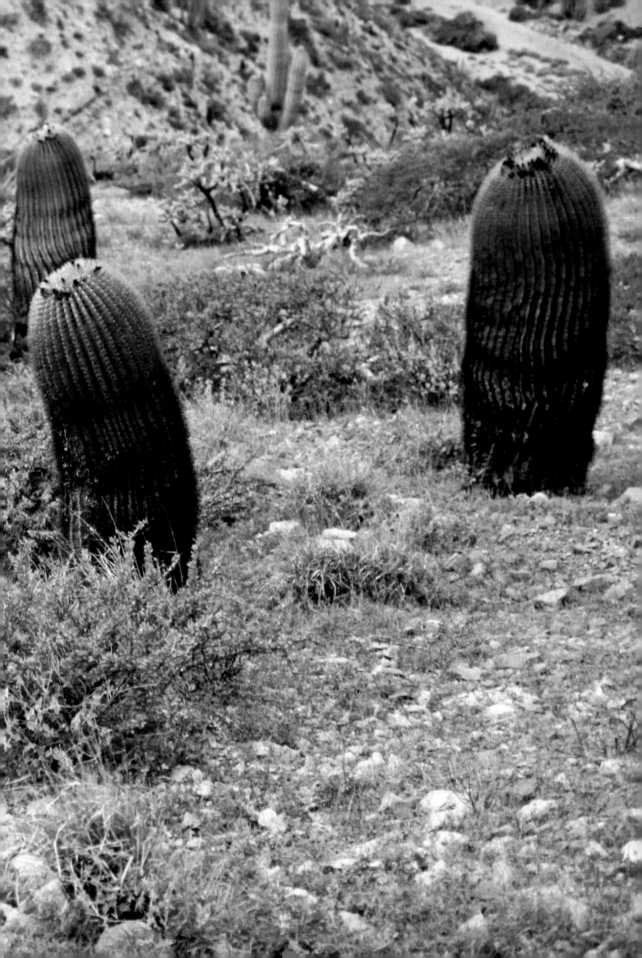

Ferocactus histrix. Hidalgo, Mexico, 1962 (GL)

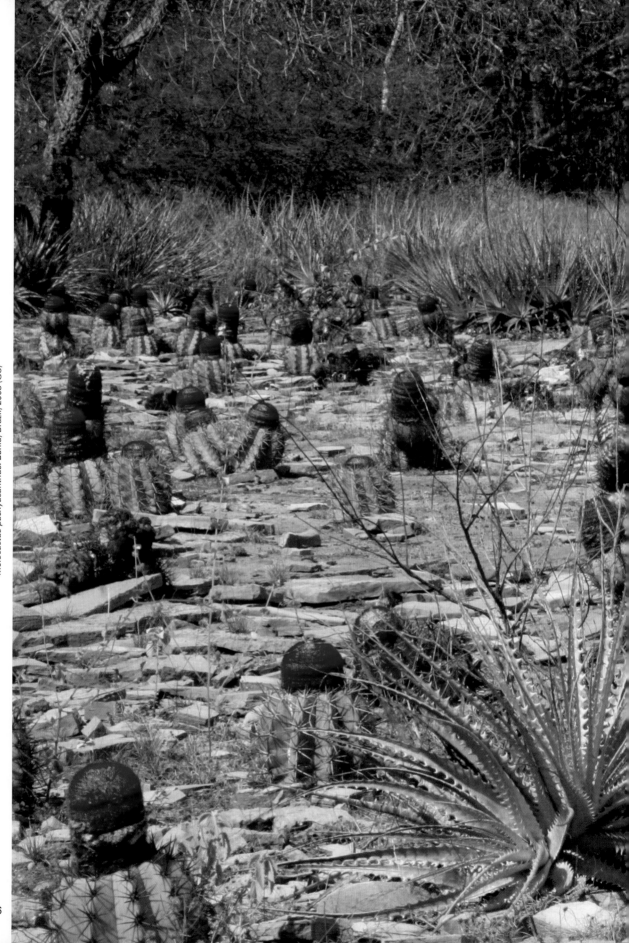

Melocactus pachyacanthus. Bahia, Brazil, 2008 (GC)

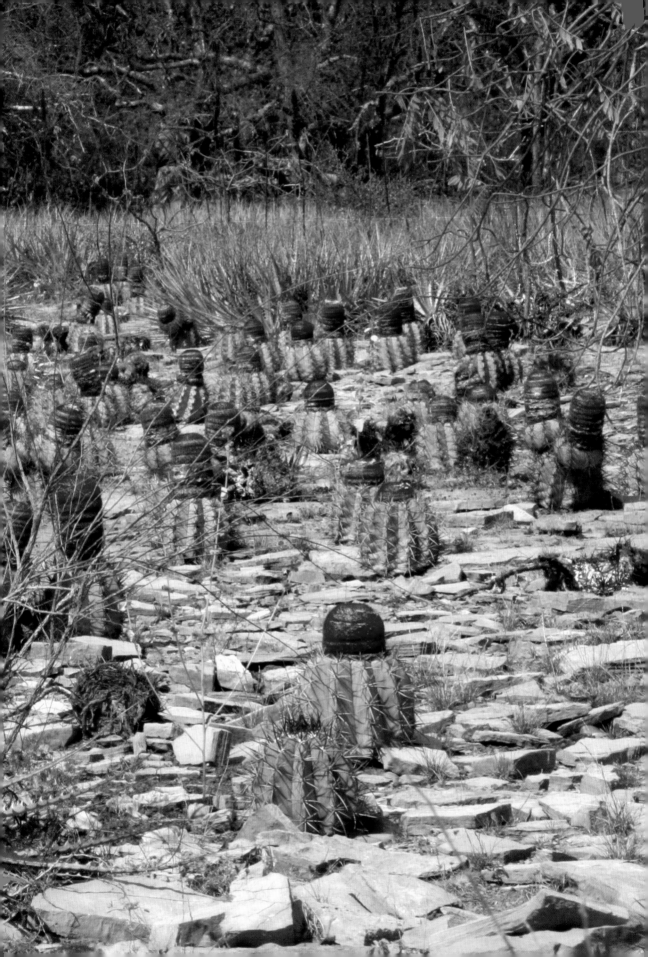

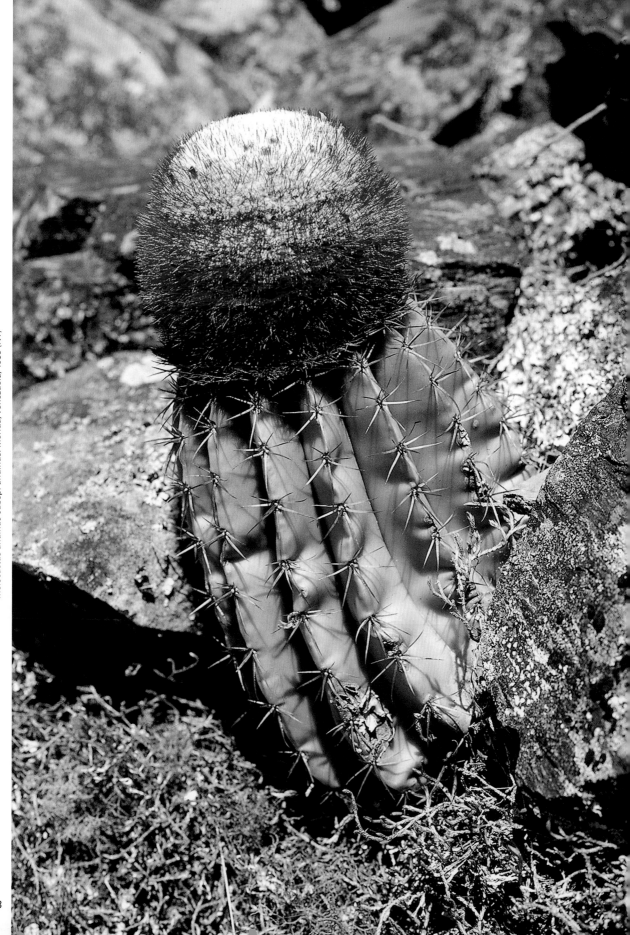

Melocactus andinus subsp. *andinus*. Mérida, Venezuela, 1988 (NT)

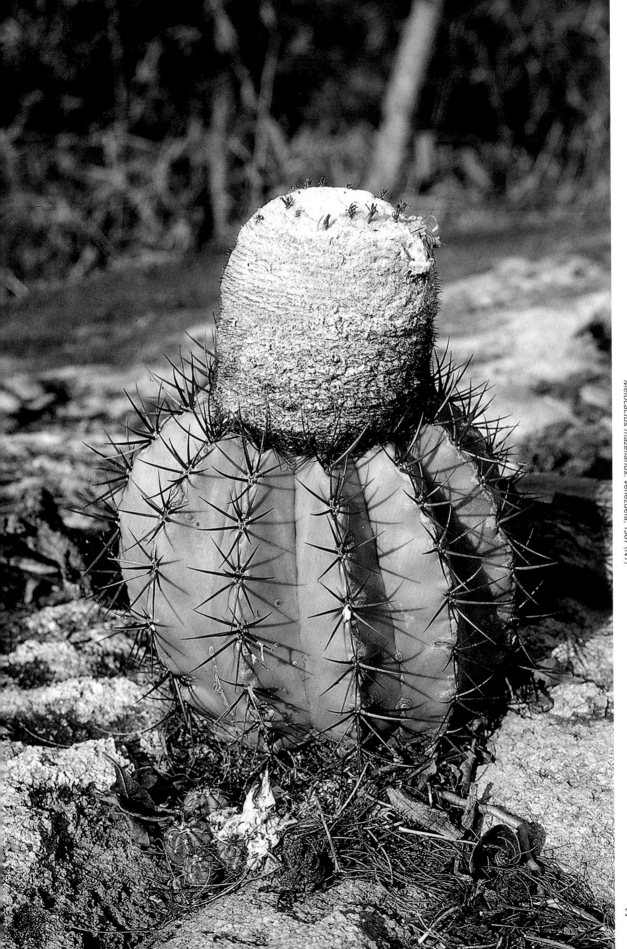

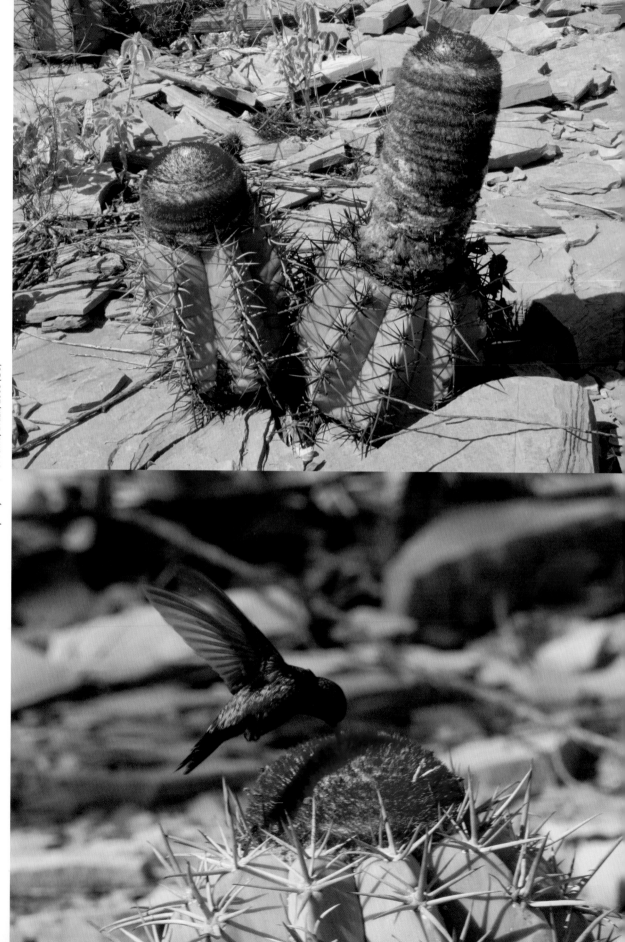

Melocactus pachyacanthus. Bahia, Brazil, 2008 (GC)

40

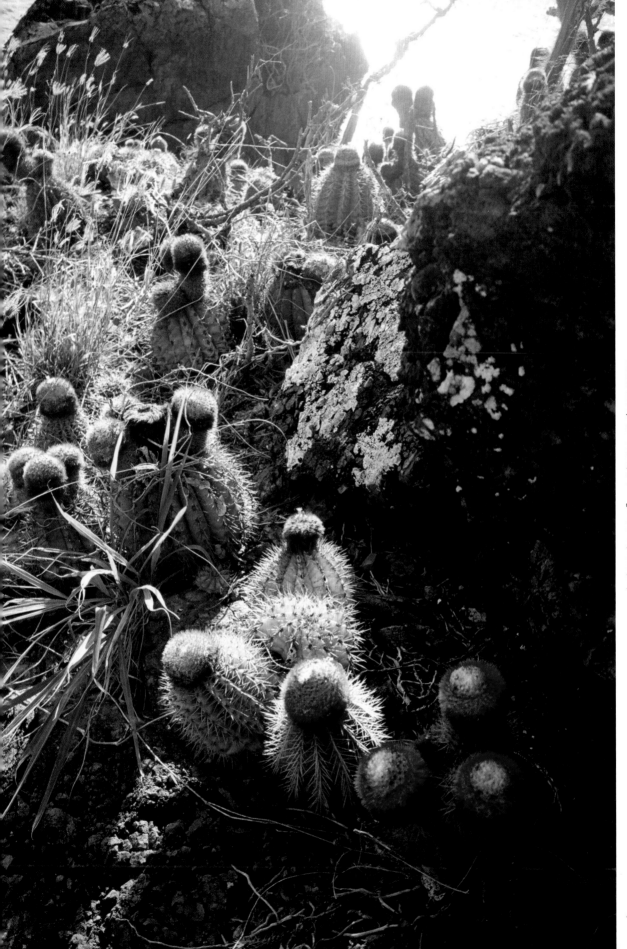

Melocactus sp. Saint John, U.S. Virgin Islands, 2015 (BB)

Cylindropuntia santamaria. Baja California Sur, Mexico, 1994 (JR)

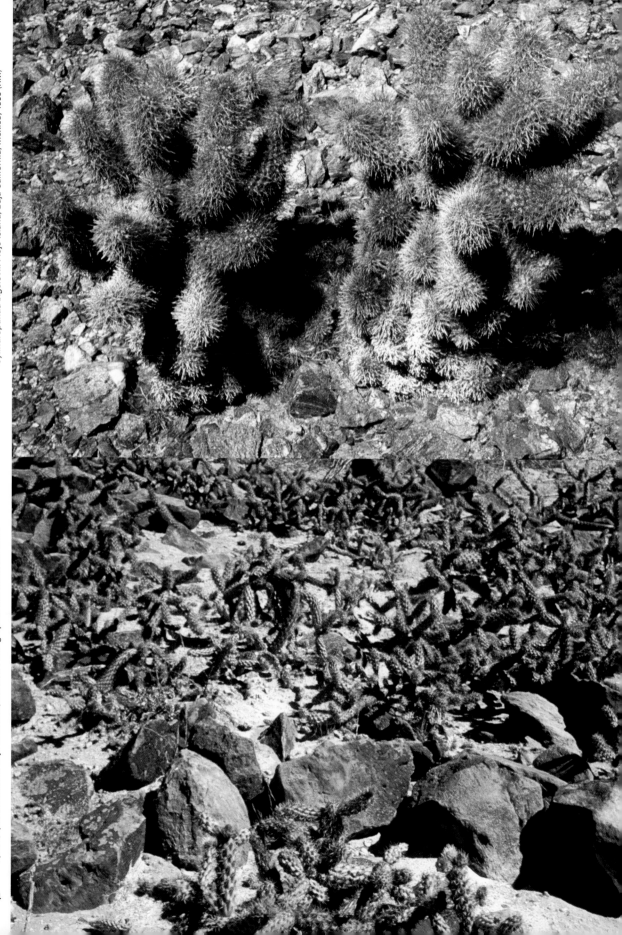

Cylindropuntia bigelovii. Piojo Island, Baja California, Mexico, 1959 (RM)

Cylindropuntia alcahes. Baja California, Mexico. Photographer and date unknown.

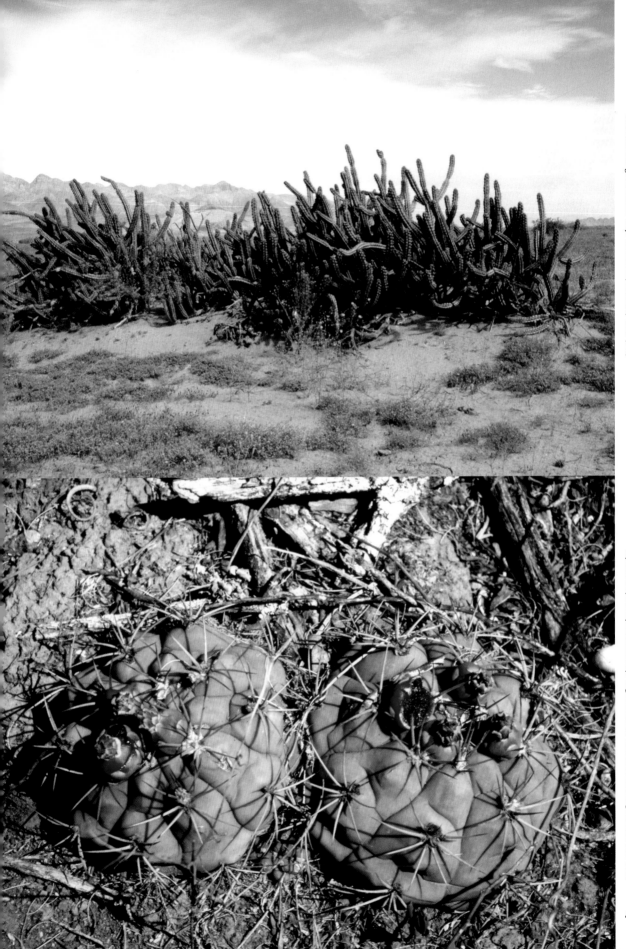

Stenocereus gummosus. Baja California, Mexico, 1963 (GL)

Gymnocalycium pflanzii subsp. *argentinense*. Cobra Corral, Argentina, 2000 (GC)

45

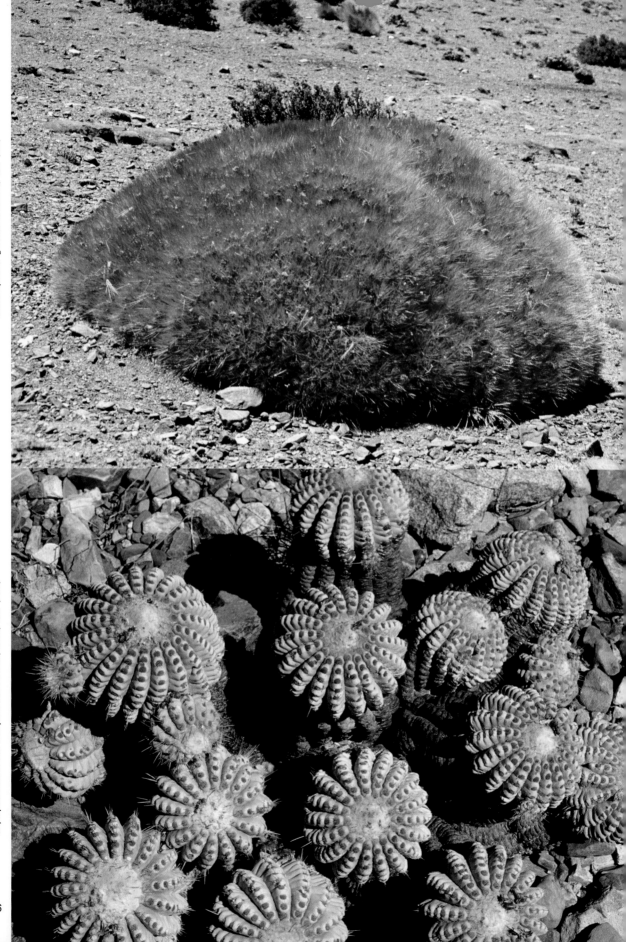

Cumulopuntia ignescens. Bolivia, 1997 (ML)

Copiapoa cinerea var. albispina. San Ramon, Chile, 1997 (WM)

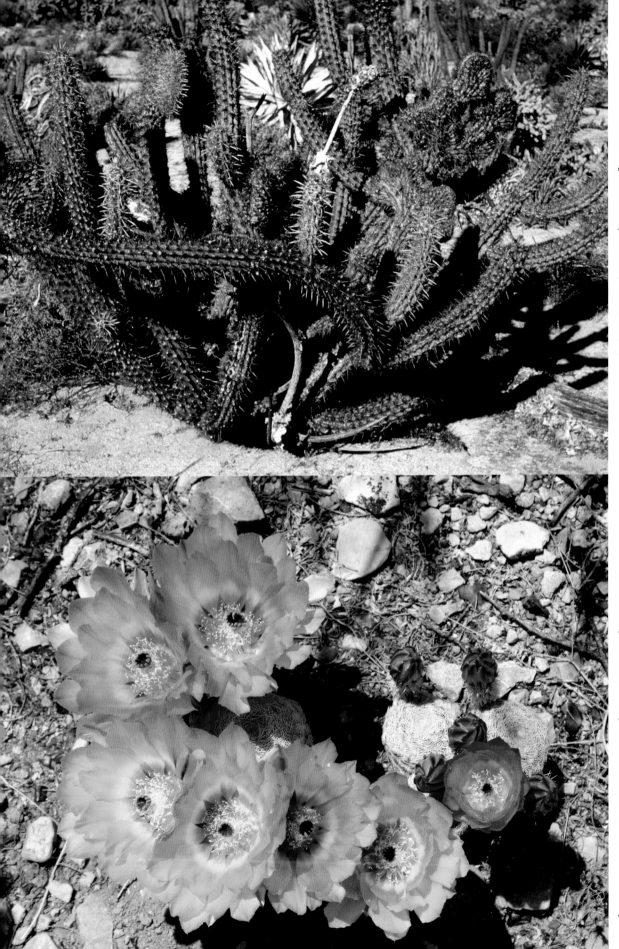

Stenocereus gummosus, Baja California, Mexico, 1962 (GL)

Echinocereus pectinatus, Sierra Mojada, Coahuila, Mexico, 2014 (PB)

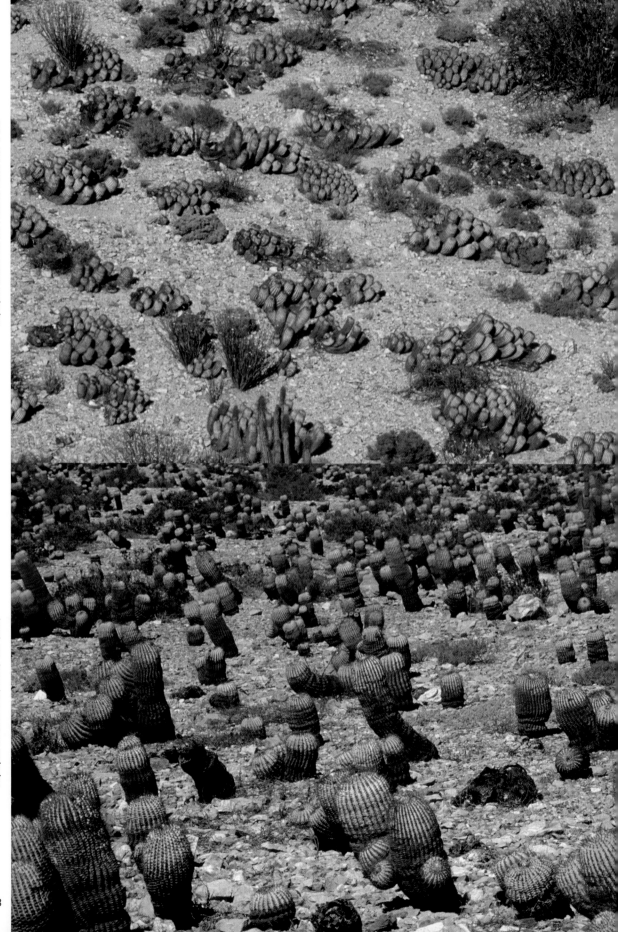

Copiapoa tenebrosa. Mt. Perales, Chile, 1997 (WM)

Copiapoa cinerea. Taltal, Chile, 1997 (WM)

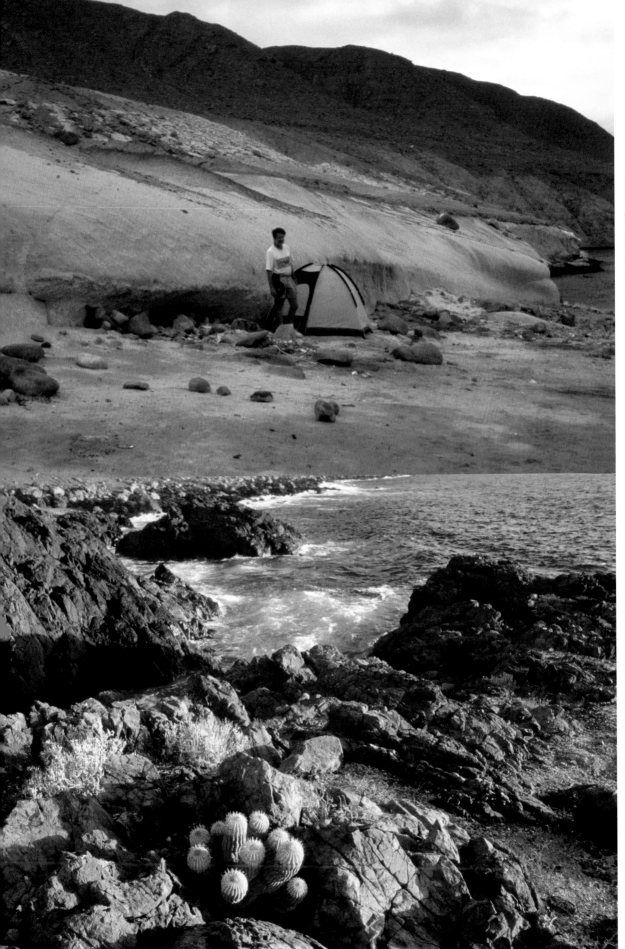

Carrizal Bajo, Chile, 1997 (WM)

Copiapoa cinerea var. albispina, San Ramon, Chile, 1997 (WM)

49

Copiapoa columna-alba. Esmeralda, Chile, 1997 (WM).

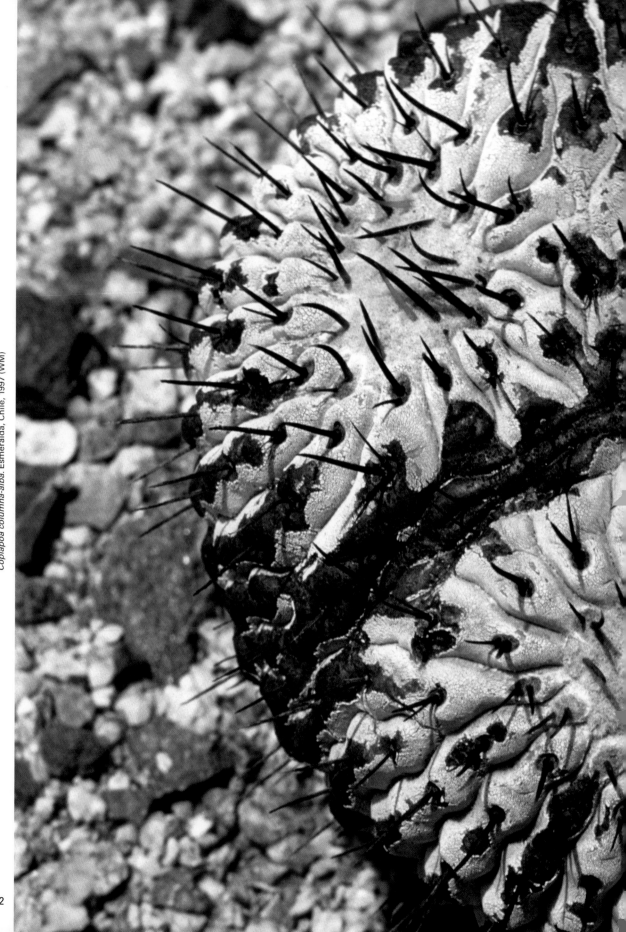

Copiapoa columna-alba. Esmeralda, Chile, 1997 (WM)

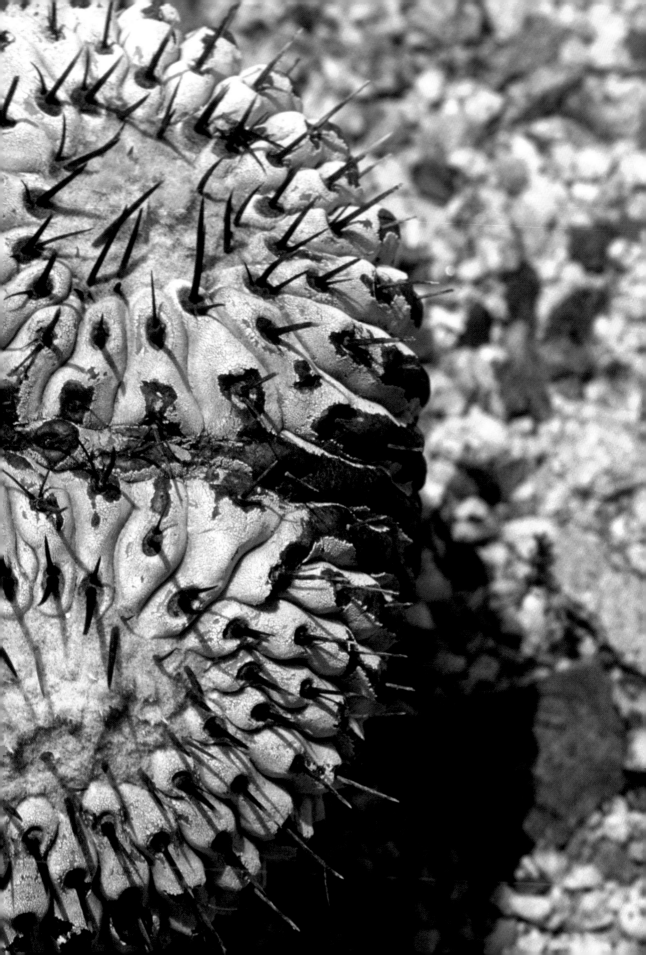

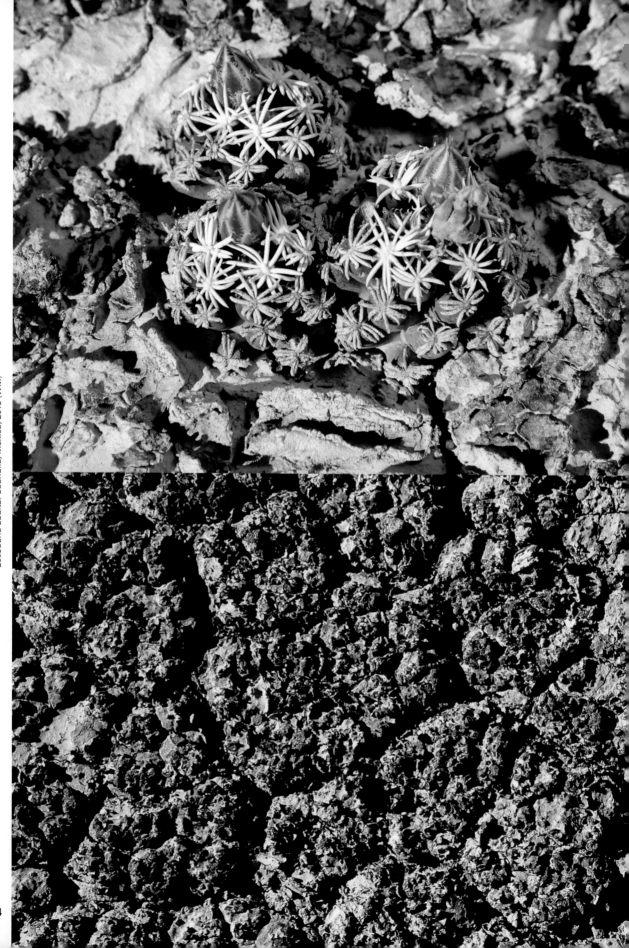

54

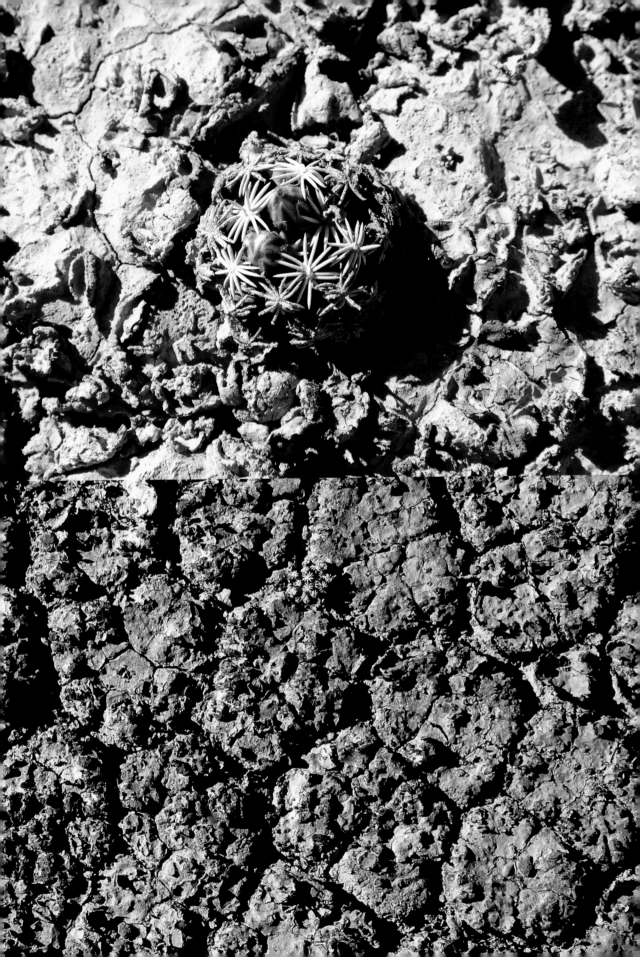

Neochilenia tenebrica. Domeyko, Chile, 1997 (WM)

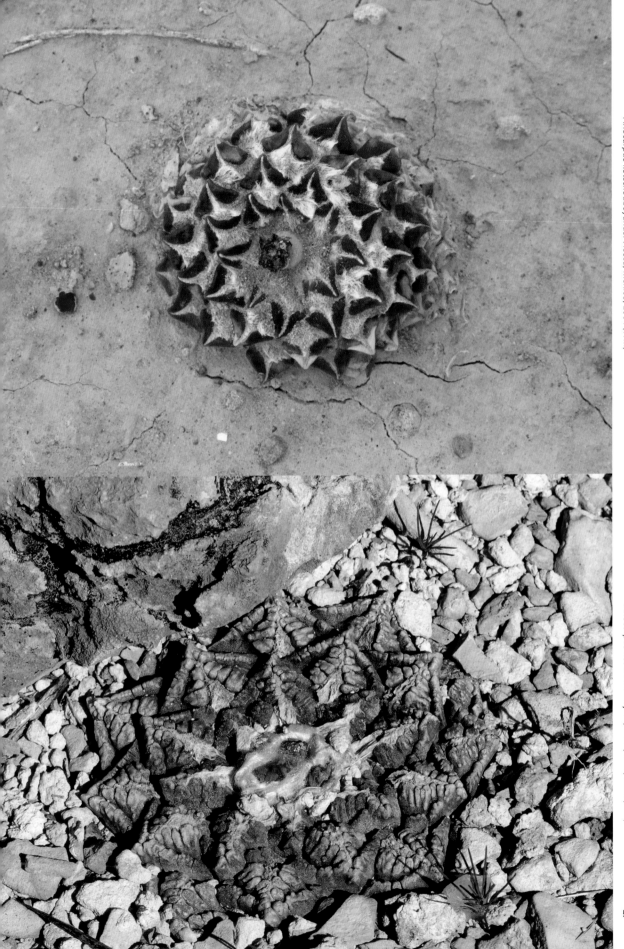

Ariocarpus kotschoubeyanus, Viesca, Mexico, 2004 (WM)

Ariocarpus fissuratus, Lajitas, Texas, USA, 2008 (WM)

57

Lithops gracilidelineata. Namibia, 2011 (WM)

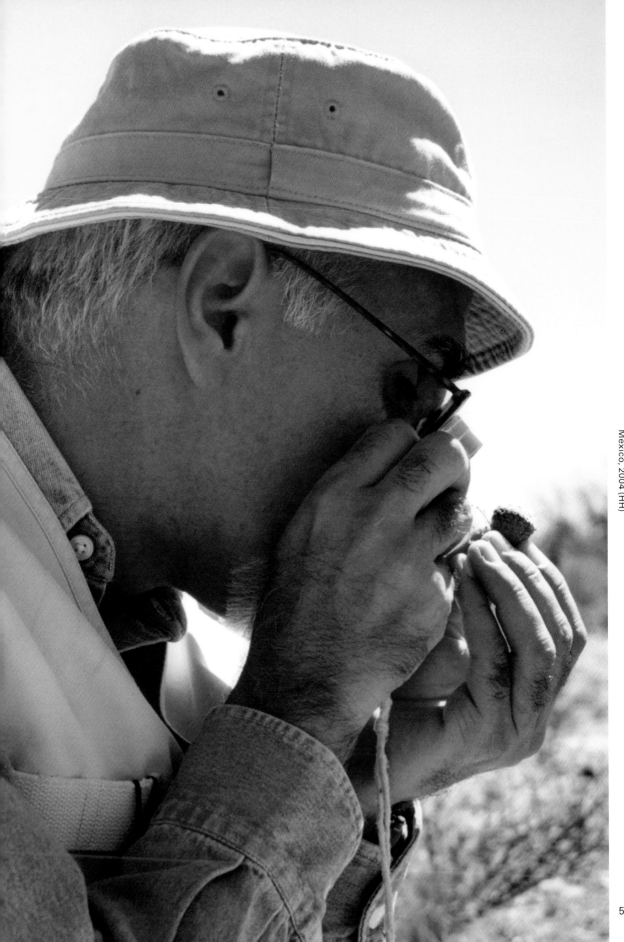

Mexico, 2004 (HH)

Ferocactus diguetii. Cerralvo Island, Baja California Sur, Mexico, 1952 (RM)

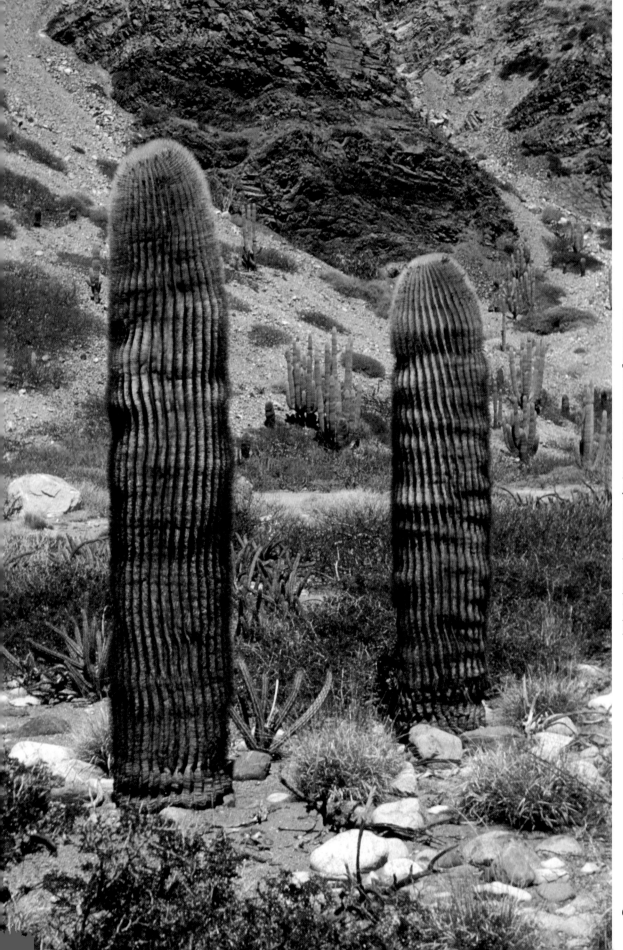

Ferocactus diguetii, Santa Catalina Island, Baja California Sur, Mexico, 1952 (GL)

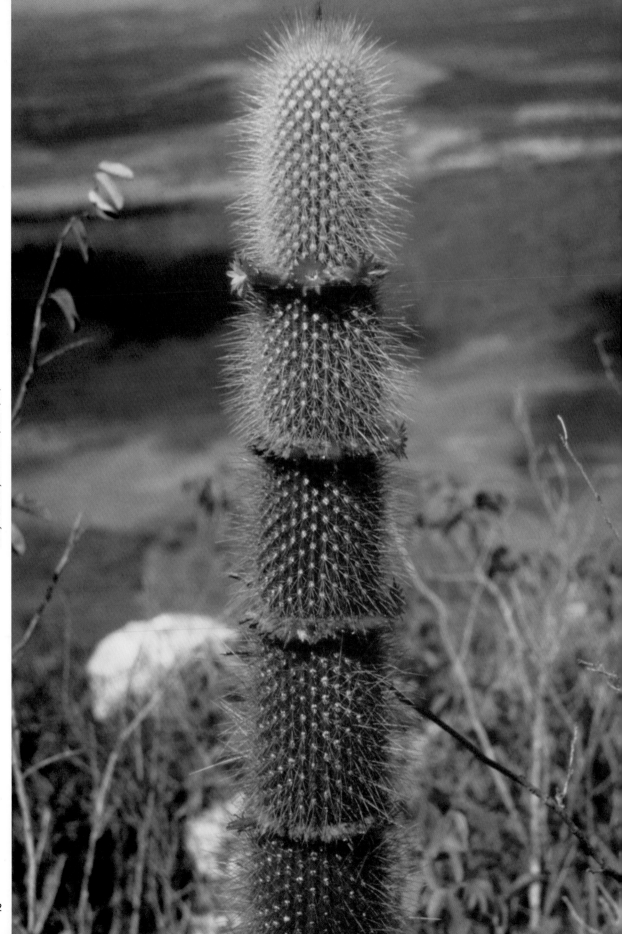

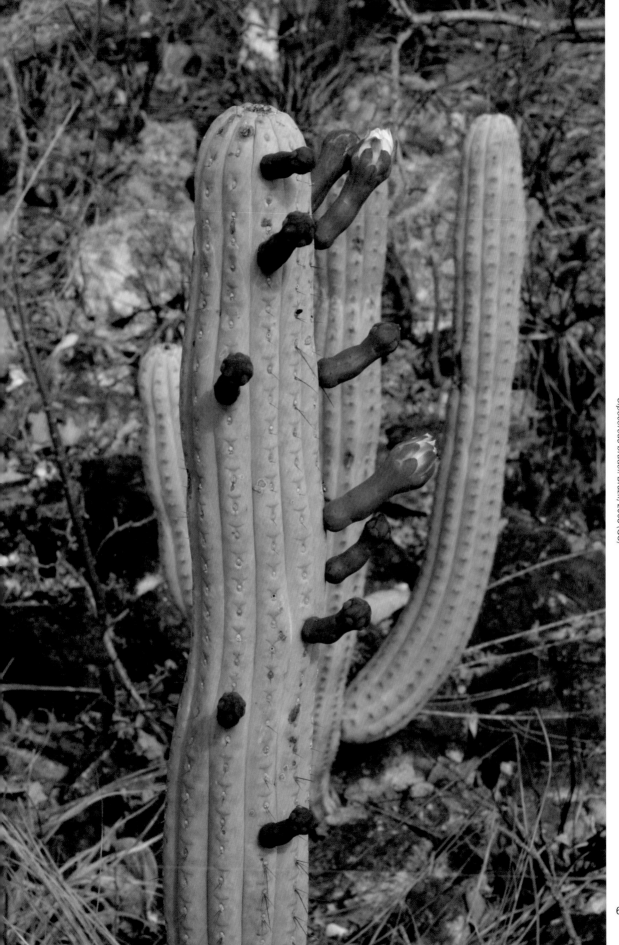

Cipocereus bradei. Brazil, 2008 (GC)

63

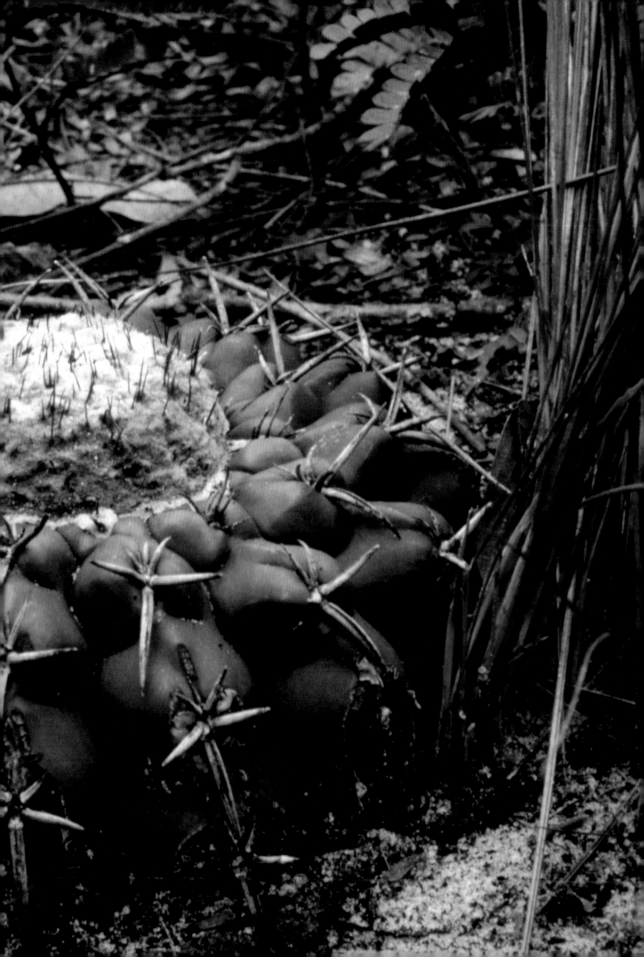

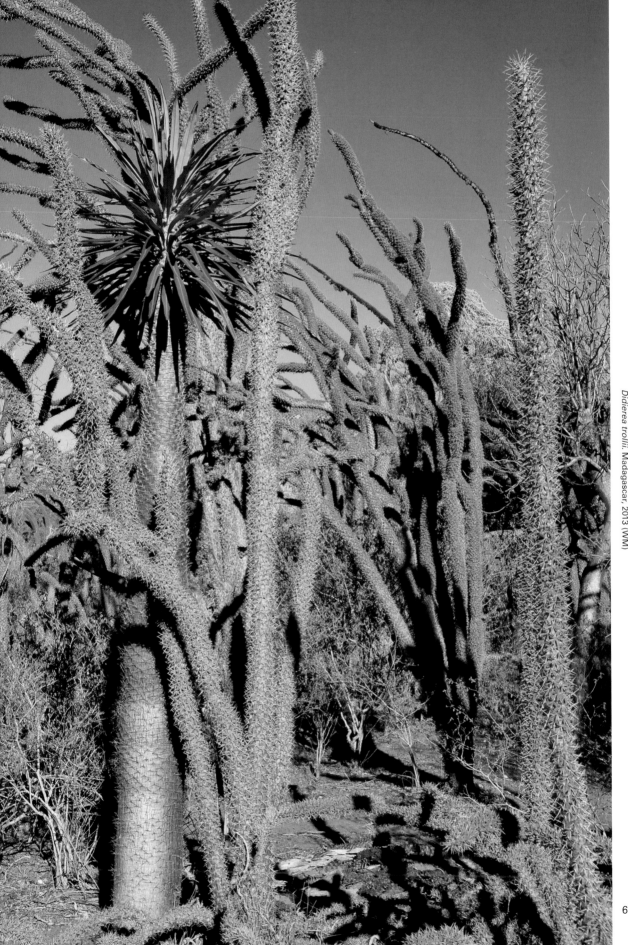

Adenium boehmianum, Namibia, 2011 (WM)

Blossfeldia liliputana. Bolivia, 2012 (ML)

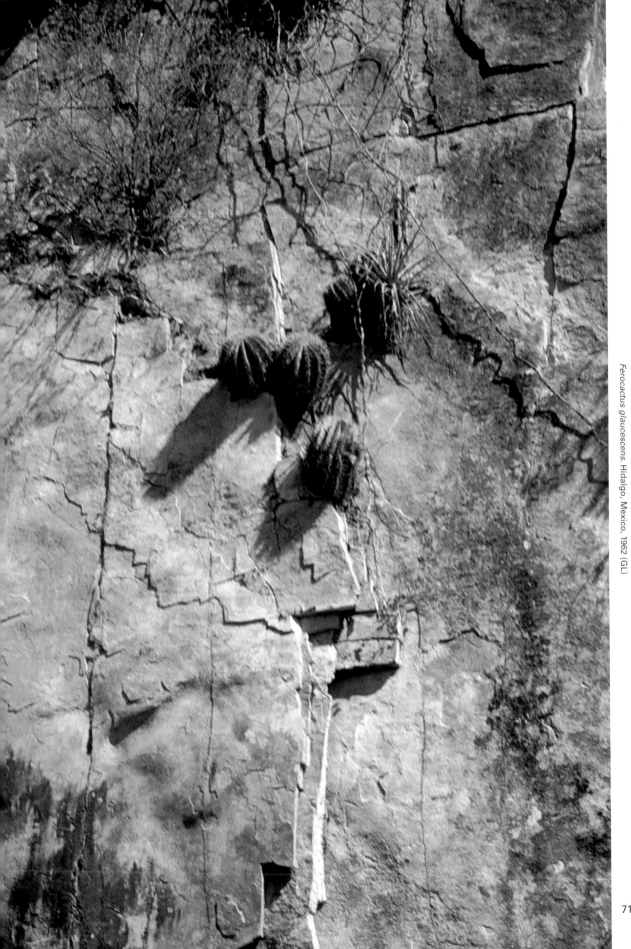

Ferocactus glaucescens. Hidalgo, Mexico, 1962 (GL)

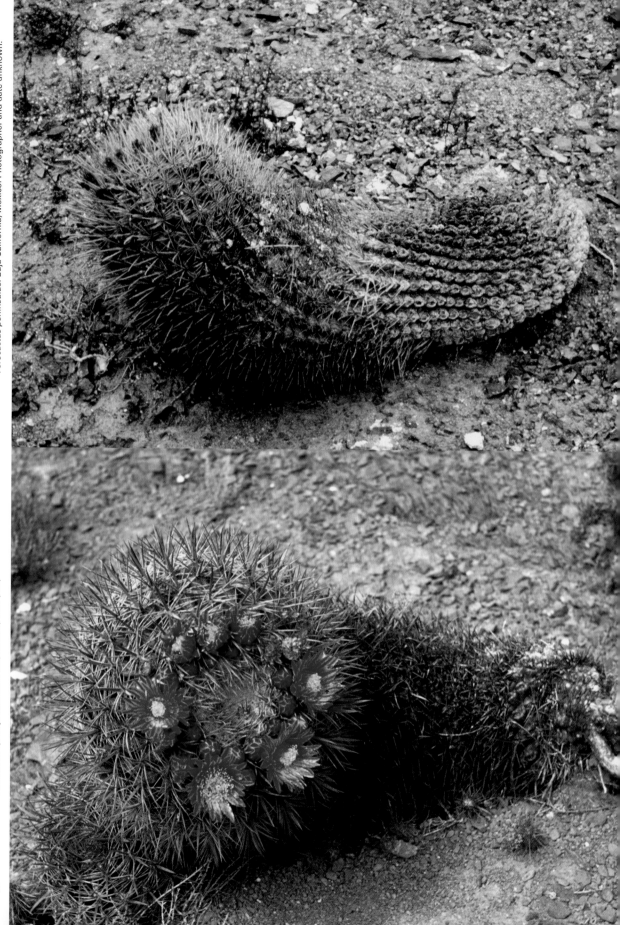

Ferocactus peninsulae. Baja California, Mexico. Photographer and date unknown.

Ferocactus sp. Baja California Sur, Mexico, 1948 (RM)

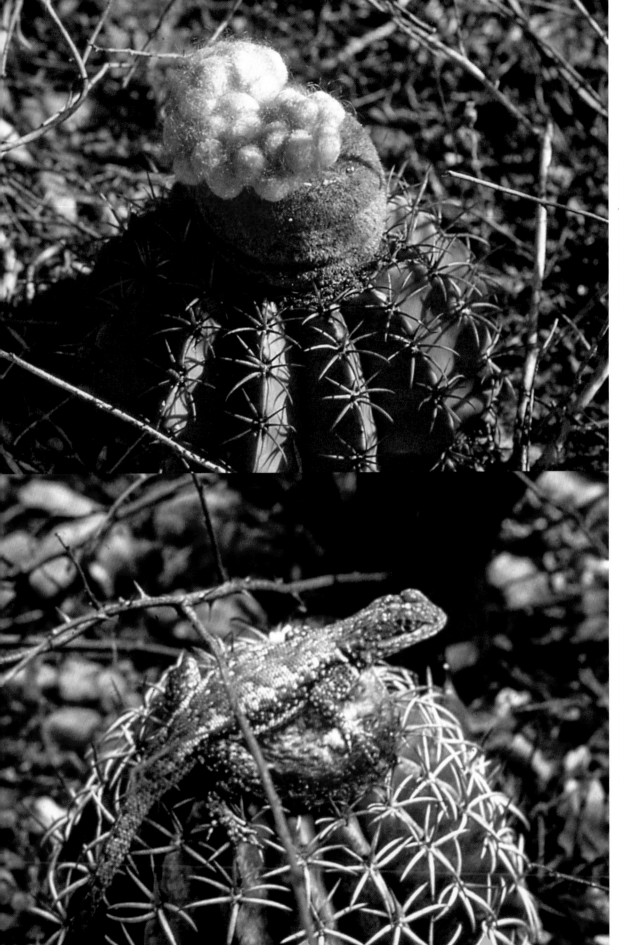

Melocactus. sp. Bahia, Brazil, 1986 (JL)

Melocactus zehntneri. Bahia, Brazil, 1986 (JL)

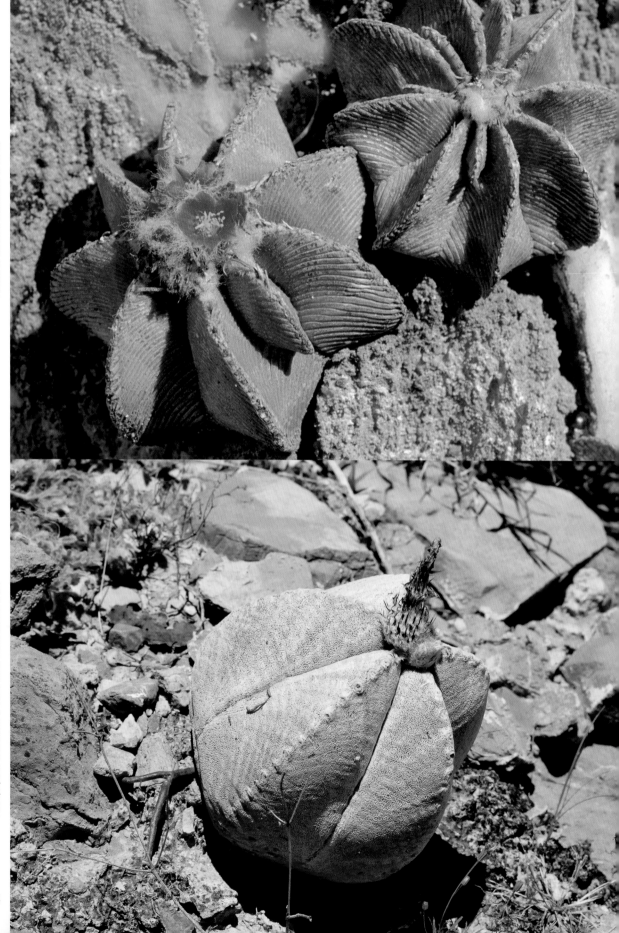

Aztekium hintonii. Mexico, 2002 (WM)

Astrophytum coahuilense. Cerro Bola, Mexico, 2015 (WM)

74

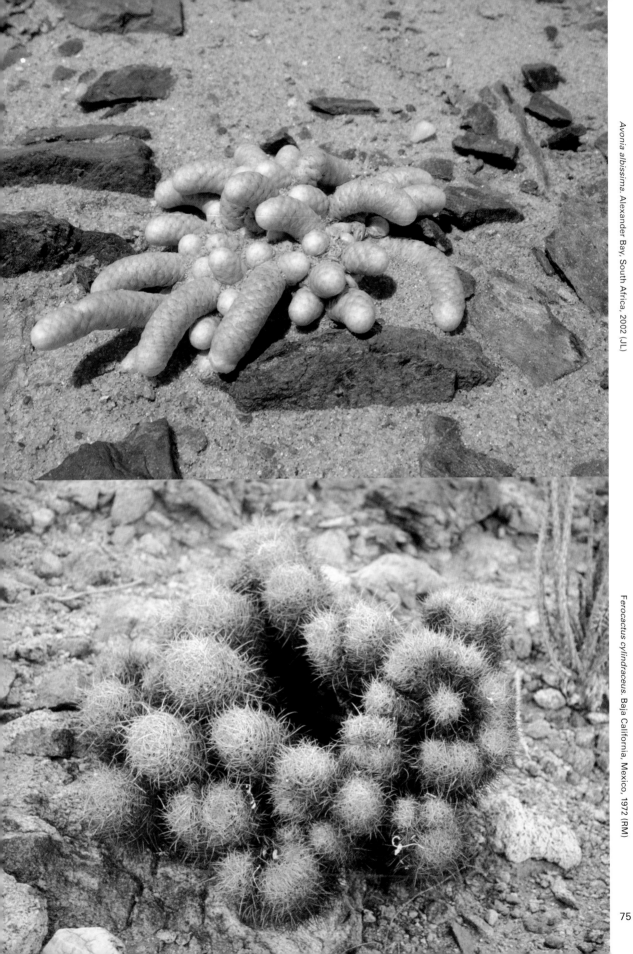

Avonia albissima. Alexander Bay, South Africa, 2002 (JL)

Ferocactus cylindraceus. Baja California, Mexico, 1972 (RM)

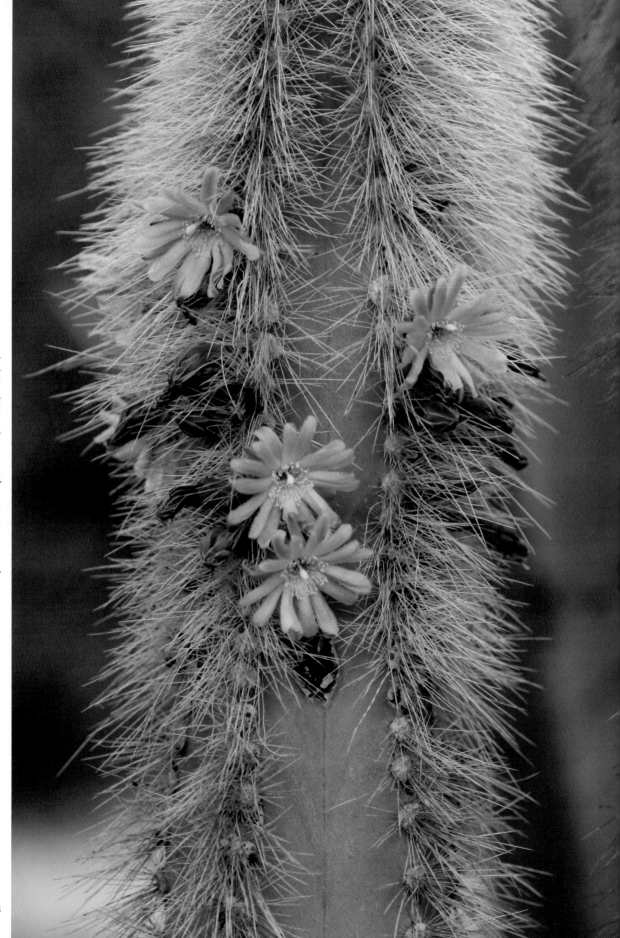

Oreocereus celsianus. Bolivia, 2011 (ML)

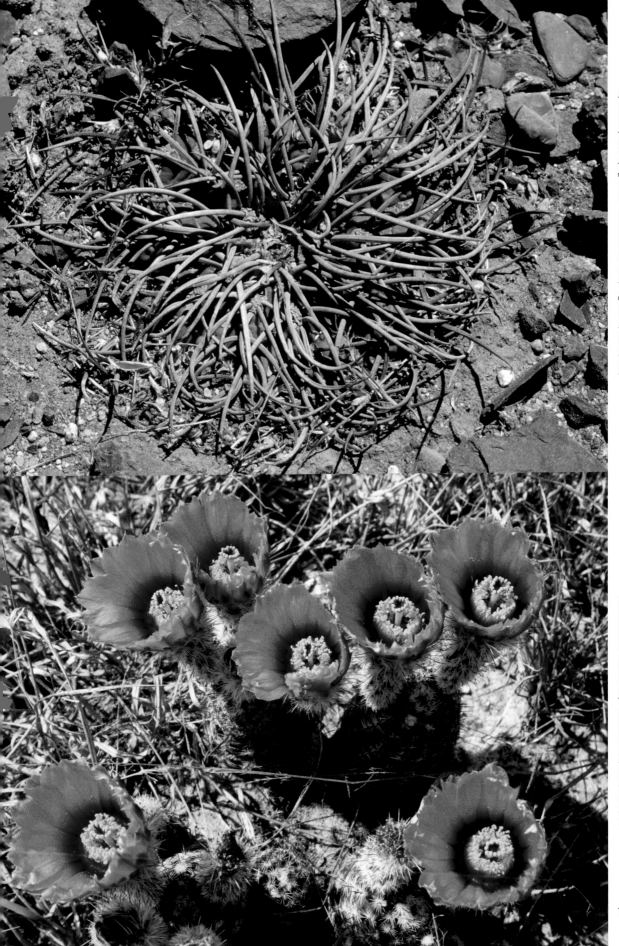

Gymnocalycium spegazzinii, Quebrada del Toro, Argentina, 2002 (WM)

Echinocereus fitchii subsp. *albertii*, Texas, USA, 2011 (PB)

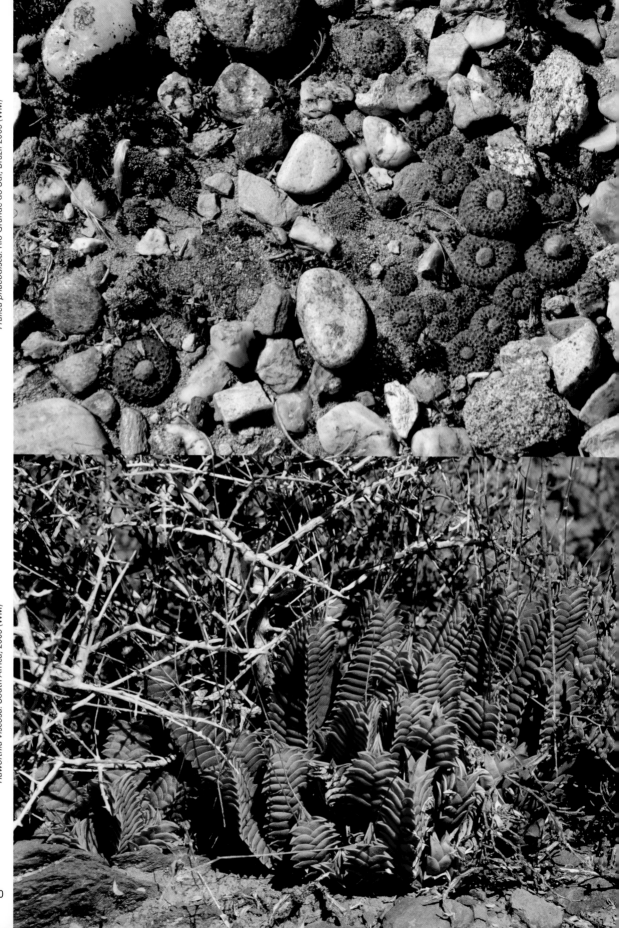

Frailea phaeodisca. Rio Grande do Sul, Brazil 2009 (WM)

Haworthia viscosa. South Africa, 2009 (WM)

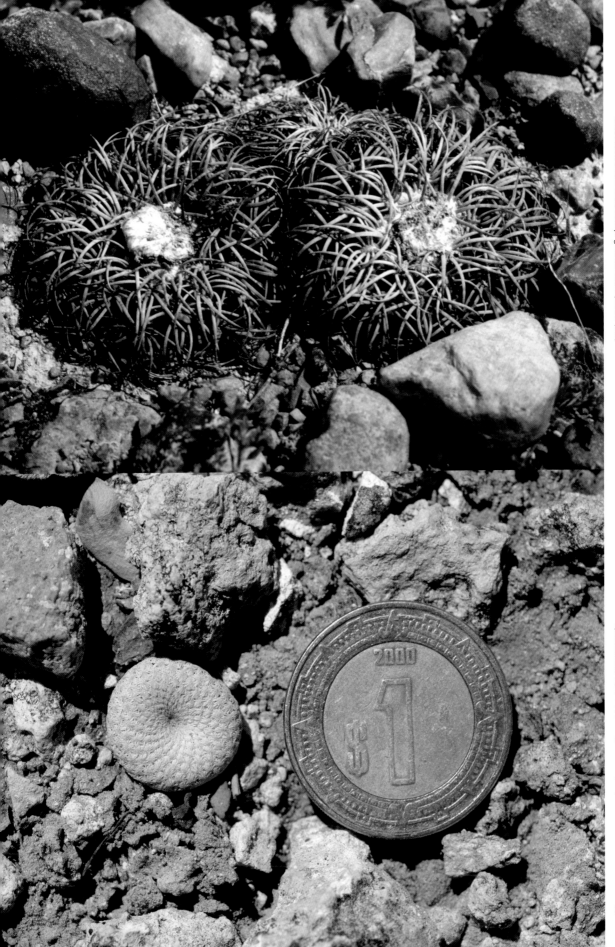

Discocactus bahiensis subsp. *gracilis*, Brazil, 2000 (GC)

Epithelantha bokei, Coahuila, Mexico (HH)

81

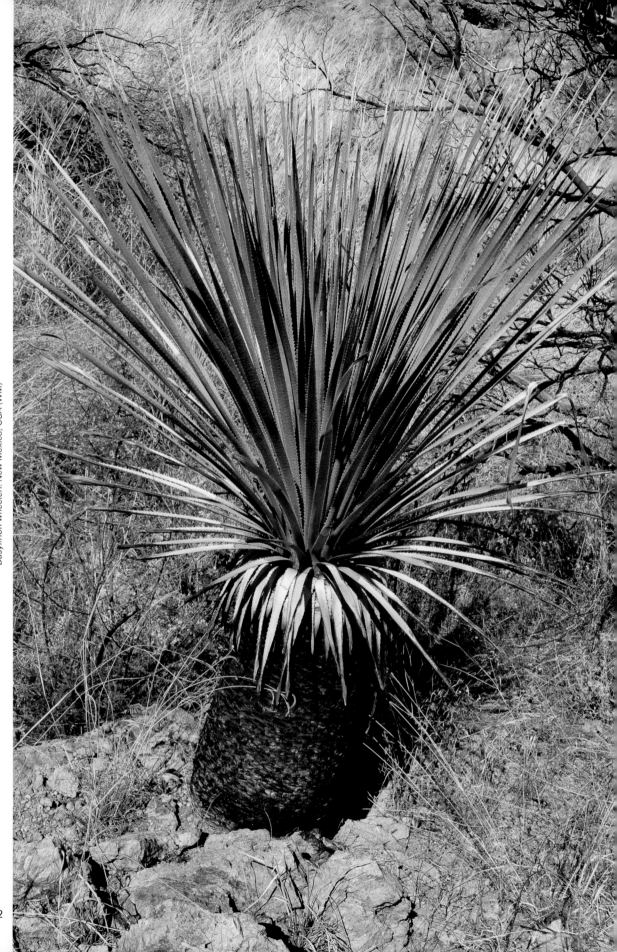

Dasylirion wheeleri. New Mexico, USA (WM)

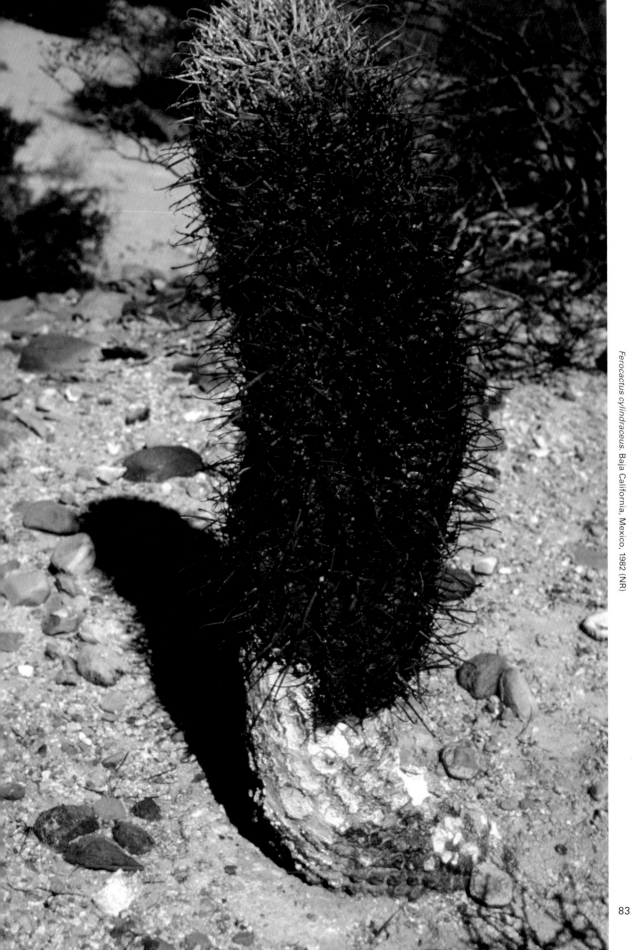

Ferocactus cylindraceus, Baja California, Mexico, 1982 (NR)

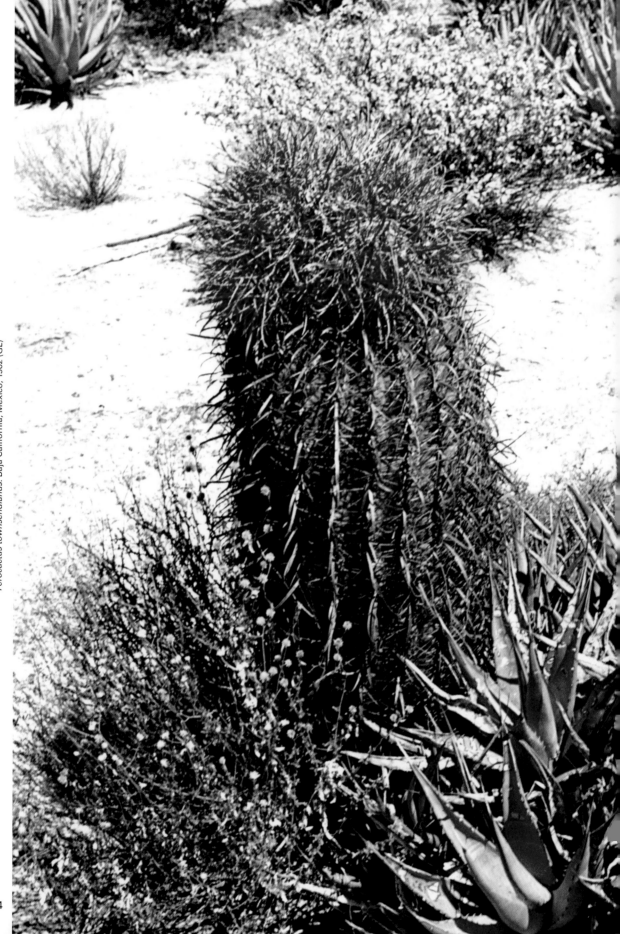

Ferocactus townsendianus. Baja California, Mexico, 1962 (GL)

Ferocactus diguetii. Baja California, Mexico. Photographer and date unknown.

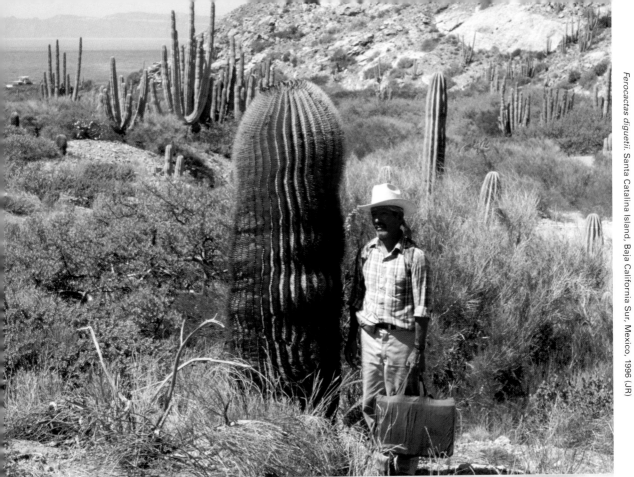

Ferocactus diguetii, Santa Catalina Island, Baja California Sur, Mexico, 1996 (JR)

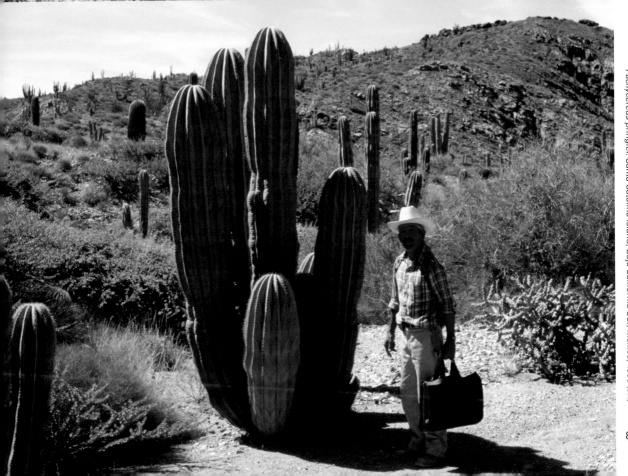

Pachycereus pringlei, Santa Catalina Island, Baja California Sur, Mexico, 1996 (JR)

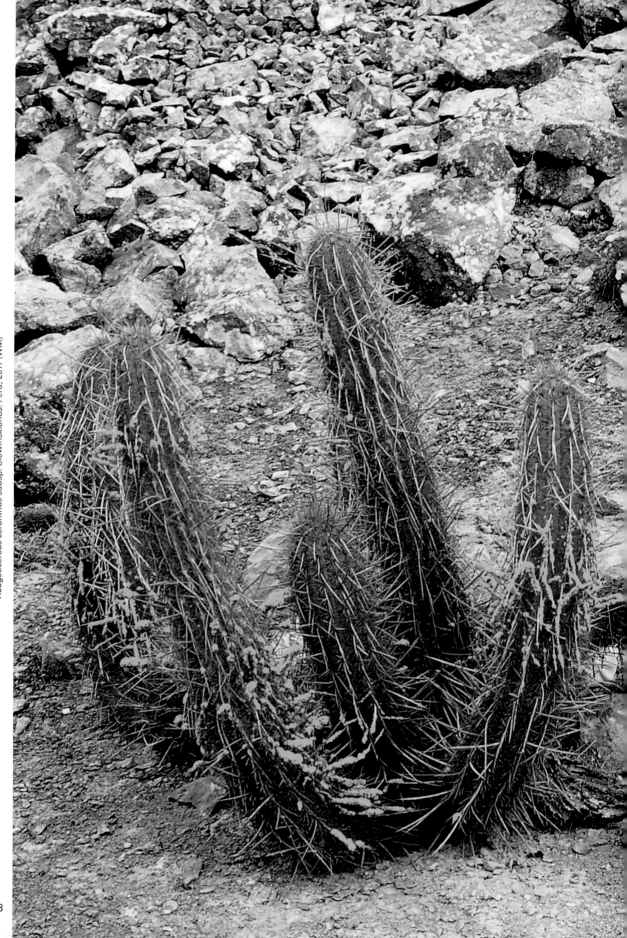

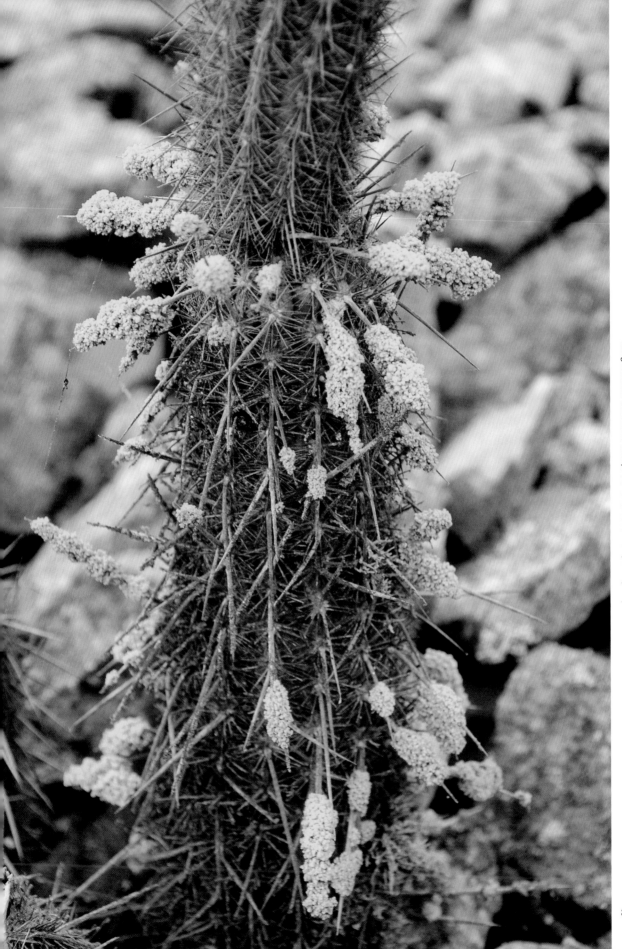

Haageocereus acranthus subsp. *olowinskianus*, Peru, 2011 (WM)

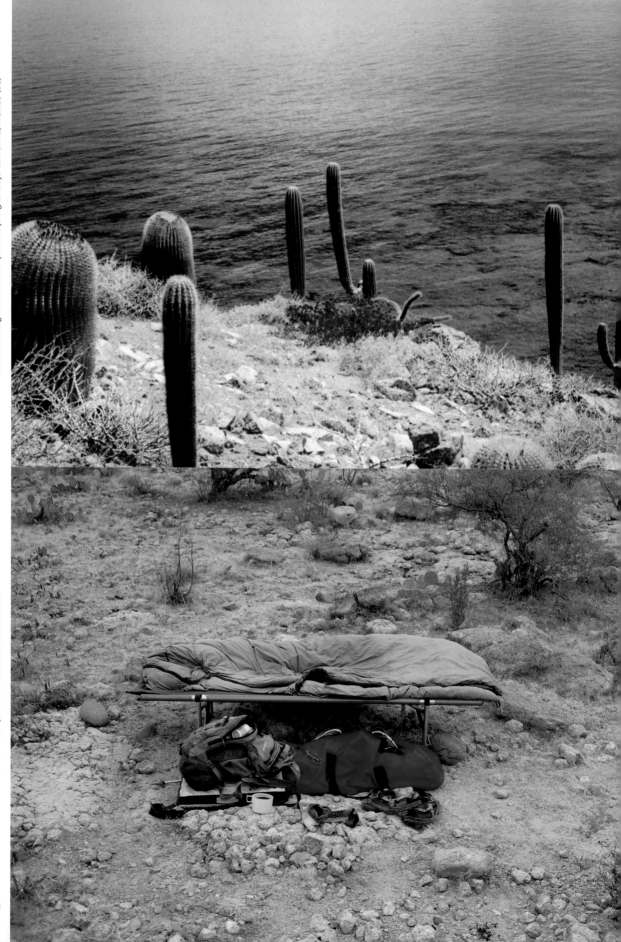

Ferocactus diguetii and Pachycereus pringlei. Baja California, Mexico (JL)

Sierra de la Libertad, Baja California, Mexico, 2009 (JR)

Bahia de Los Angeles, Baja California, 2013 (JR)

Copiapoa tenebrosa and Euphorbia lactiflua. Mt. Perales, Chile, 1997 (WM)

Cylindropuntia fulgida. Arizona, USA, date unknown (GL)

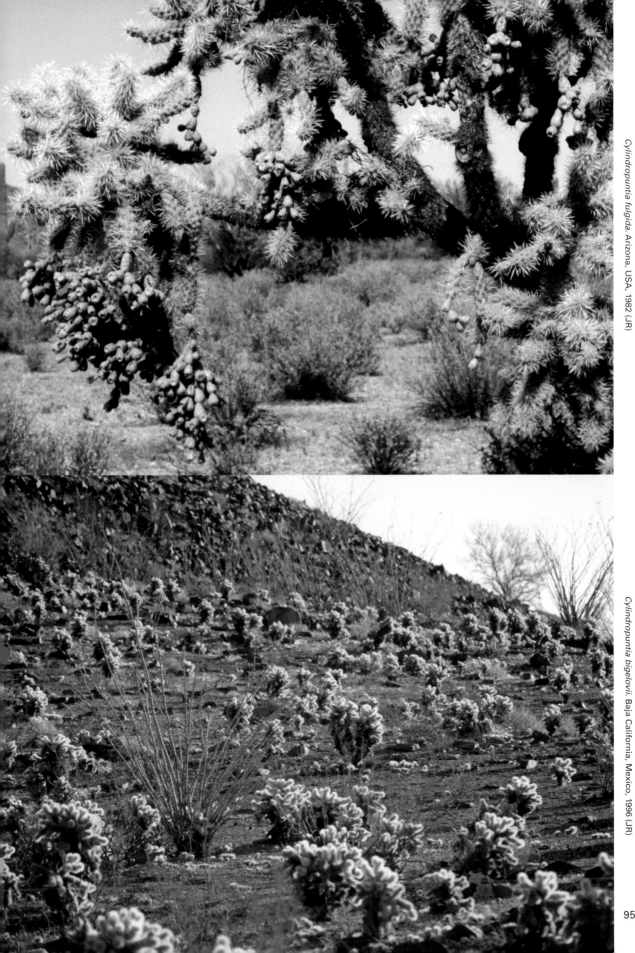

Cylindropuntia fulgida. Arizona, USA, 1982 (JR)

Cylindropuntia bigelovii. Baja California, Mexico, 1996 (JR)

95

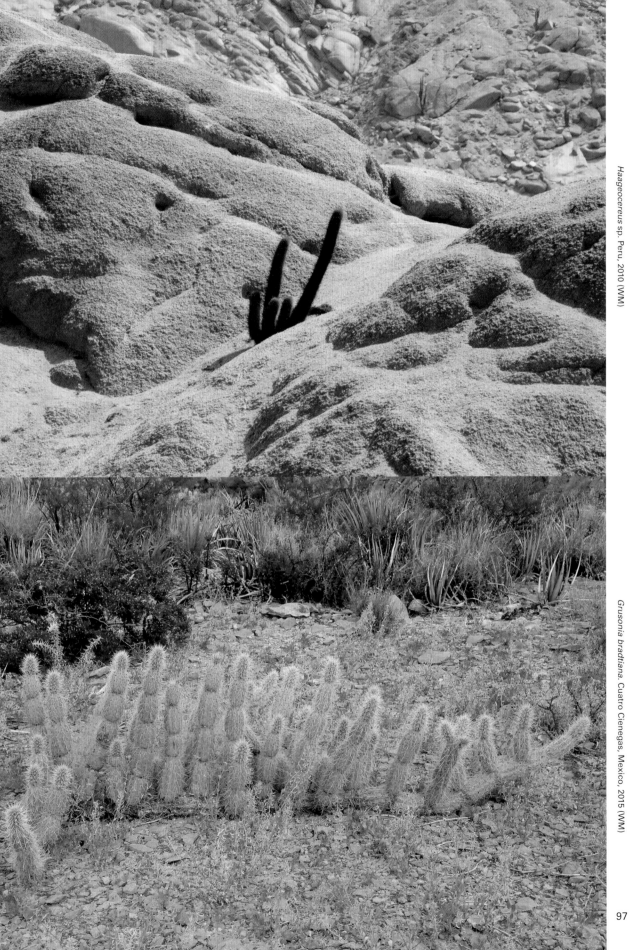

Haageocereus sp. Peru, 2010 (WM)

Grusonia bradtiana. Cuatro Cienegas, Mexico, 2015 (WM)

Fouquieria columnaris. Baja California, Mexico, 1973 (RM)

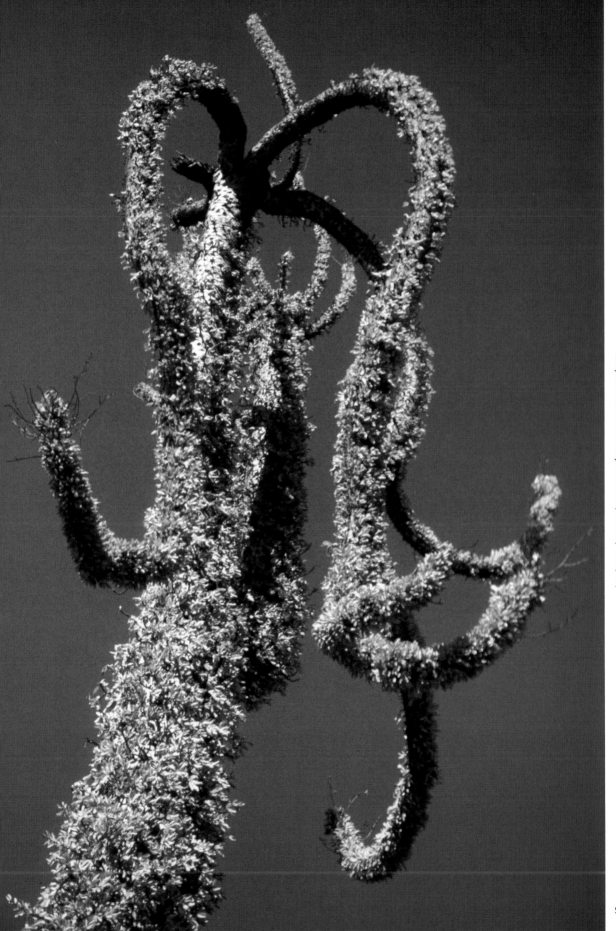

Fouquieria columnaris, Baja California, Mexico, 1973 (RM)

Fouquieria columnaris. Baja California, Mexico, 1973 (RM)

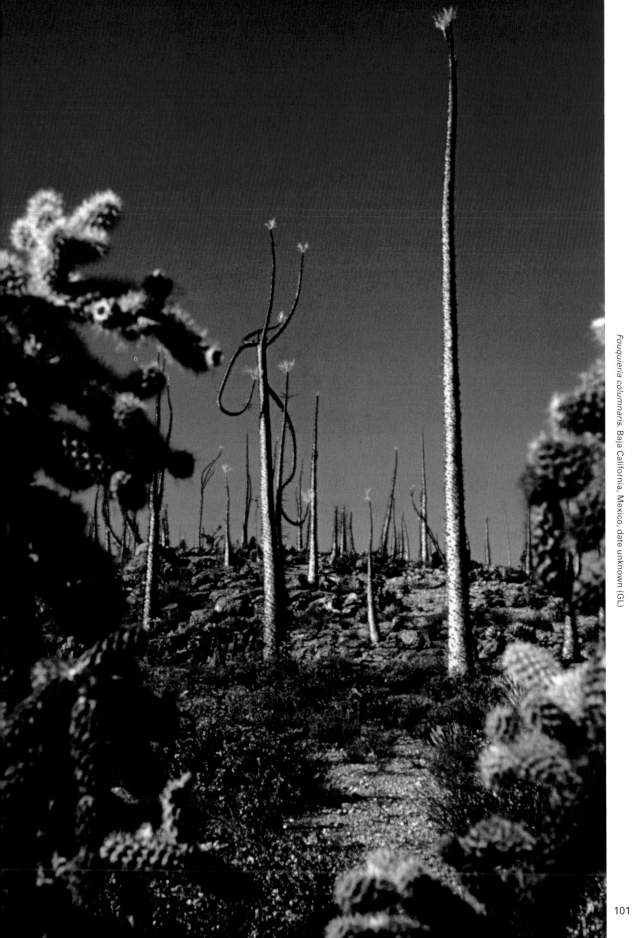

Fouquieria columnaris, Baja California, Mexico, date unknown (GL)

Brachycereus nesioticus. Fernandina, Galápagos Islands, 2009 (RG)

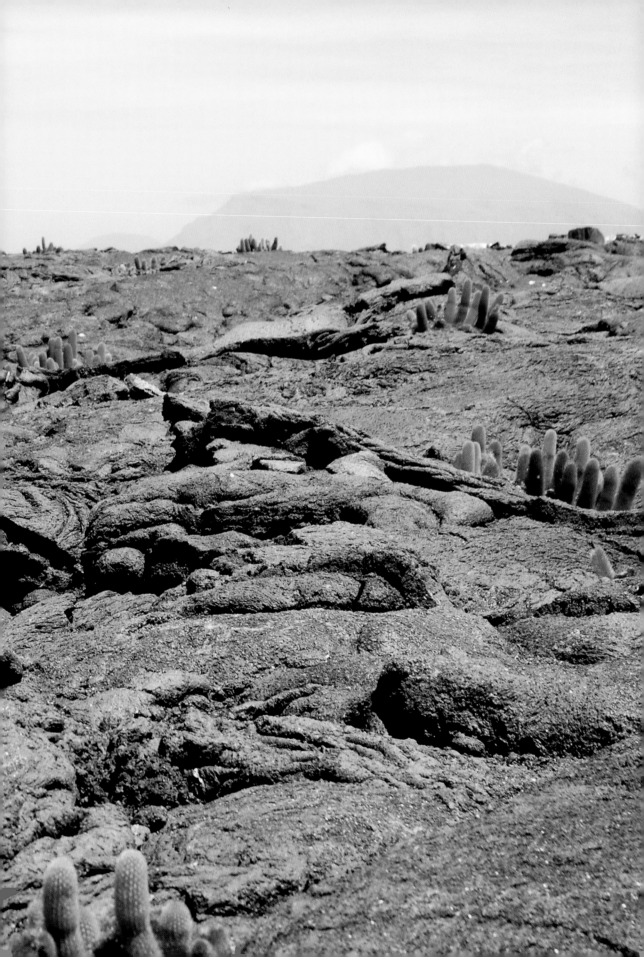

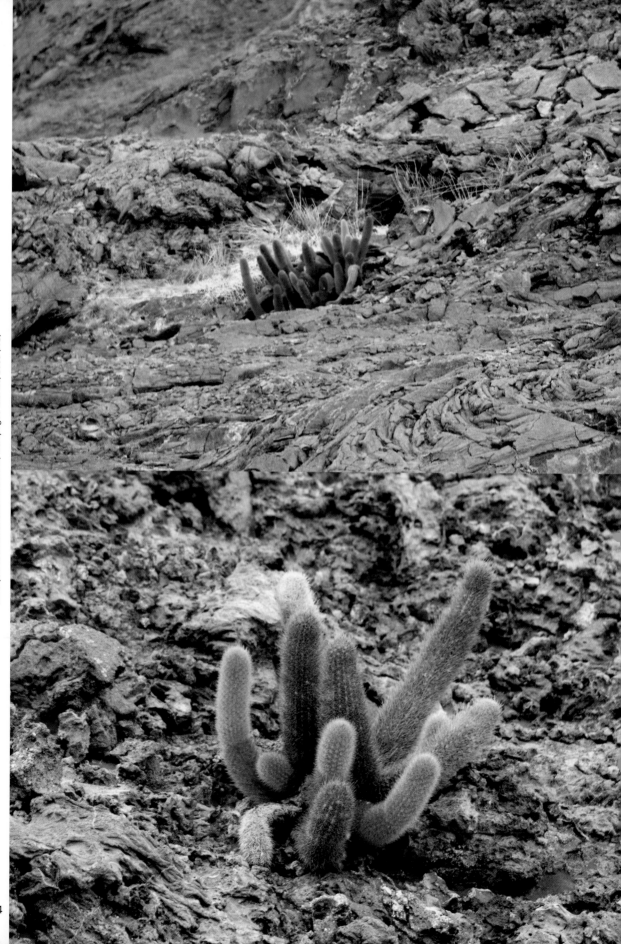

Brachycereus nesioticus. Bartolome, Galápagos Islands, 2009 (RG)

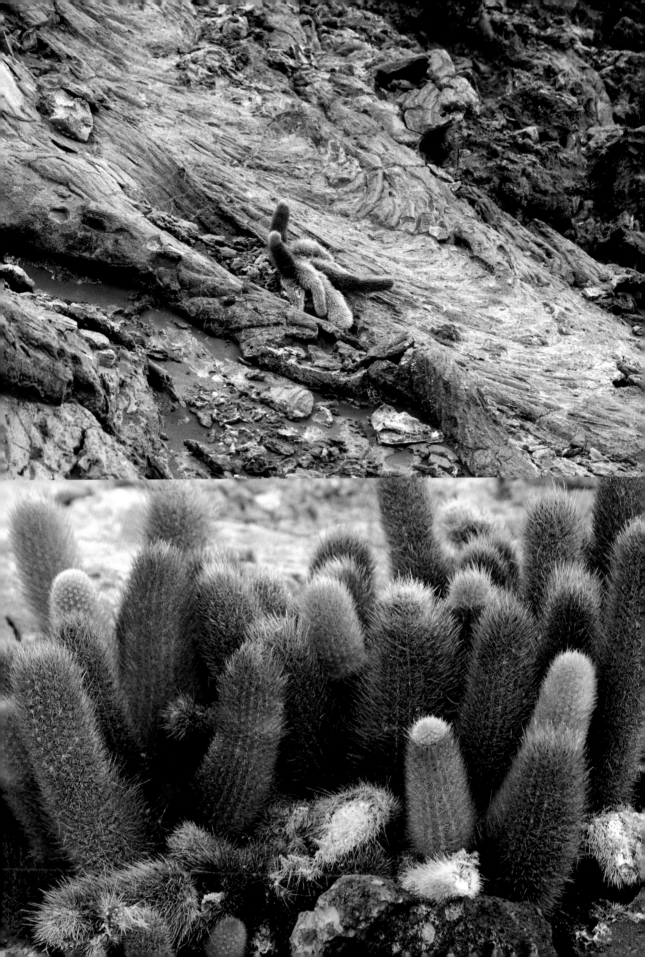

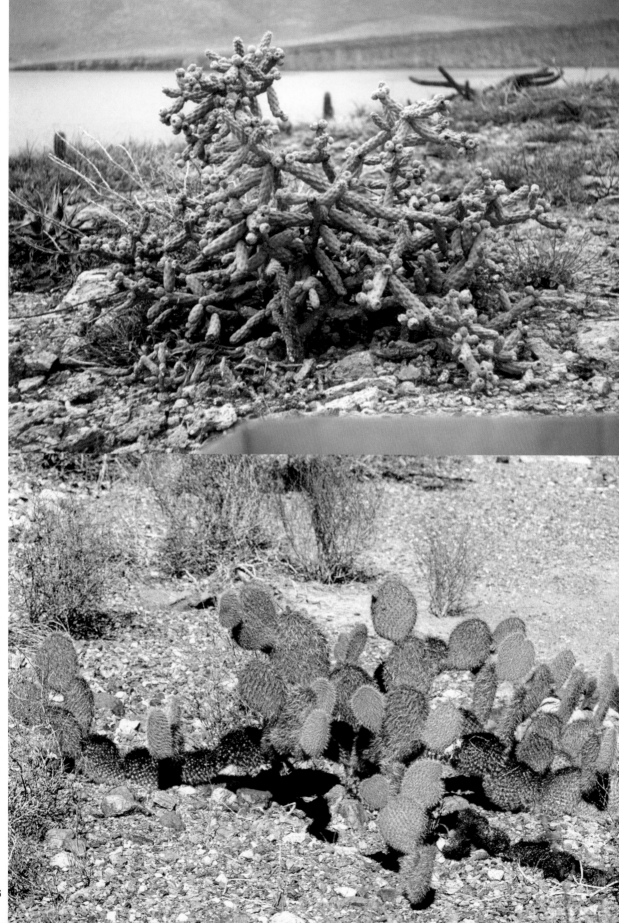

Cylindropuntia alcahes. Baja California, Mexico (GL)

Opuntia pycnantha. Baja California Sur, Mexico, 1998 (JR)

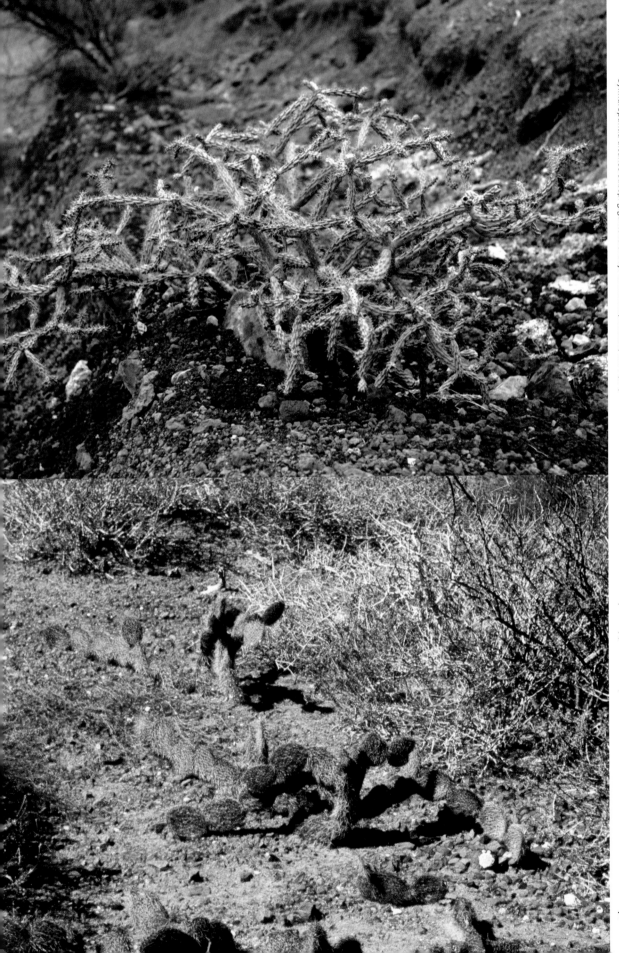

Cylindropuntia alcahes subsp. *gigantensis*, Baja California, Mexico, 1994 (JR)

Opuntia pycnantha, Baja California Sur, Mexico, 1998 (JR)

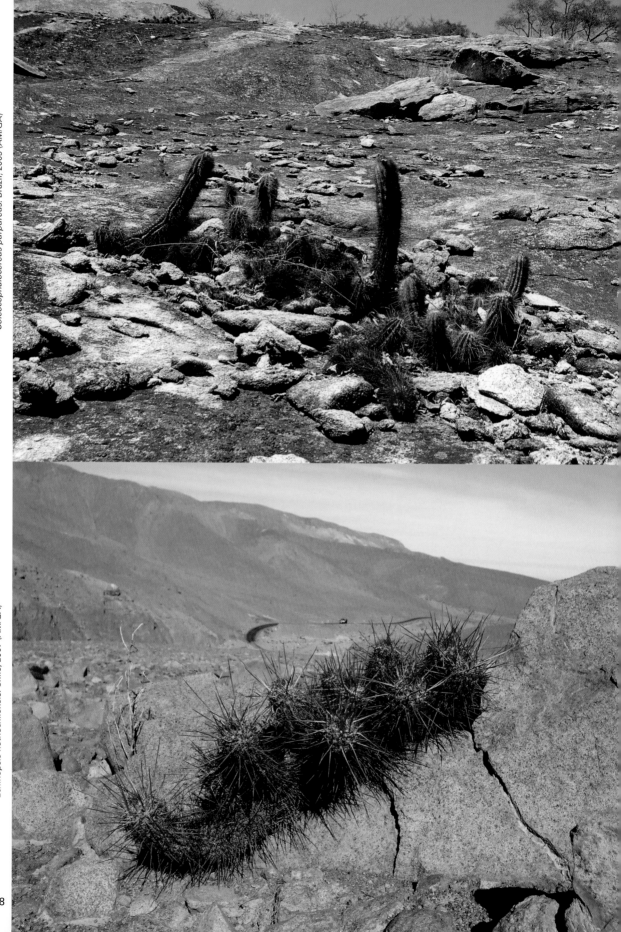

Coleocephalocereus purpureus. Brazil, 2009 (AM/GA)

Echinopsis nothochilensis. Chile, 2007 (AM/GA)

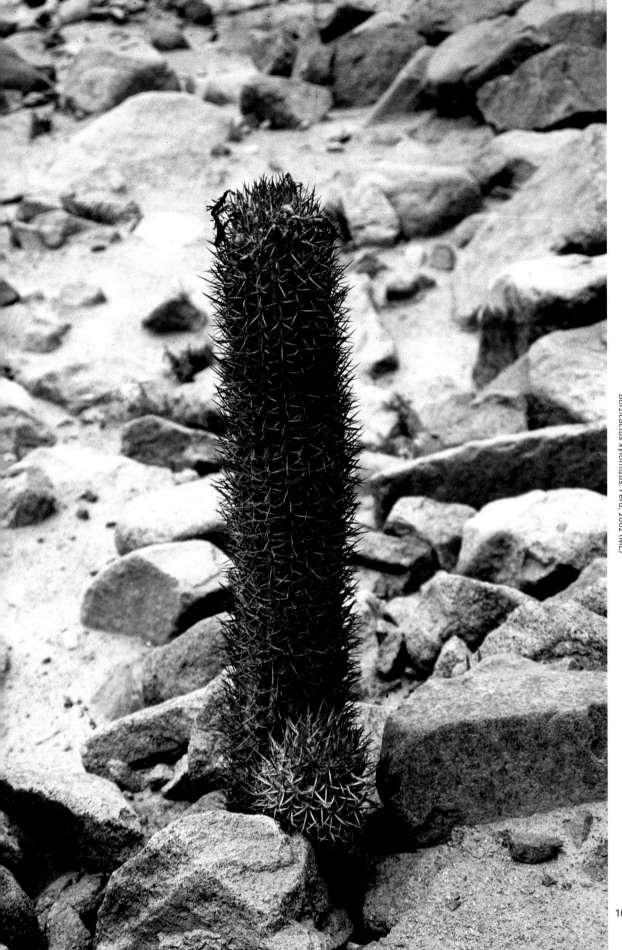

Borzicactus xylorhizus, Peru, 2002 (ML)

Gymnocalycium schickendantzii. Argentina, 1996 (GC)

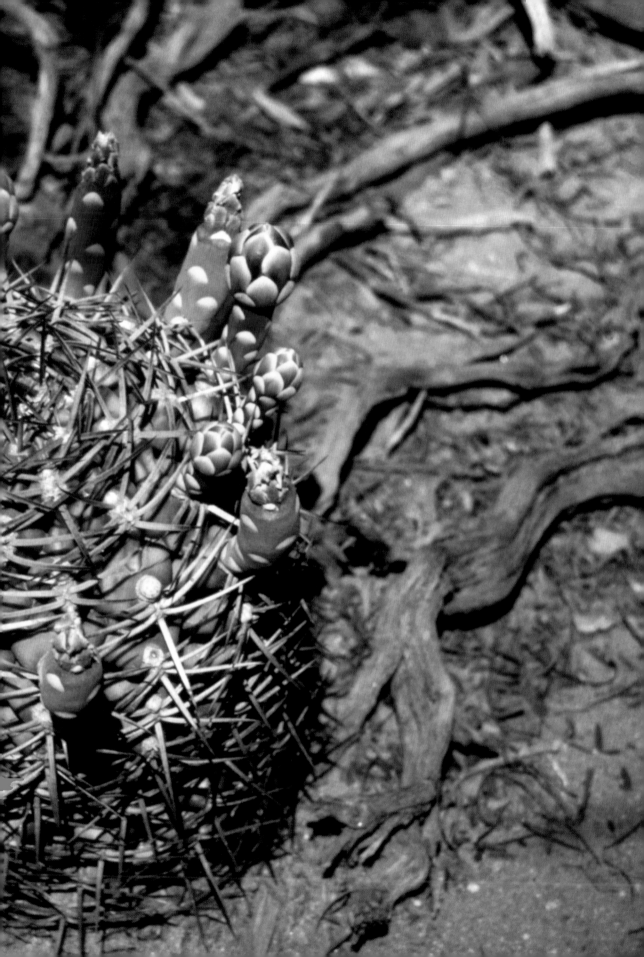

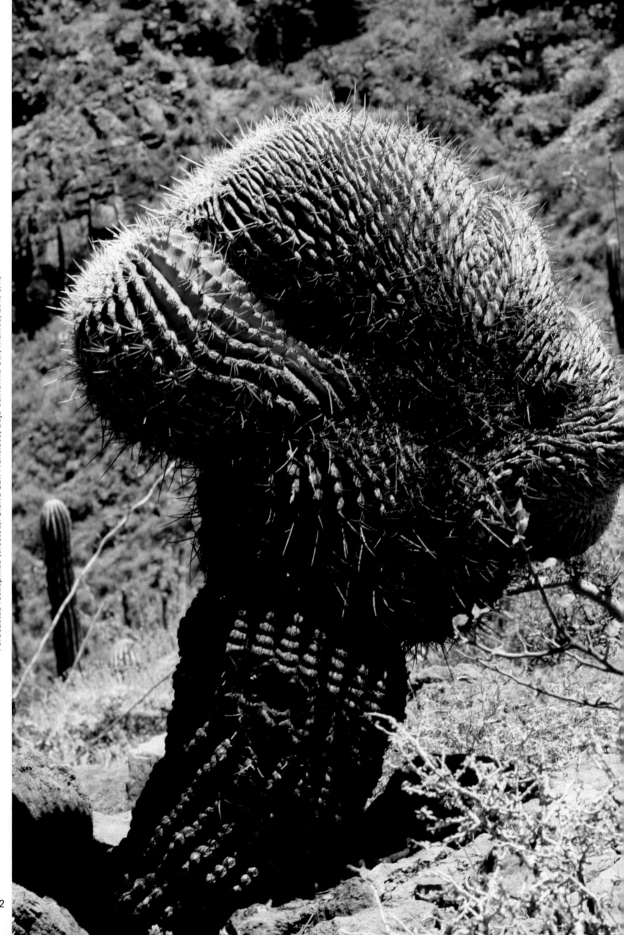

Ferocactus rectispinus (crested). Sierra San Francisco, Baja California Sur, Mexico, 2010 (JR)

Ferocactus rectispinus. Sierra San Francisco, Baja California Sur, Mexico, 2010 (JR)

114

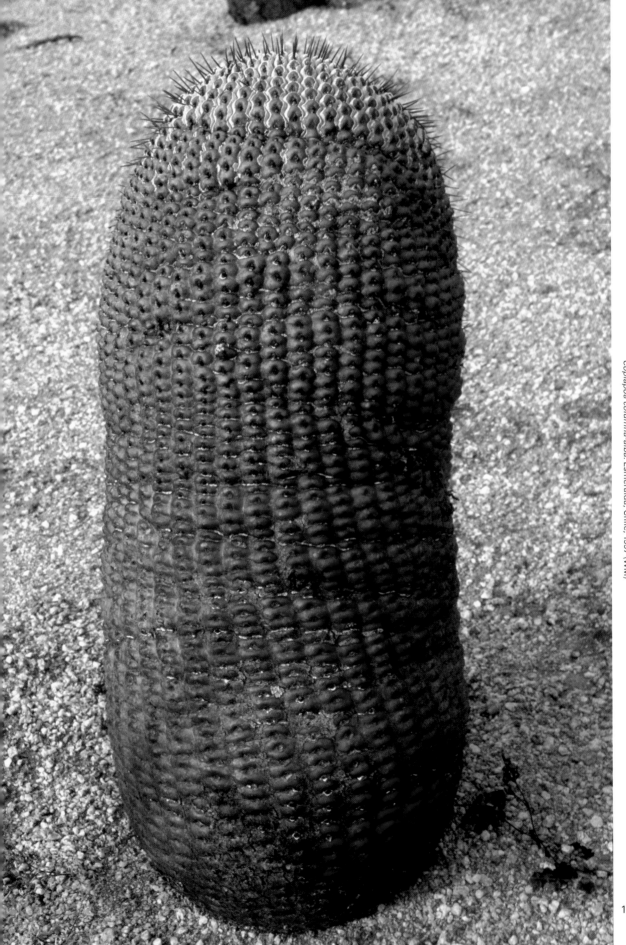

Echinopsis deserticola. Chile, 1999 (GC)

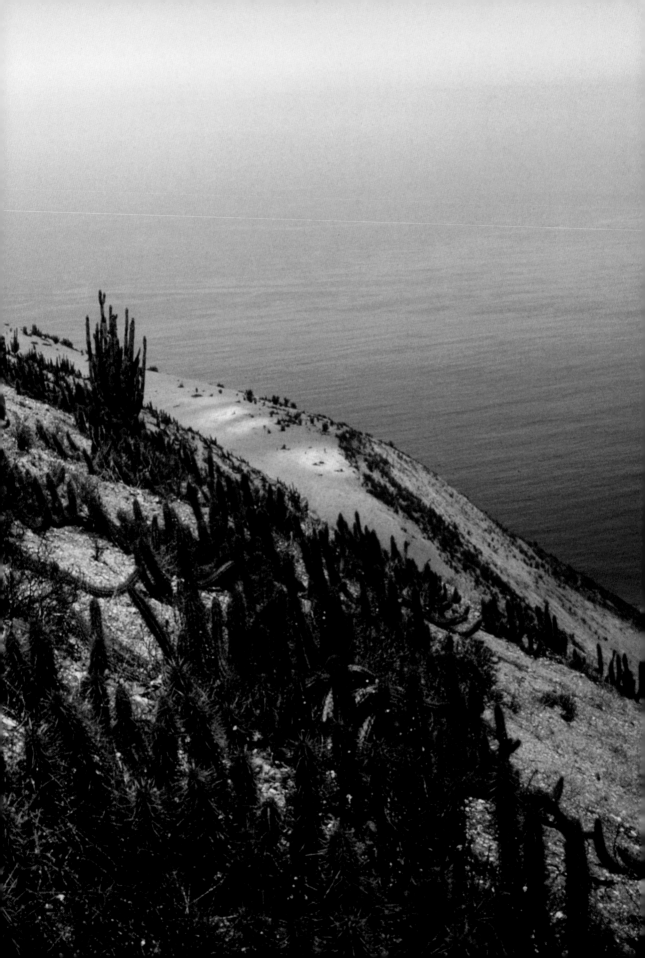

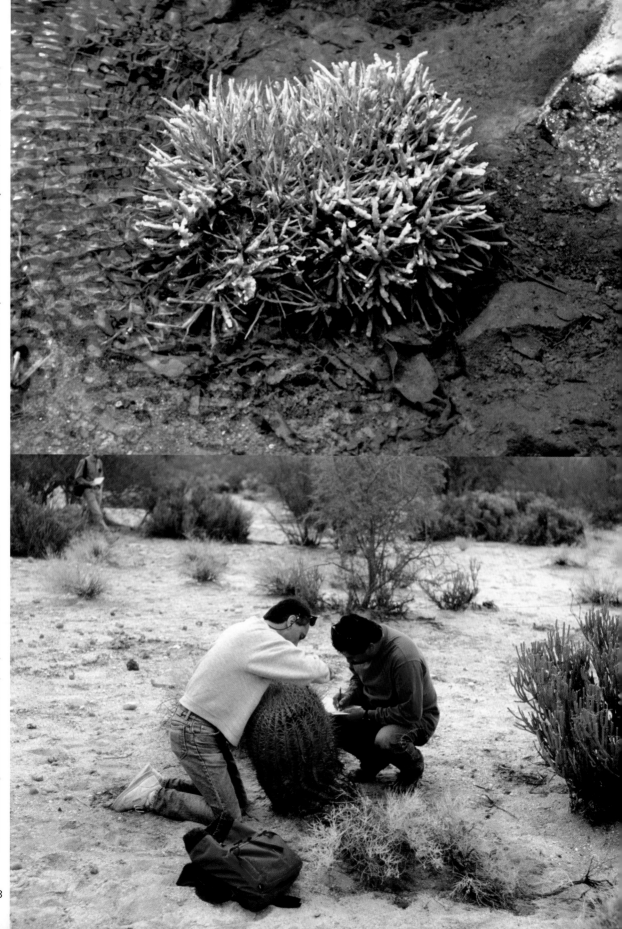

Ferocactus "aquaticus." Cedros Island, Baja California, Mexico, 1974 (RM)

Drs. Cota and Delgadillo with *Ferocactus* sp. Baja California, Mexico, 1995 (JR)

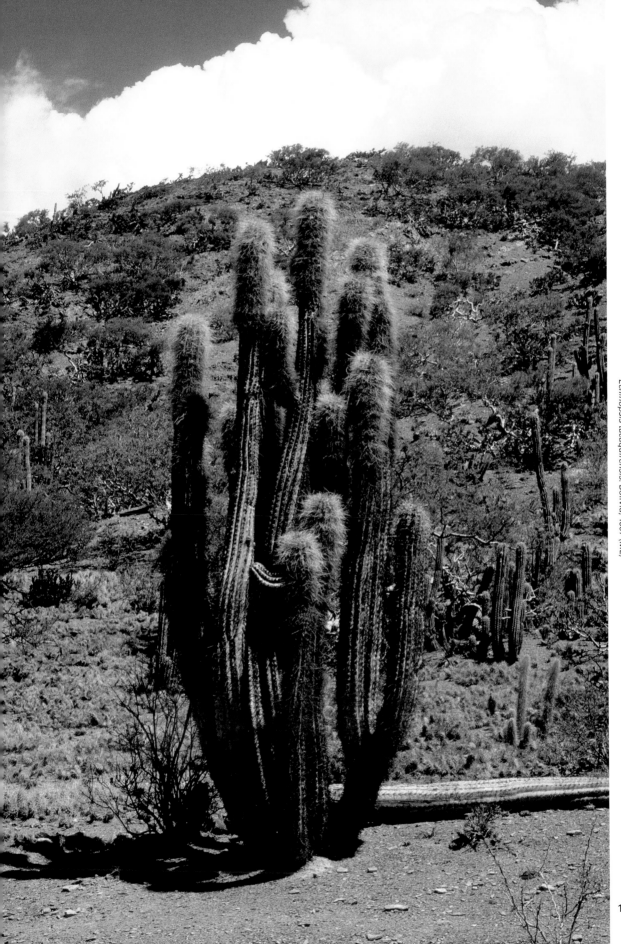

Echinopsis tacaquirensis. Bolivia, 1997 (ML)

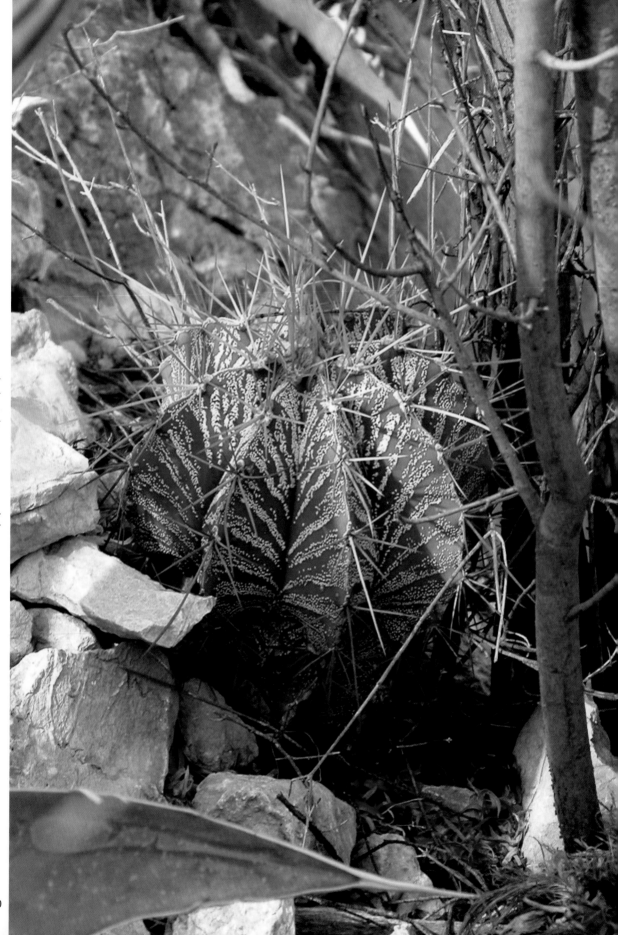

Astrophytum ornatum. Mexico, 2004 (HH)

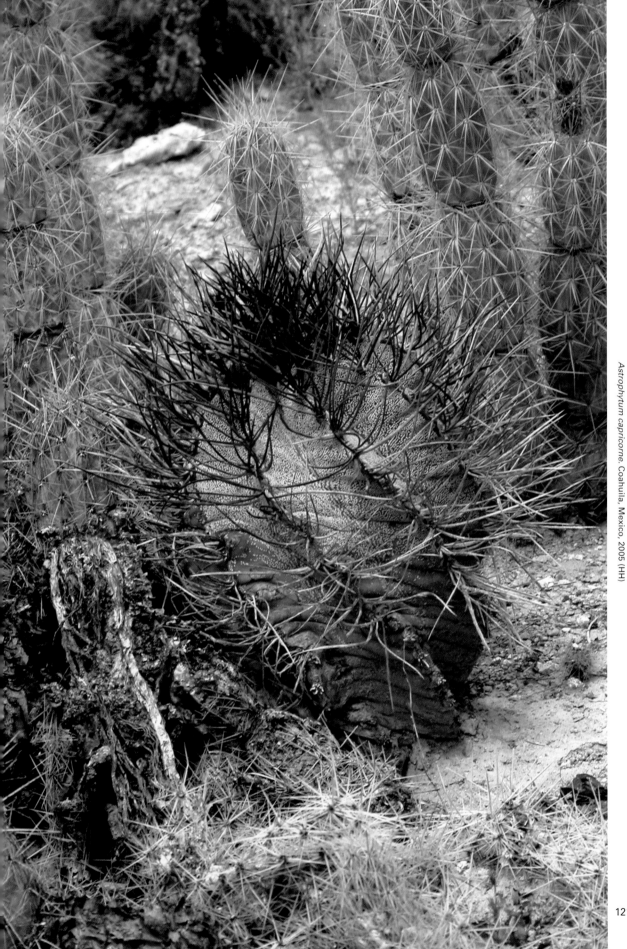

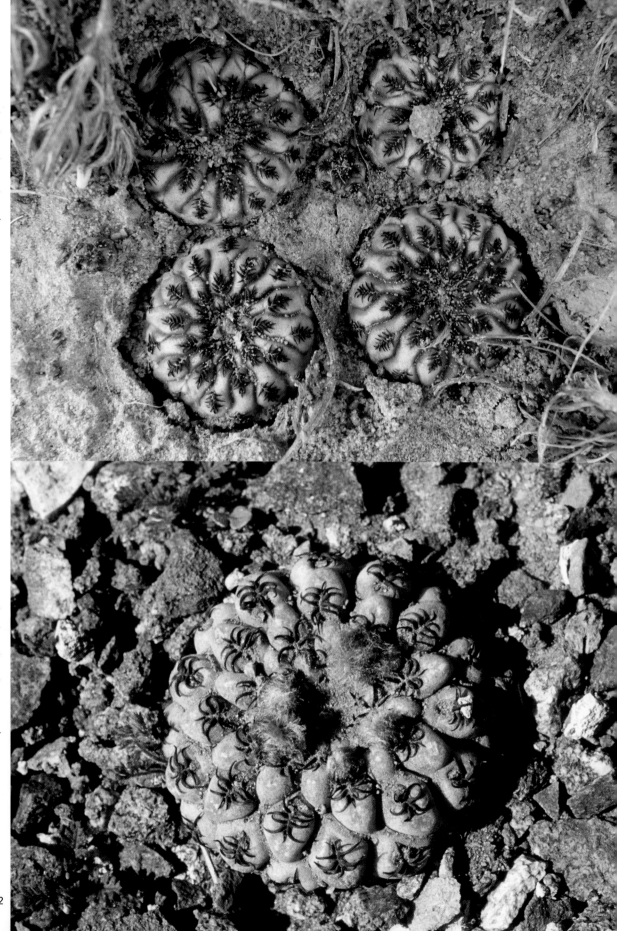

Sulcorebutia rauschii. Chuquisaca, Bolivia, 2015. (MW)

Neochilenia napina. Huasco, Chile, 1997. (WM)

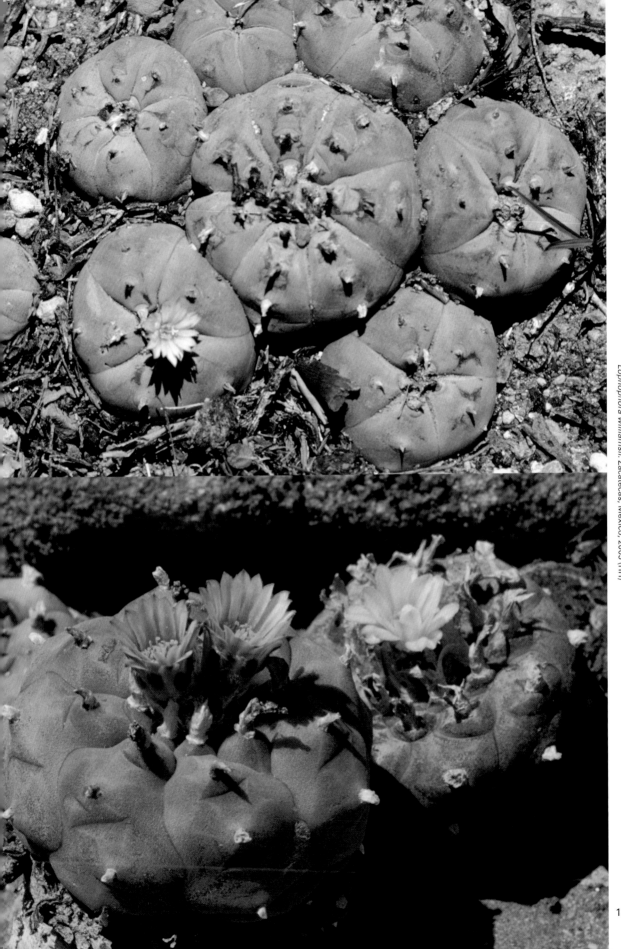

Lophophora williamsii, Zacatecas, Mexico, 2005 (HH)

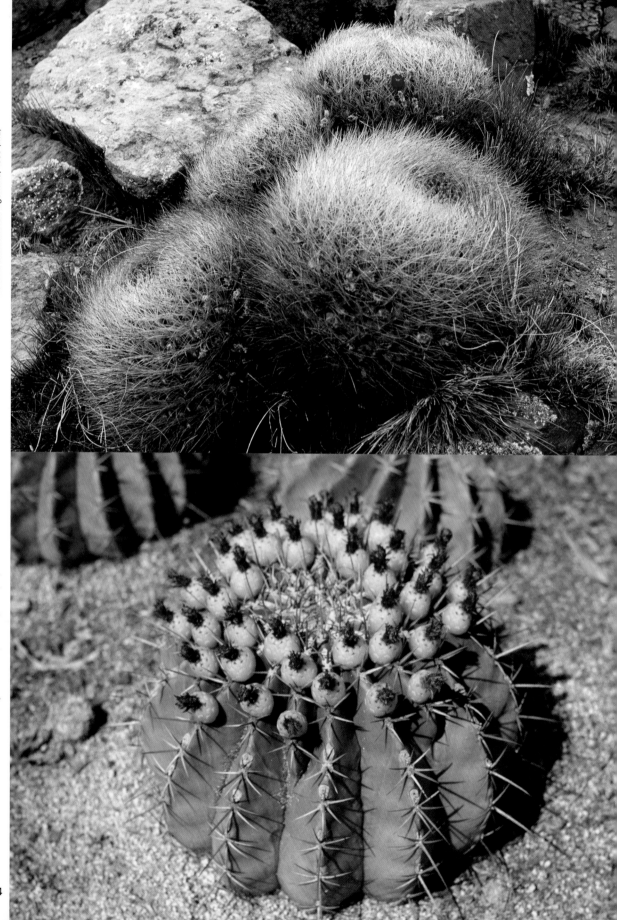

Lobivia minutiflora. Argentina, 1999 (ML)

Ferocactus alamosanus. Baja California, Mexico, 1968 (GL)

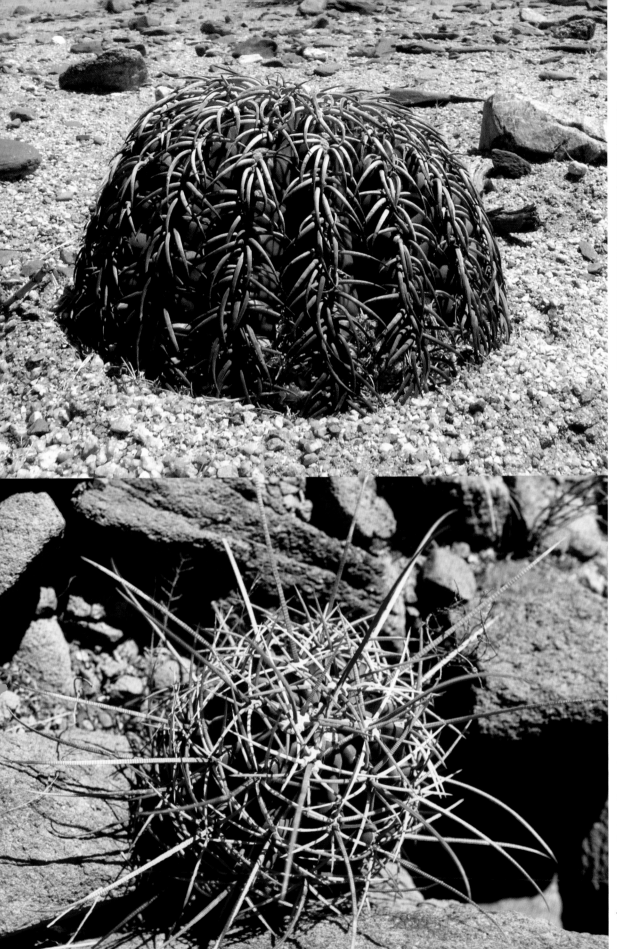

Gymnocalycium spegazzinii. Salta, Argentina, date unknown (MT)

Ferocactus rectispinus. Baja California Sur, Mexico, 1975 (GL)

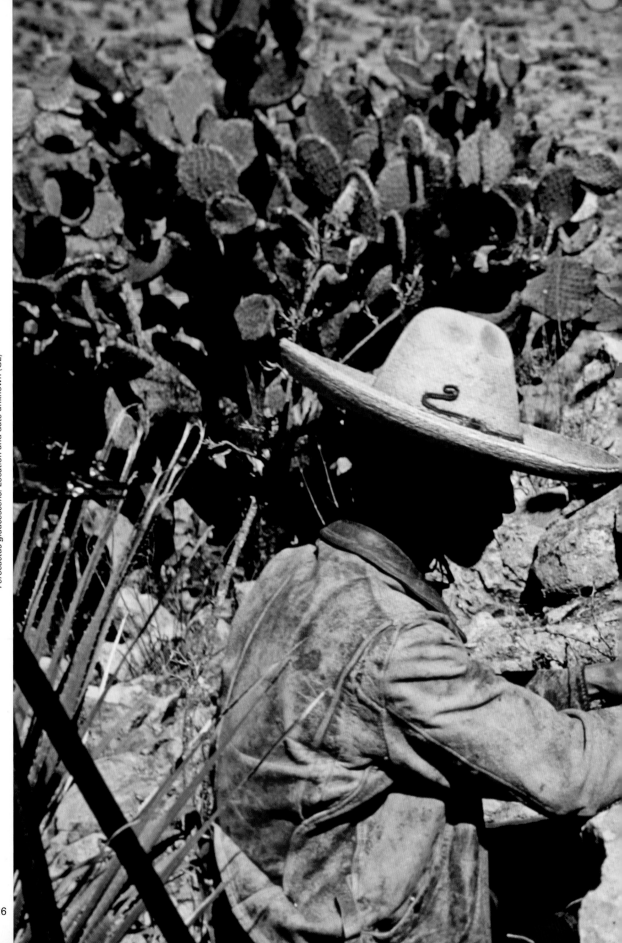

Ferocactus glaucescens. Location and date unknown (GL)

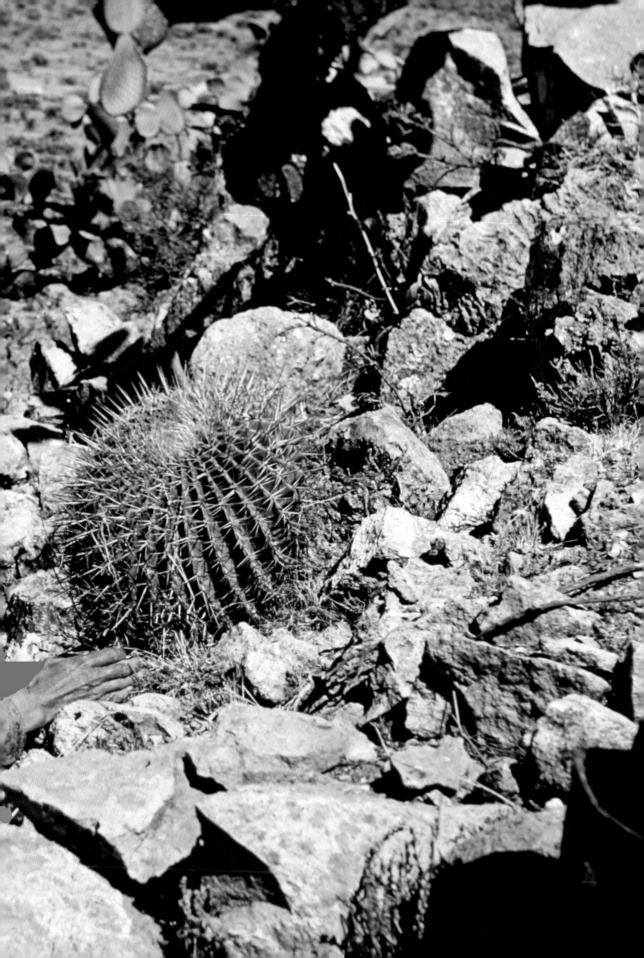

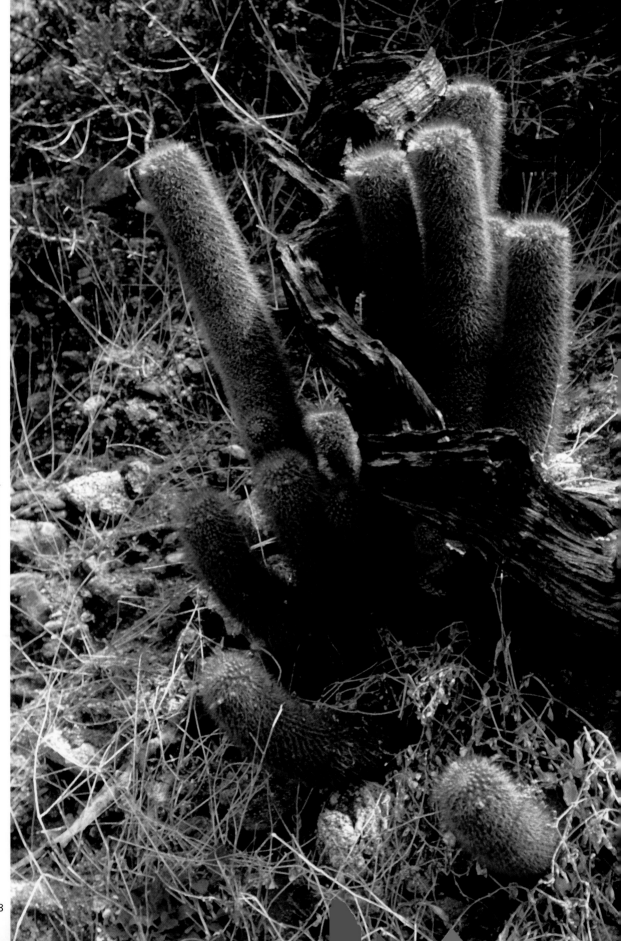

Mammillaria cerralboa. Baja California Sur, Mexico, 1965 (GL)

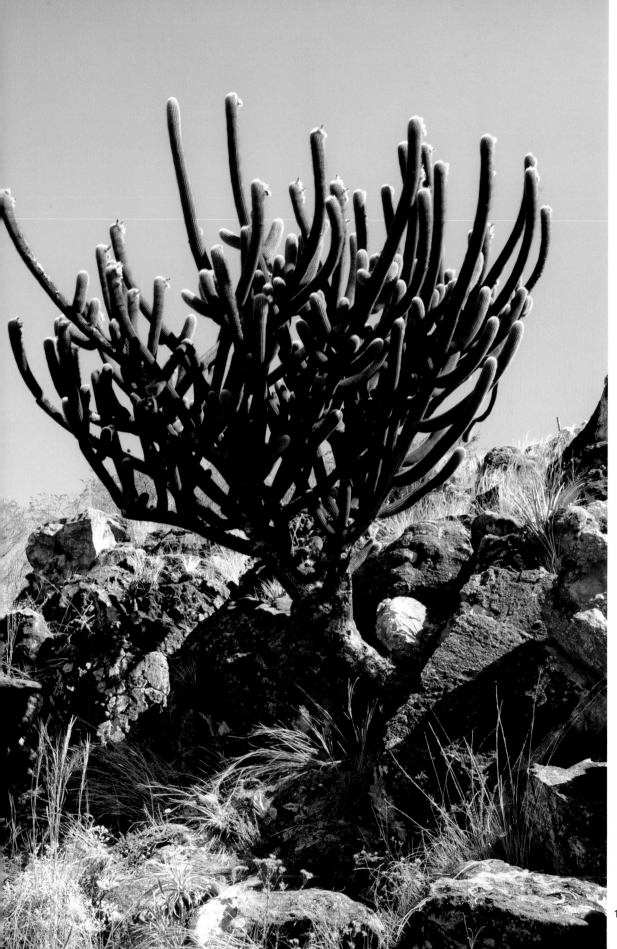

Lasiocereus rupicola, Caochabamba, Peru, 2011 (WM)

Pachycereus pringlei. Cataviña, Baja California, Mexico, 1998 (JR)

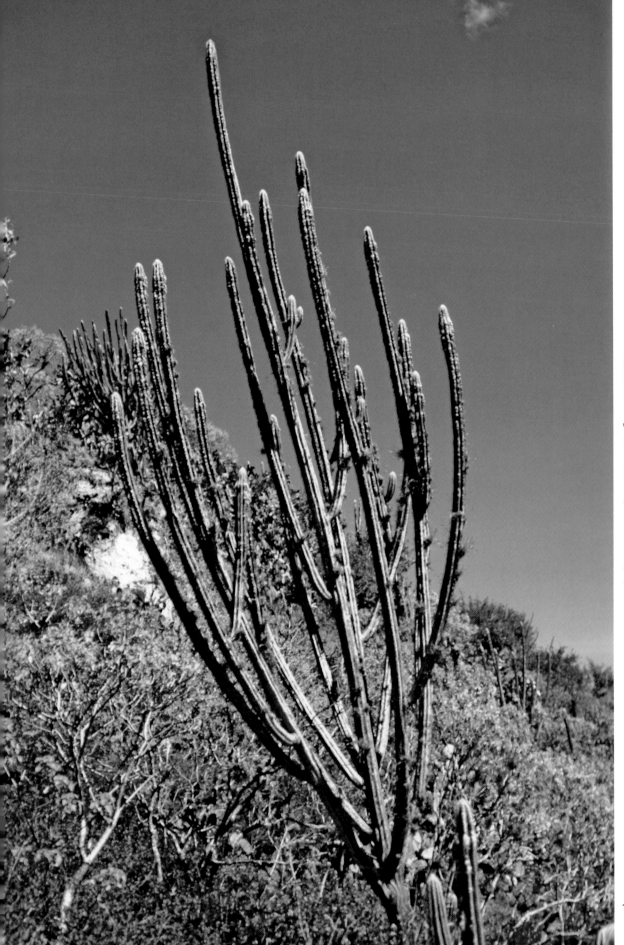

Pilosocereus lanuginosus, Venezuela, date unknown (JM)

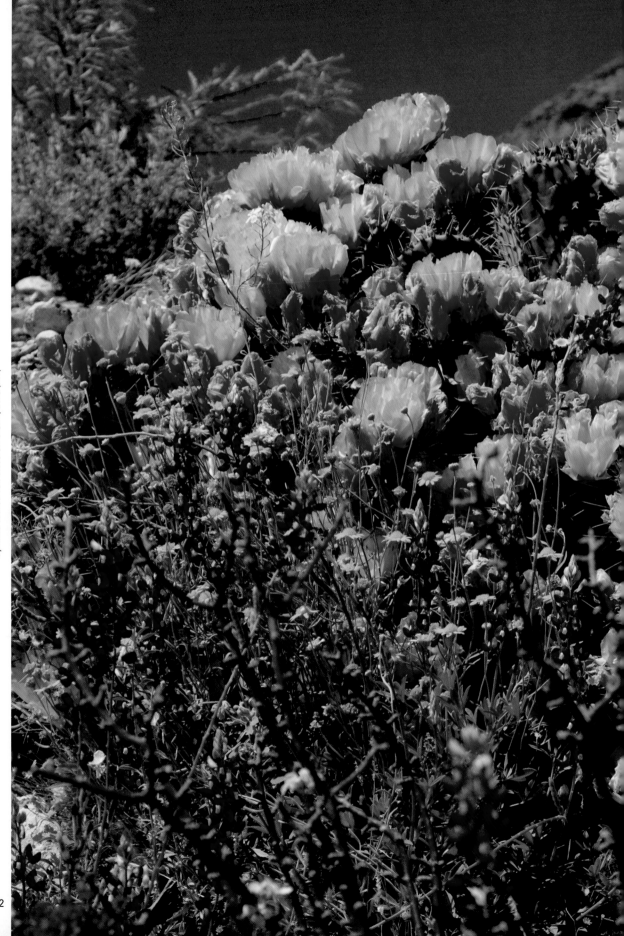

Opuntia azurea var. *discolor*. U.S.A., 2015 (JW)

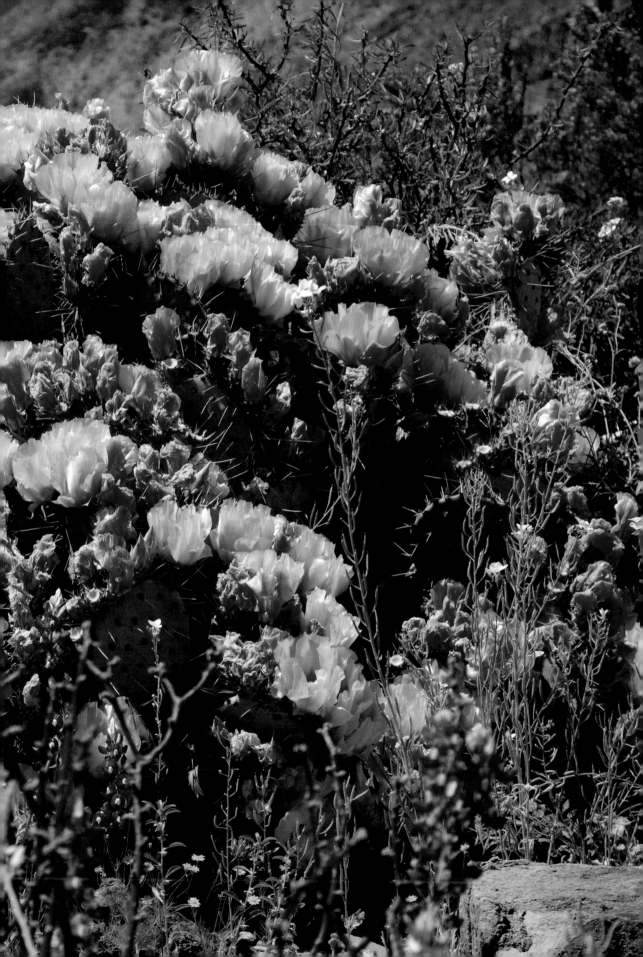

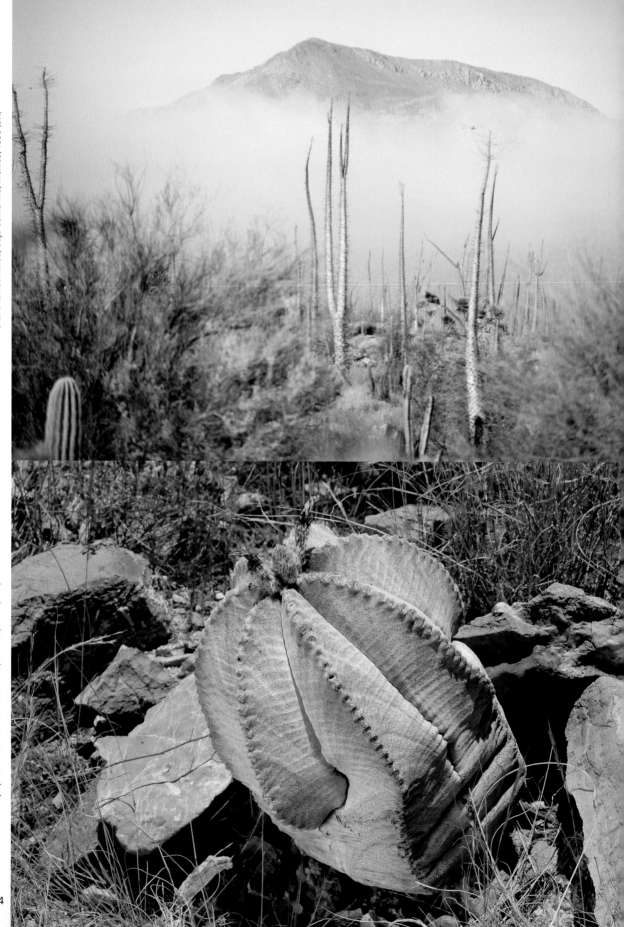

Sierra la Asamblea, Baja California, Mexico, 1996 (JR)

Astrophytum coahuilense. Cerro Bola, Mexico, 2015 (WM)

134

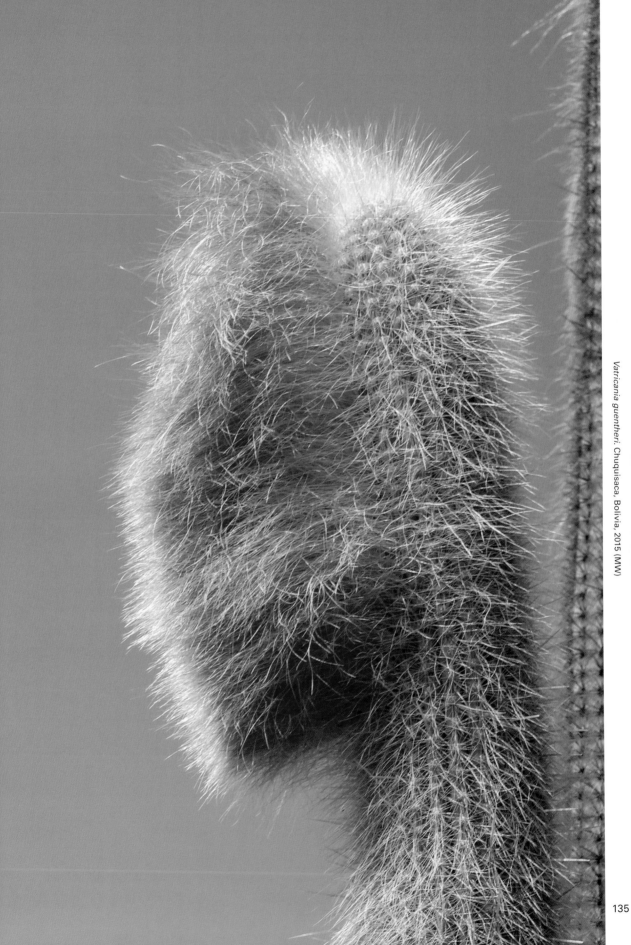

Vatricania guentheri, Chuquisaca, Bolivia, 2015 (MW)

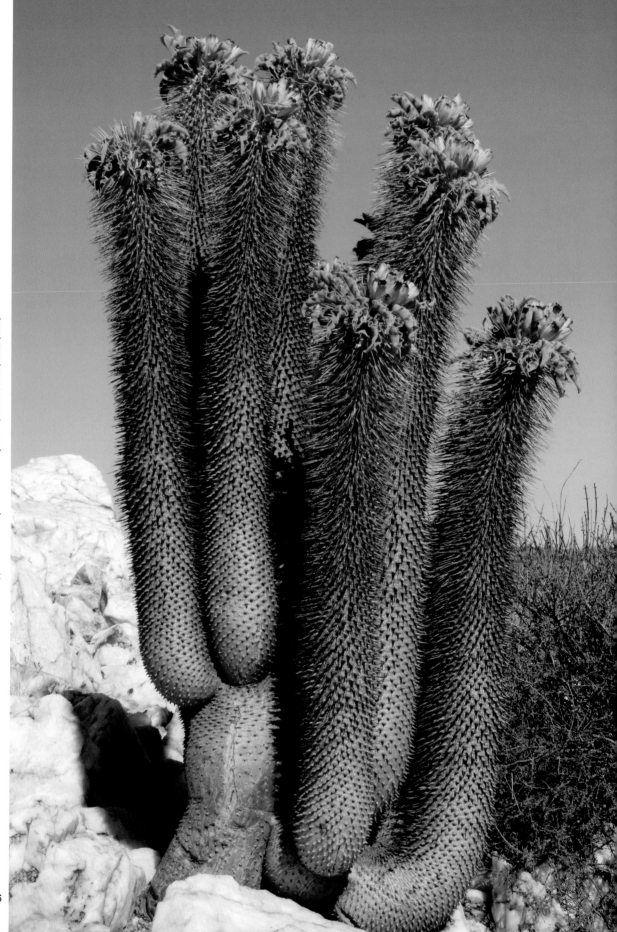

Pachypodium namaquanum. Namaqualand, South Africa, 2012 (WM)

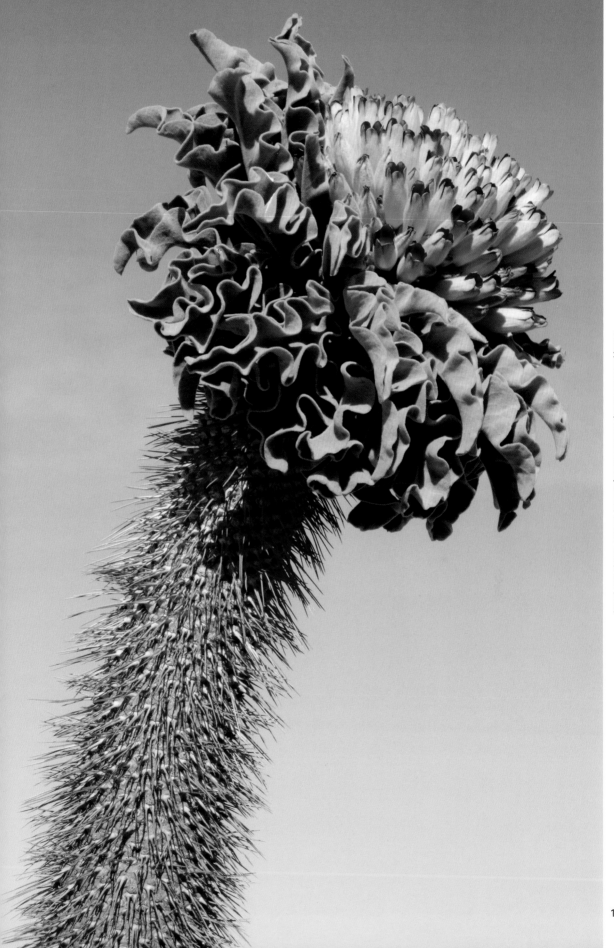

Pachypodium namaquanum. Namaqualand, South Africa, 2012 (WM)

137

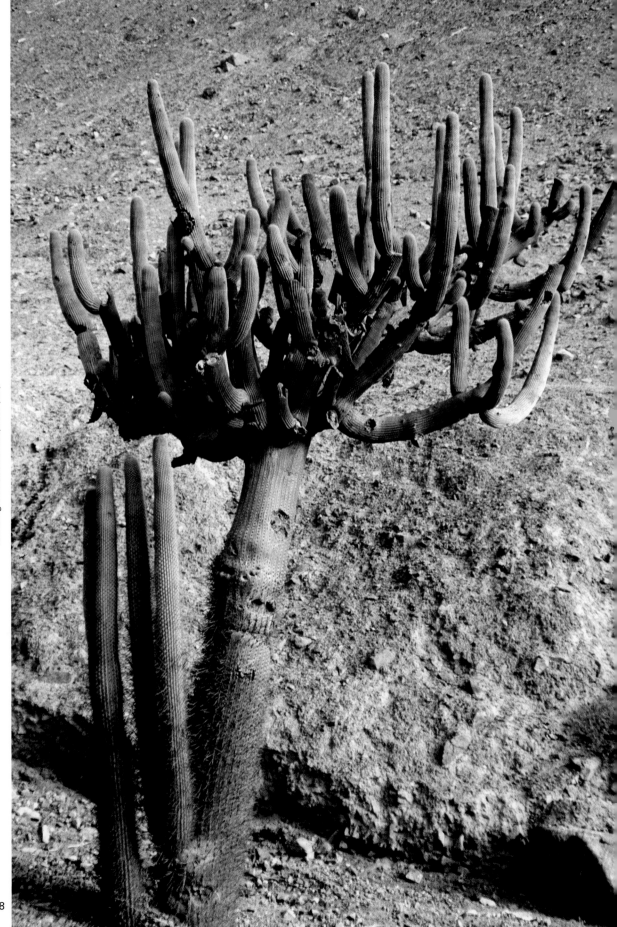

Browningia candelaris. Peru, 2002 (ML)

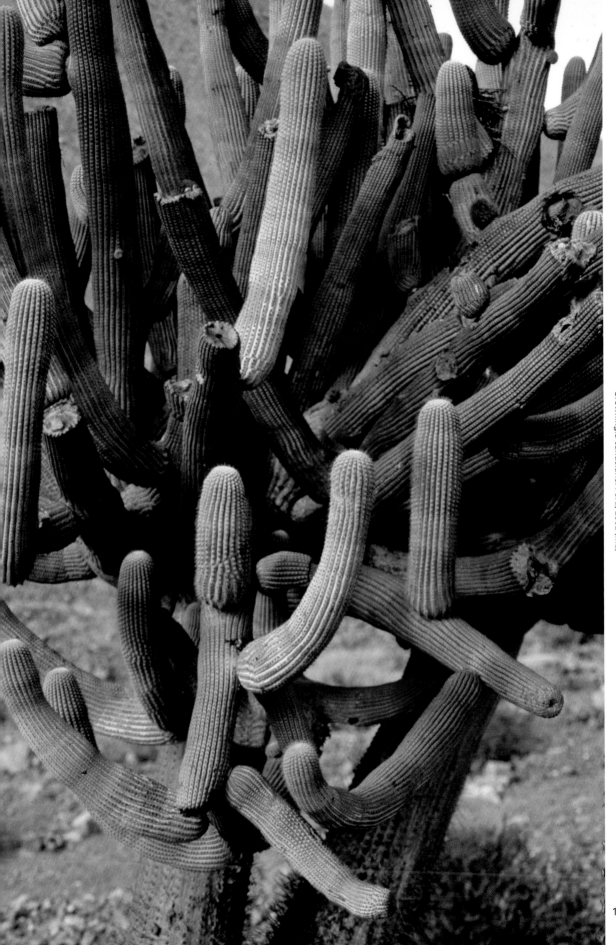

Browningia candelaris. Peru, 2002 (ML)

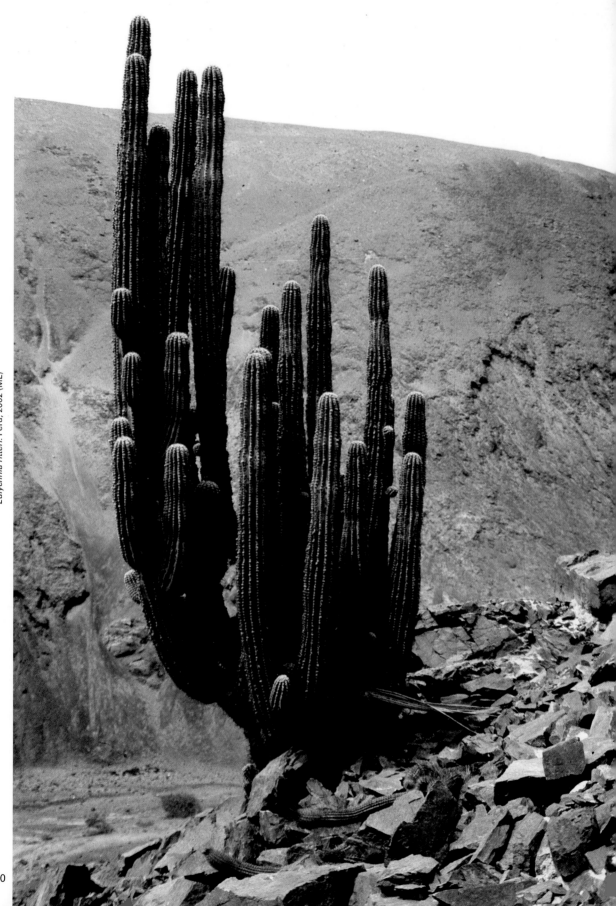

Eulychnia ritteri. Peru, 2002 (ML)

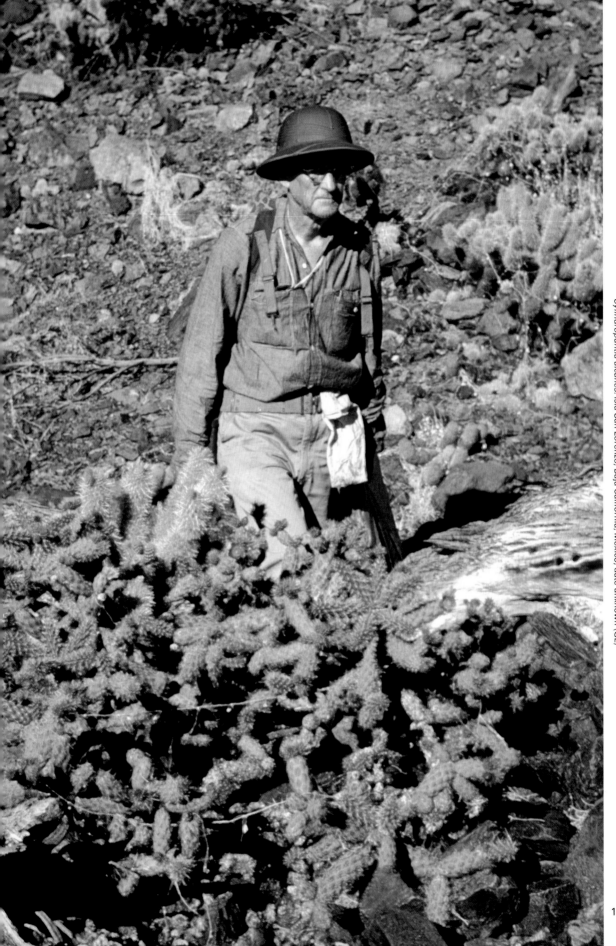

Cylindropuntia alcahes, Isla San Lorenzo, Baja California, Mexico, date unknown (GL)

Cylindropuntia alcahes subsp. *mcgillii*. Baja California, Mexico, date unknown (JR)

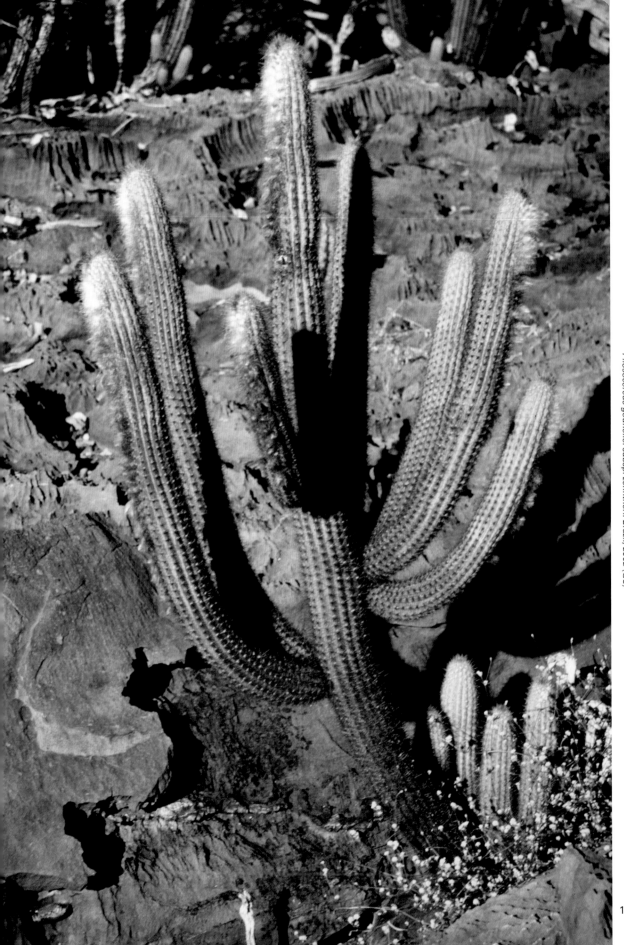

Pilosocereus gounellei subsp. *zehntneri*, Brazil, 2002 (GC)

Rebutia schatzliana. Chuquisaca, Bolivia, 2012 (MW)

Eriosyce odieri. Chañaral, Chile, date unknown (WM)

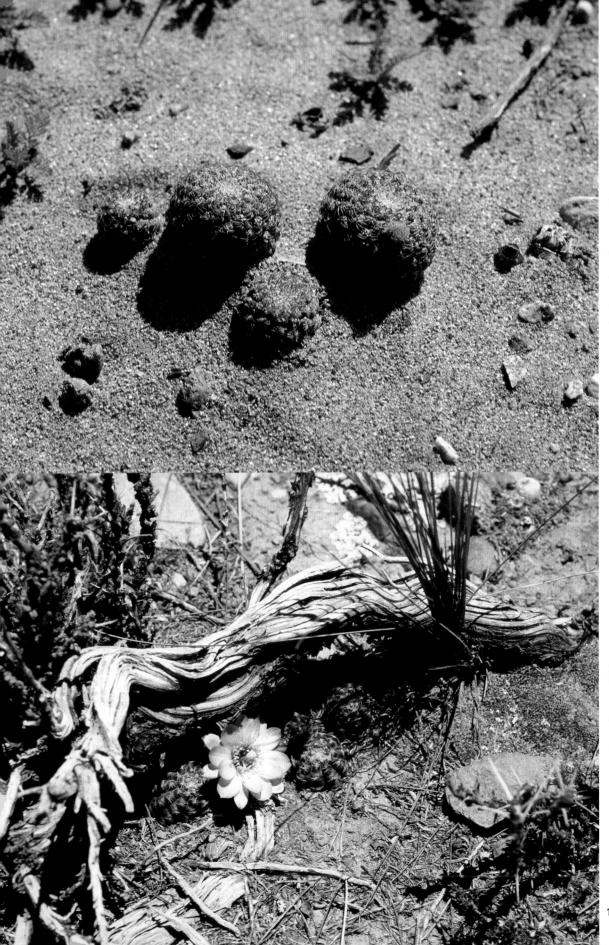

Neochilenia napina. Huasco, Chile, 1997 (WM)

Rebutia pygmaea, Argentina, 1999 (ML)

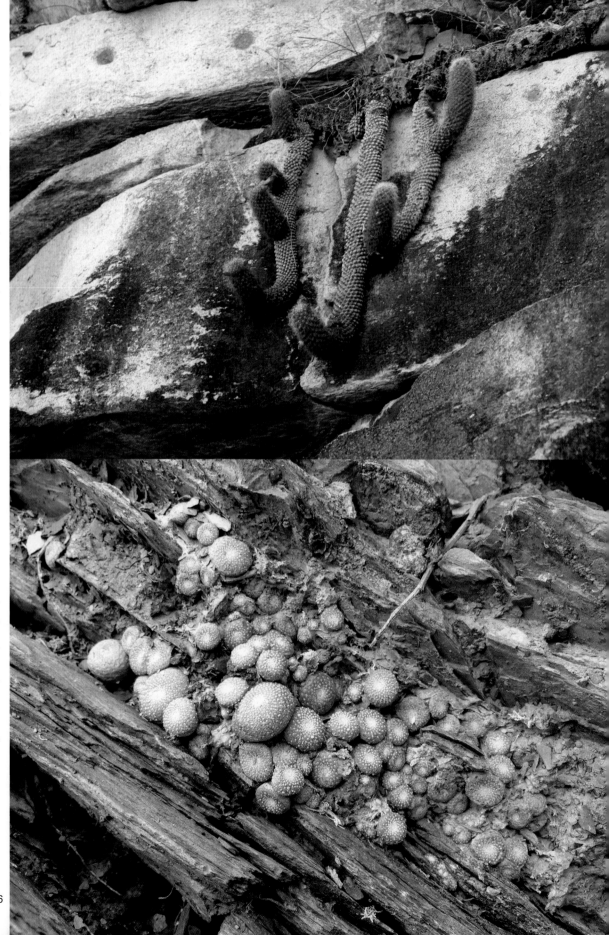

Mammillaria phitauiana. Baja California Sur, Mexico, 2015 (JR)

Blossfeldia liliputana. Potosí, Bolivia, 2012 (MW)

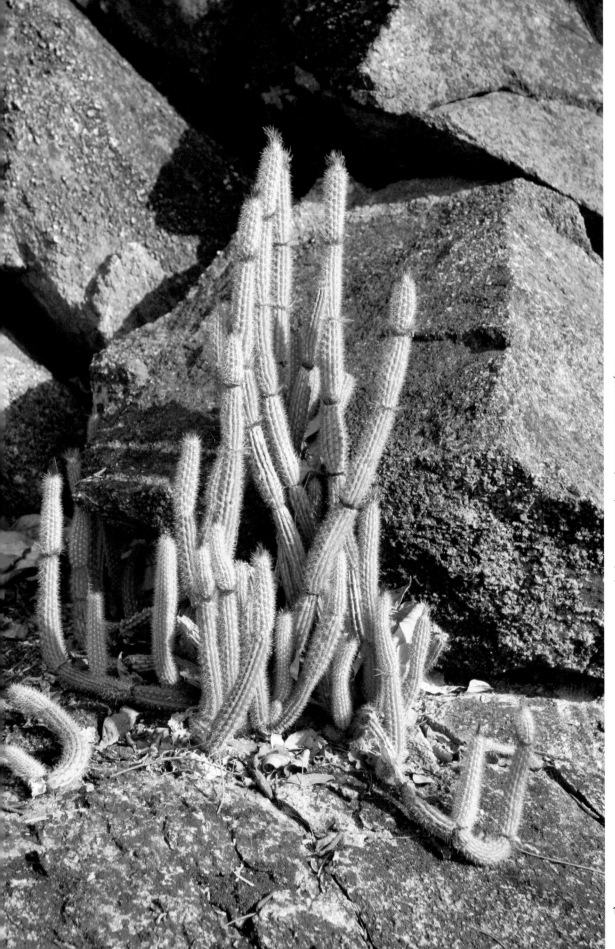

Arrojadoa rhodantha, Goiás, Brazil, date unknown (NT)

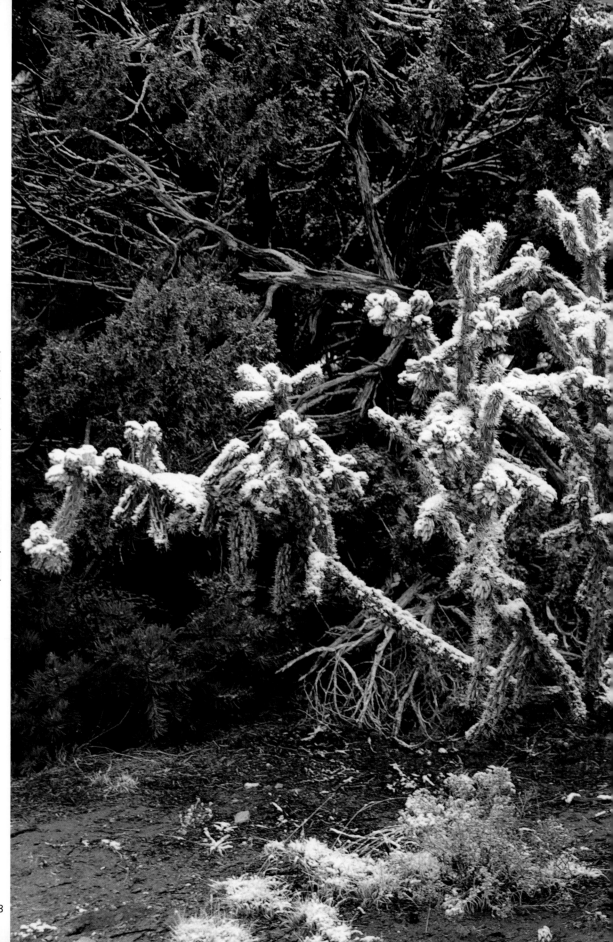

Cylindropuntia imbricata. New Mexico, U.S.A., 2006 (WM)

148

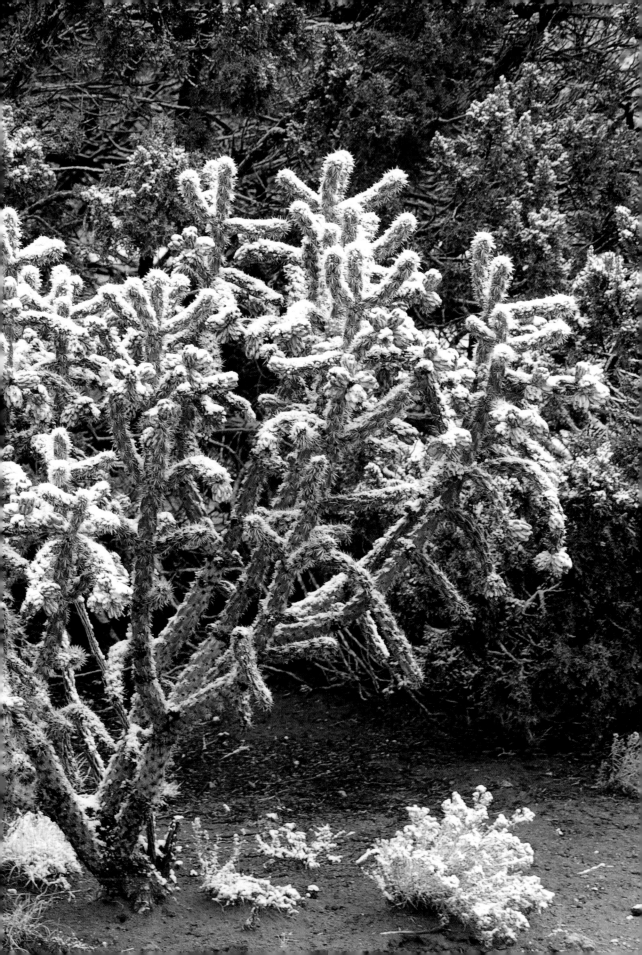

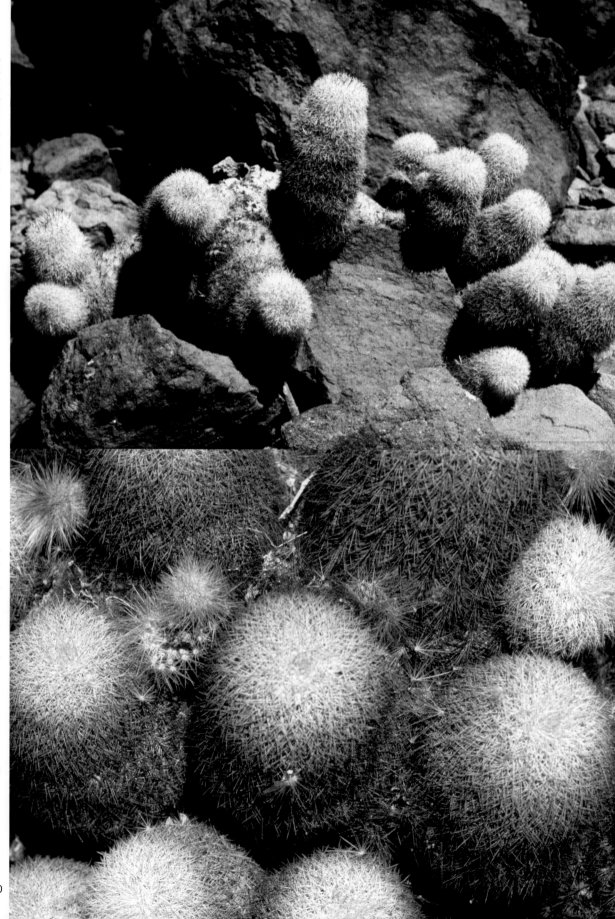

Mammillaria estebanensis. San Esteban Island, Sonora, Mexico, 1999 (JR)

Echinocereus grandis. San Esteban Island, Sonora, Mexico, 1999 (JR)

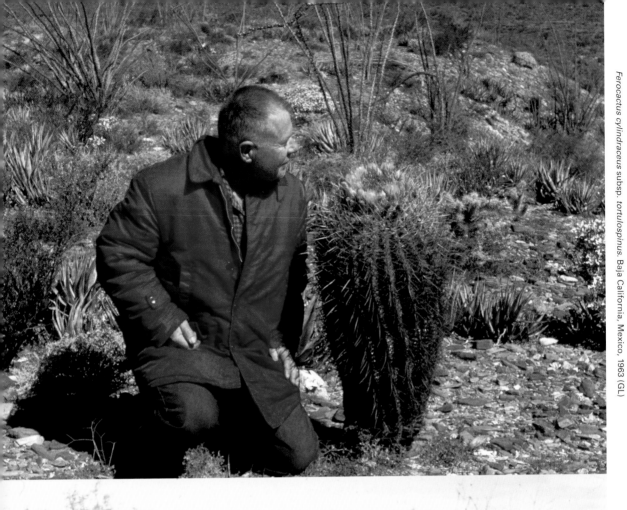

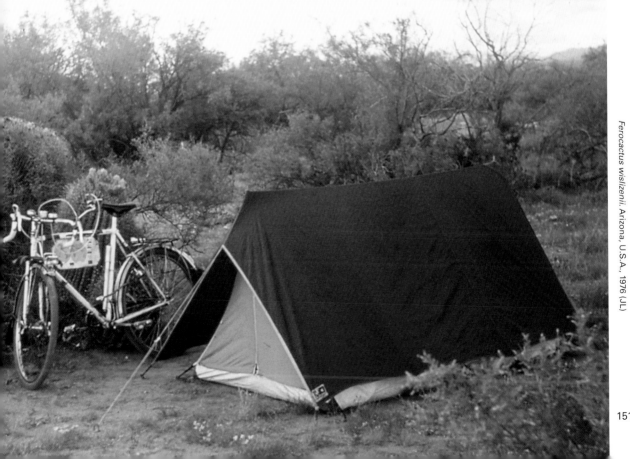

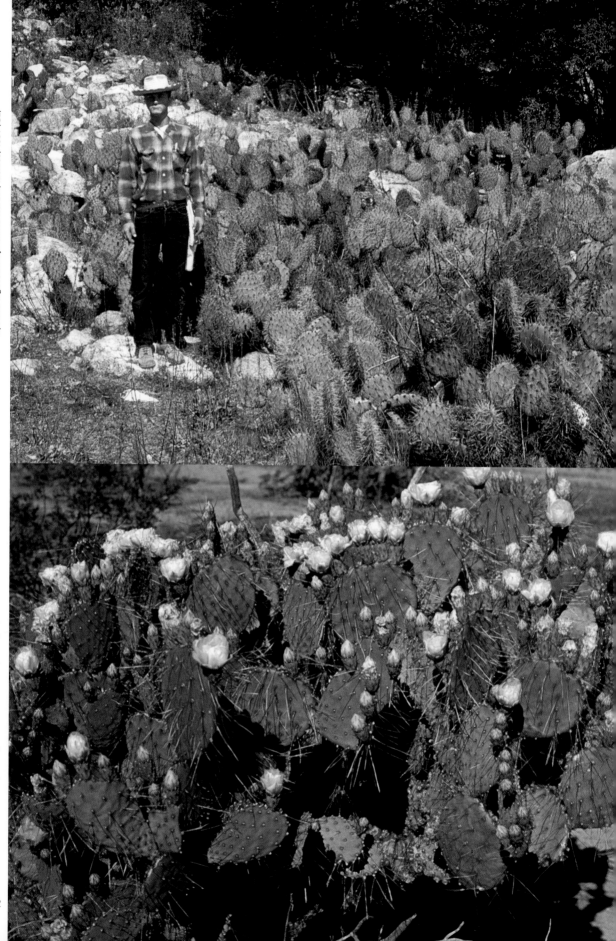

Opuntia lagunae. Baja California Sur, Mexico, 1961 (GL)

Opuntia gosseliniana. Mexico, 1962 (GL)

152

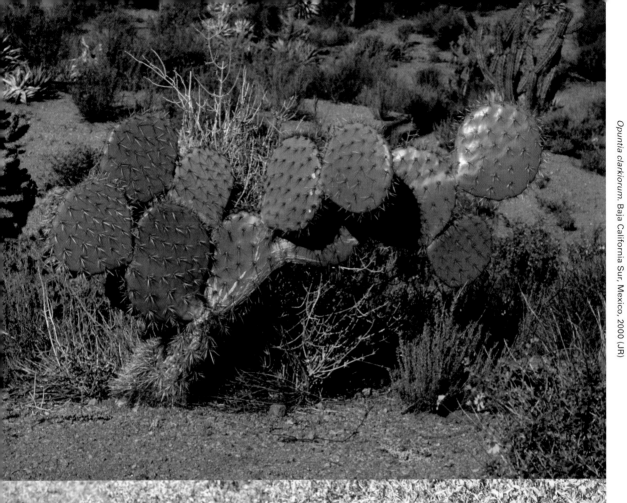

Opuntia clarkiorum. Baja California Sur, Mexico, 2000 (JR)

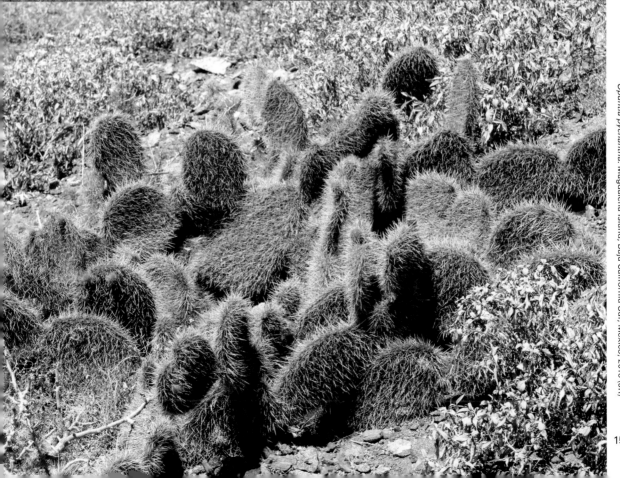

Opuntia pycnantha. Magdalena Island, Baja California Sur, Mexico, 2016 (JR)

153

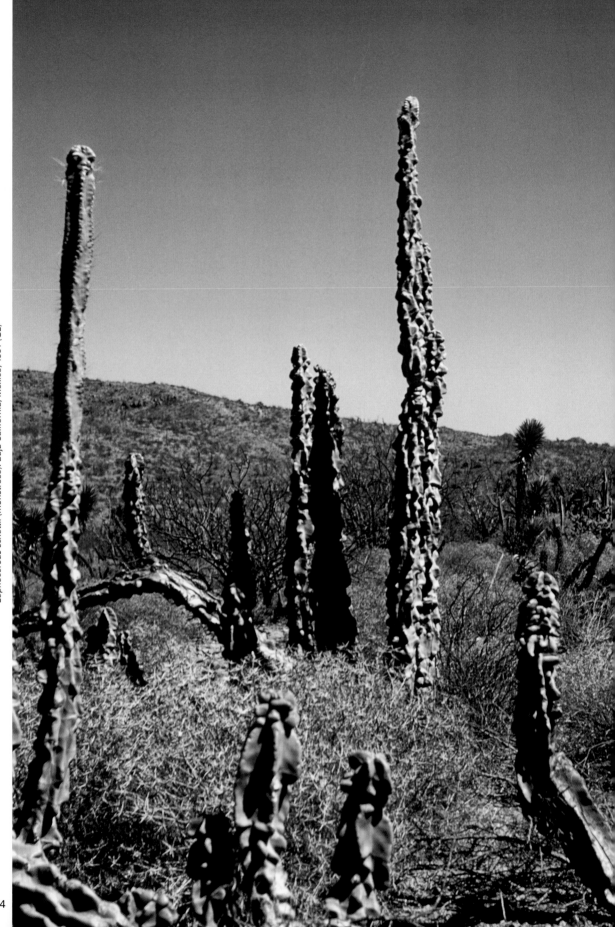

Lophocereus schottii (monstrose). Baja California, Mexico, 1961 (GL)

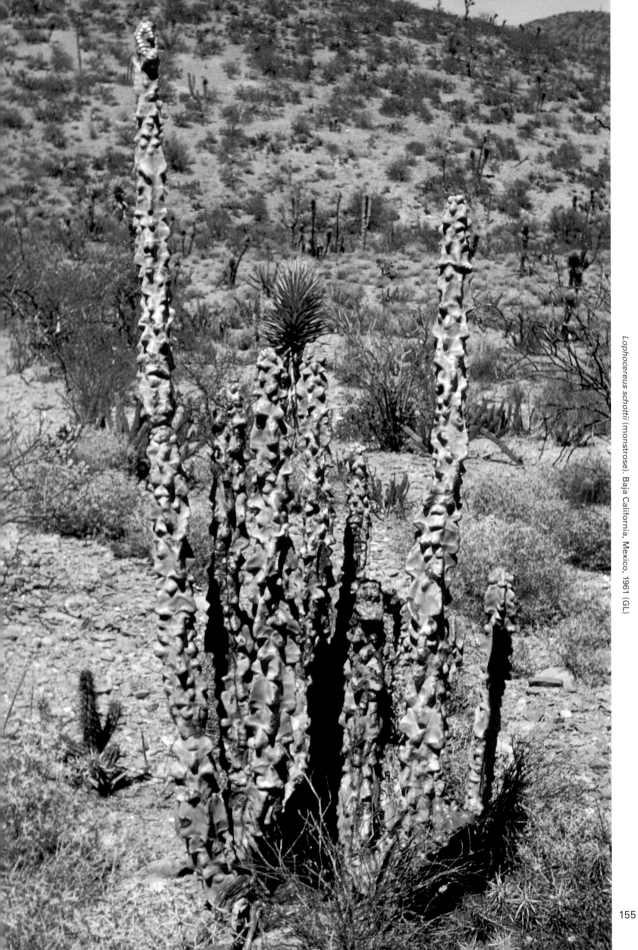

Lophocereus schottii (monstrose) Baja California, Mexico, 1961 (GL)

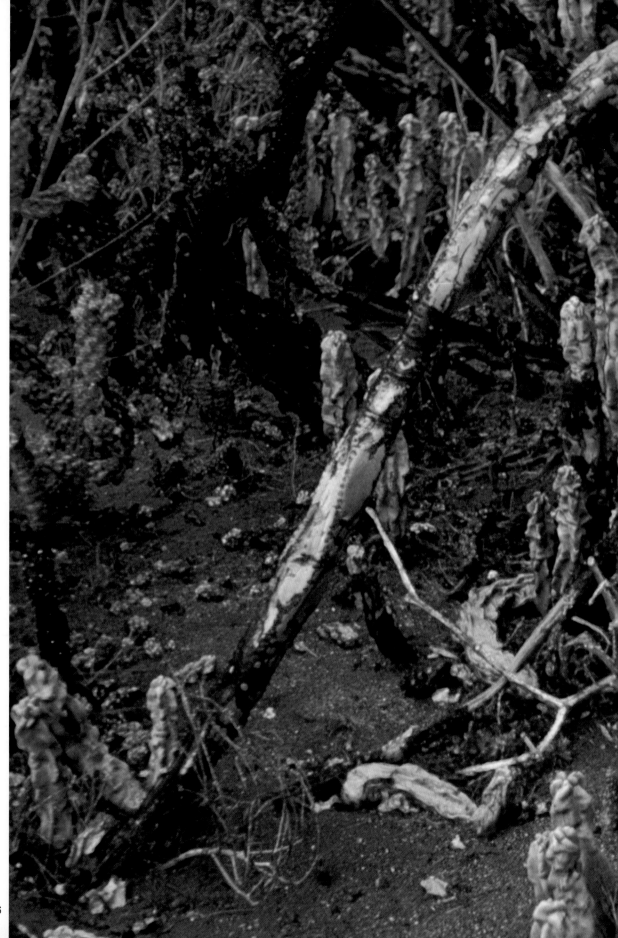

Lophocereus schottii (monstrose). Baja California, Mexico, 1960 (GL)

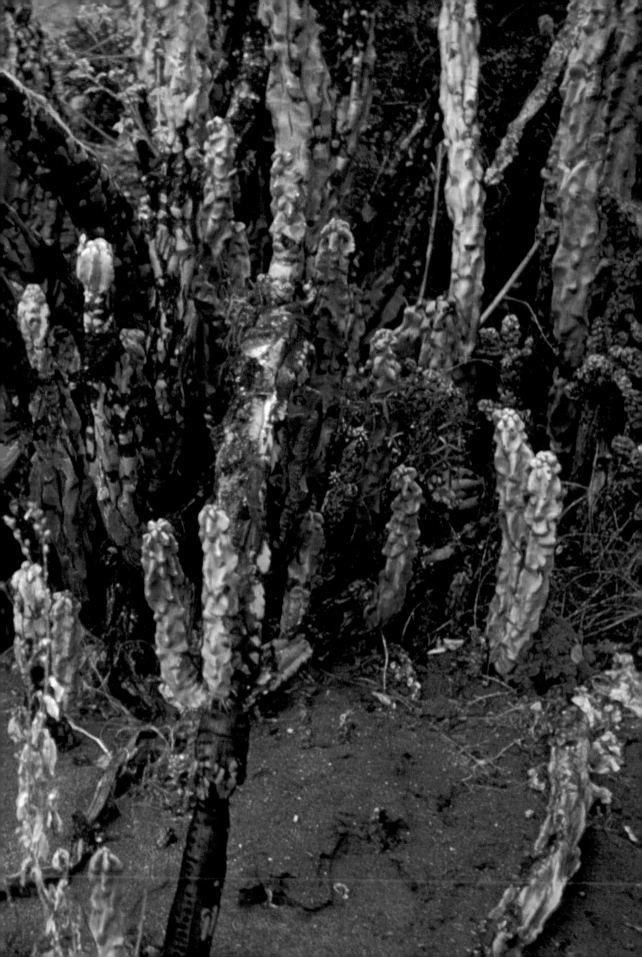

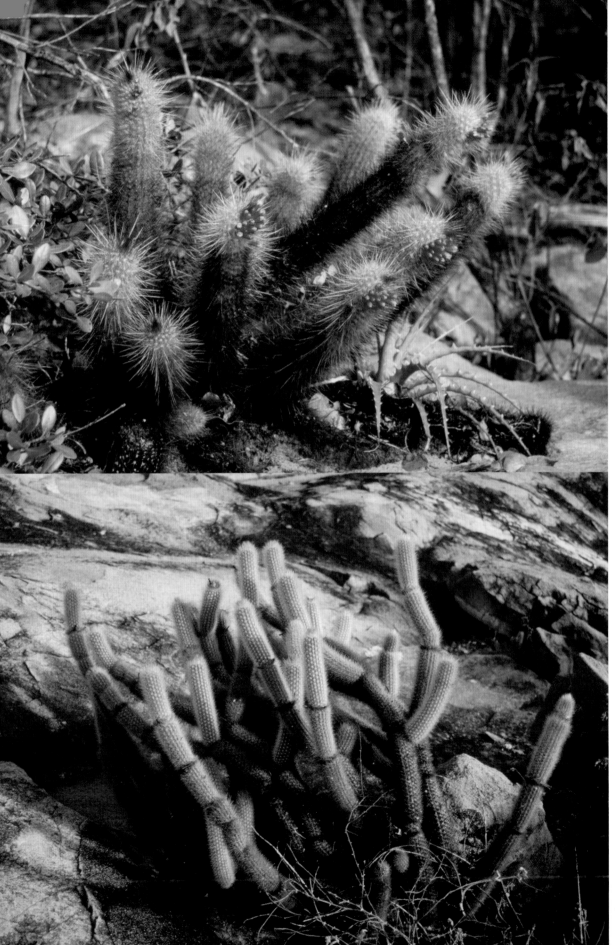

Arrojadoa marylanae. Brazil, 2004 (GC)

Arrojadoa rhodantha. Brazil, 2002 (GC)

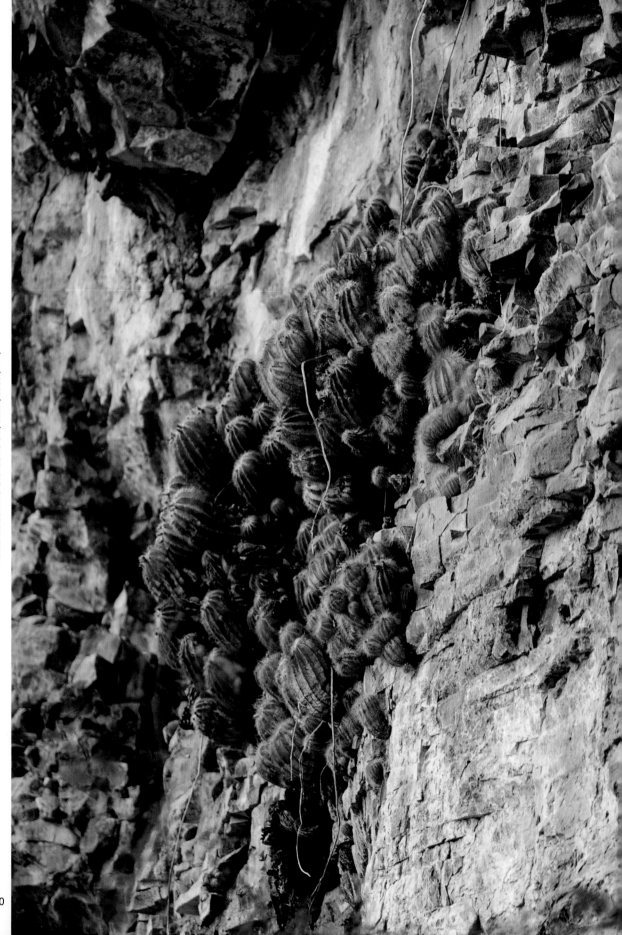

Parodia warasii. Rio Grande do Sul, Brazil, 2009 (WM)

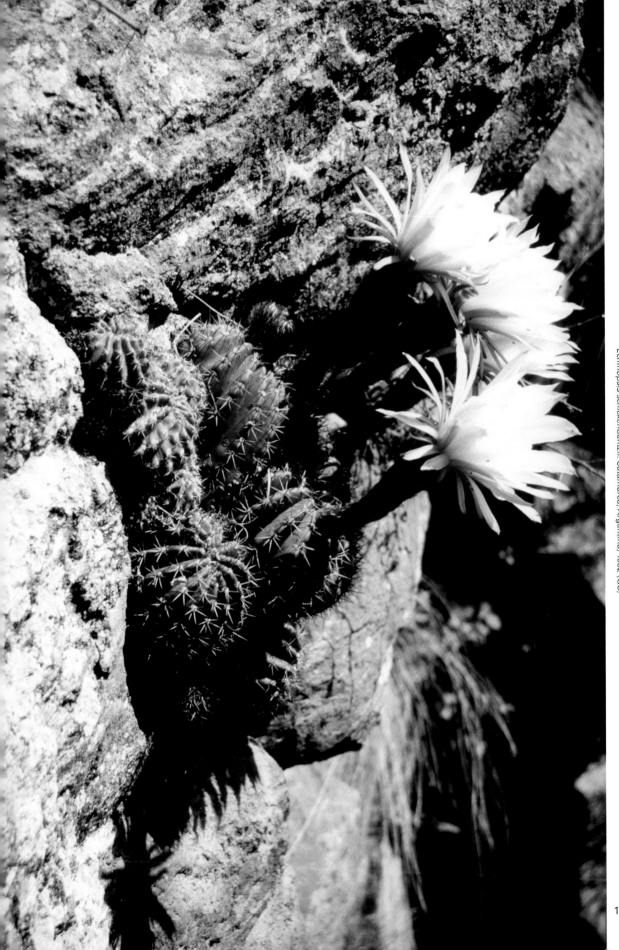

Echinopsis schickendantzii, Catamarca, Argentina, 1992 (GC)

Parodia succinea. Rio Grande do Sul, Brazil, 2009 (WM)

163

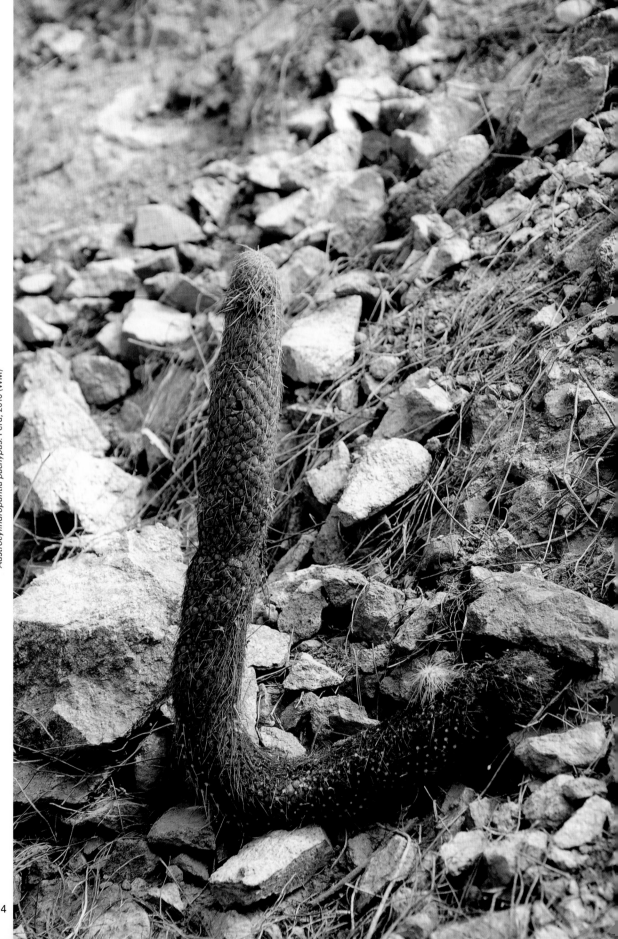

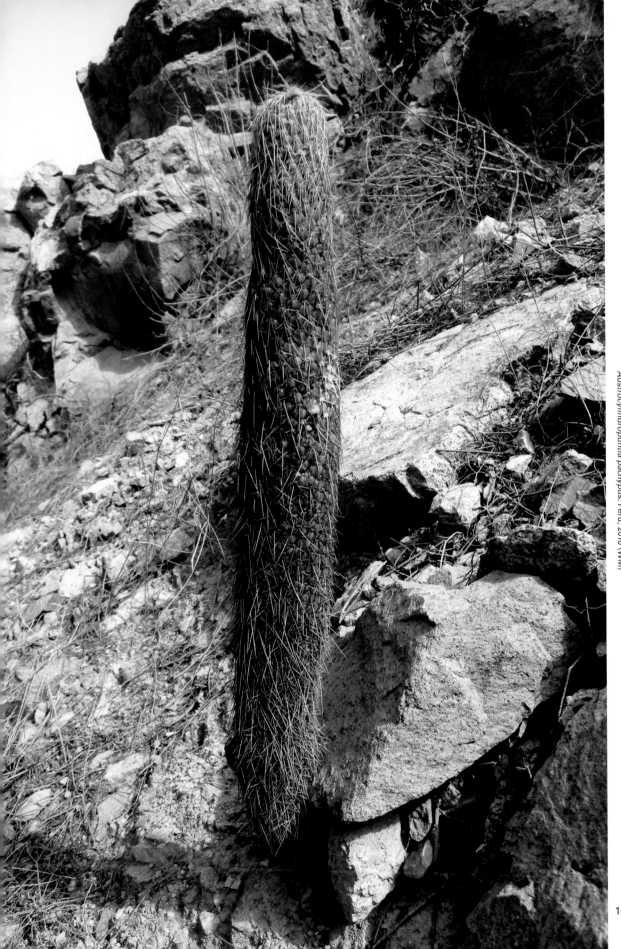

Austrocylindropuntia pachypus, Peru, 2010 (WM)

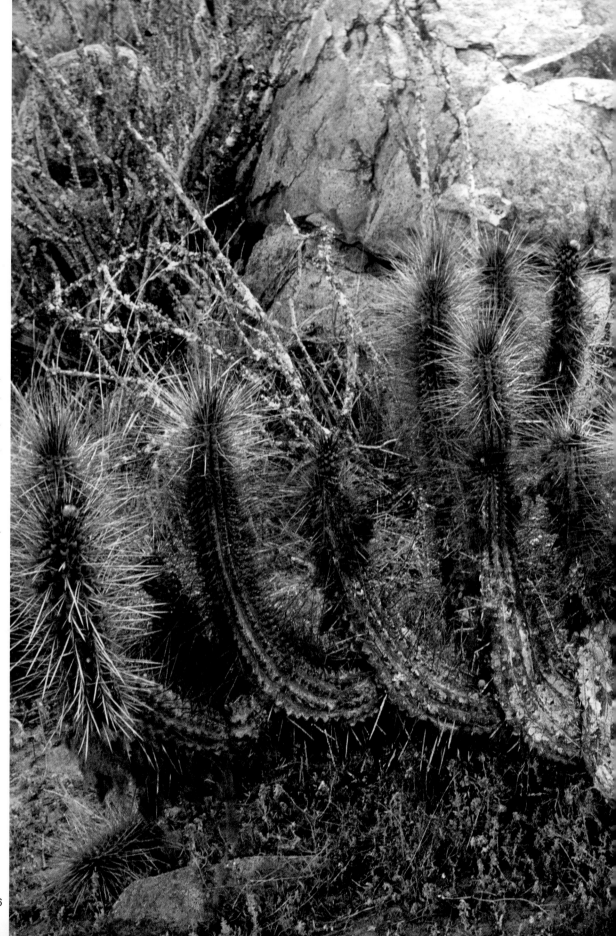

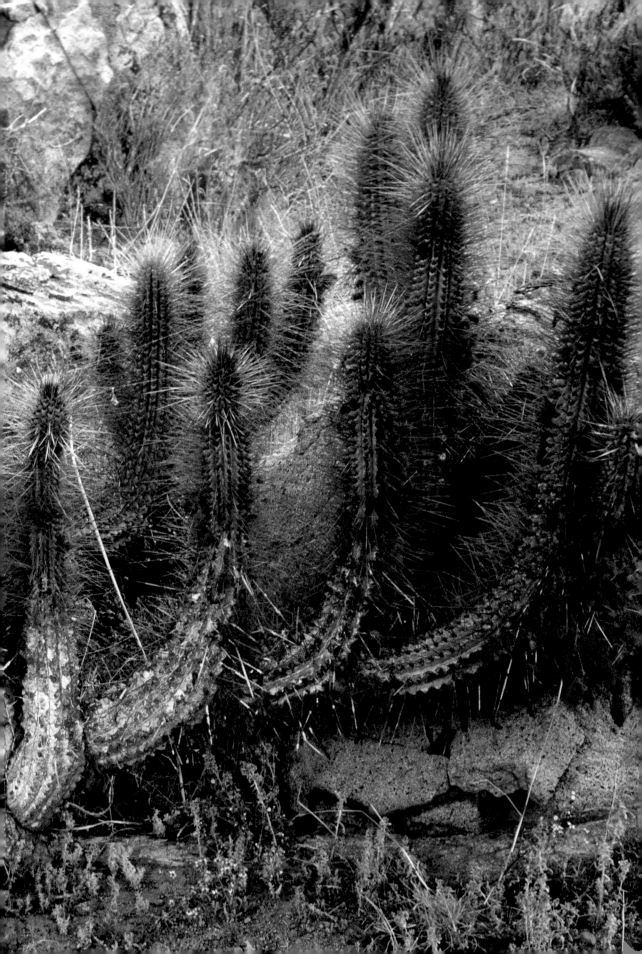

Copiapoa dealbata (dead). Carrizal Bajo, Chile, 2001 (WM)

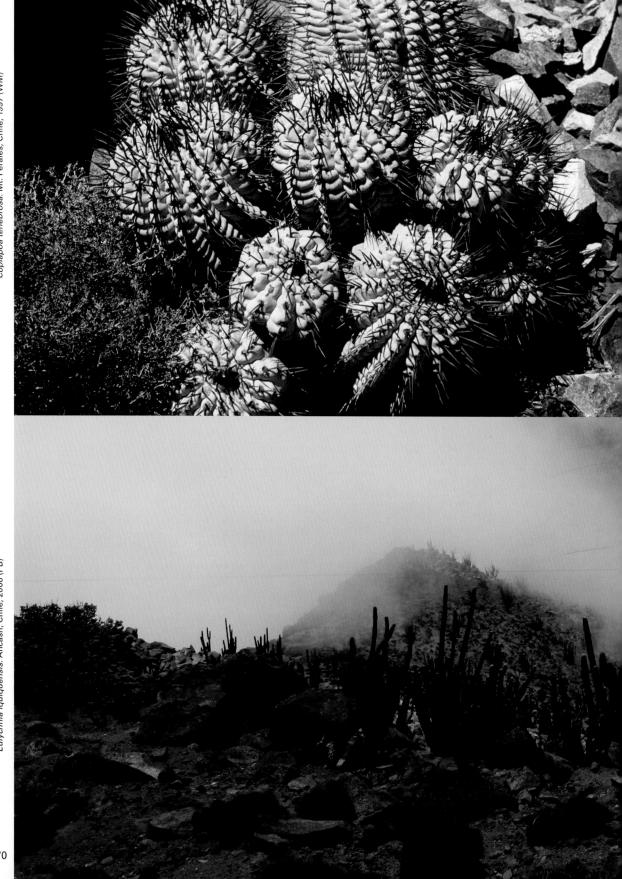

Copiapoa tenebrosa. Mt. Perales, Chile, 1997 (WM)

Eulychnia iquiquensis. Ancash, Chile, 2006 (PB)

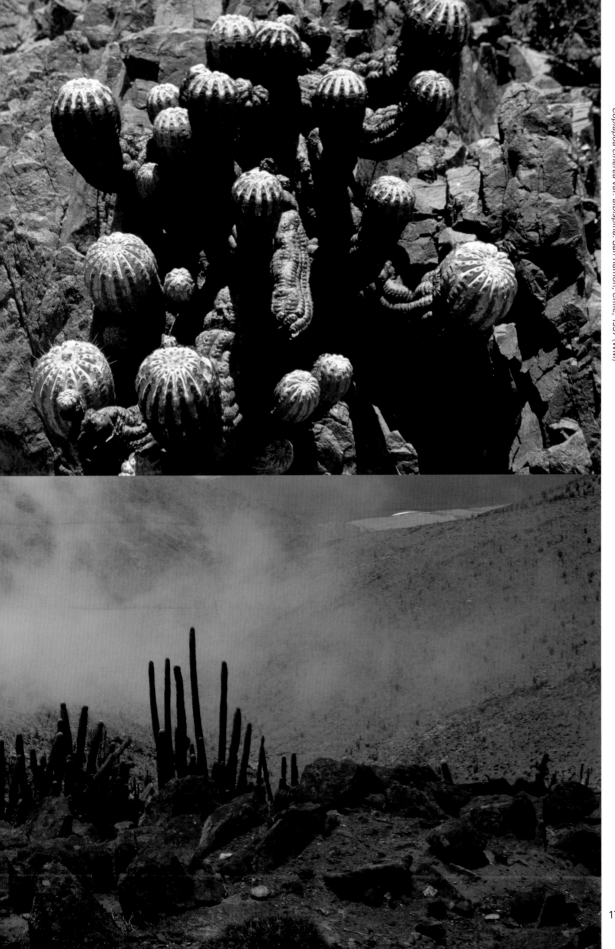

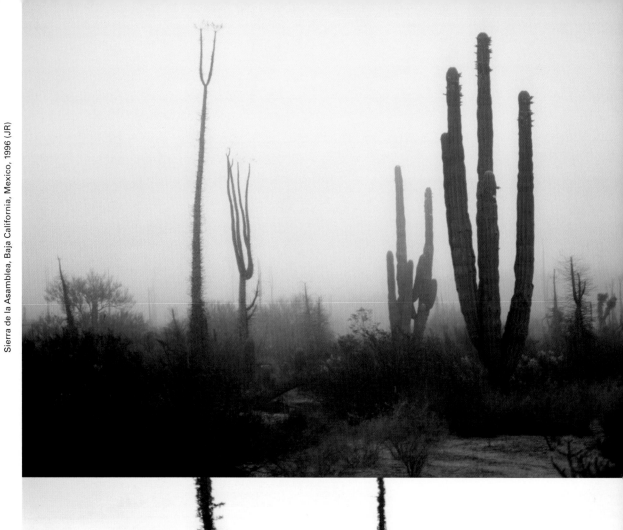

Sierra de la Asamblea, Baja California, Mexico, 1996 (JR)

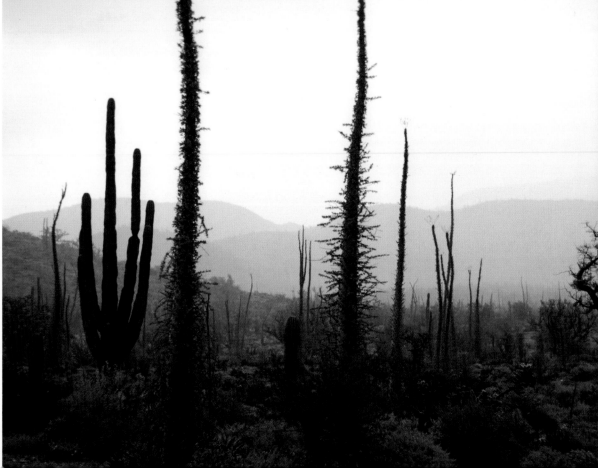

Vizcaino Desert, Baja California, Mexico, 1988 (GL)

172

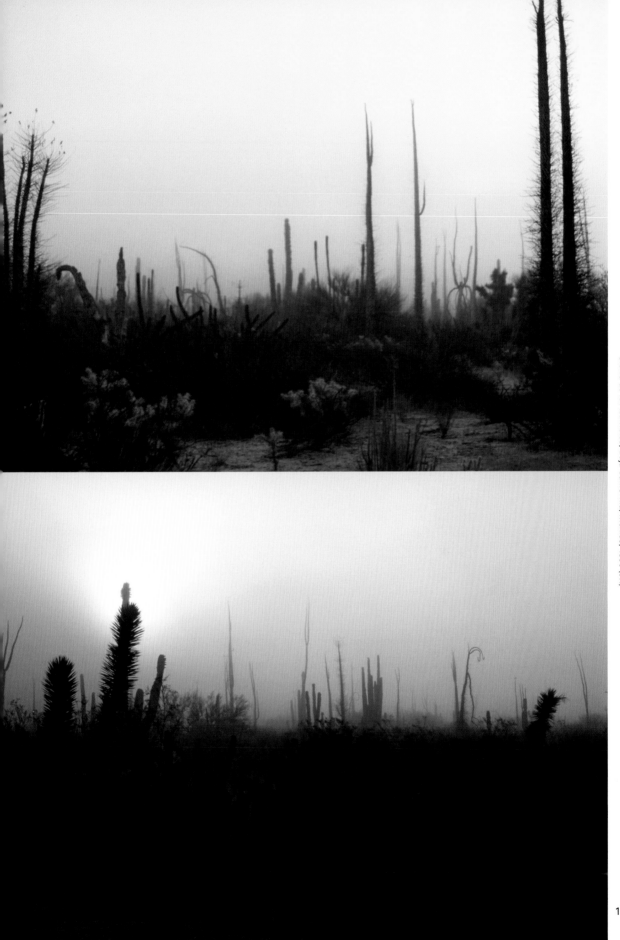

Sierra de la Asamblea, Baja California, Mexico, 1996 (JR)

173

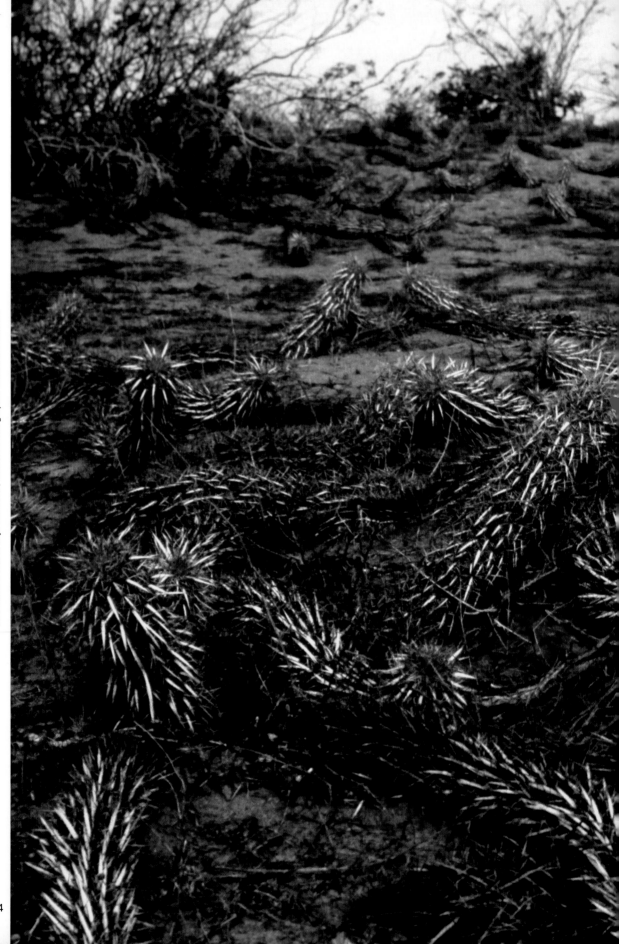

Stenocereus eruca, Baja California, Mexico. Photographer and date unknown.

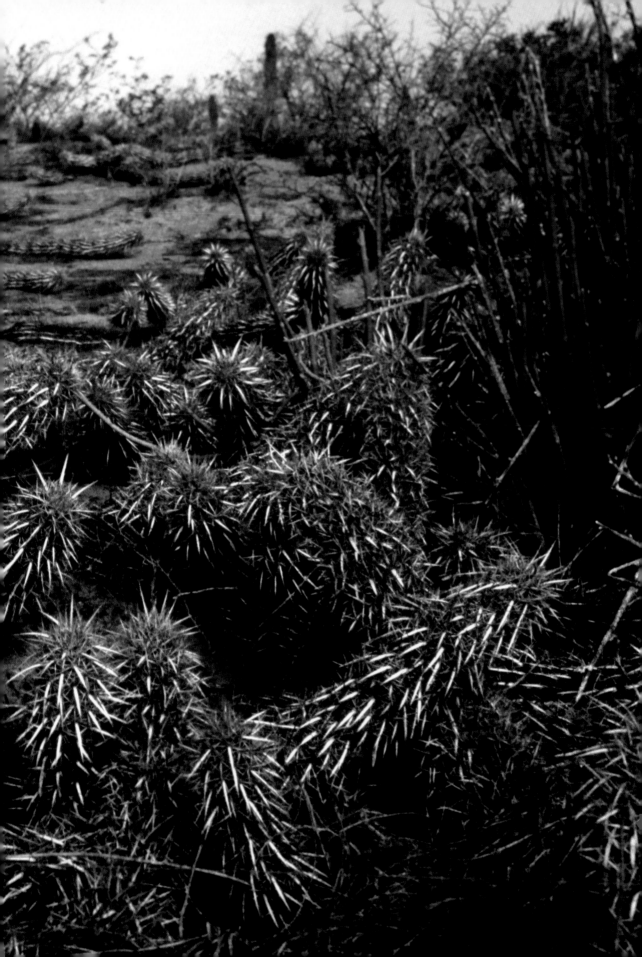

Pilosocereus tuberculatus. Brazil, 2000 (GC)

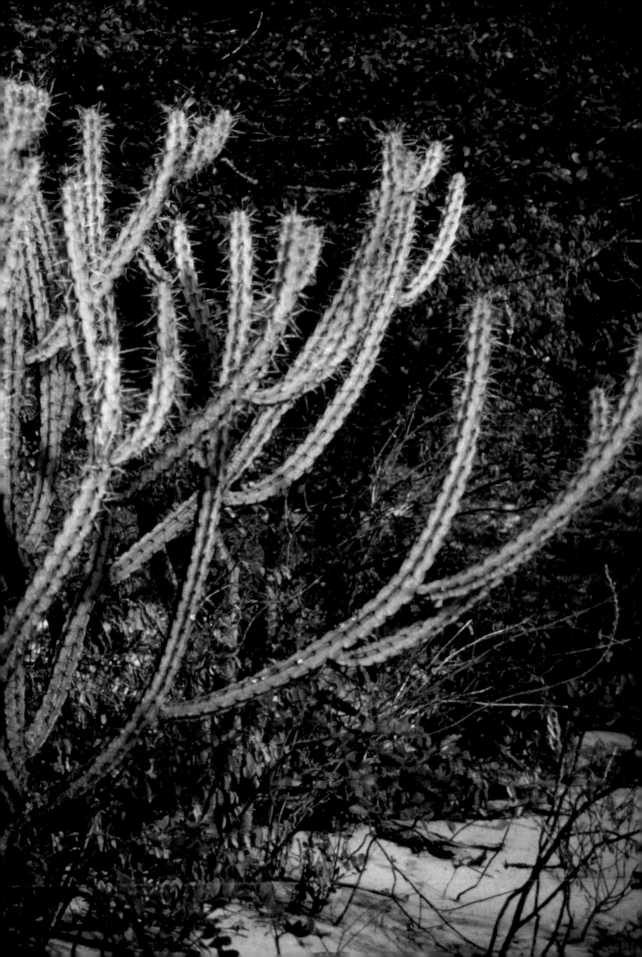

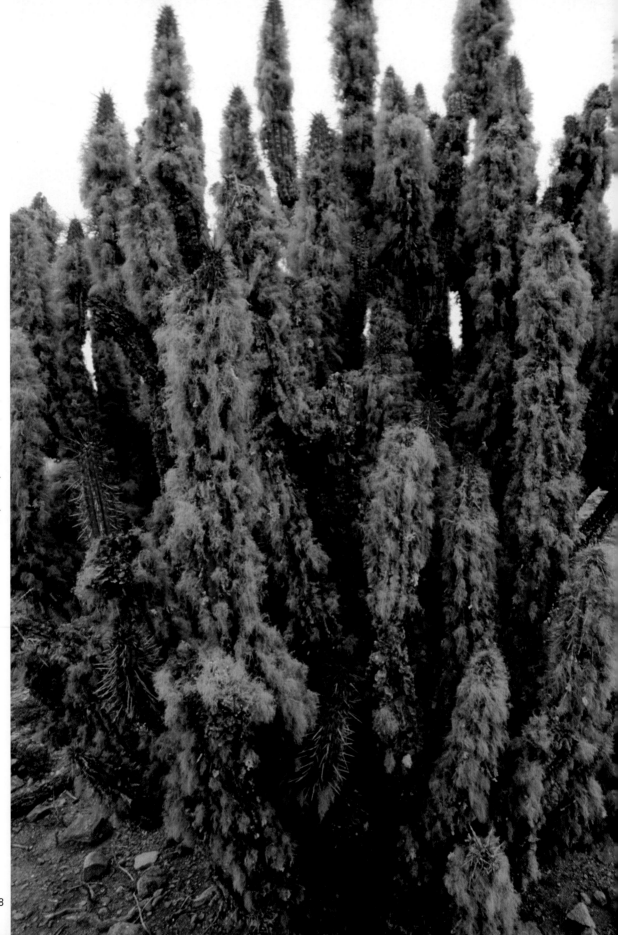

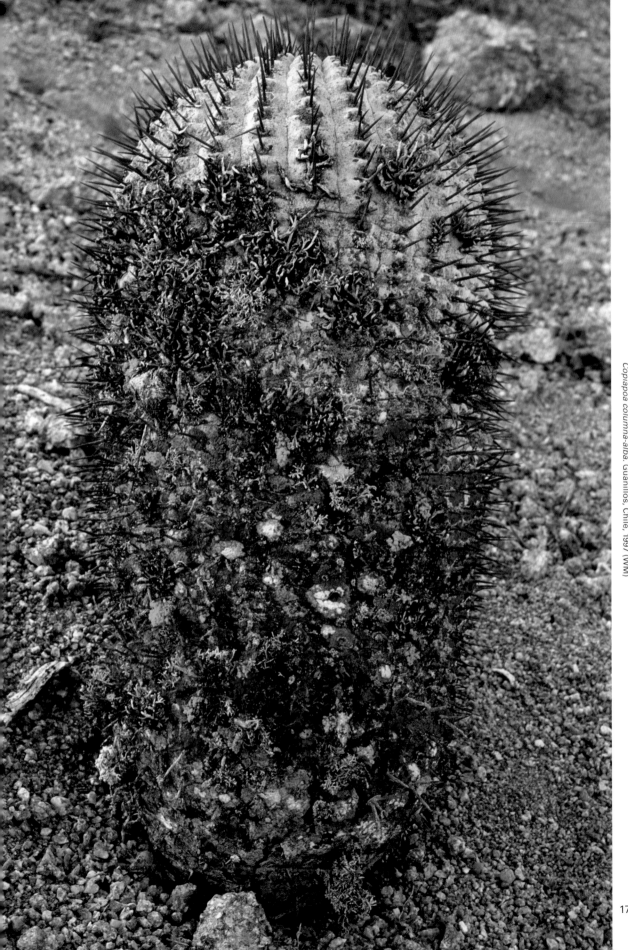

179

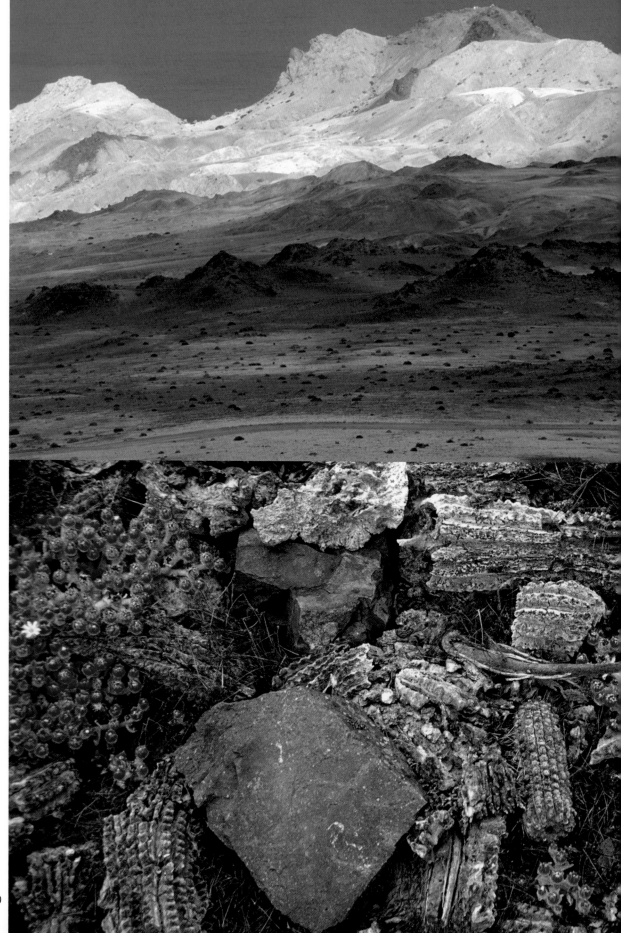

Badlands of northern Chile, 1997 (WM)

Remains of *Eulychnia*. Coast of Chile, 1997 (WM)

180

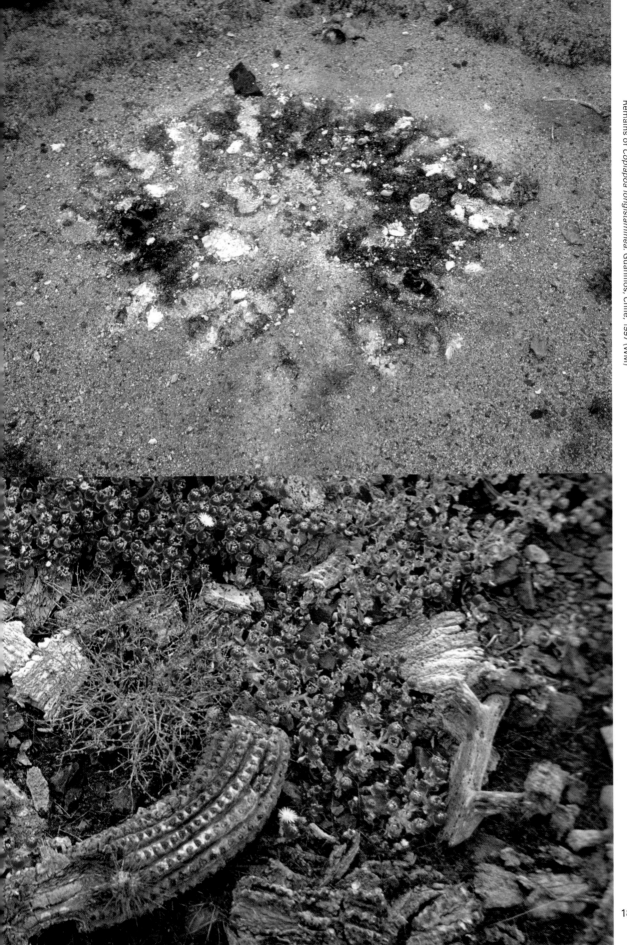

181

Trichocereus atacamensis subsp. *pasacana*. Quebrada del Toro, Argentina, 2002 (WM)

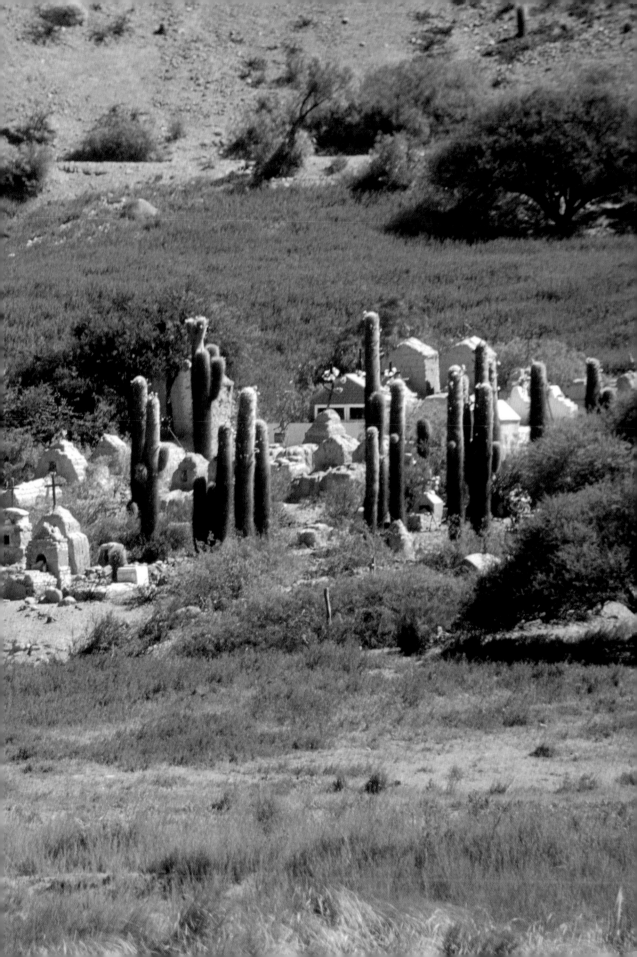

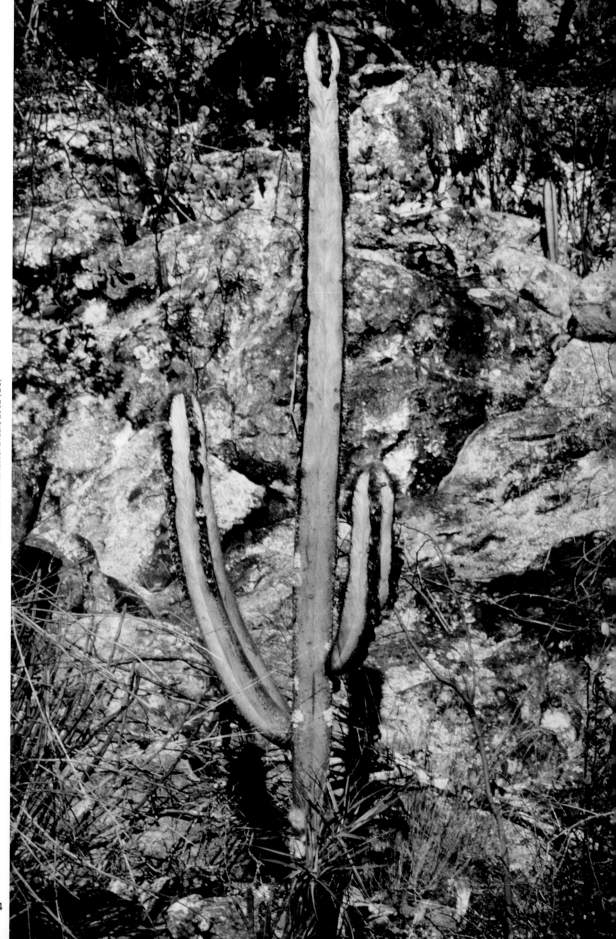

Pilosocereus fulvilanatus. Brazil, 2002 (GC)

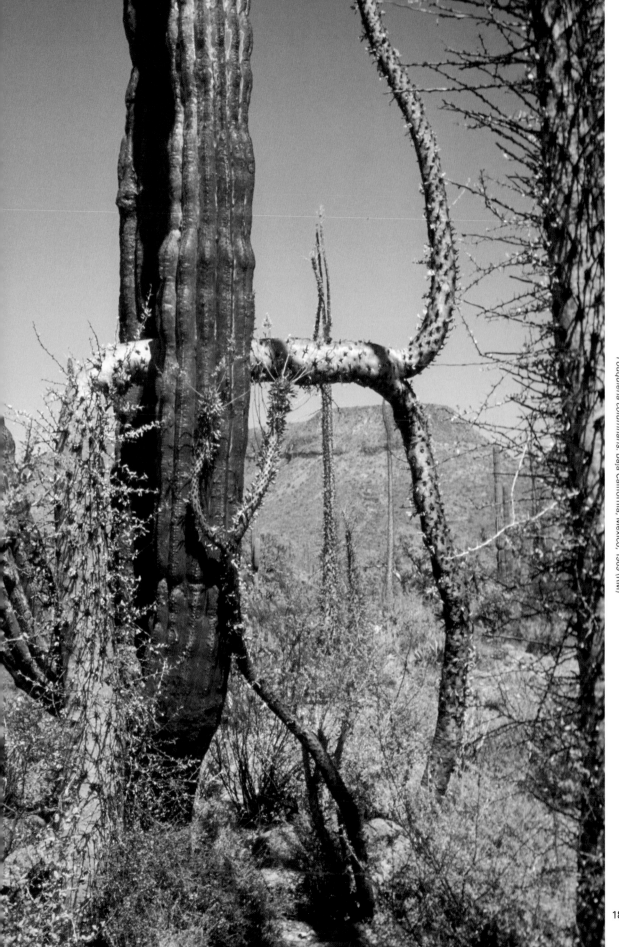

Fouquieria columnaris, Baja California, Mexico, 1969 (RM)

Tephrocactus articulatus (black spined). Peru, 2004 (WM)

Tephrocactus alexanderi. Argentina, 2002 (WM)

186

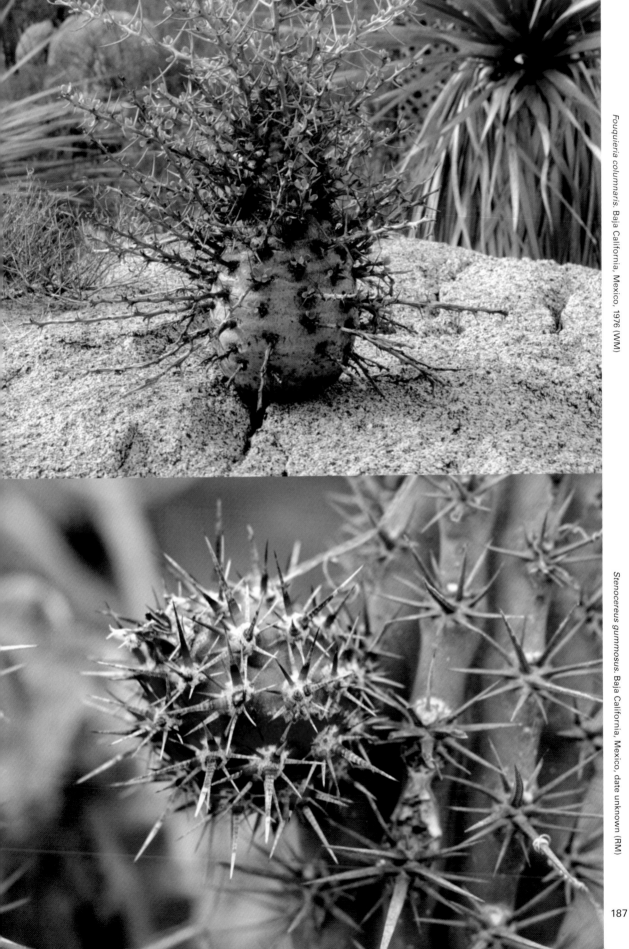

Fouquieria columnaris, Baja California, Mexico, 1976 (WM)

Stenocereus gummosus, Baja California, Mexico, date unknown (RM)

187

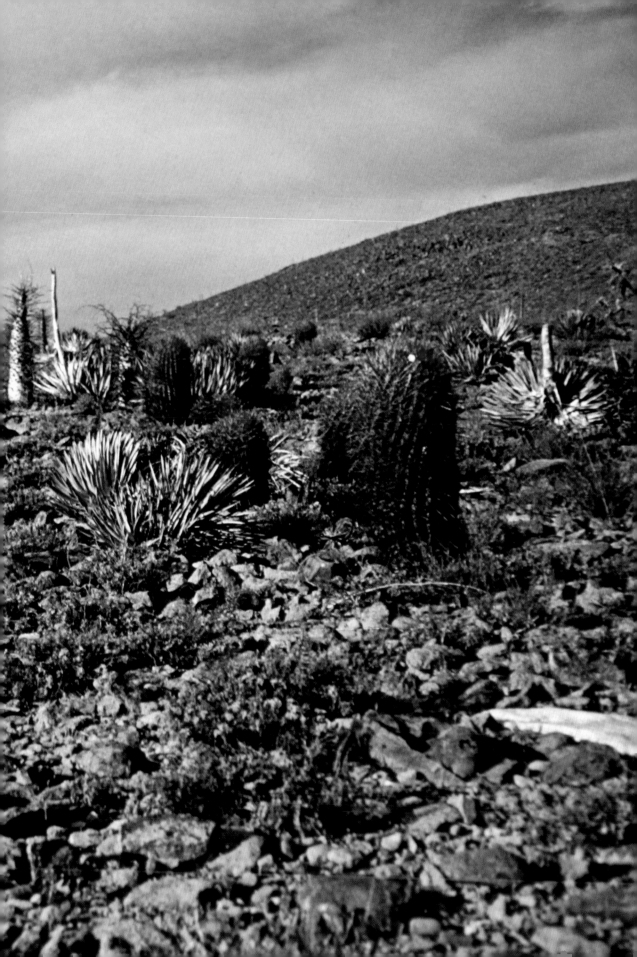

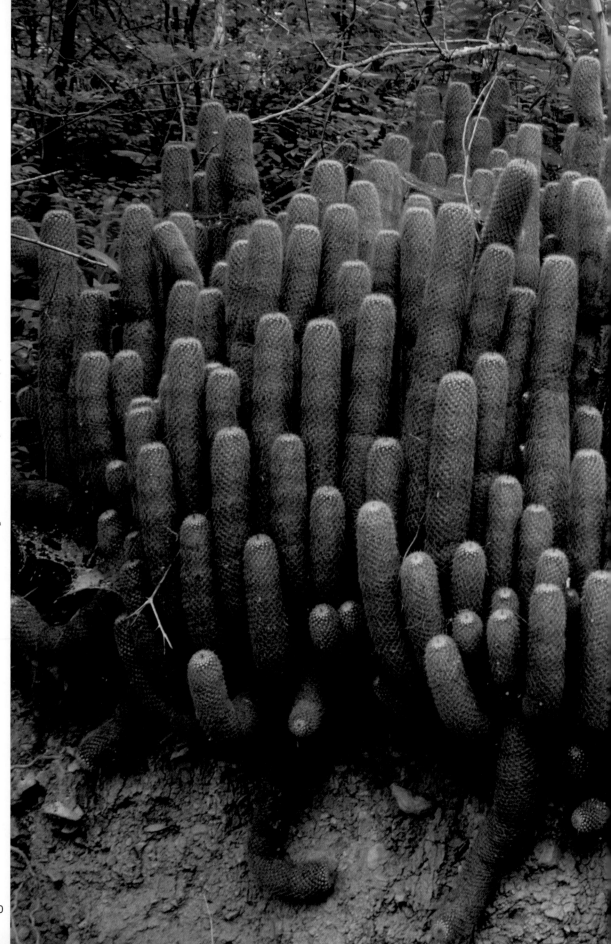

Mammillaria guerreronis. Guerrero, Mexico, 2002 (PH)

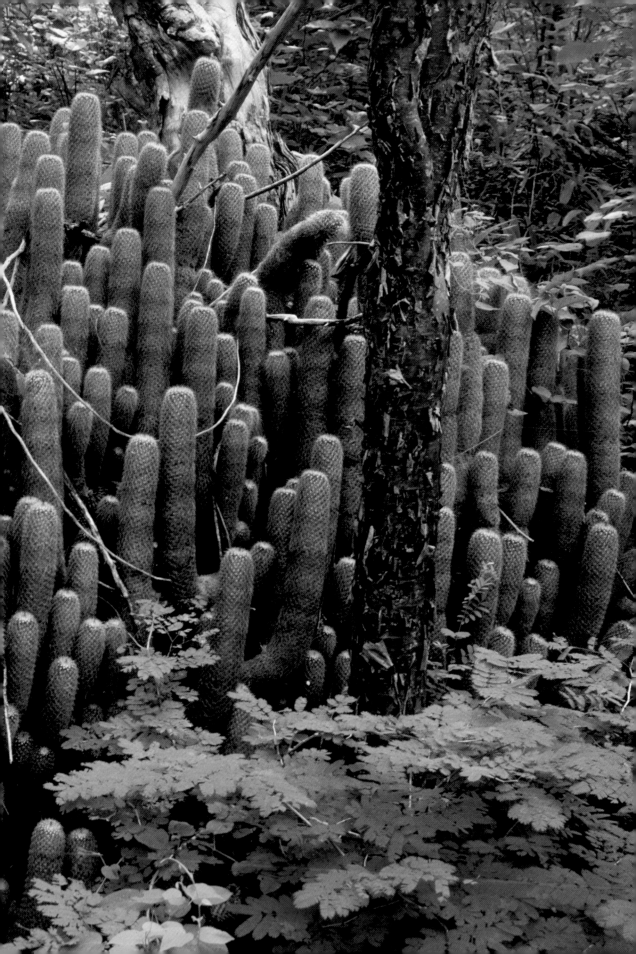

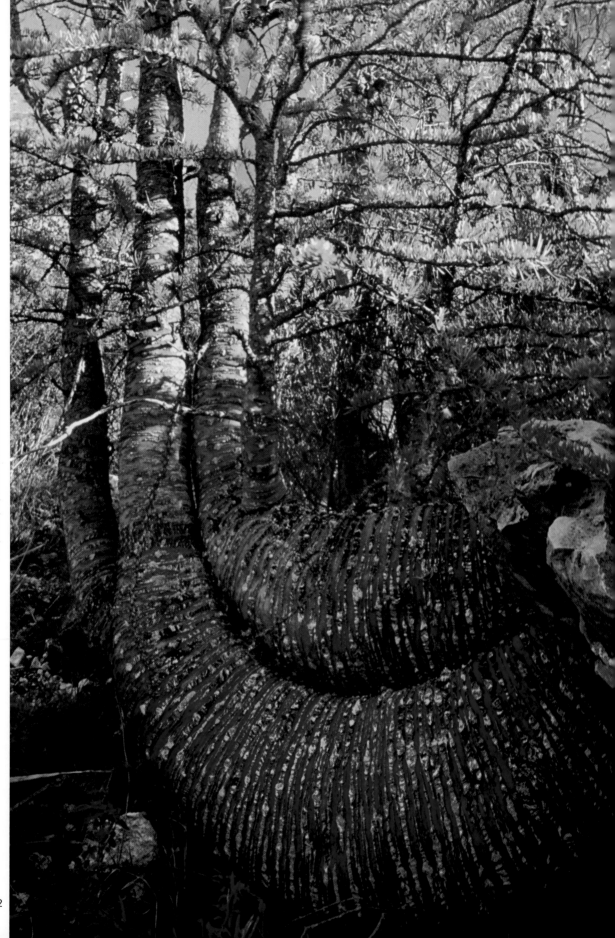

Fouquieria purpusii. Puebla, Mexico, 1976 (WM)

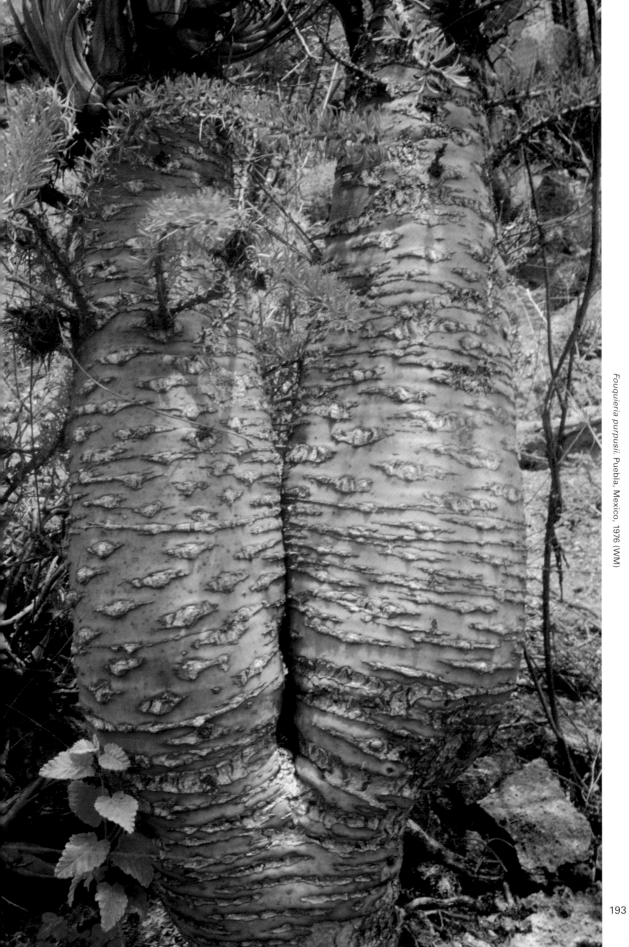

Fouquieria purpusii, Puebla, Mexico, 1976 (WM)

193

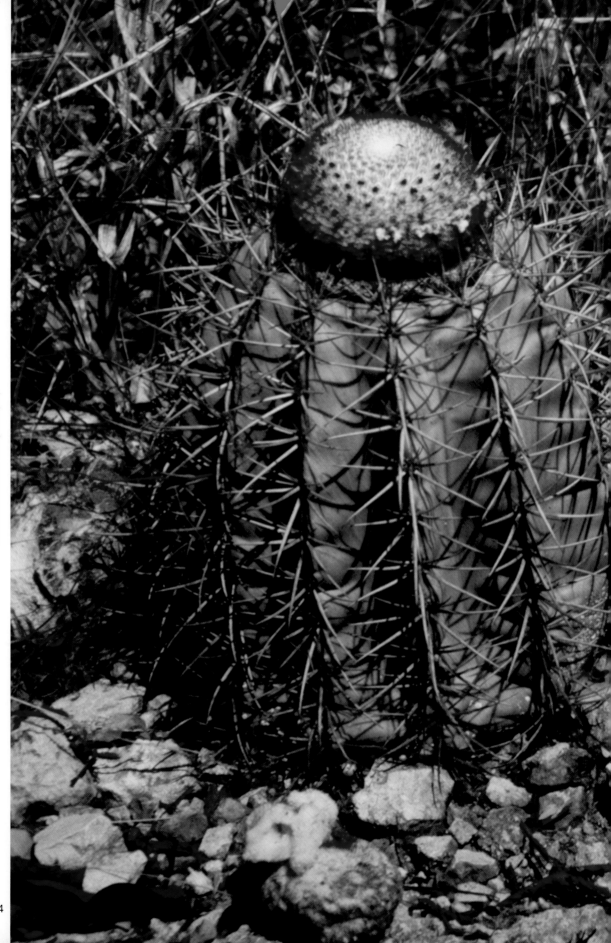

Melocactus azureus. Brazil, 2000 (GC)

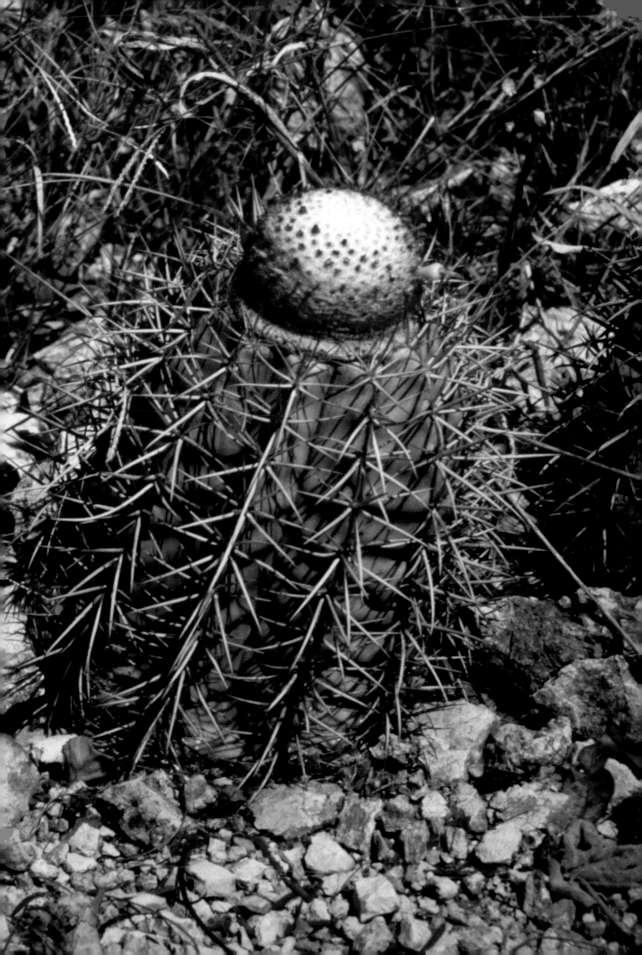

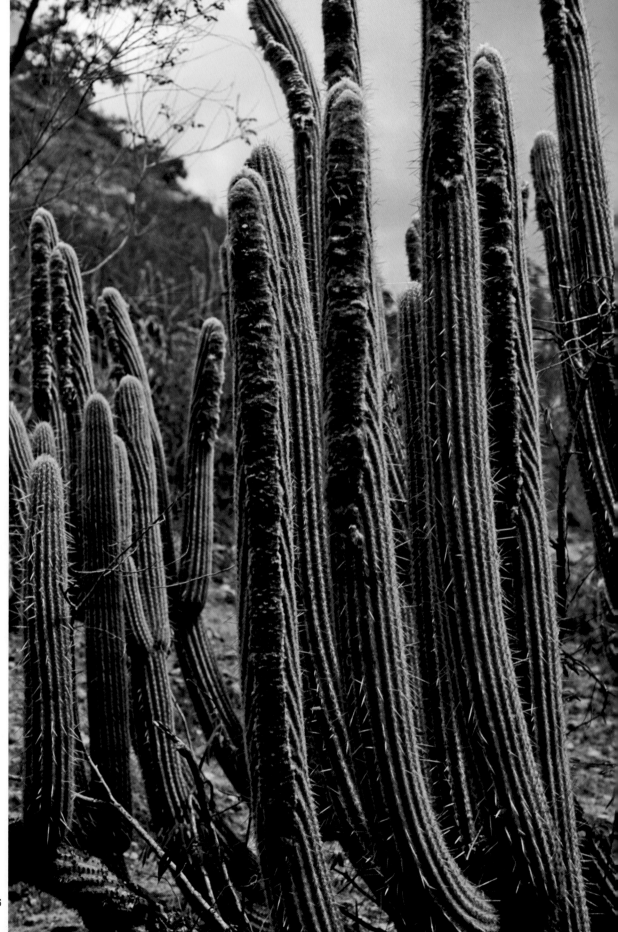

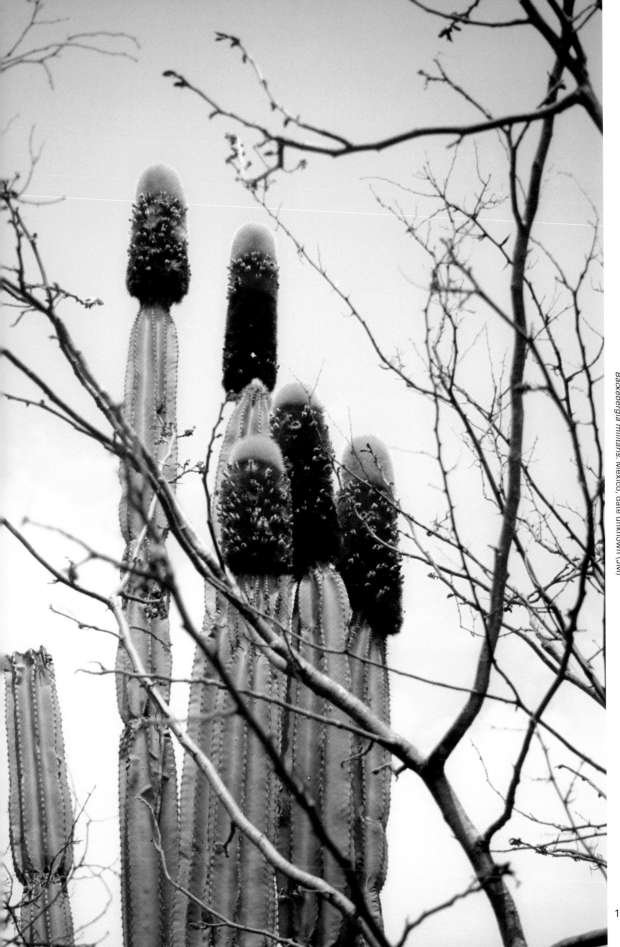

Backebergia militaris. Mexico, date unknown (JM)

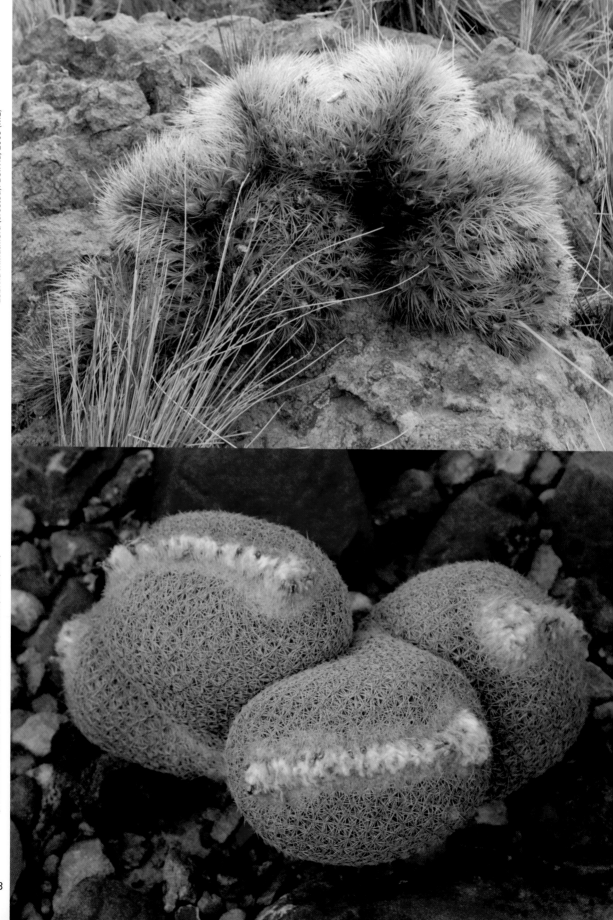

Lobivia minutiflora (crested). Bolivia, 2009 (ML)

Epithelantha micromeris (crested). Coahuila, Mexico, 2015 (WM)

198

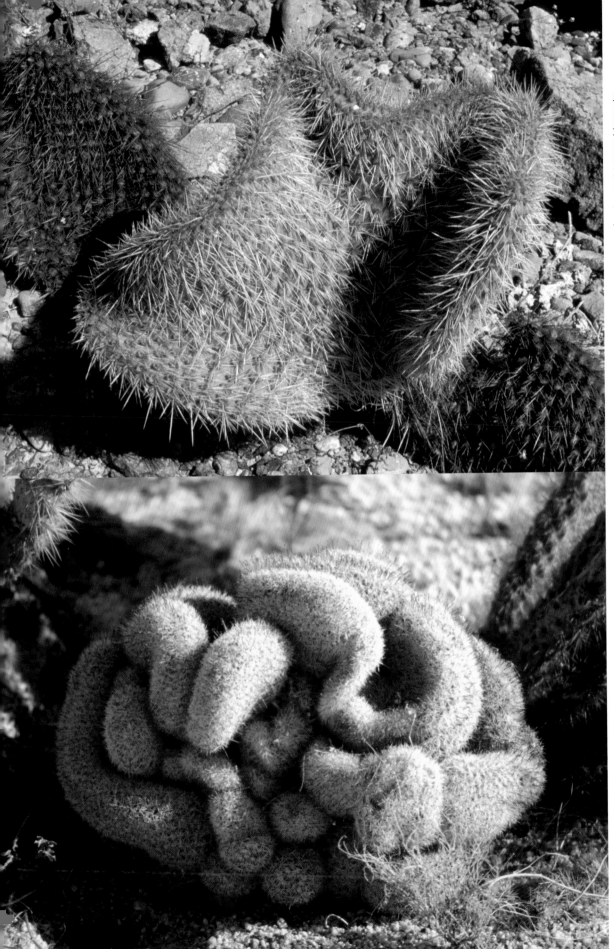

Opuntia pycnantha (crested), Baja California Sur, Mexico, 1952 (RM)

Mammillaria dioica (crested), California, USA, 1997 (JR)

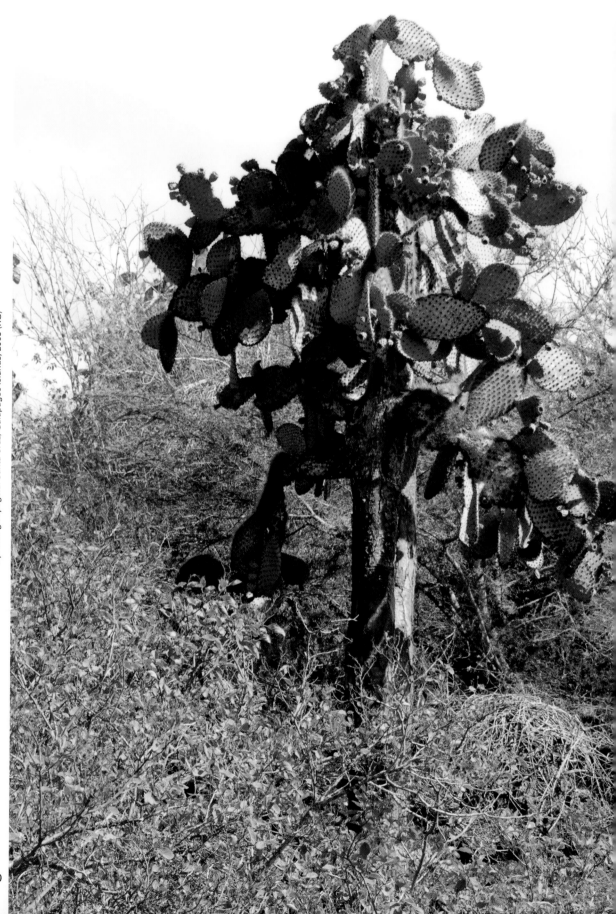

Opuntia galapageia. Santa Cruz, Galápagos Islands, 2009 (RG)

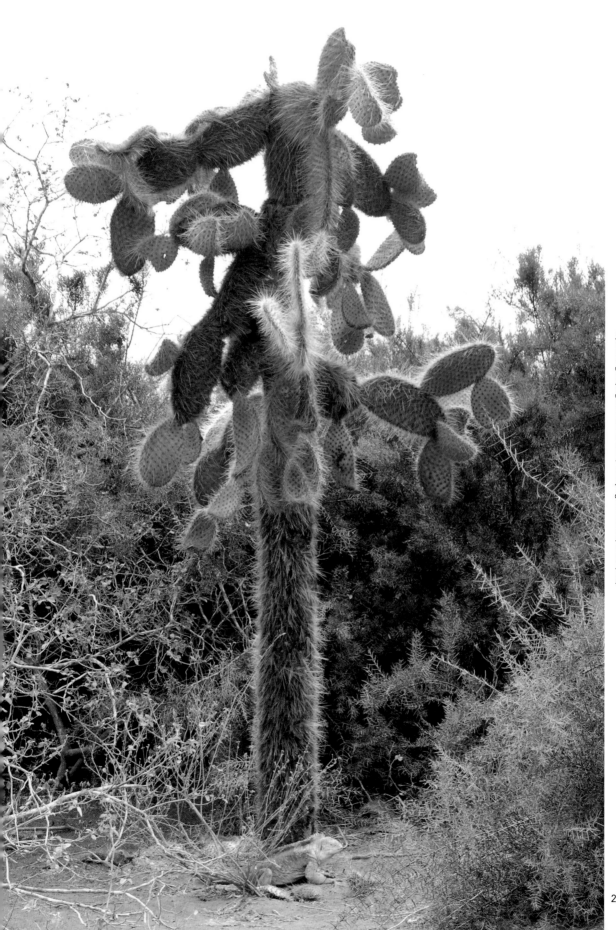

Opuntia galapageia, Santa Cruz, Galápagos Islands, 2009 (RG)

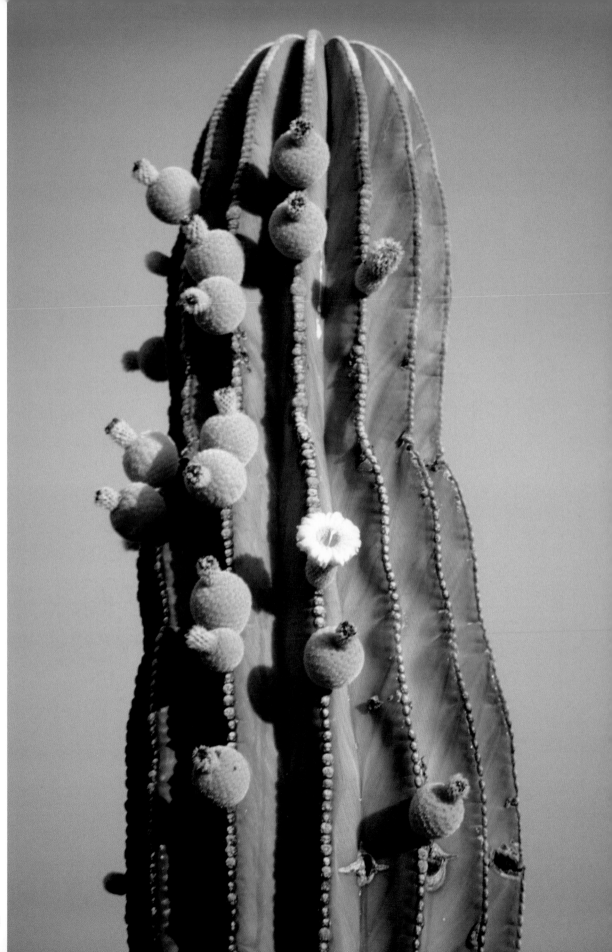

Pachycereus pringlei. Cataviña, Baja California, Mexico, 1996 (JR)

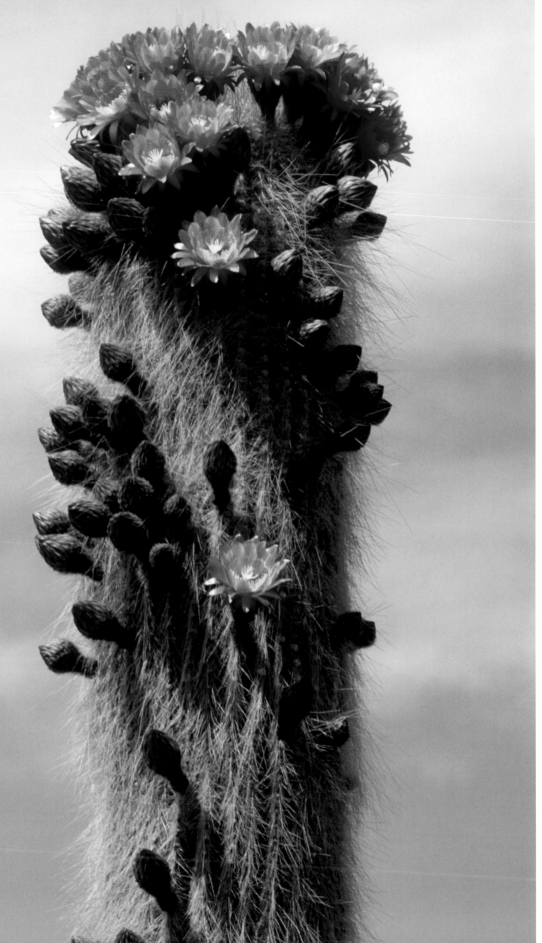

Trichocereus poco. Argentina, 2002 (WM)

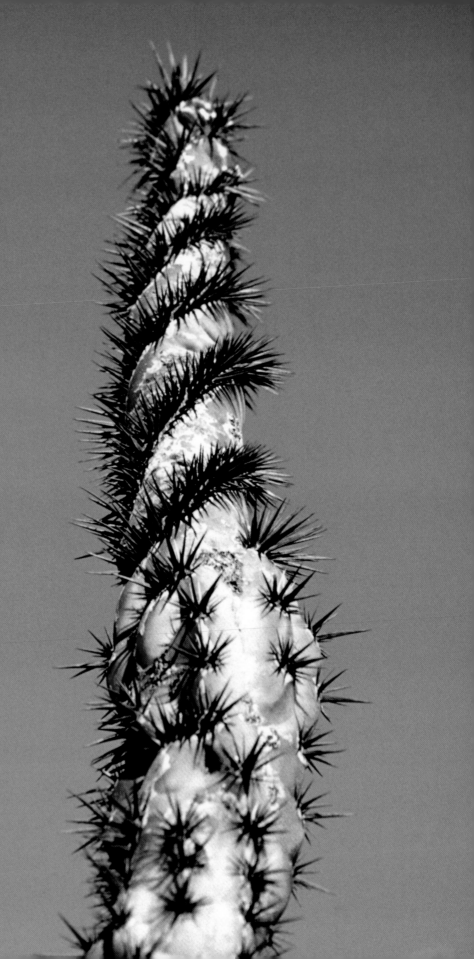

Stenocereus gummosus (spiralis). Baja California, Mexico, 1994 (JR)

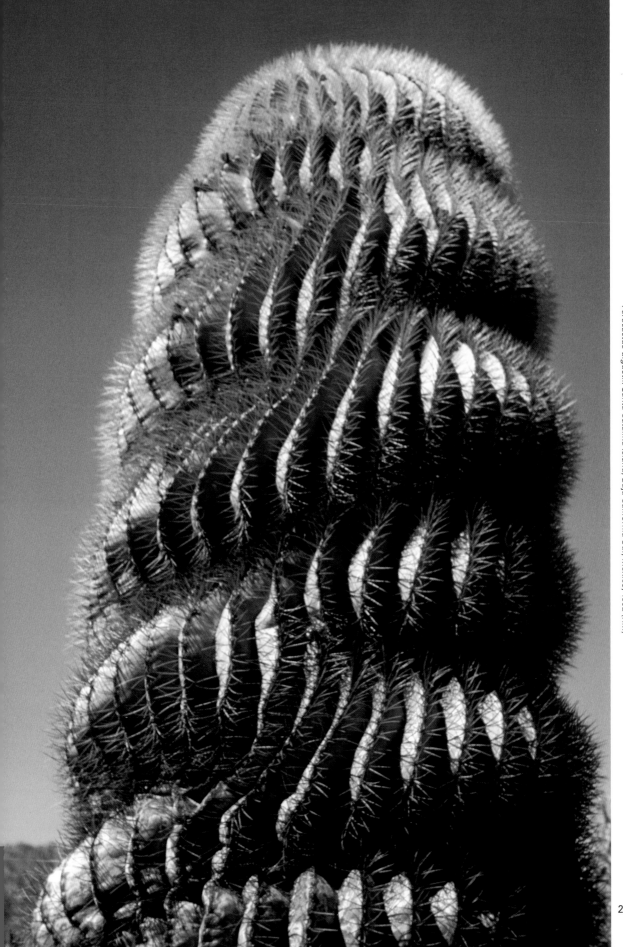

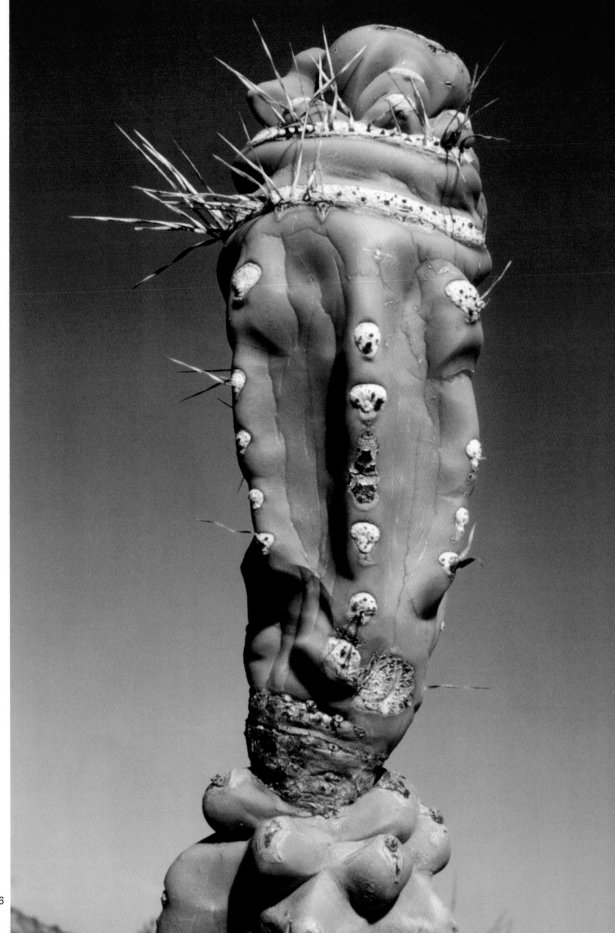

Lophocereus schottii. Baja California, Mexico, 1961 (RM)

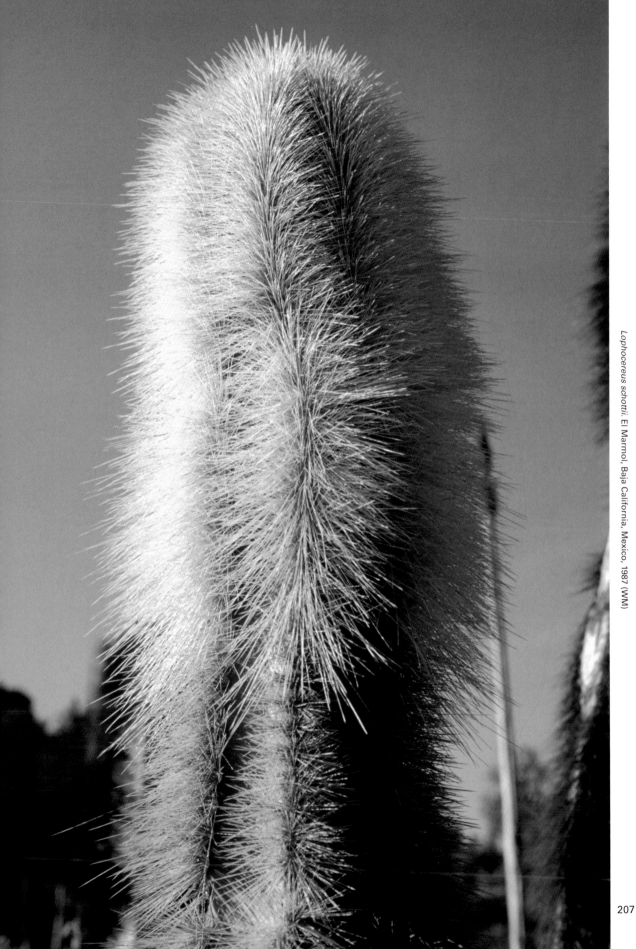

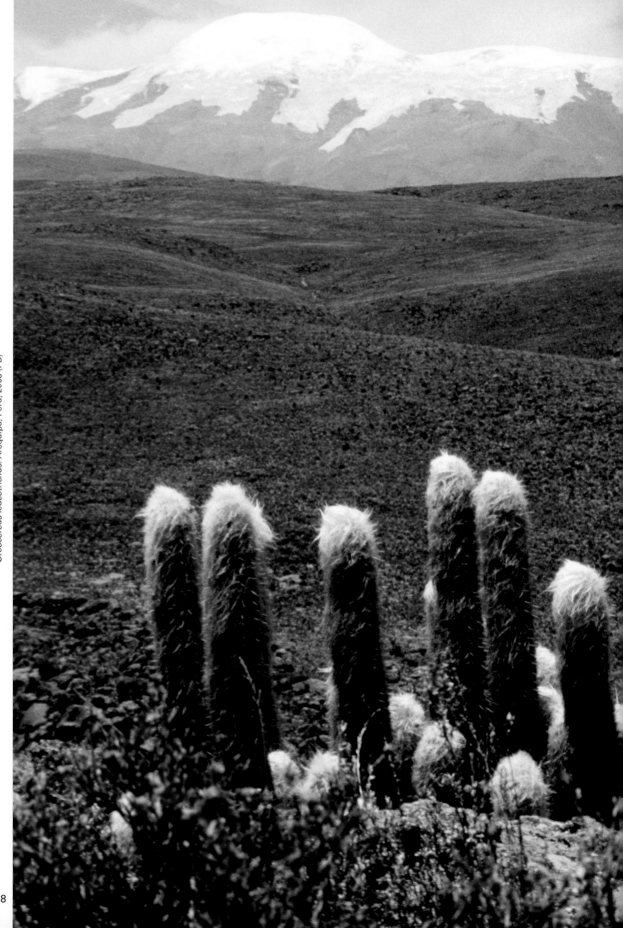

Oreocereus leucotrichus. Arequipa, Peru, 2003 (PB)

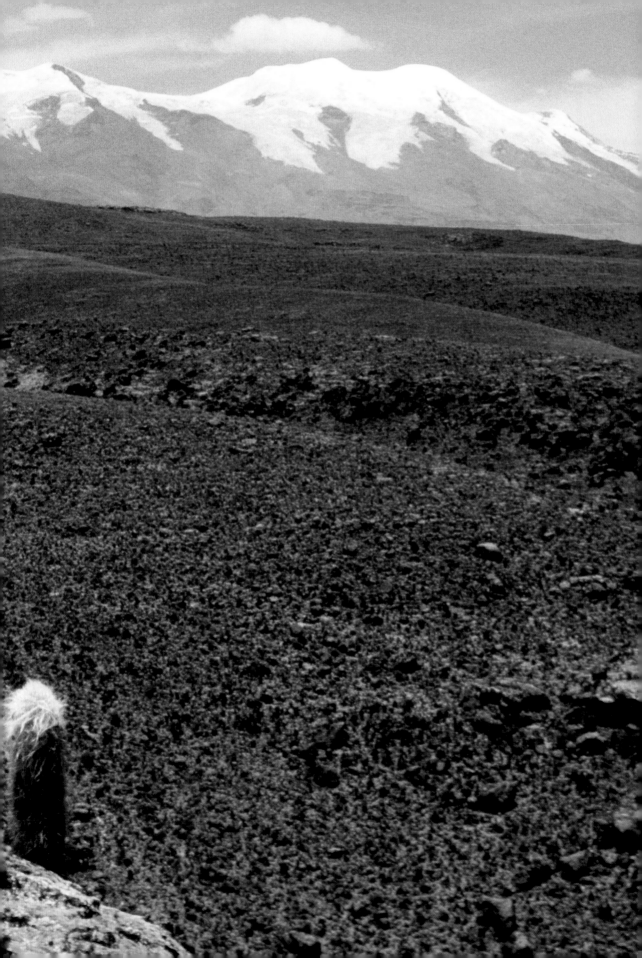

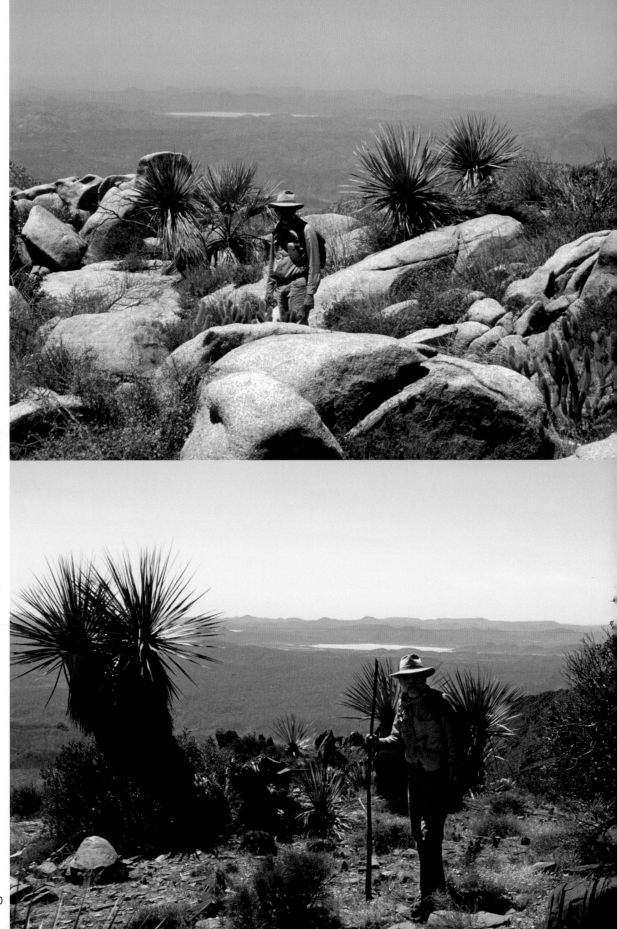

Dr. Hugo Riemann. Sierra de la Asamblea, Baja California, Mexico, 2004 (JR)

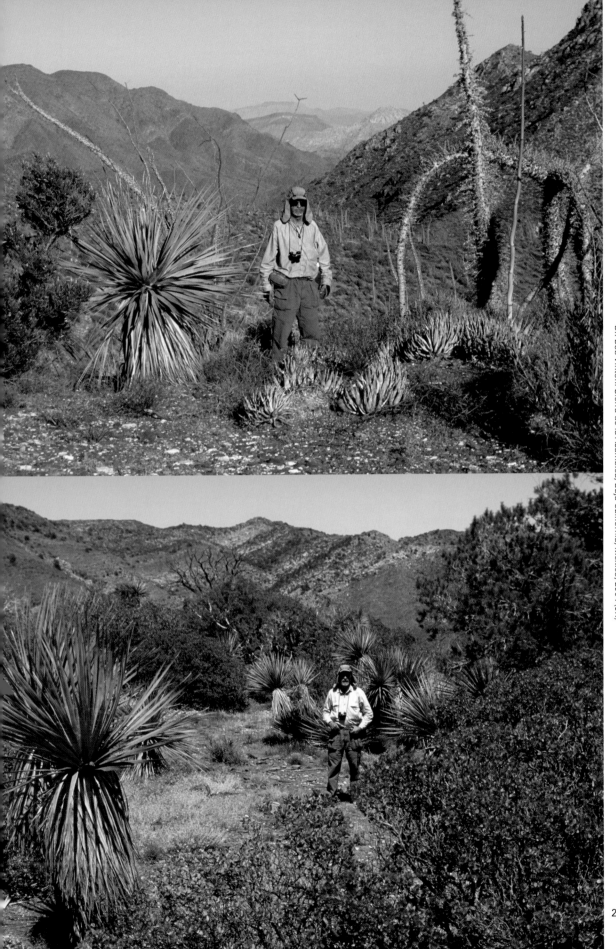

Dr. Bob Vinton. Sierra de la Asamblea, Baja California, Mexico, 2004 (JR)

211

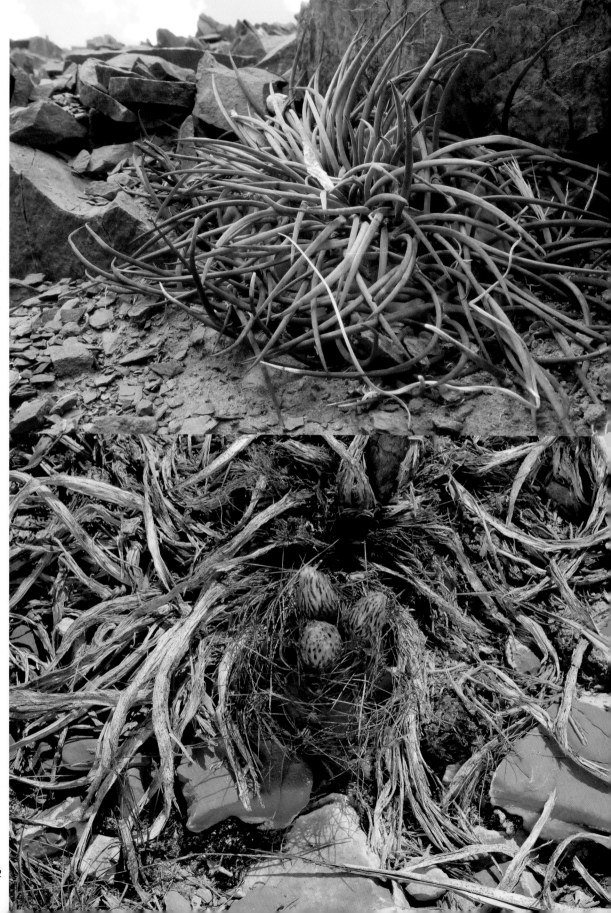

Gymnocalycium spegazzinii. Argentina, date unknown (MT)

Astrophytum capricorne var. aureum. Sierra de la Paila, Mexico, 2015 (WM)

212

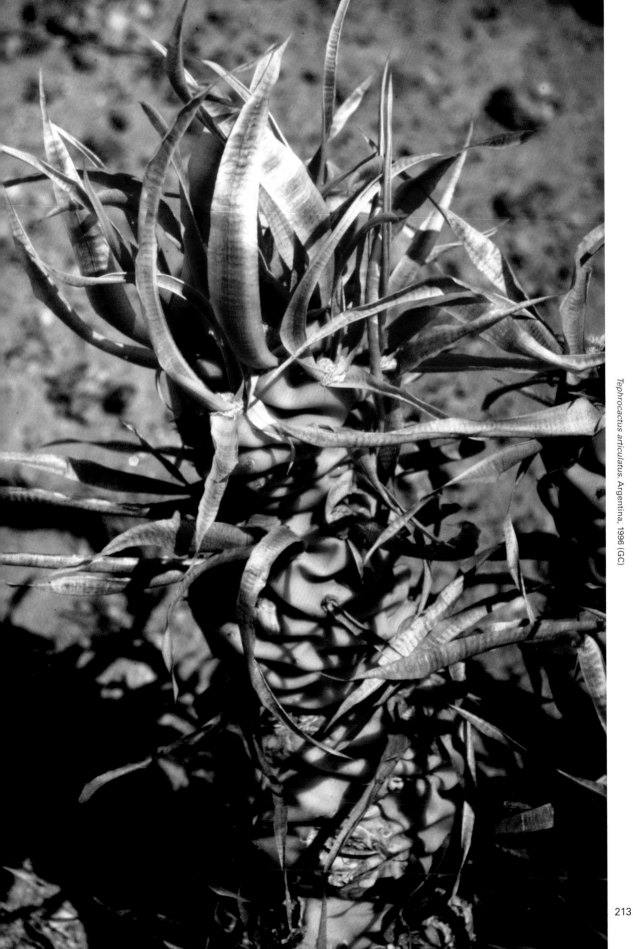

Tephrocactus articulatus, Argentina, 1996 (GC)

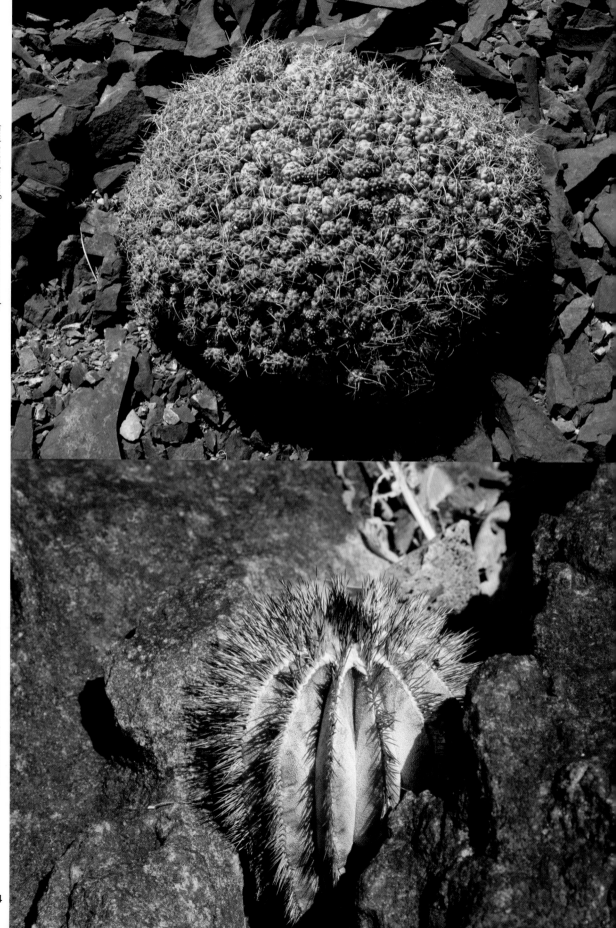

Tephrocactus recurvatus. Argentina, 2016 (ML)

Uebelmannia pectinifera. Brazil, 2008 (GC)

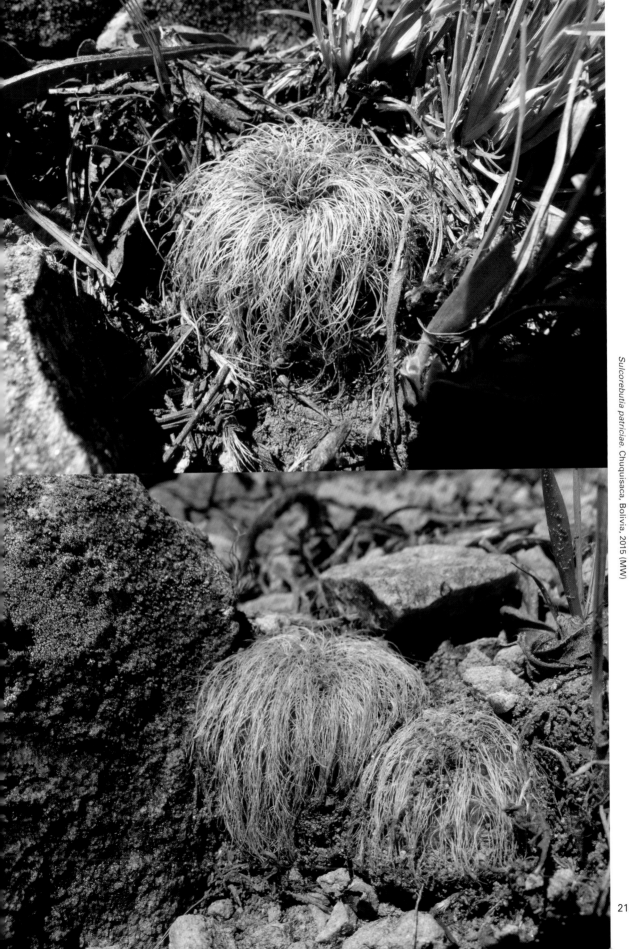

Sulcorebutia patriciae, Chuquisaca, Bolivia, 2015 (MW)

215

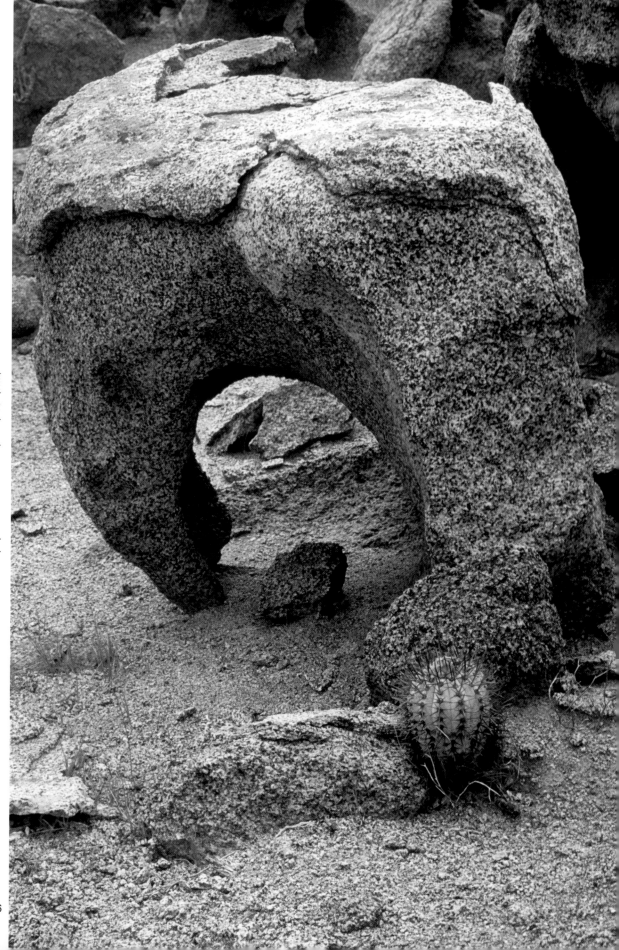

216

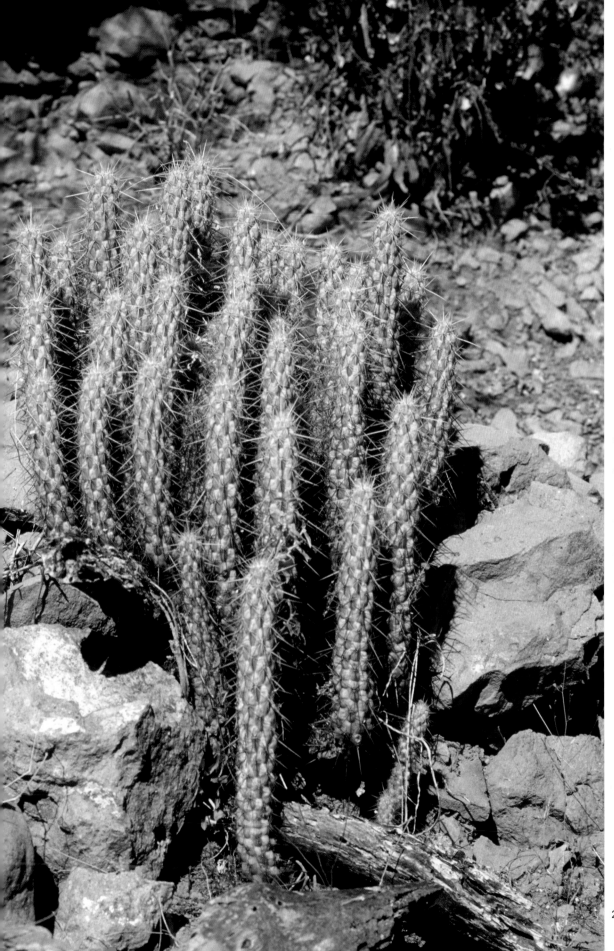

Echinocereus brandegeei, Baja California, Mexico, 1999 (JR)

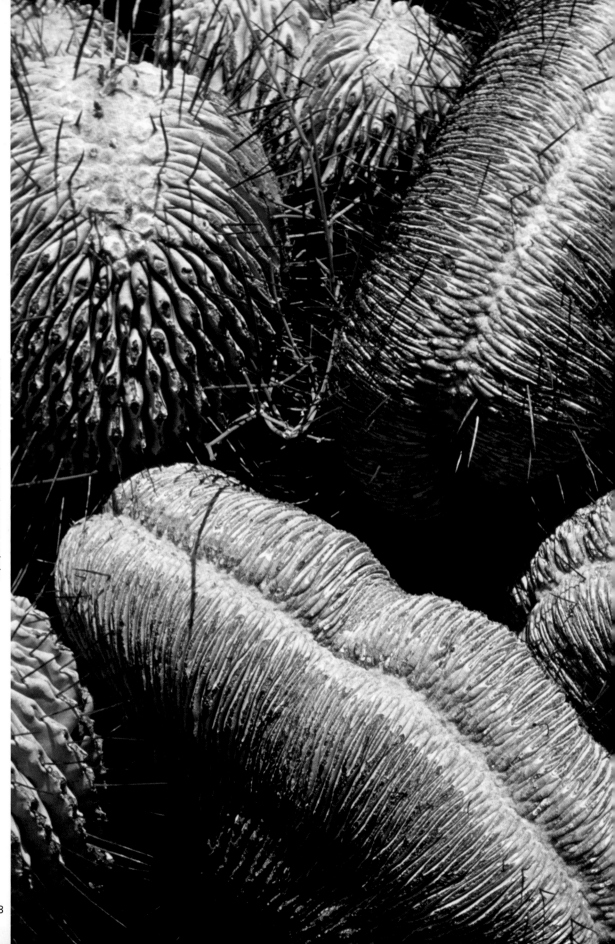

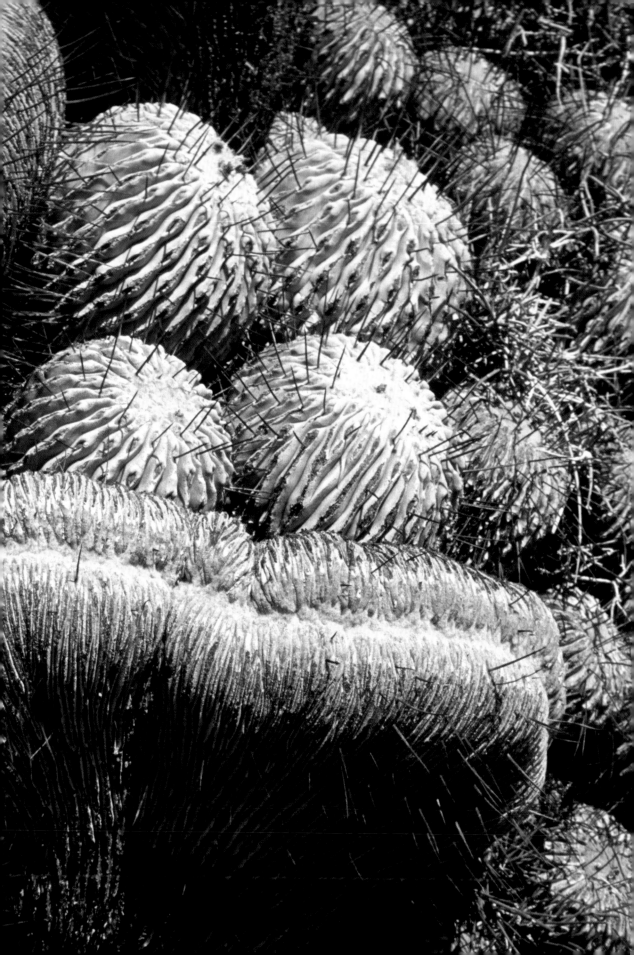

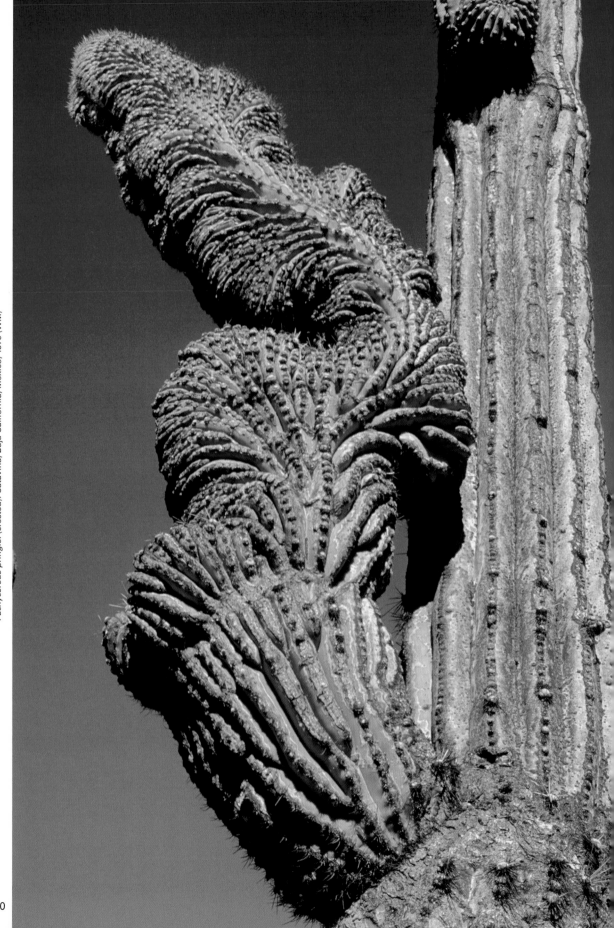

220

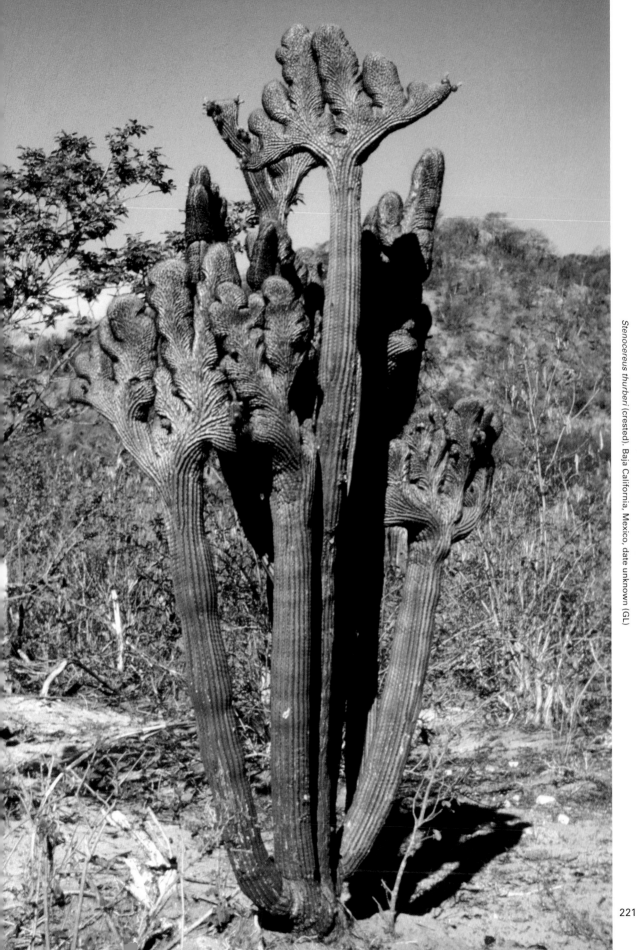

Stenocereus thurberi. Sonora, Mexico, date unknown (DY)

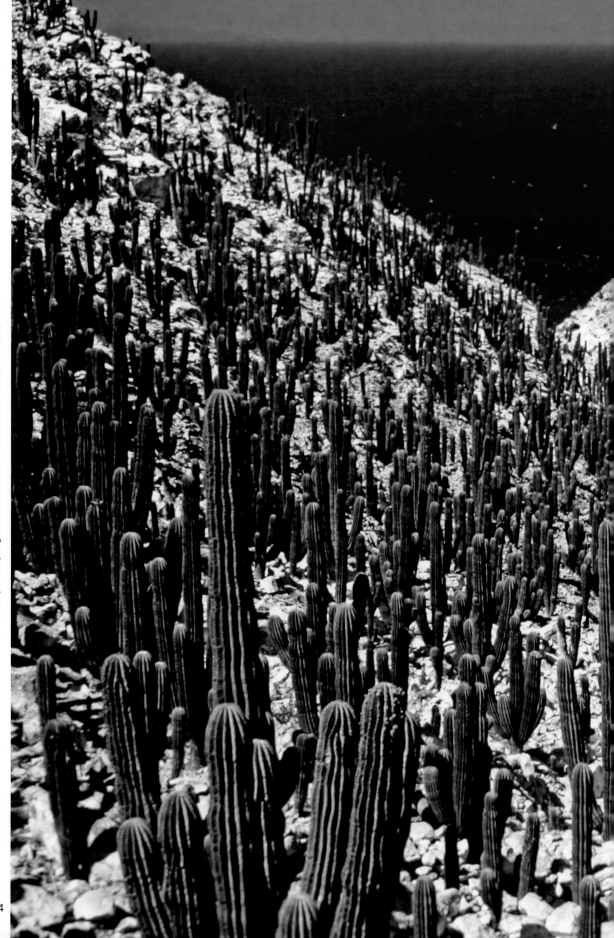

Pachycereus pringlei. Isla San Pedro Mártir, Sonora, Mexico, 1966 (RM)

224

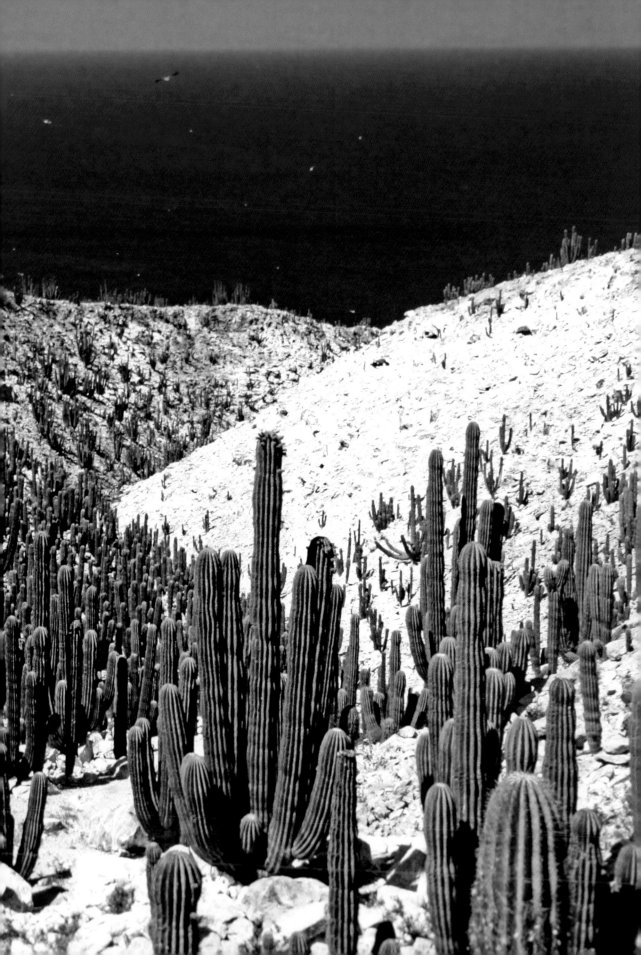

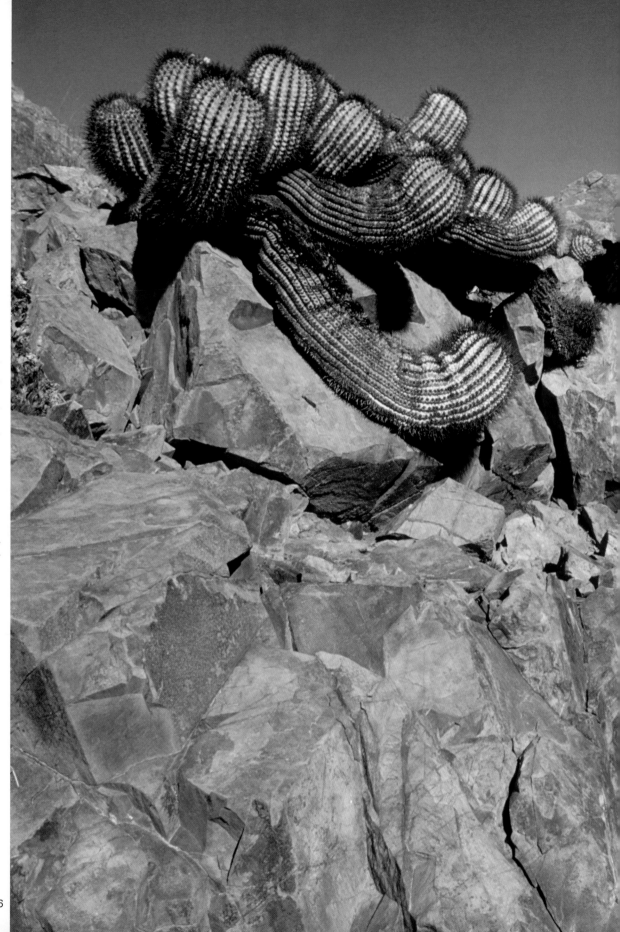

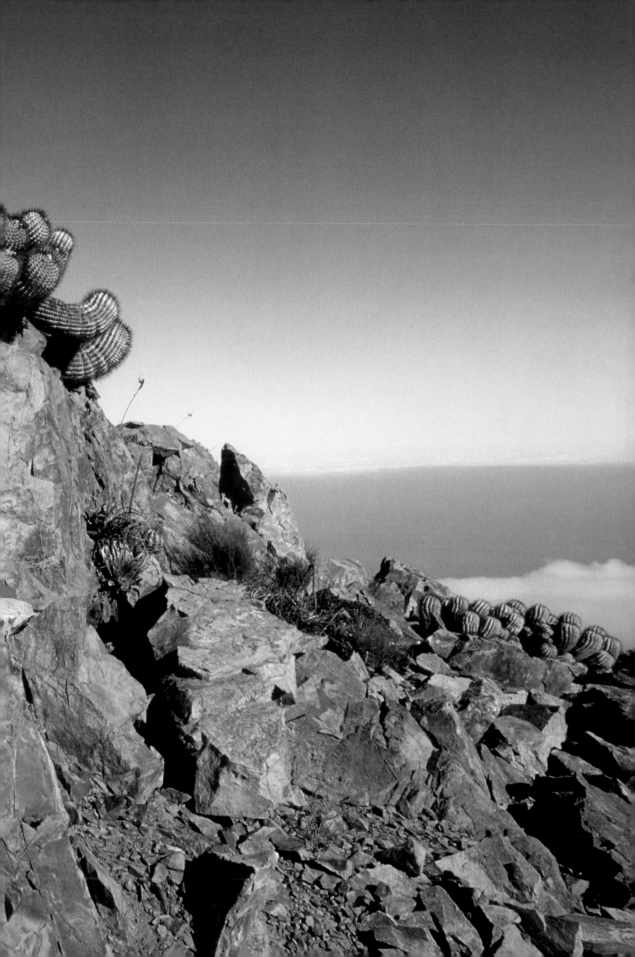

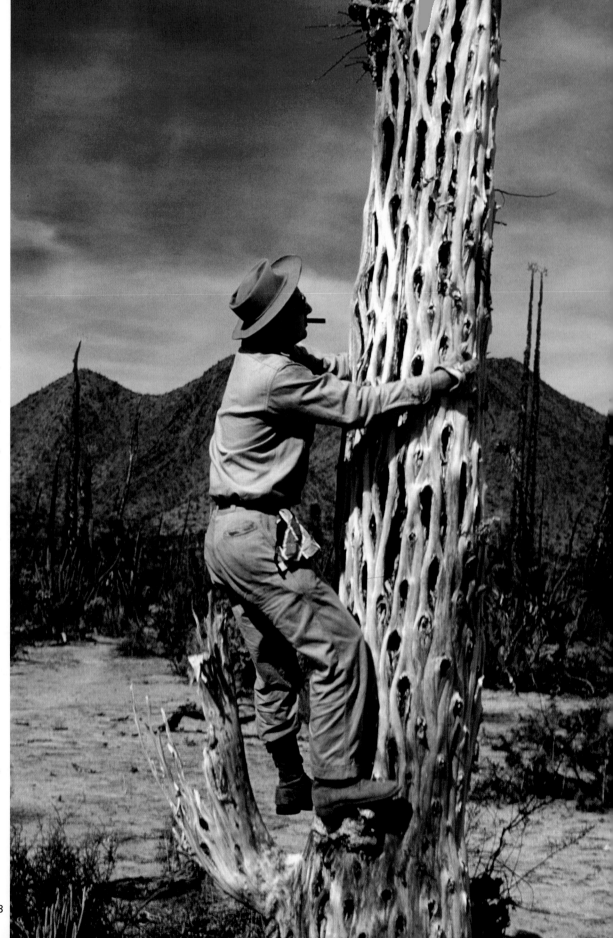

Remnants of *Fouquieria columnaris*, Baja California, Mexico, 1961 (GL)

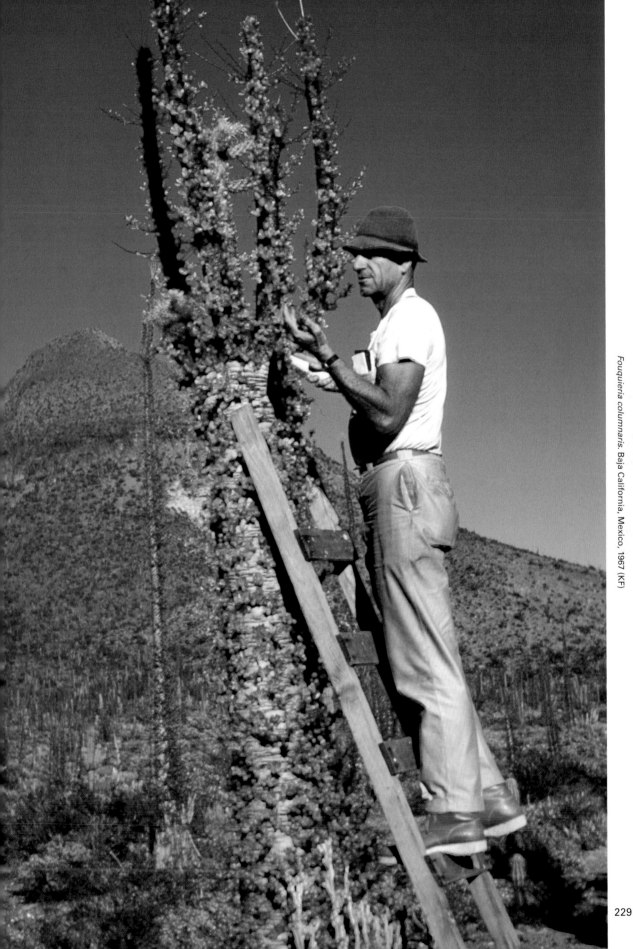

Fouquieria columnaris. Baja California, Mexico, 1967 (KF)

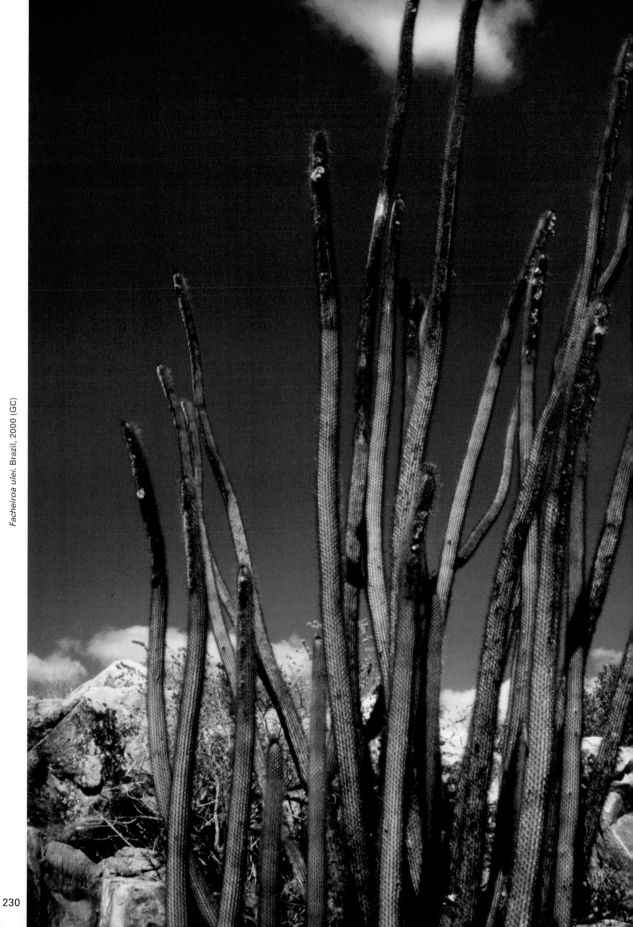

Facheiroa ulei. Brazil, 2000 (GC)

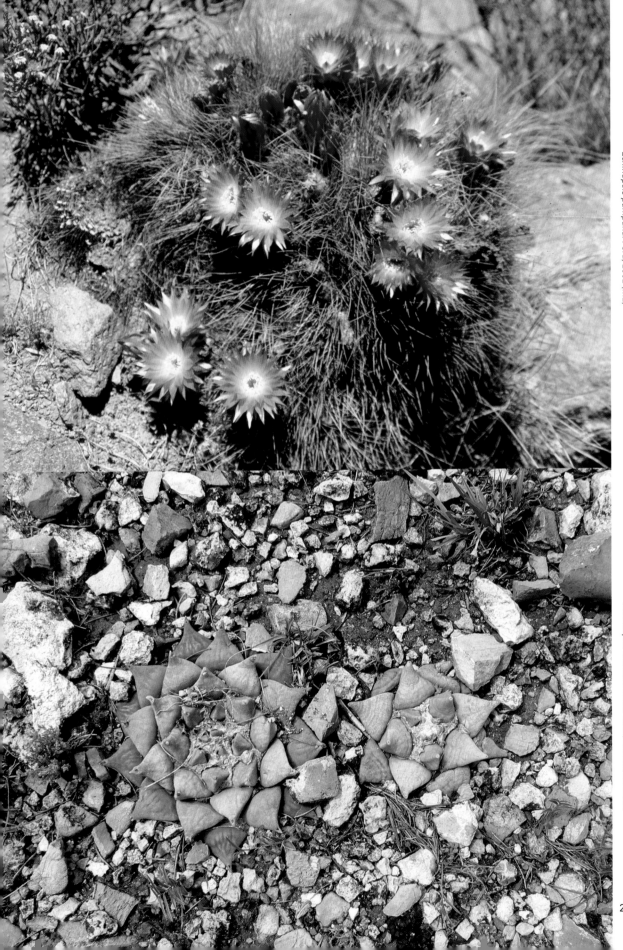

Echinopsis pampana. Peru, 2002 (ML)

Ariocarpus retusus. Nuevo León, Mexico, 2010 (JL)

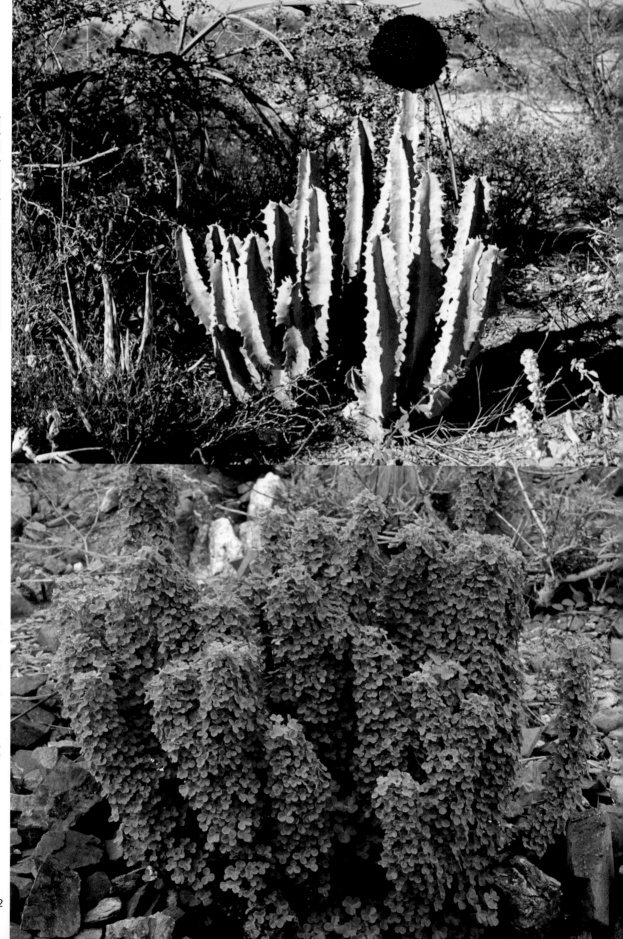

Caralluma russeliana. Bulo Burti, Somalia, 1969 (JJL)

Oxalis gigantea. Taltal, Chile, 1997 (WM)

Boswellia frereana. Somalia, 1970 (JJL)

Euphorbia ramiglans (crested). Alexander Bay, South Africa, 2002 (JL)

233

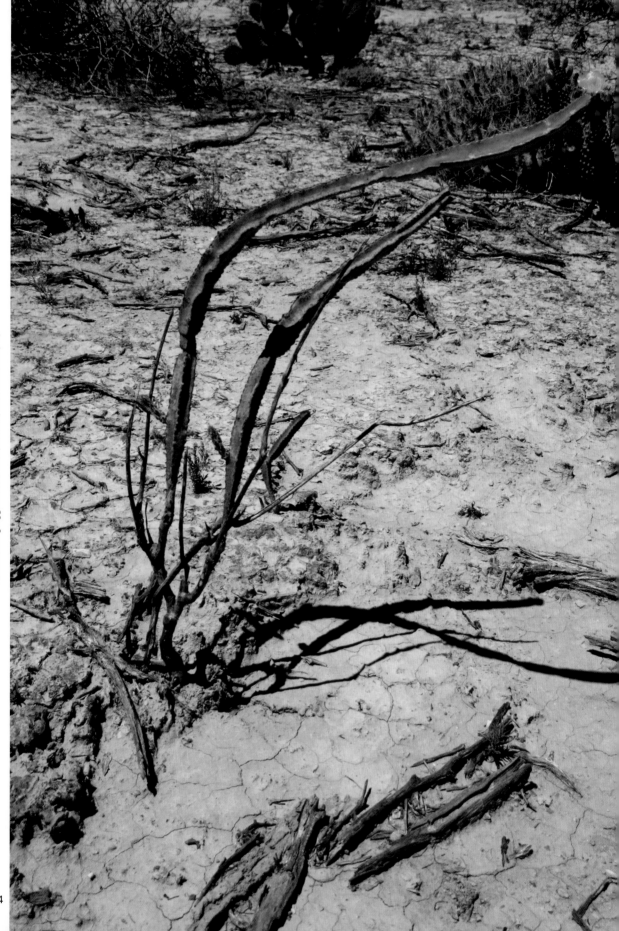

Peniocereus greggii. Nuevo León, Mexico, date unknown (PB)

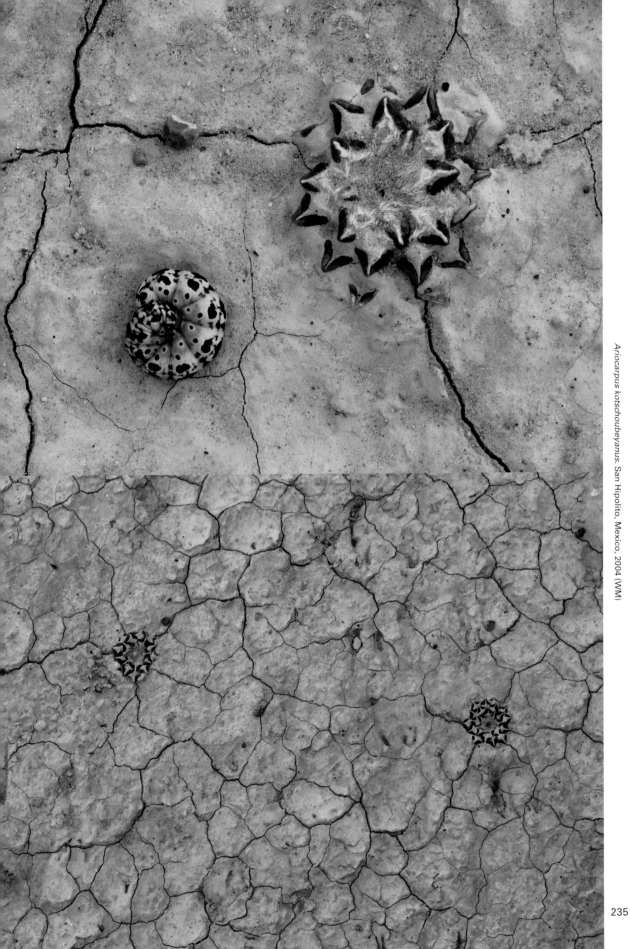

235

Euphorbia fianarantsoae. Madagascar, 2013 (WM)

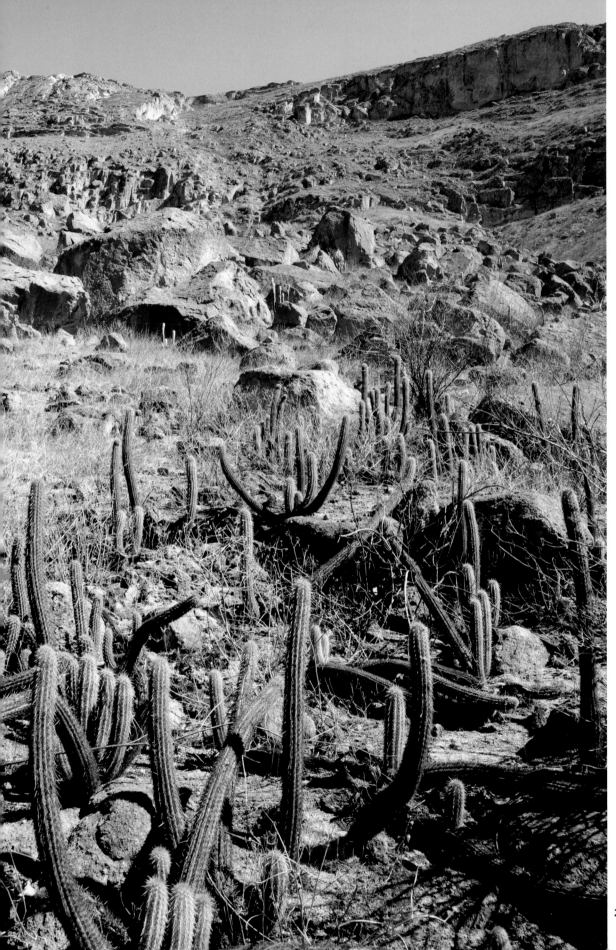

Haageocereus sp. Peru, 2010 (WM)

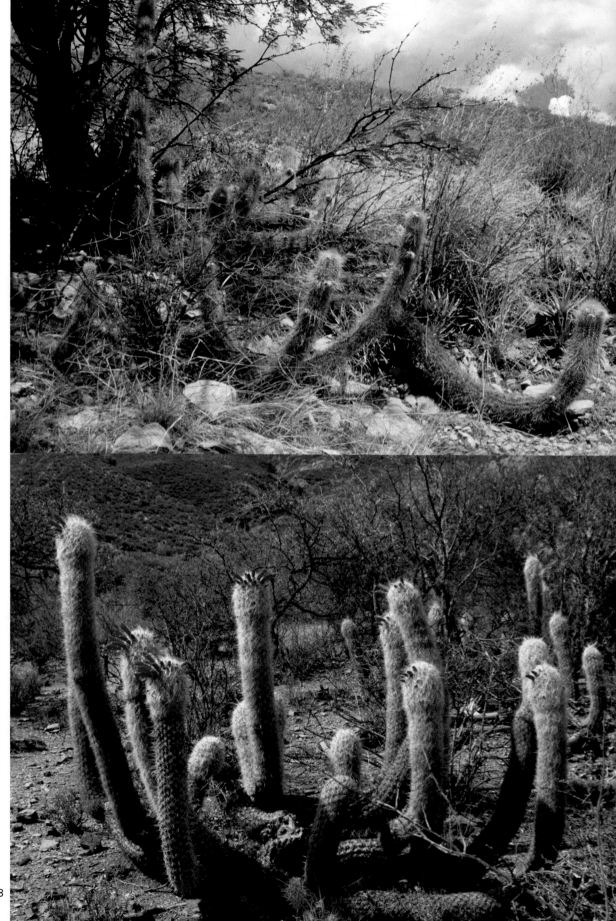

Echinopsis camarguensis. Bolivia, 1997 (ML)

Oreocereus celsianus. Bolivia, 2006 (ML)

238

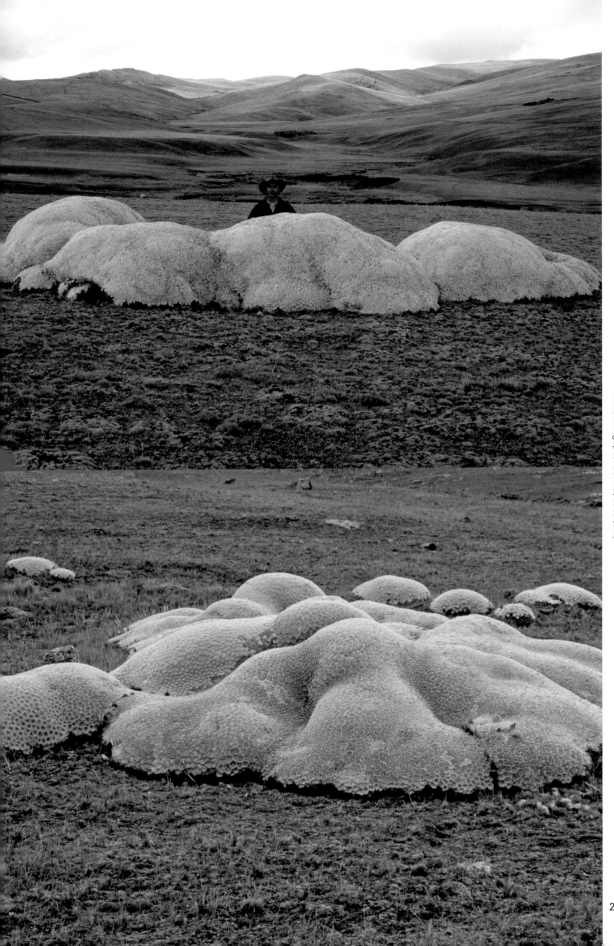

Cistanthe guadalupensis. Guadalupe Island, Baja California, Mexico, 2000 (JR)

Echinopsis maximiliana. Peru, 2002 (ML)

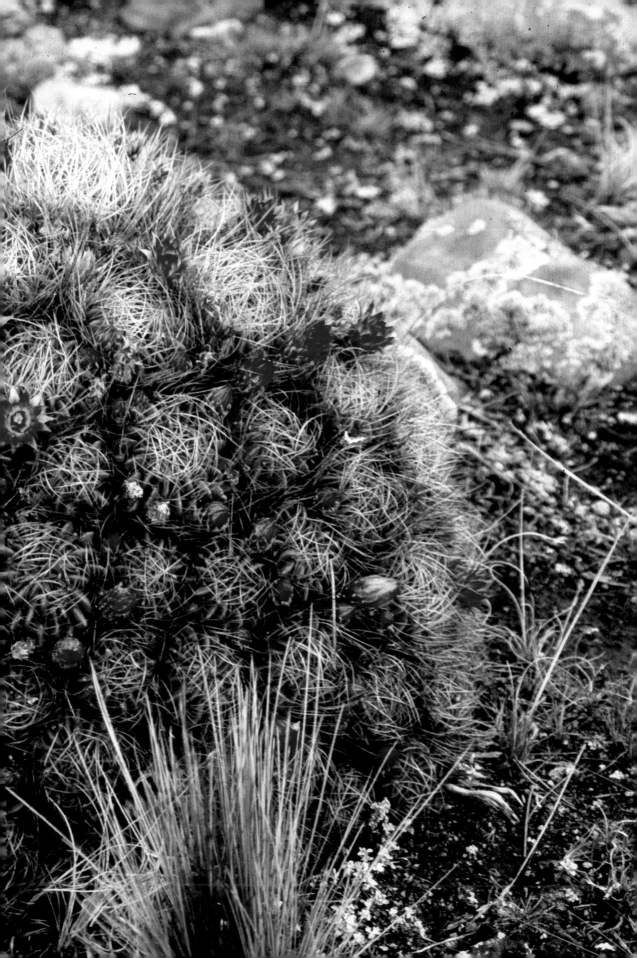

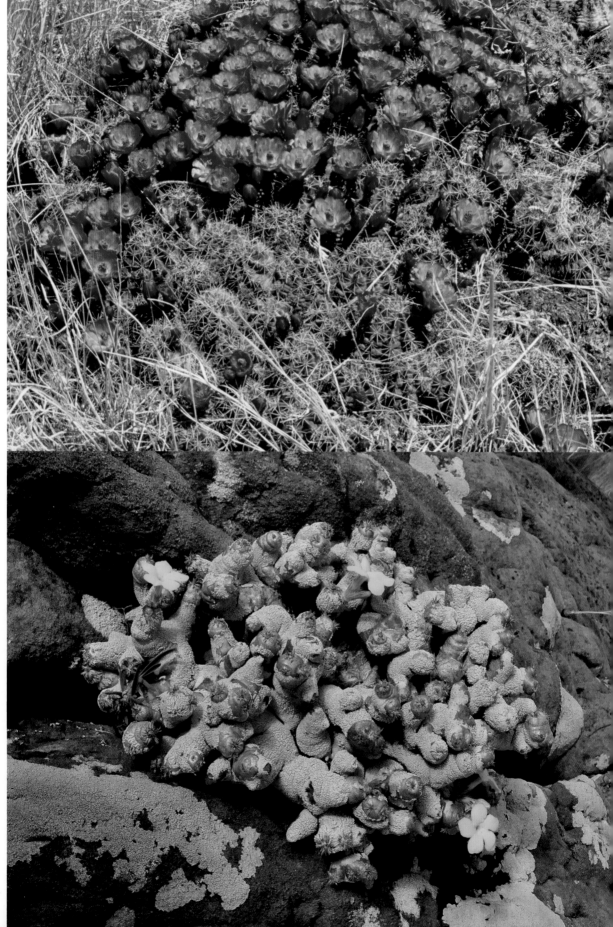

Echinocereus coccineus subsp. *transpecosensis*. Guadalupe Mountains, Texas, 2000 (PB)

Pachypodium brevicaule. Madagascar, 2013 (WM)

244

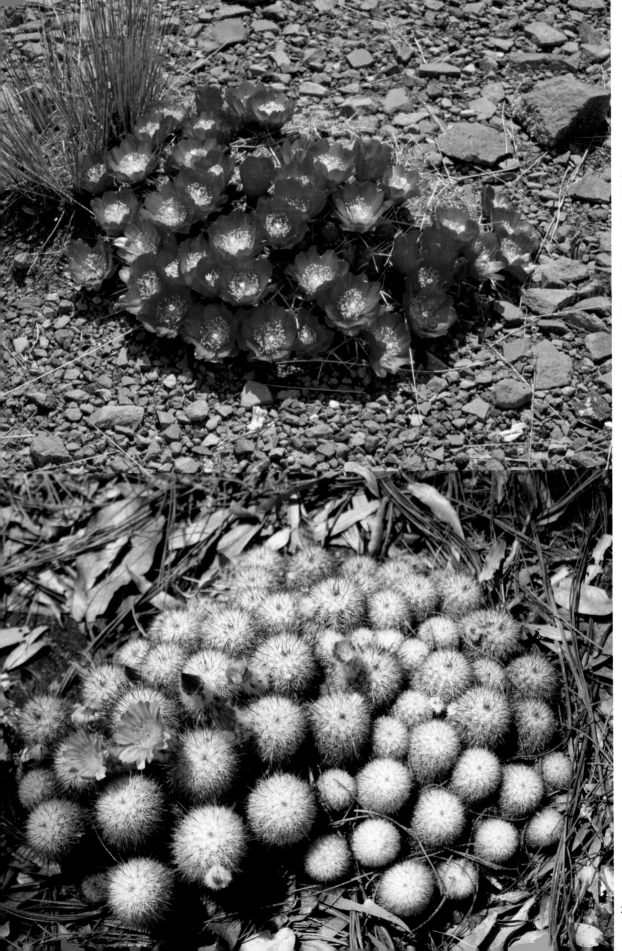

Cumulopuntia rossiana, Bolivia, 2012 (ML)

Echinocereus lauii, Undisclosed location, 2008 (PB)

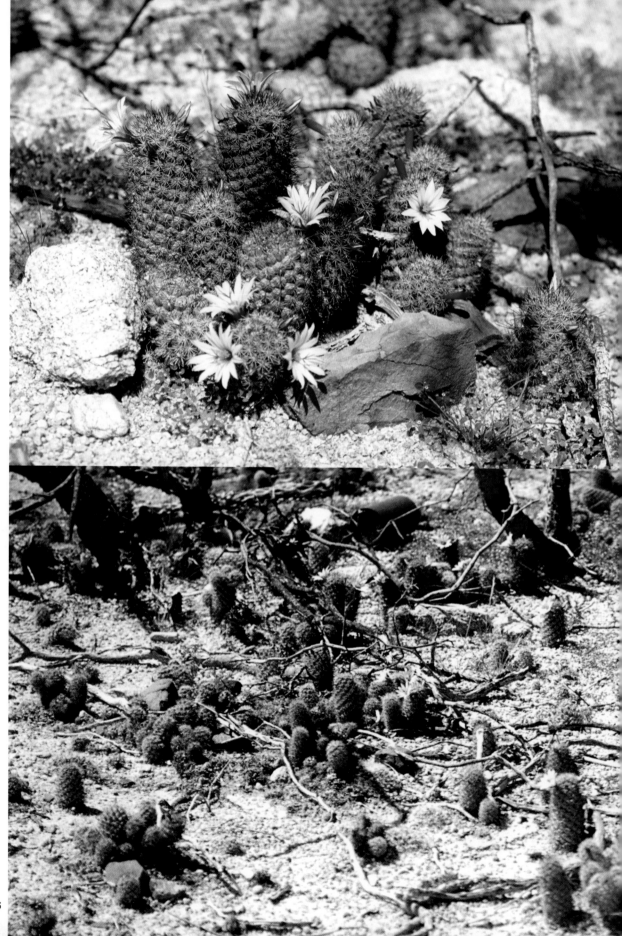

Mammillaria fraileana. Baja California Sur, Mexico, 1998 (JR)

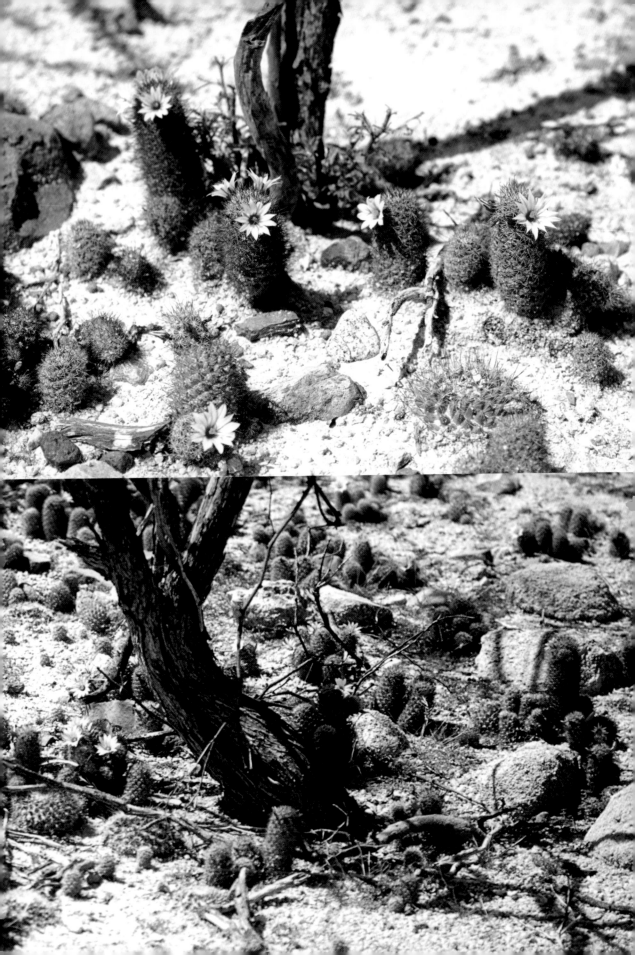

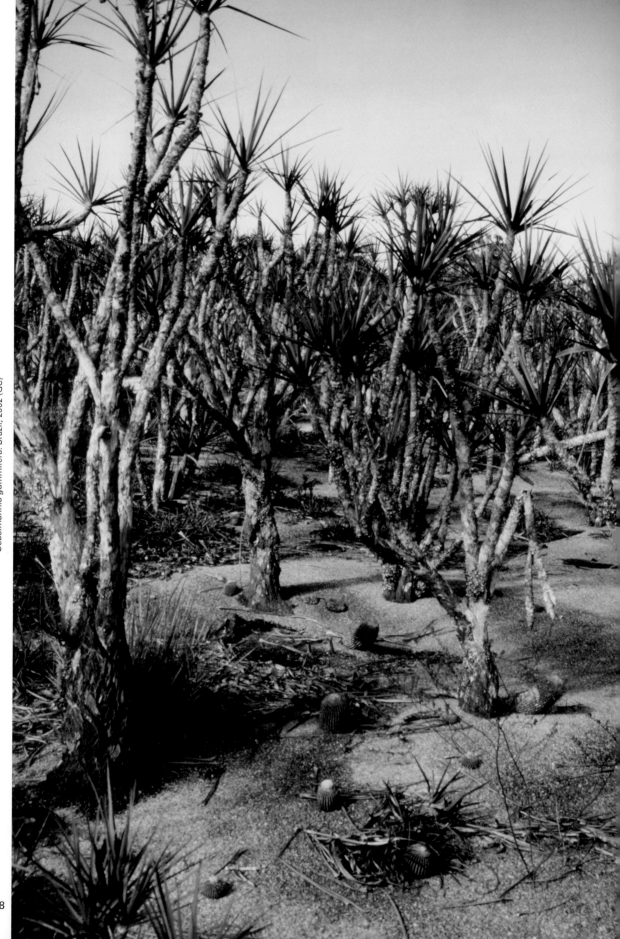

Uebelmannia gummifera. Brazil, 2002 (GC)

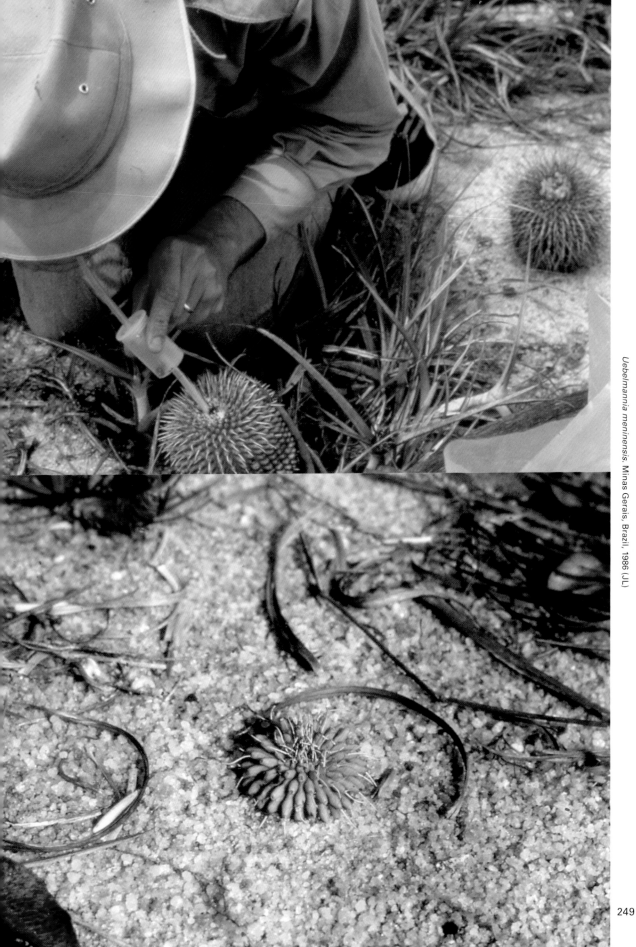

Uebelmannia meninensis, Minas Gerais, Brazil, 1986 (JL)

Lophocereus gatesii. Baja California, Mexico, date unknown (GL)

Yucca schidigera. Baja California, Mexico, 1971 (RM)

250

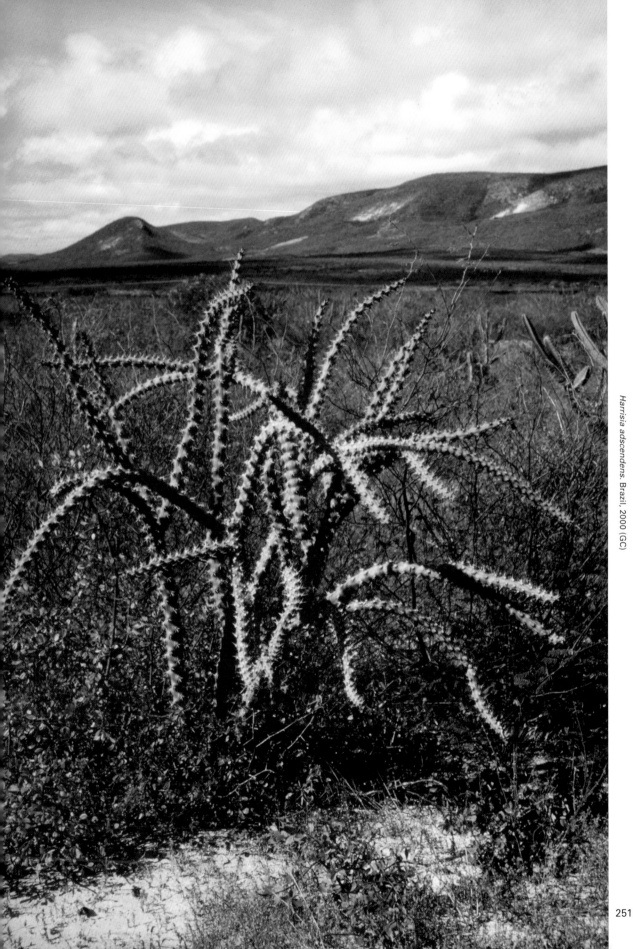

Harrisia adscendens, Brazil, 2000 (GC)

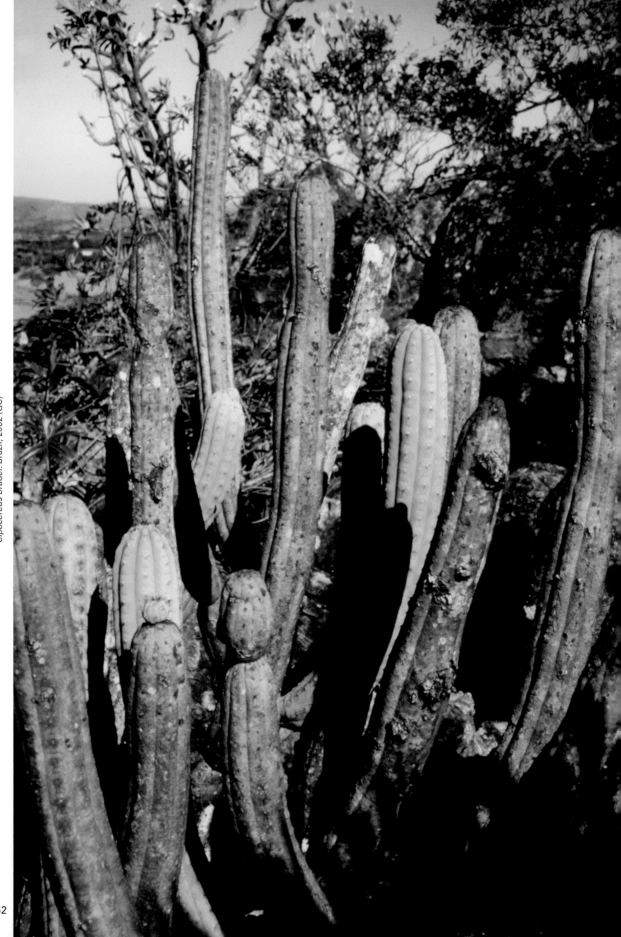

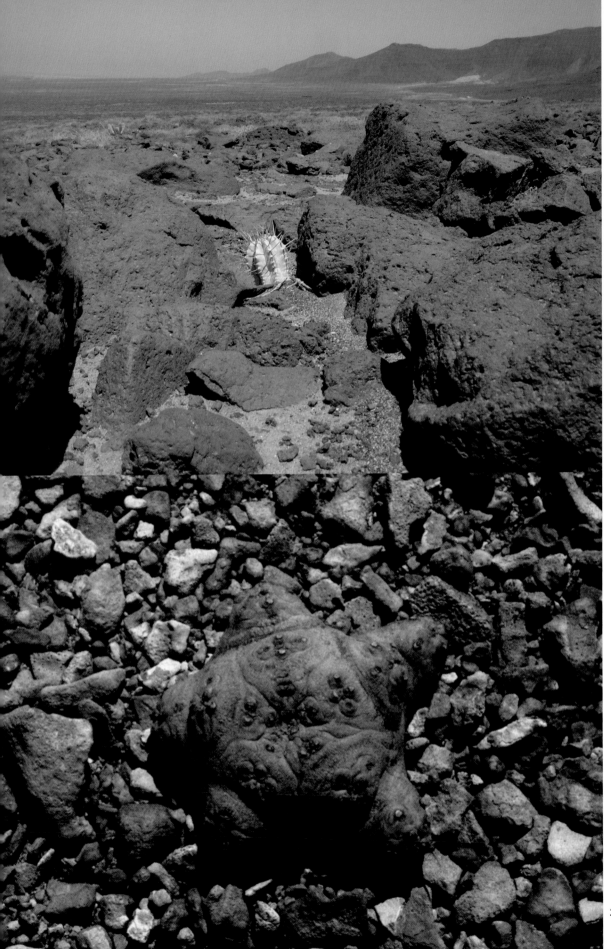

Euphorbia handiensis. Fuerteventura, Canary Islands, 2004 (JL)

Euphorbia harwoodii. Somalia, 1972 (JJL)

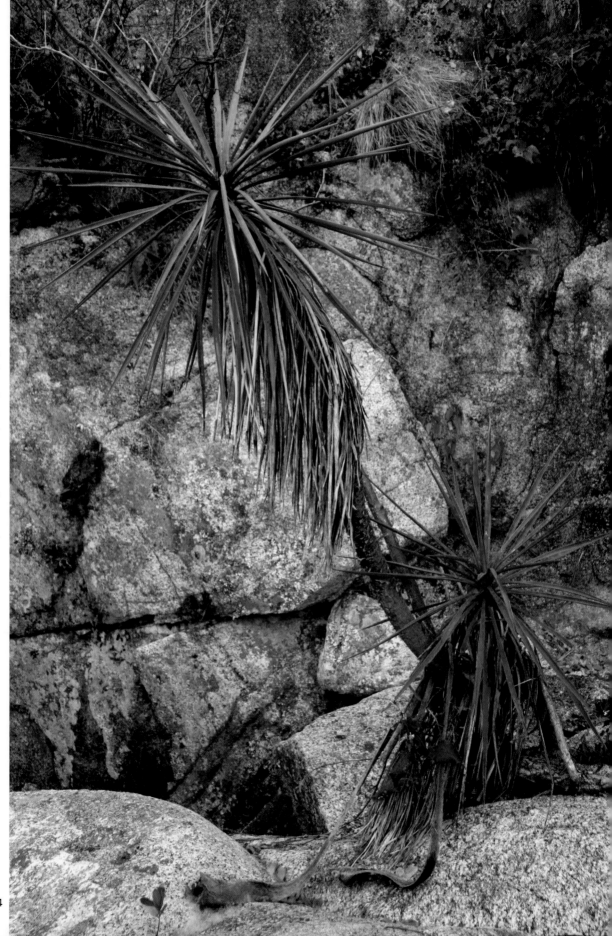

Yucca capensis. Baja California Sur, Mexico, 2008 (LR)

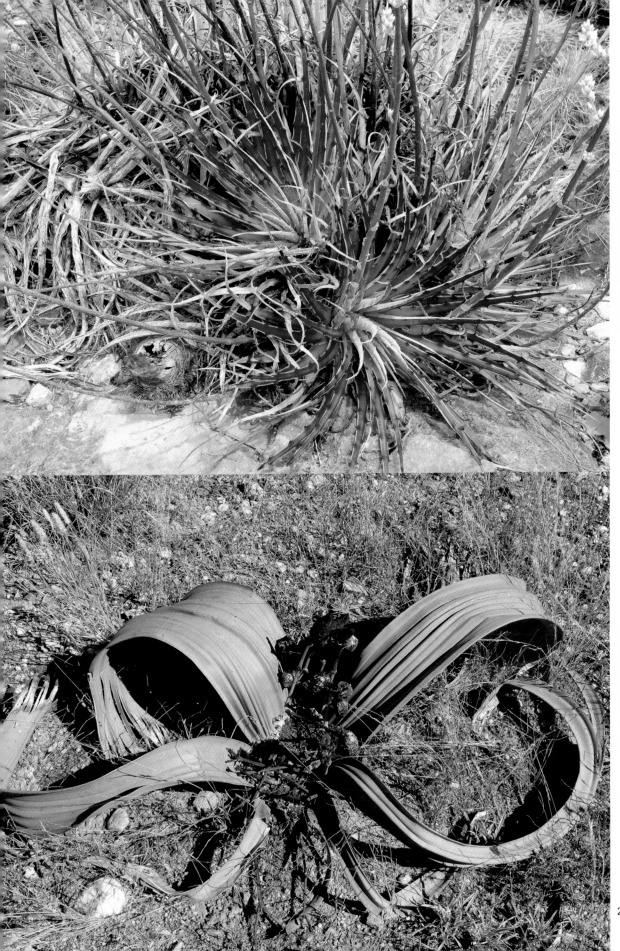

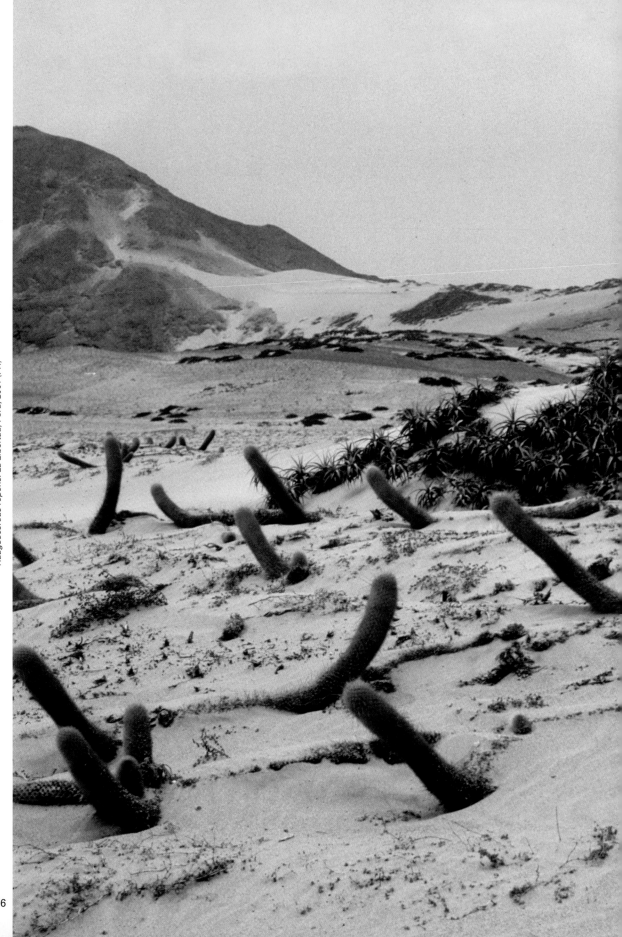

Haageocereus repens. La Libertad, Peru, 2001 (PH)

256

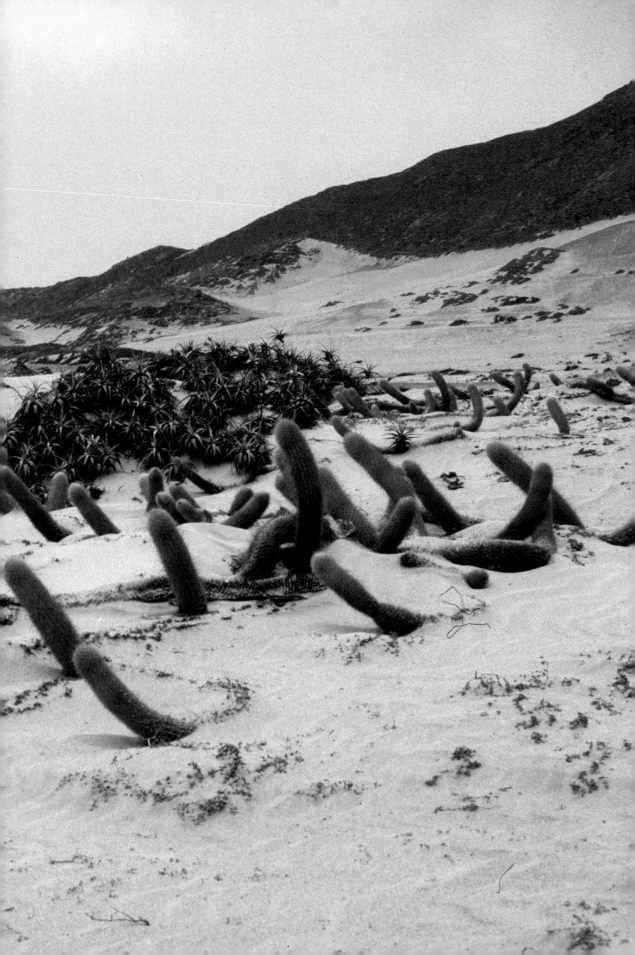

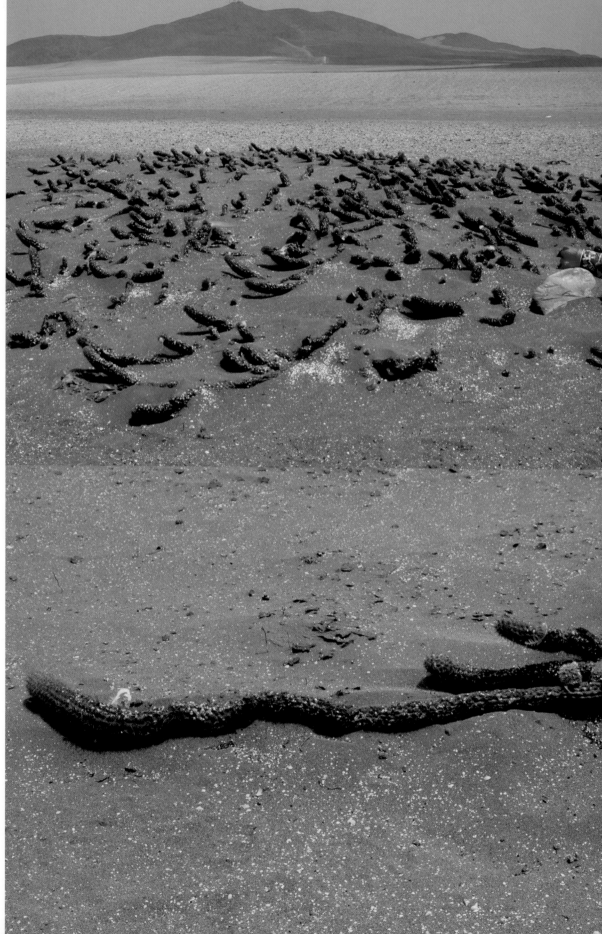

Haageocereus tenuis. Lima, Peru, 2005 (PH)

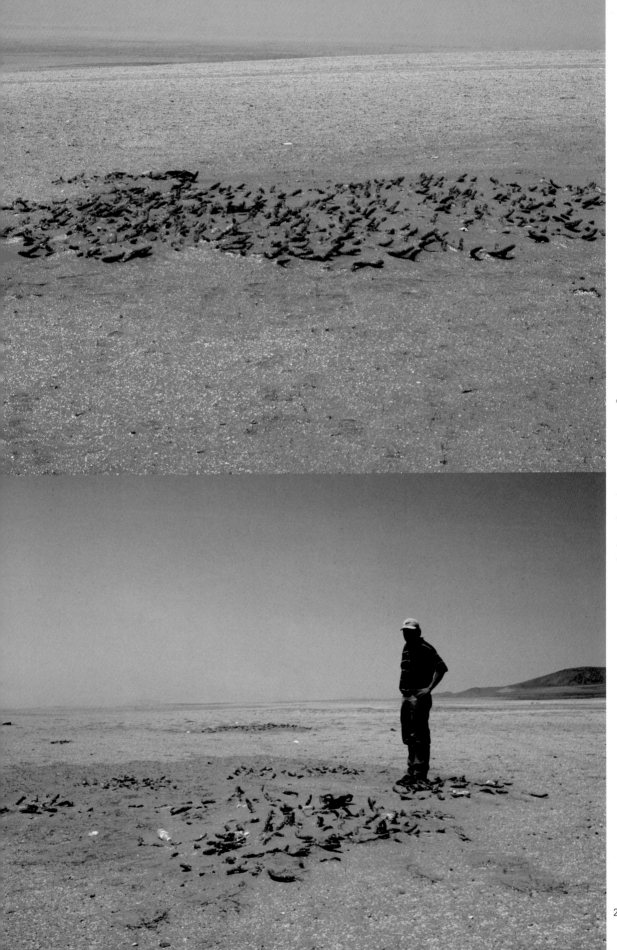

Haageocereus tenuis, Lima, Peru, 2005 (PH)

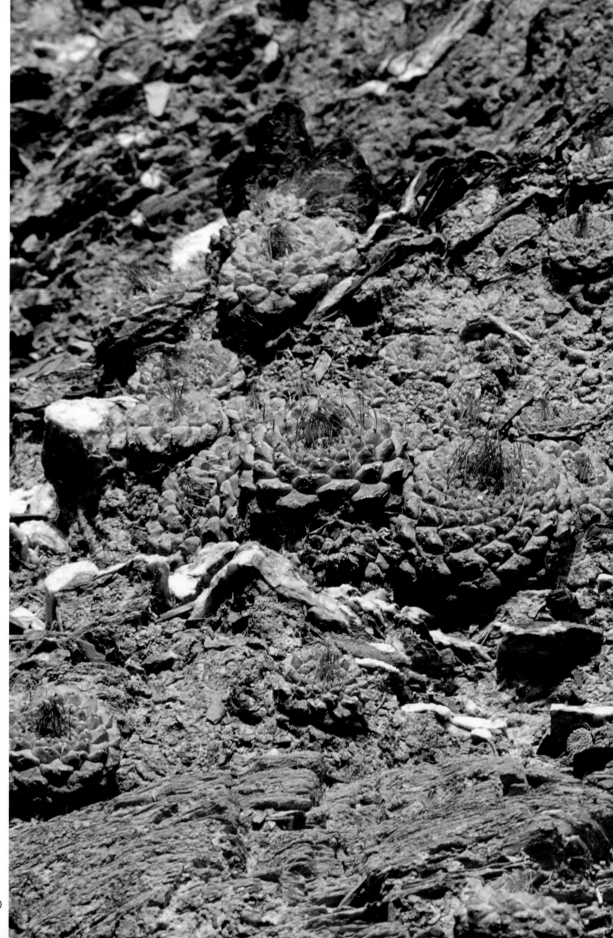

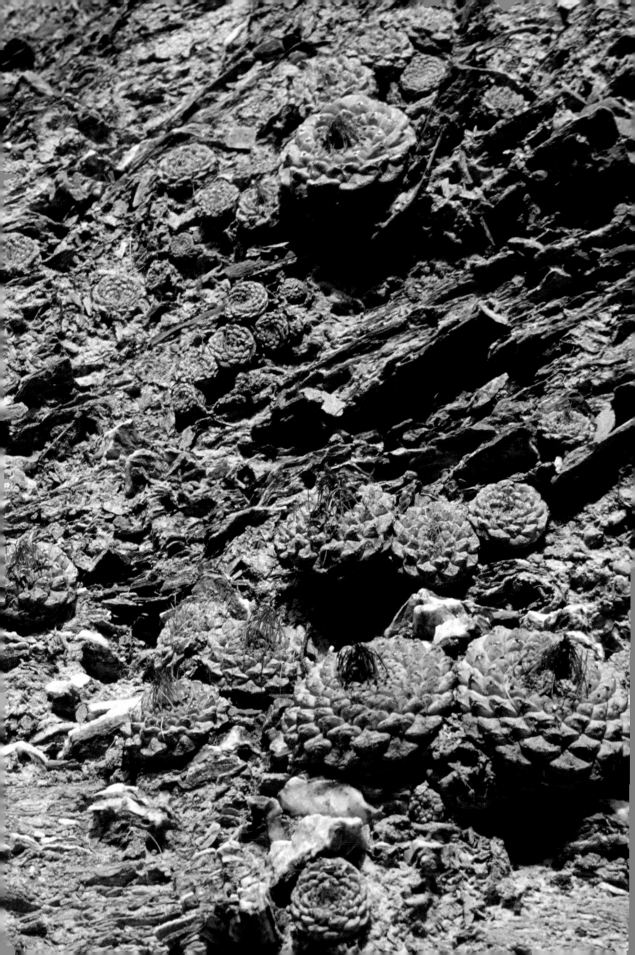

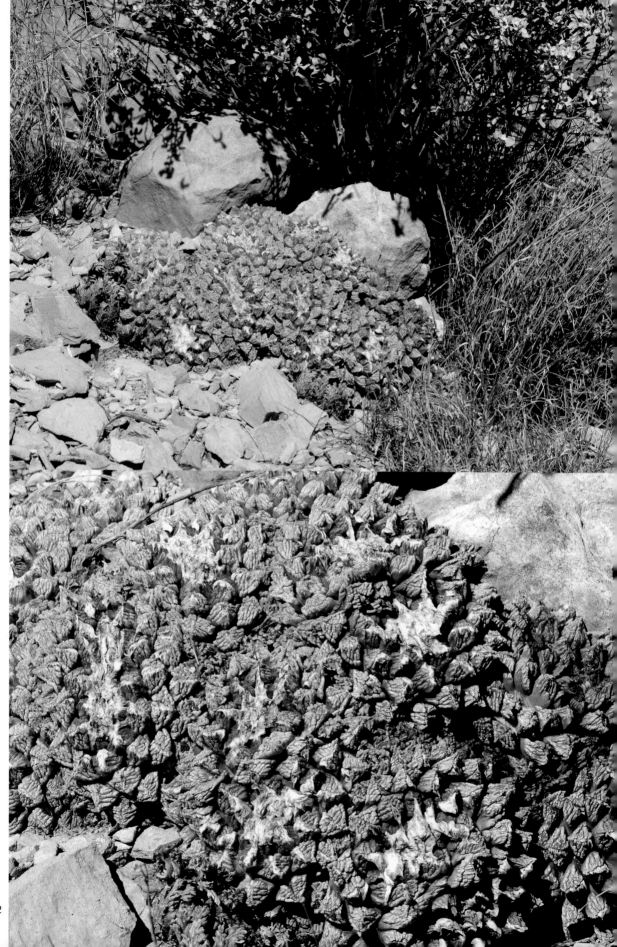

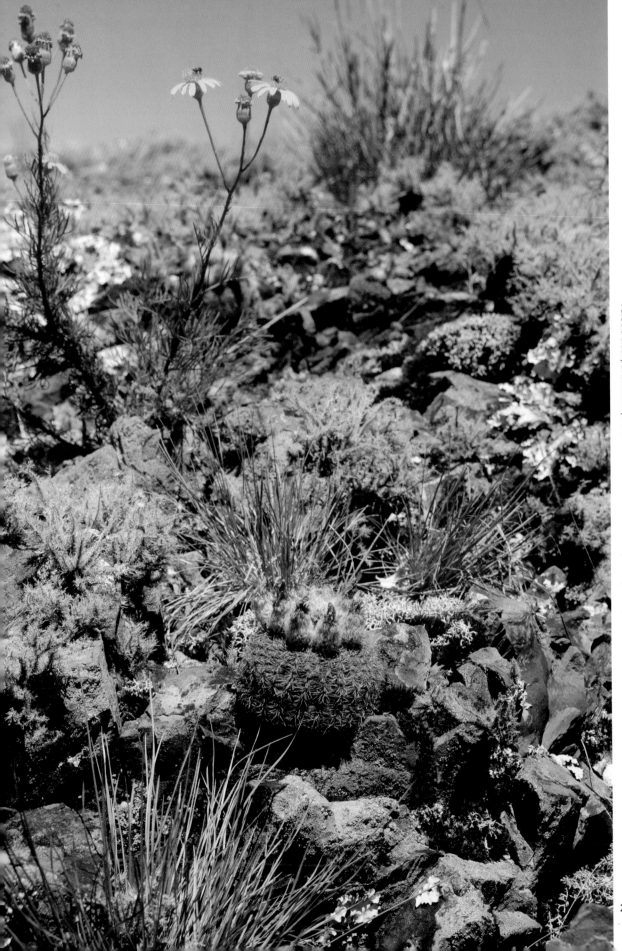

Parodia alacriportana subsp. brevihamata Rio Grande do Sul, Brazil, 2009 (WM)

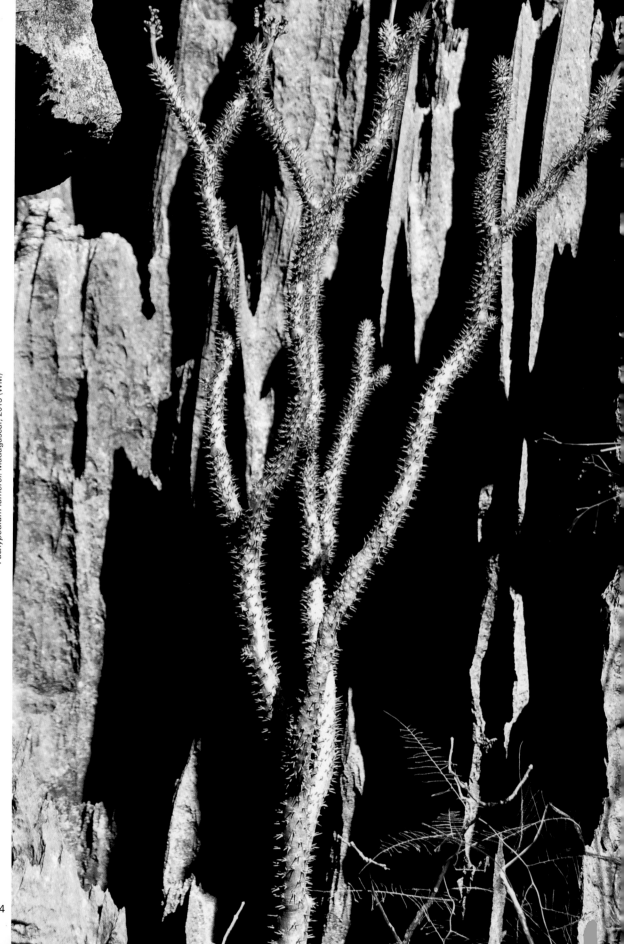

Pachypodium lamerei. Madagascar, 2013 (WM)

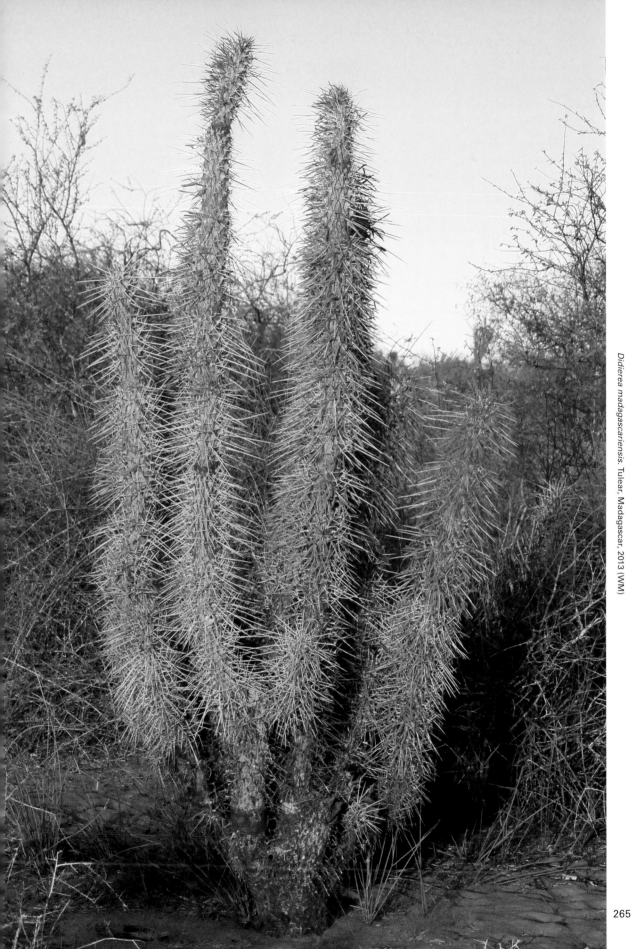

Didierea madagascariensis, Tulear, Madagascar, 2013 (WM)

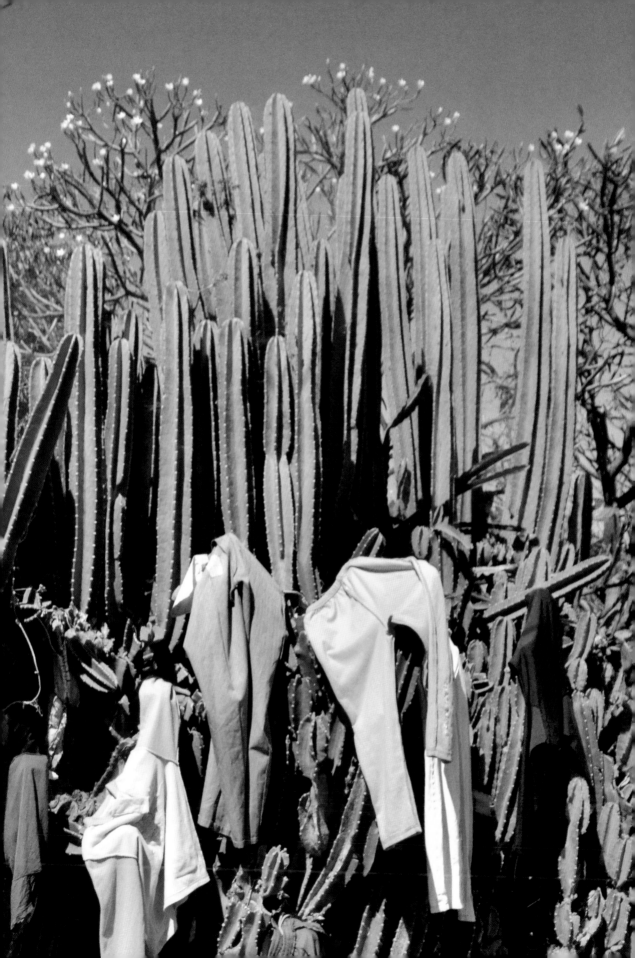

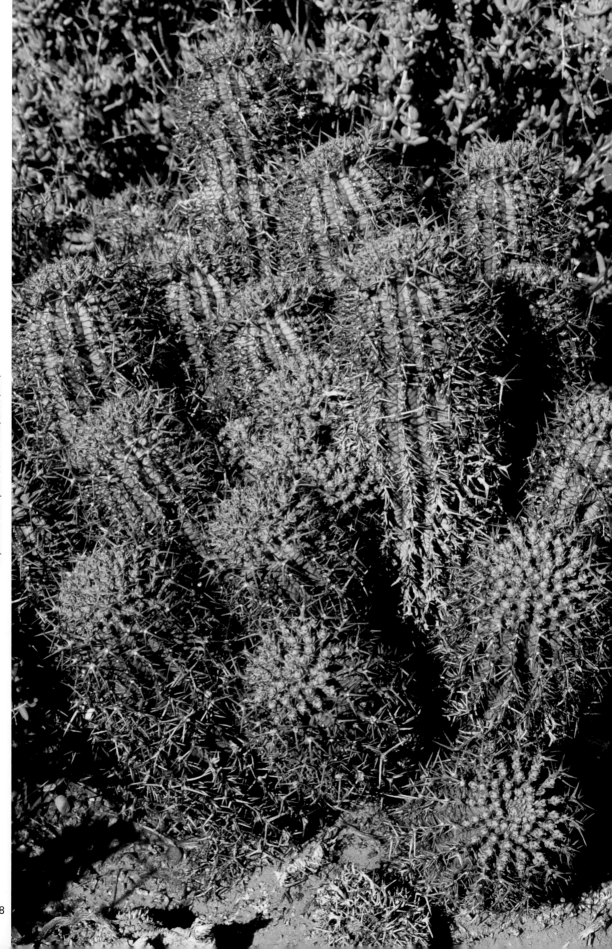

Euphorbia stellispina. South Africa, 2009 (WM)

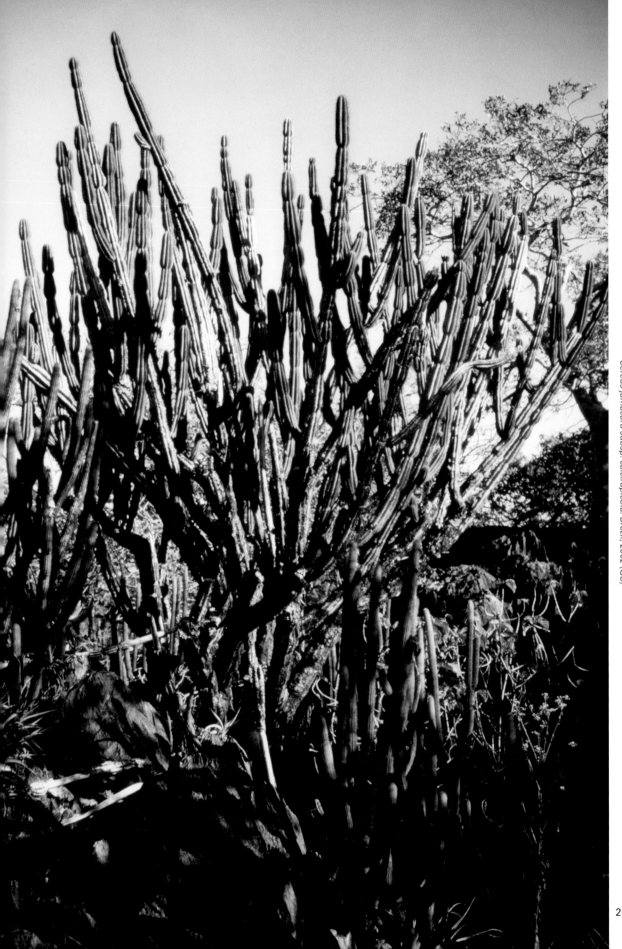

Cereus jamacaru subsp. *calcirupicola*, Brazil, 2002 (GC)

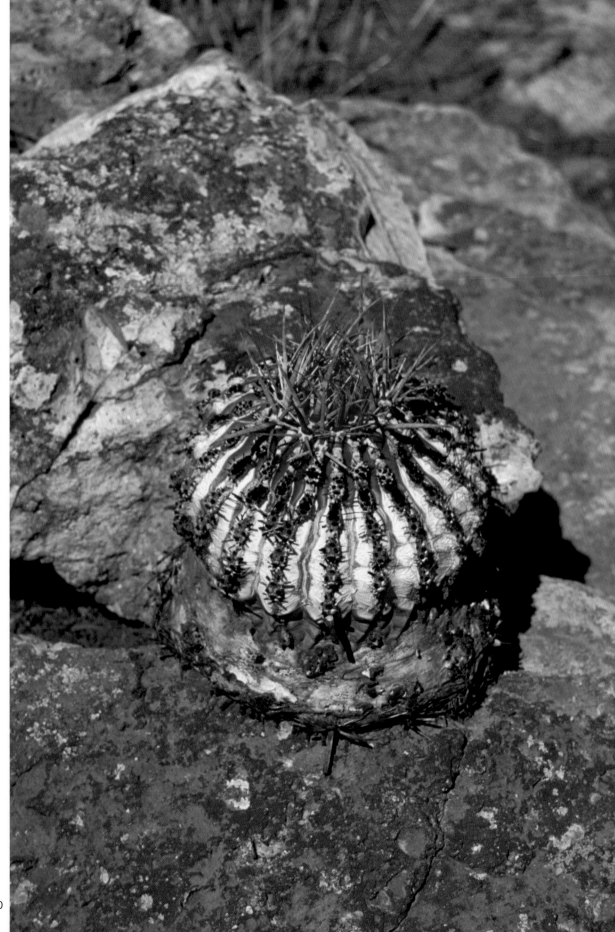

Ferocactus viridescens. San Diego, California, U.S.A., 2004 (JR)

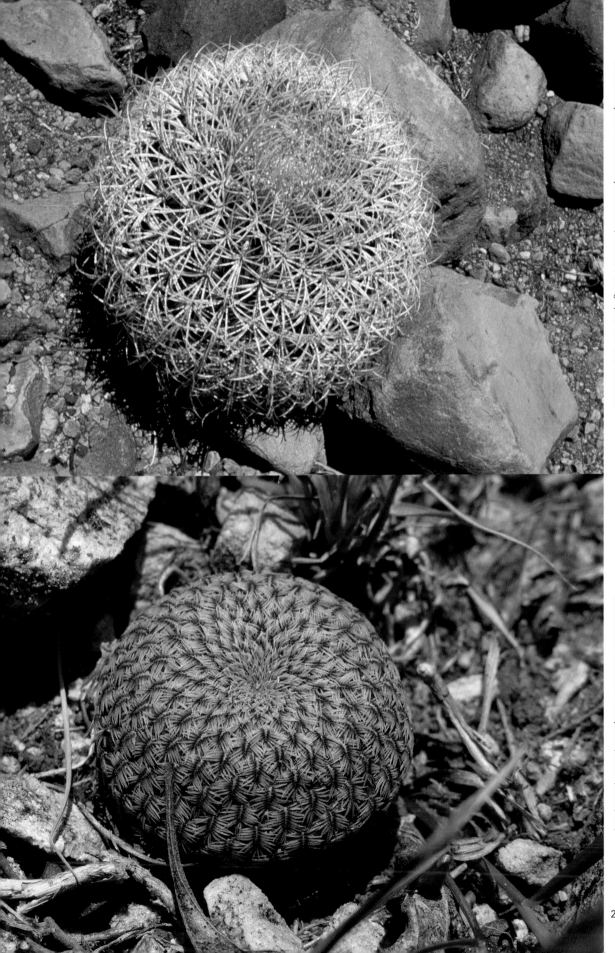

Ferocactus johnstonianus, Baja California, Mexico. Photographer and date unknown.

Sulcorebutia heliosoides, Chuquisaca, Bolivia, 2015 (MW)

271

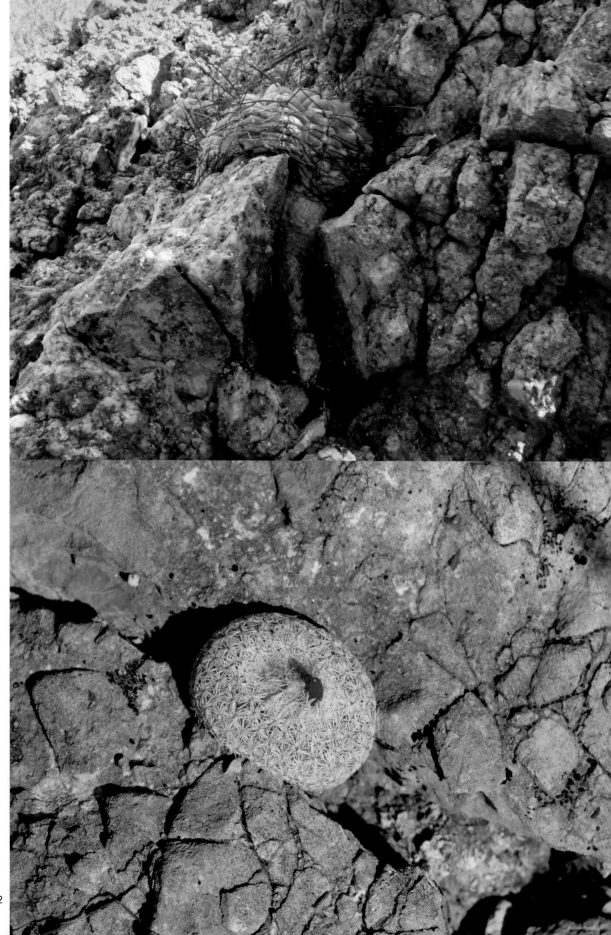

Gymnocalycium ferrari. La Rioja, Argentina, 2012 (MT)

Epithelantha micromeris. Coahuila, Mexico, 2015 (WM)

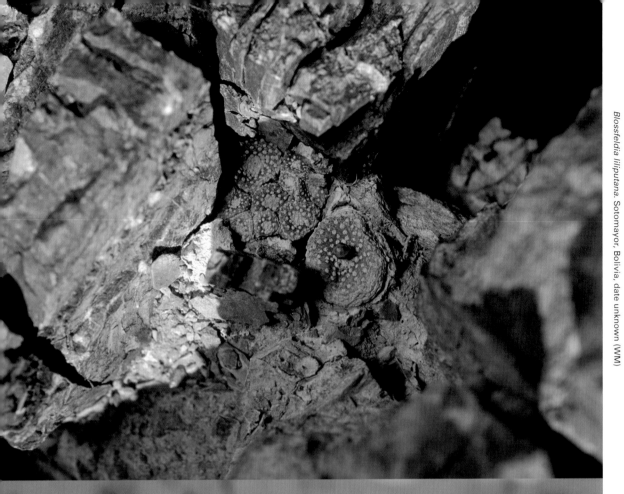

Blossfeldia liliputana. Sotomayor, Bolivia, date unknown (WM)

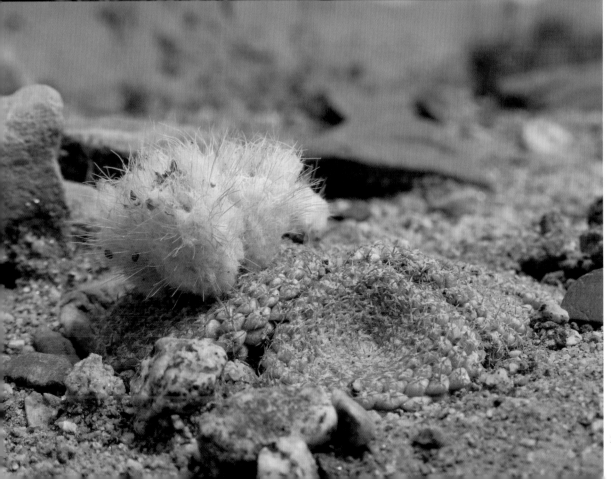

Eriosyce odieri subsp. *krausii.* Chile, 2012 (MT)

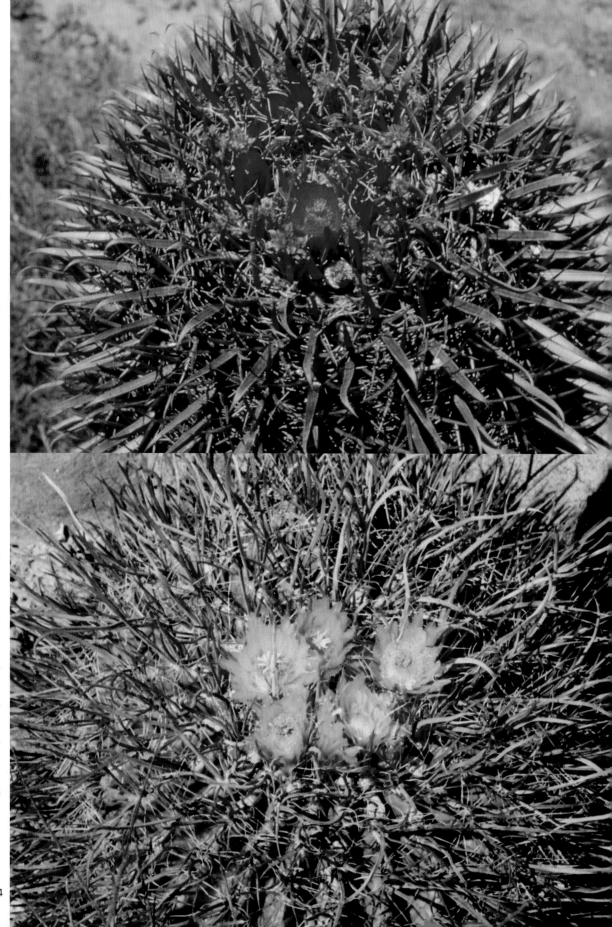

Ferocactus gracilis subsp. *coloratus.* Baja California, Mexico, 1984 (JL)

Ferocactus gracilis subsp. *tortulispinus.* Baja California, Mexico, 1990 (JL)

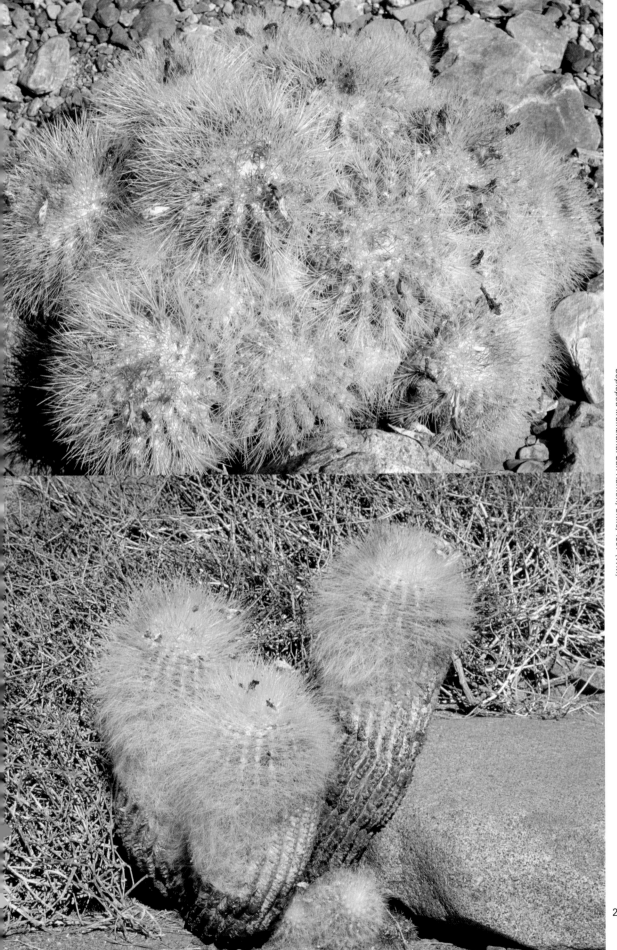

Copiapoa krainziana San Ramon, Chile, 1997 (WM)

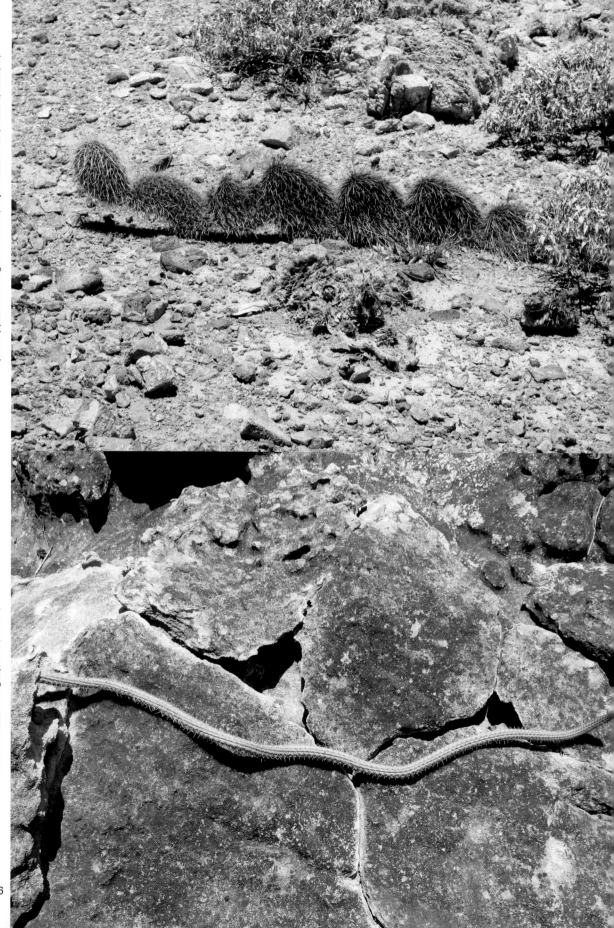

Opuntia pycnantha. Magdalena Island, Baja California Sur, Mexico, 2016 (JR)

Cereus saxicola. Paraguay, 2011 (AM/GA)

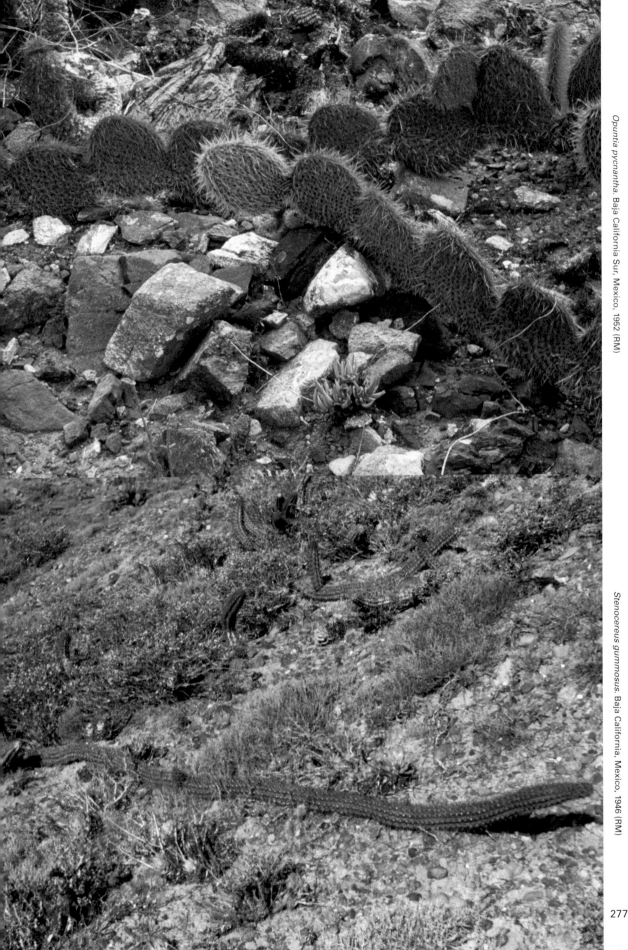

Opuntia pycnantha, Baja California Sur, Mexico, 1952 (RM)

Stenocereus gummosus, Baja California, Mexico, 1946 (RM)

Pachycereus pringlei. Islas Melisas, Sonora, Mexico, date unknown (DY)

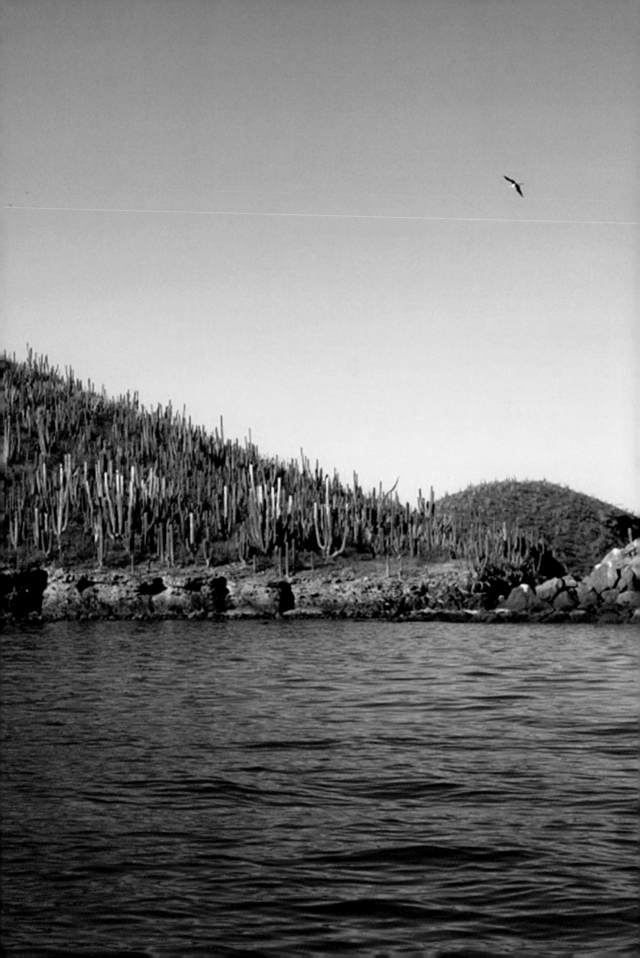

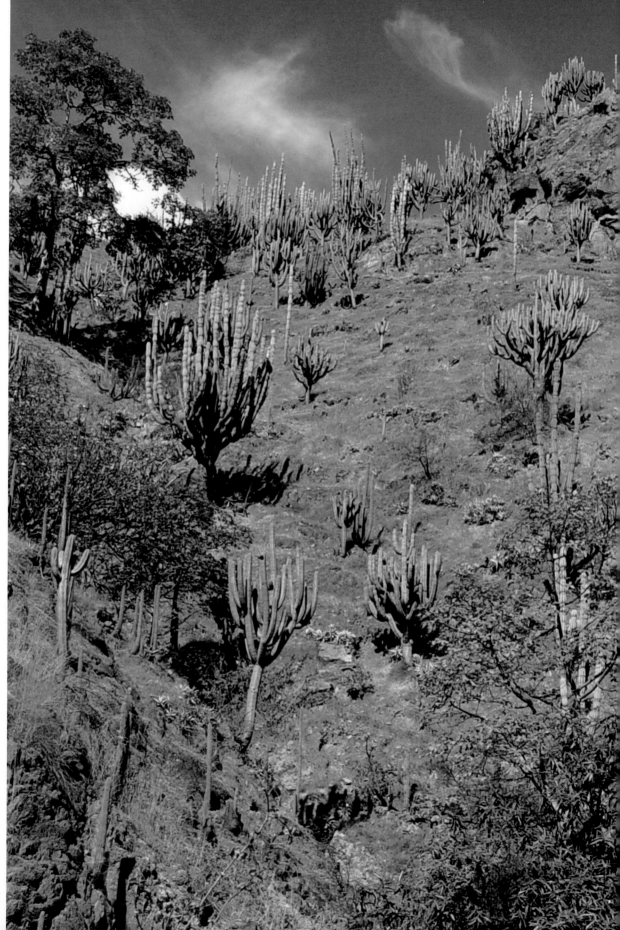

Browningia pilleifera and *Armatocereus rauhii*. Rio Marañón, Peru, date unknown (DY)

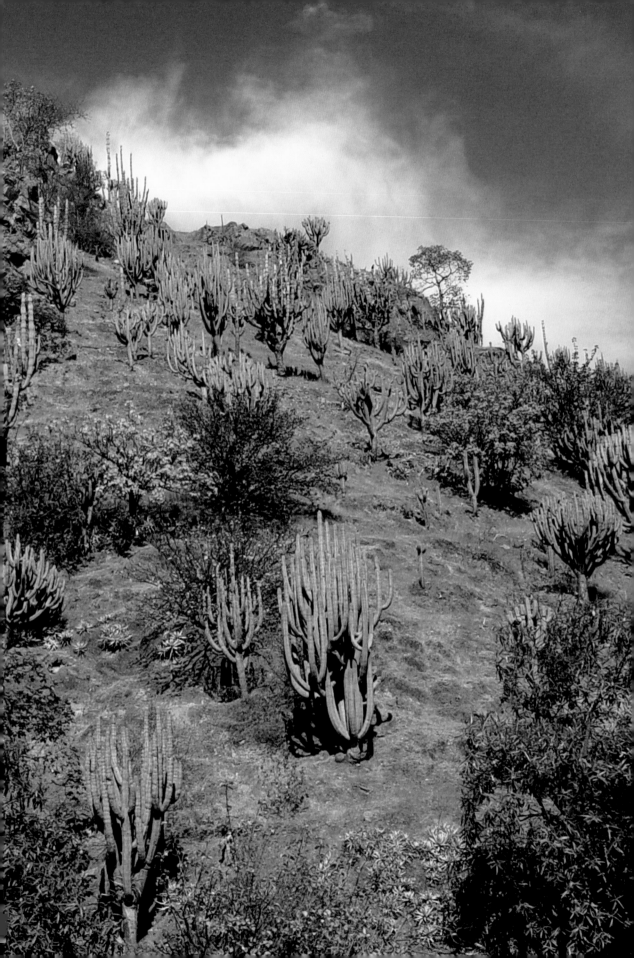

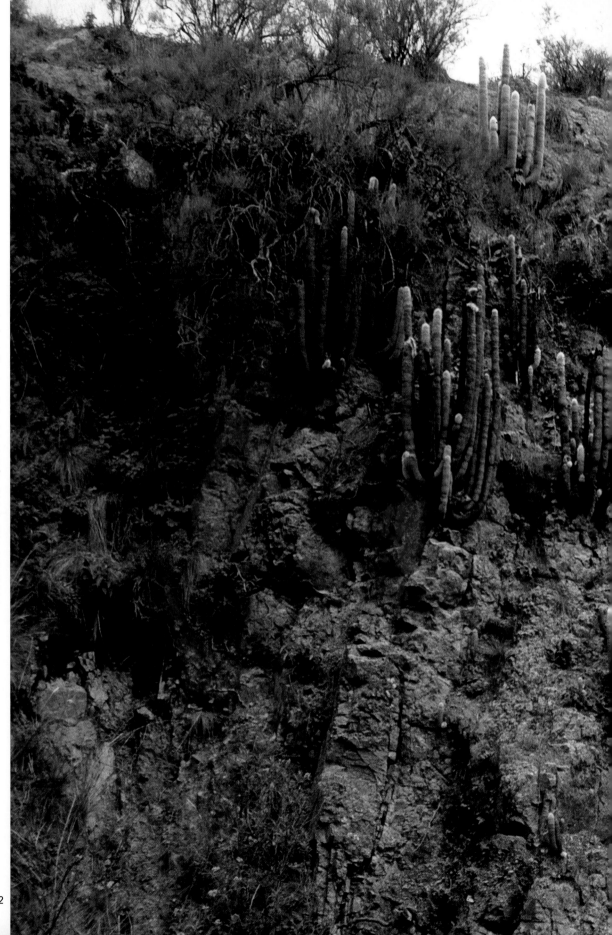

Cleistocactus strausii and *Echinopsis schickendantzii*. Bolivia, 1996 (ML)

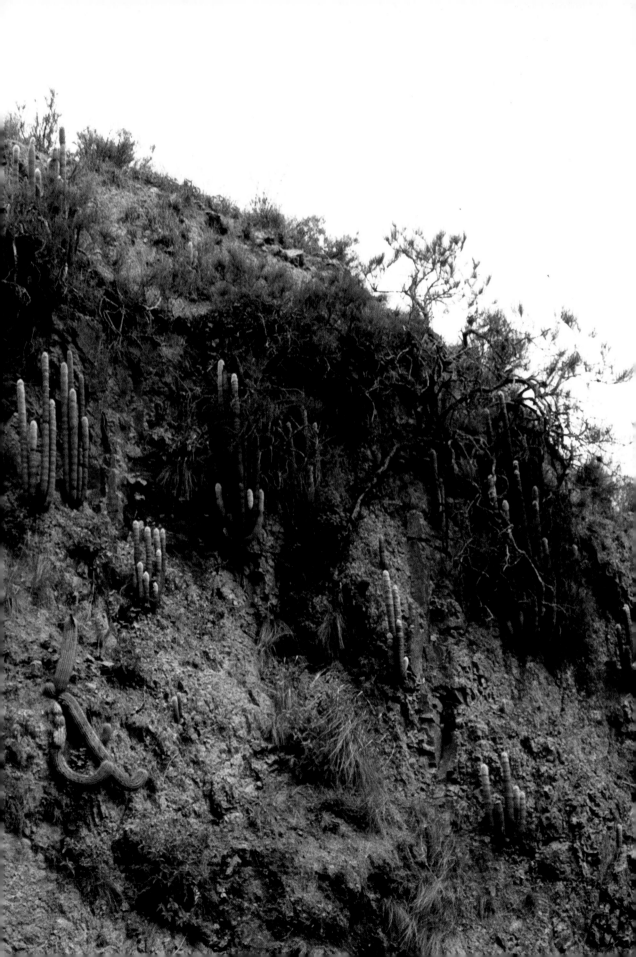

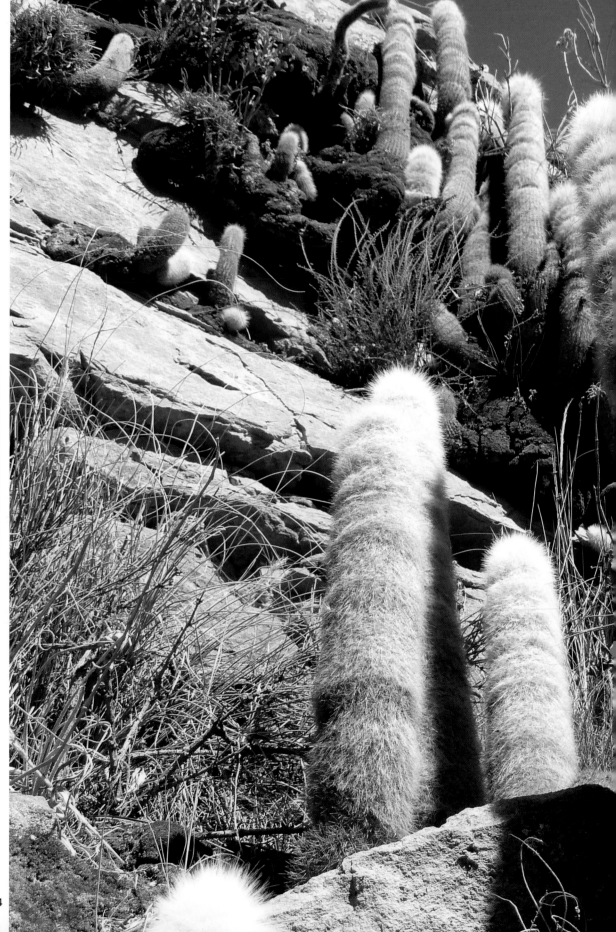

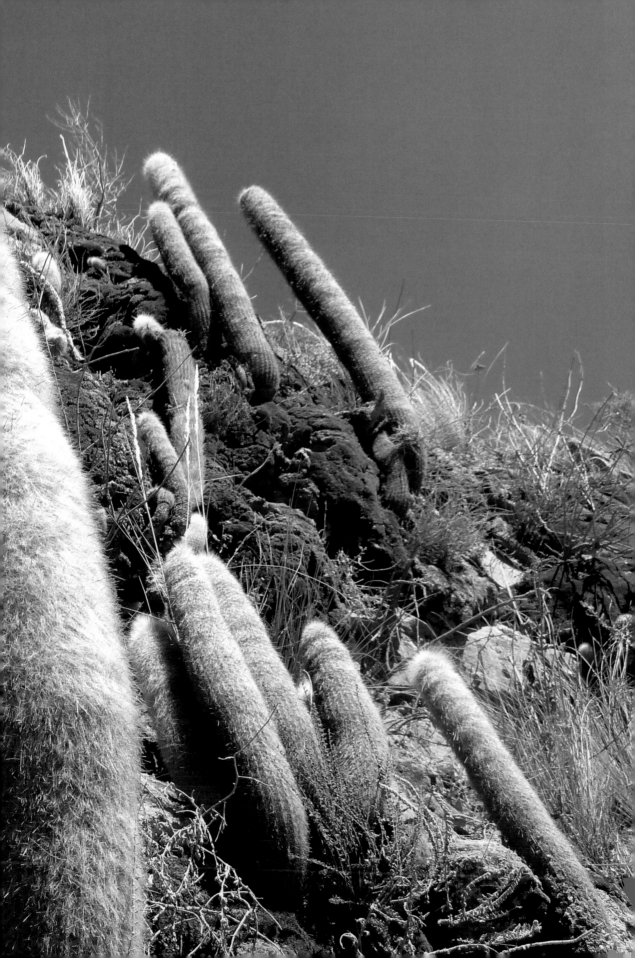

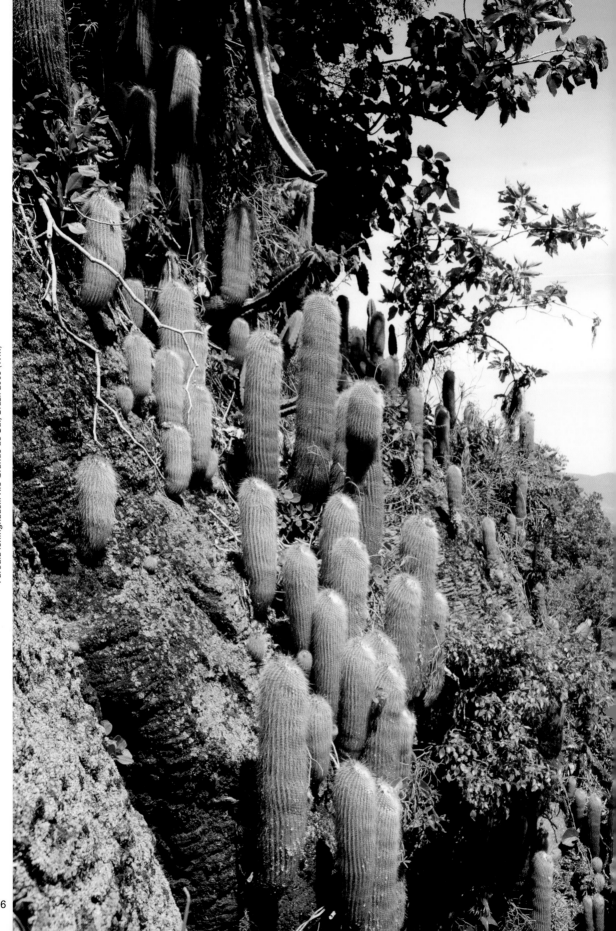

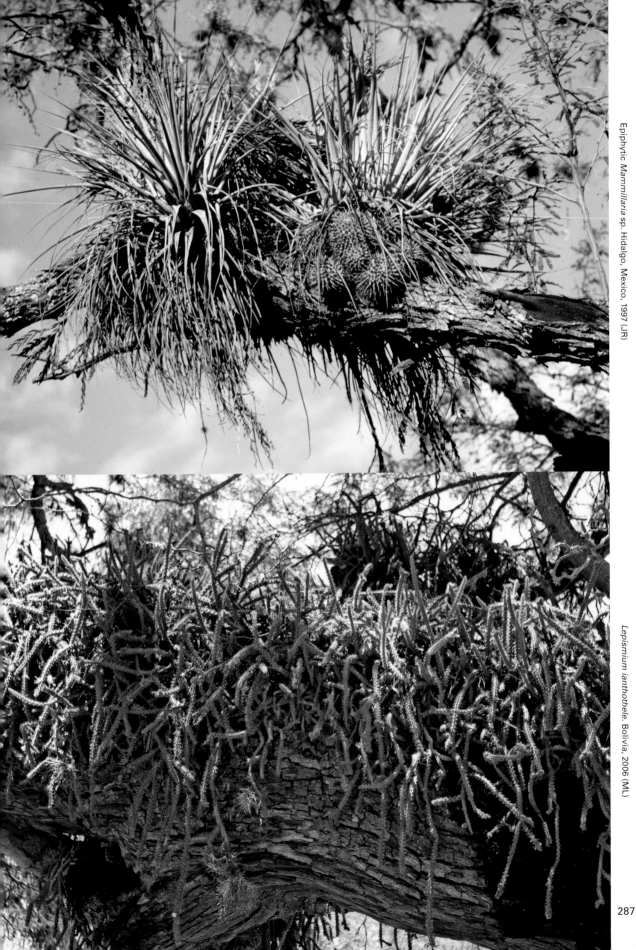

Epiphytic *Mammillaria* sp. Hidalgo, Mexico, 1997 (JR)

Lepismium ianthothele, Bolivia, 2006 (ML)

287

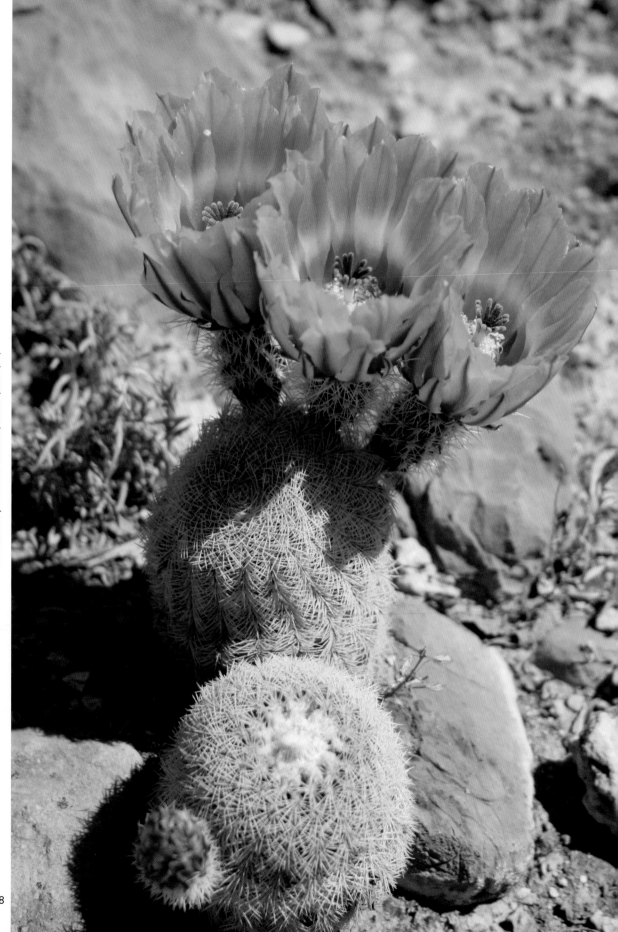

Echinocereus pectinatus. Coahuila, Mexico, 2014 (PB)

288

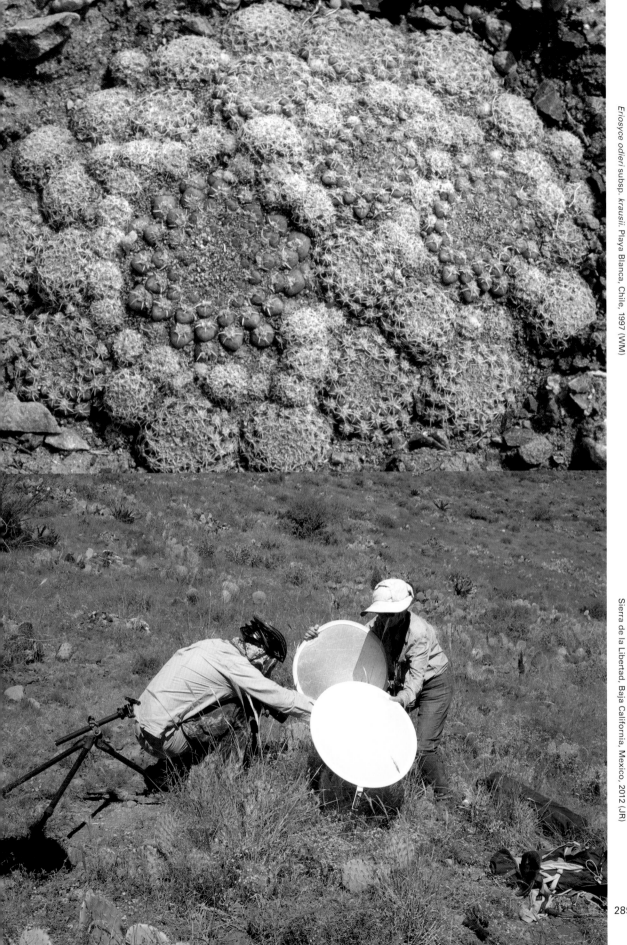

Eriosyce odieri subsp. *krausii*. Playa Blanca, Chile, 1997 (WM)

Sierra de la Libertad, Baja California, Mexico, 2012 (JR)

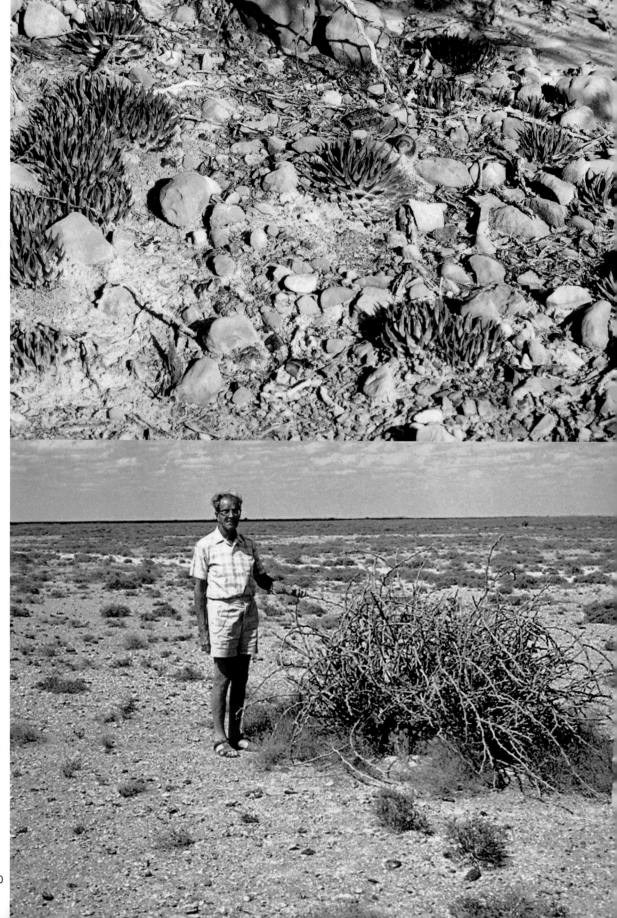

Ariocarpus trigonus. Tamaulipas, Mexico, 1994 (JL)

Dr. P. R. O. Bally with *Adenia ballyi.* Sinujif, Somalia, 1972 (JJL)

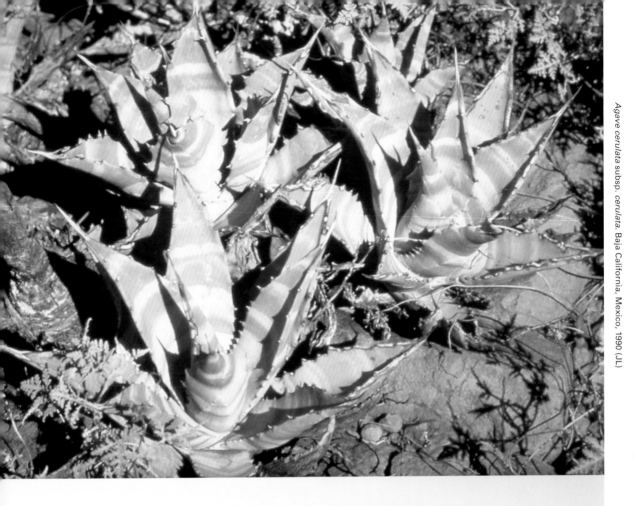

Agave cerulata subsp. cerulata. Baja California, Mexico, 1990 (JL)

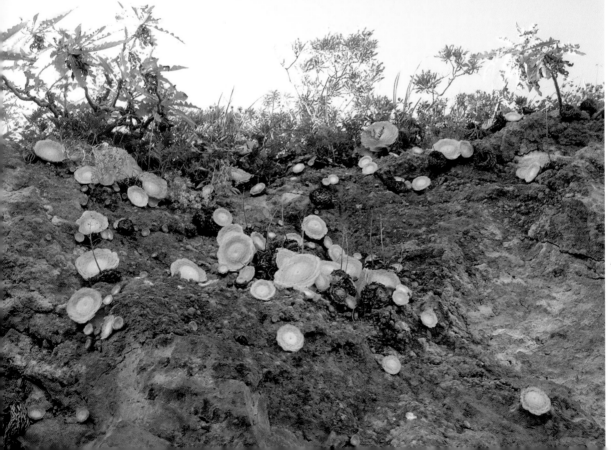

Aeonium tabuliforme. Tenerife, Canary Islands, 2002 (JL)

Espostoopsis dybowskii. Brazil, 2000 (GC)

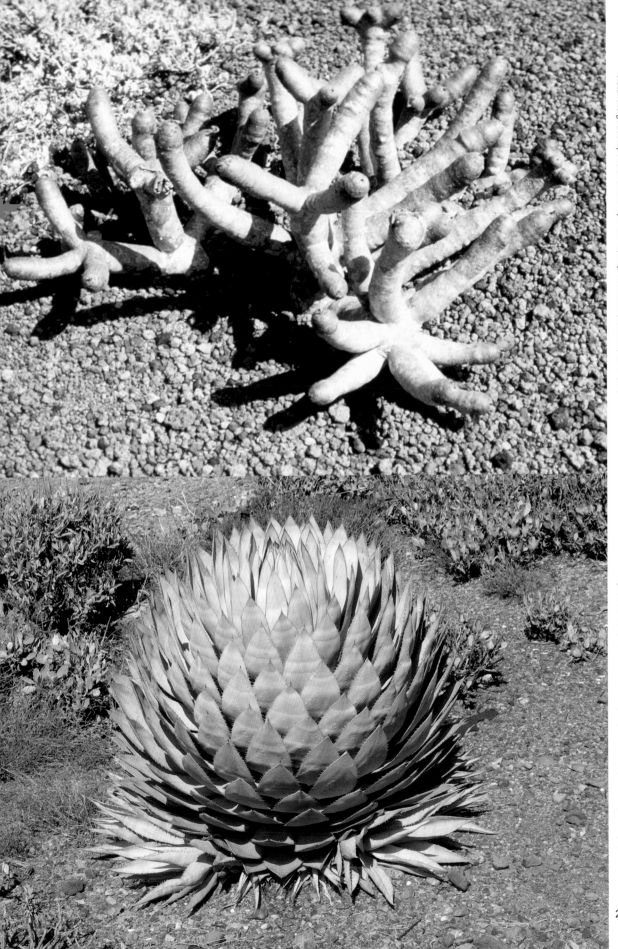

Cistanthe guadalupensis, Guadalupe Island, Baja California, Mexico, 2000 (JR)

Agave sebastiana, Cedros Island, Baja California, Mexico, 2007 (JR)

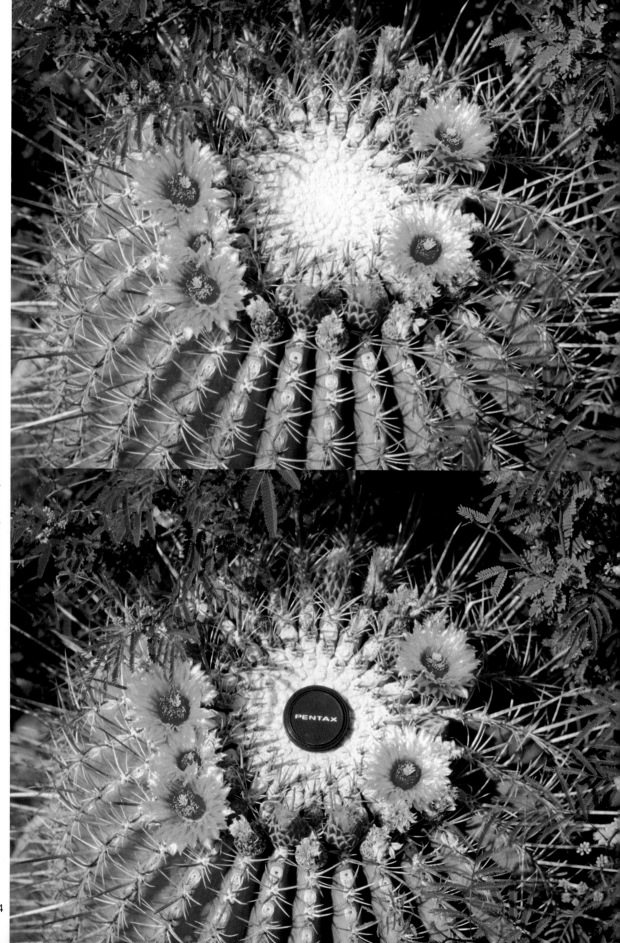

Ferocactus rectispinus. Baja California Sur, Mexico, 1995 (JR)

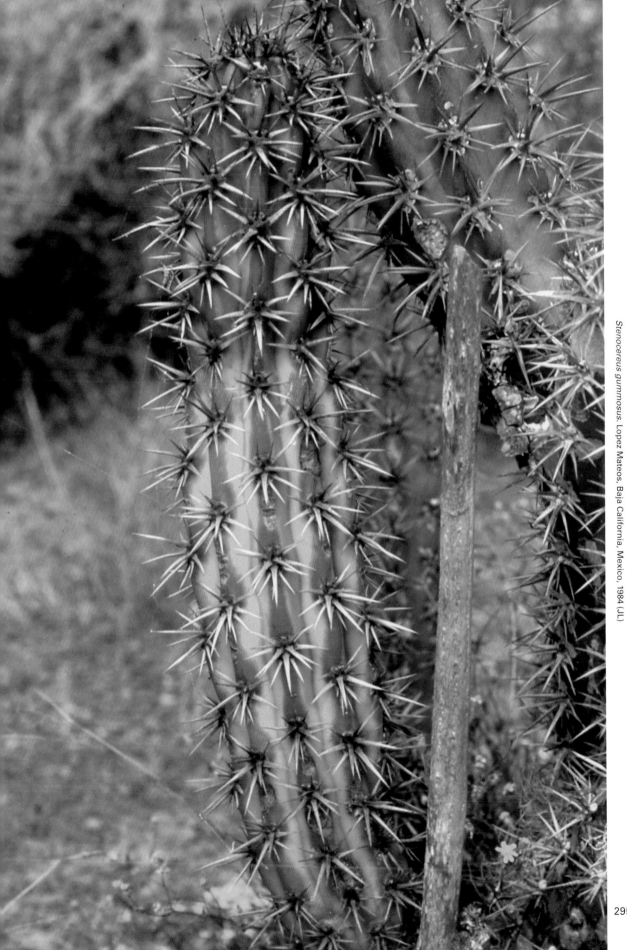

Stenocereus gummosus, Lopez Mateos, Baja California, Mexico, 1984 (JL)

295

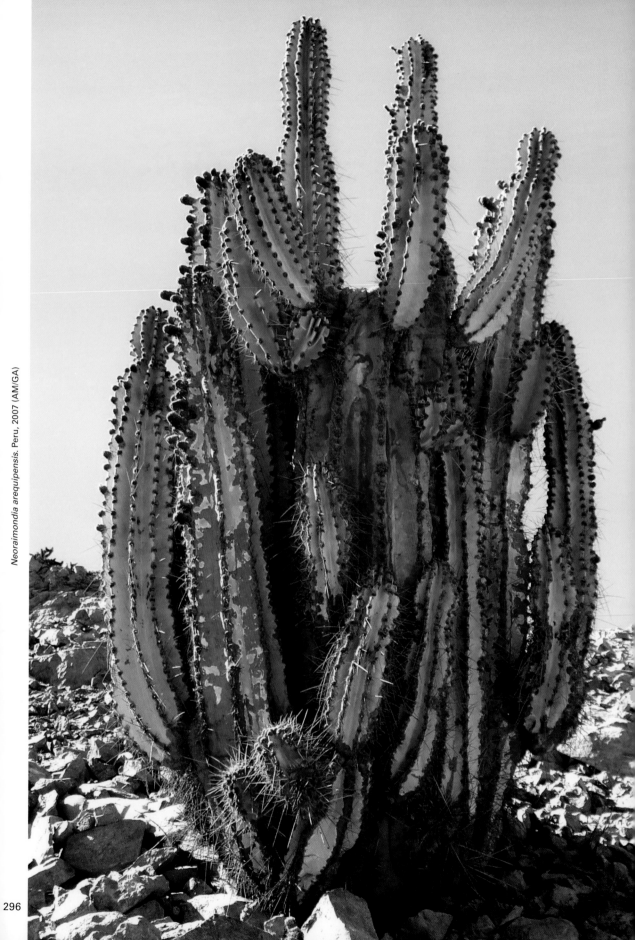

Neoraimondia arequipensis. Peru, 2007 (AM/GA)

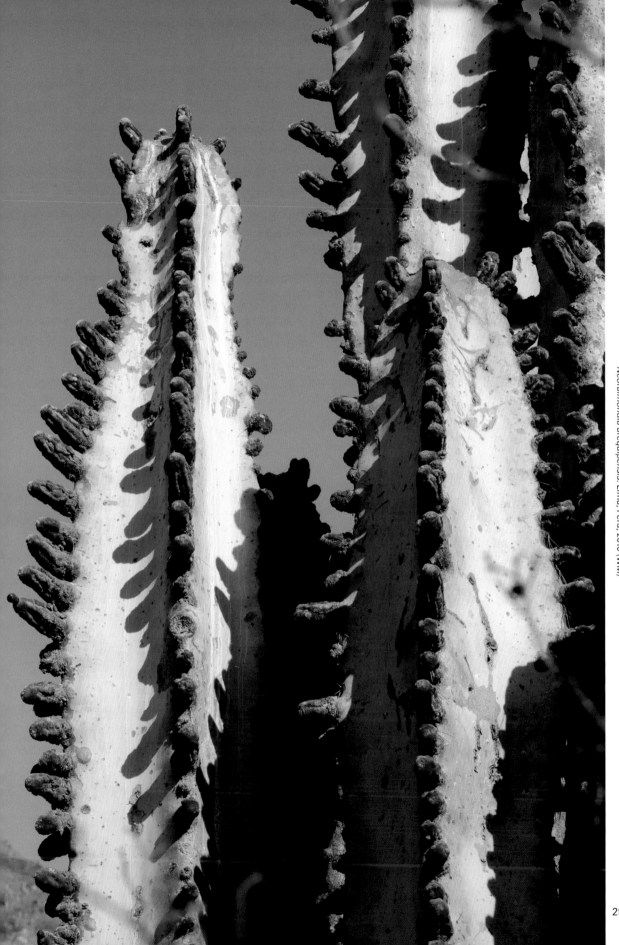

297

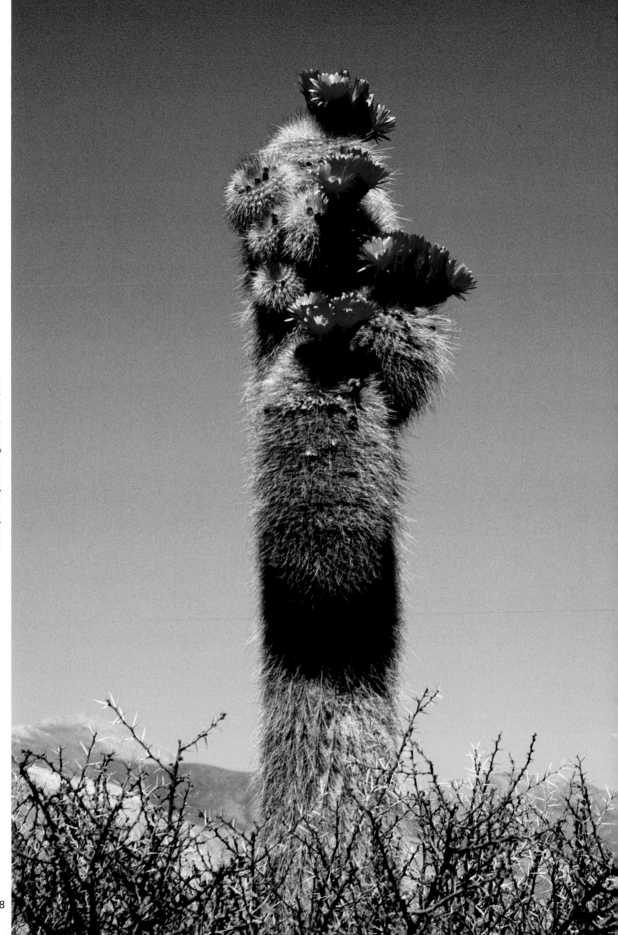

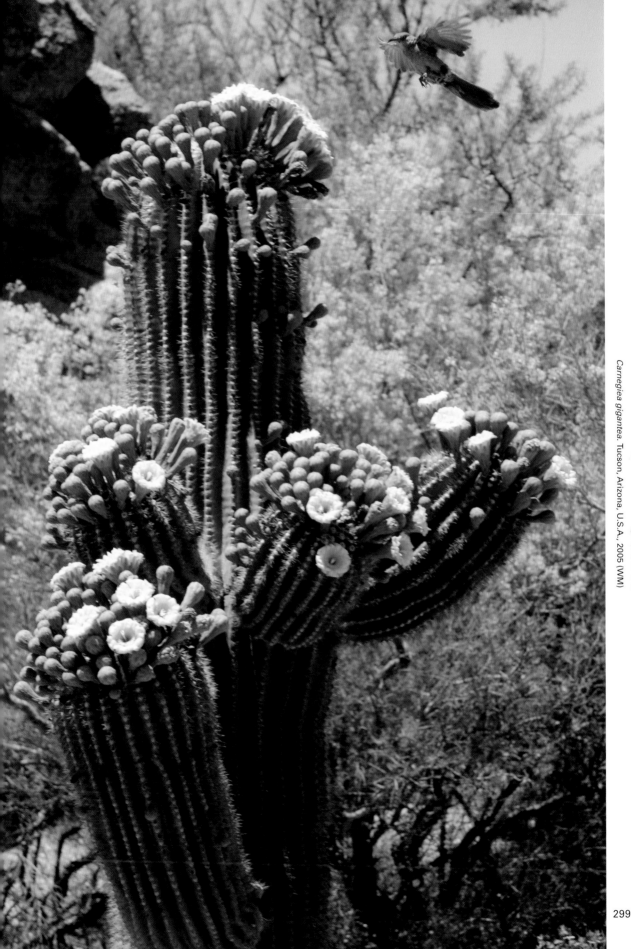

Carnegiea gigantea. Tucson, Arizona, U.S.A., 2005 (WM)

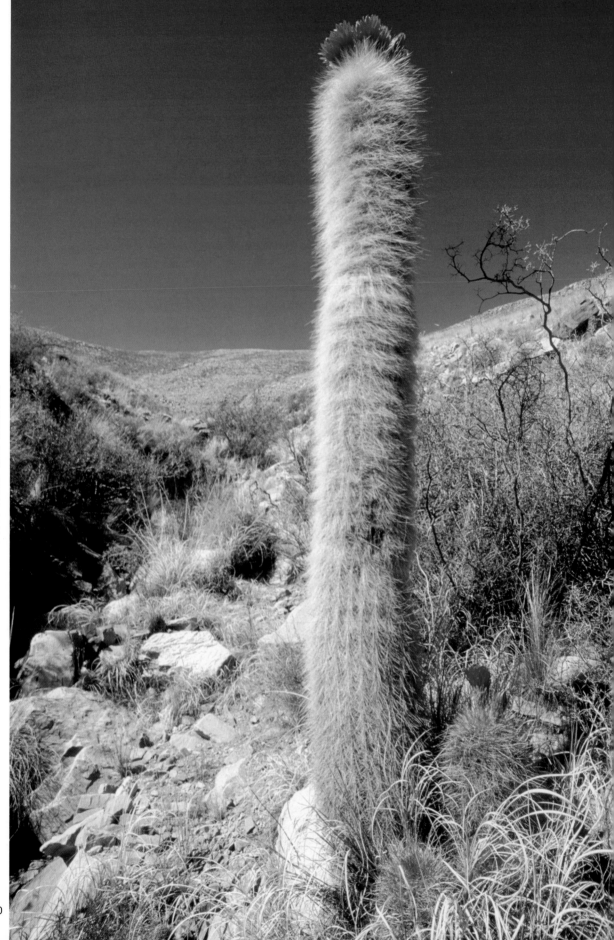

Trichocereus poco. Argentina, 2002 (WM)

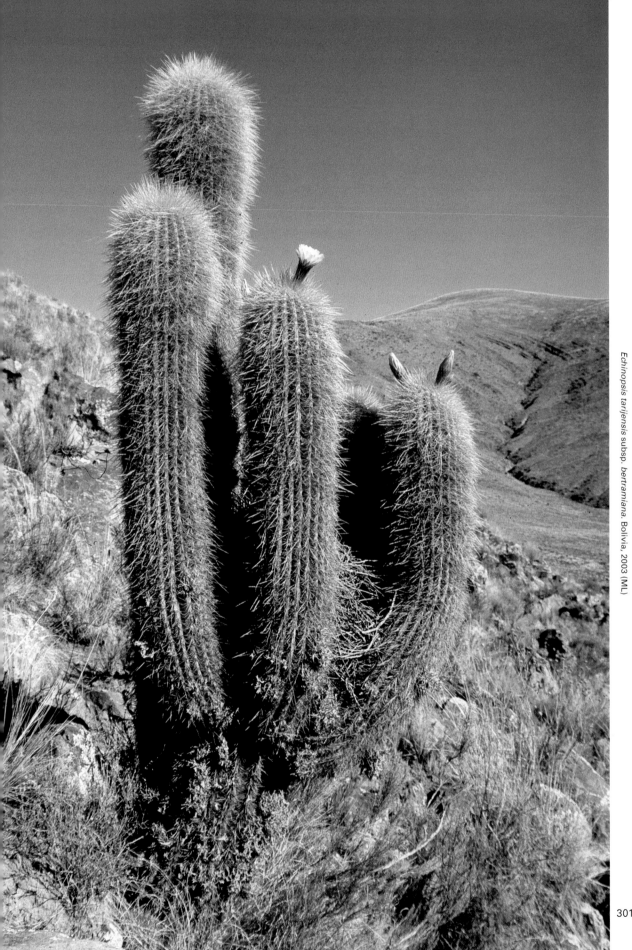

*Echinopsis tarijensis* subsp. *bertramiana*, Bolivia, 2003 (ML)

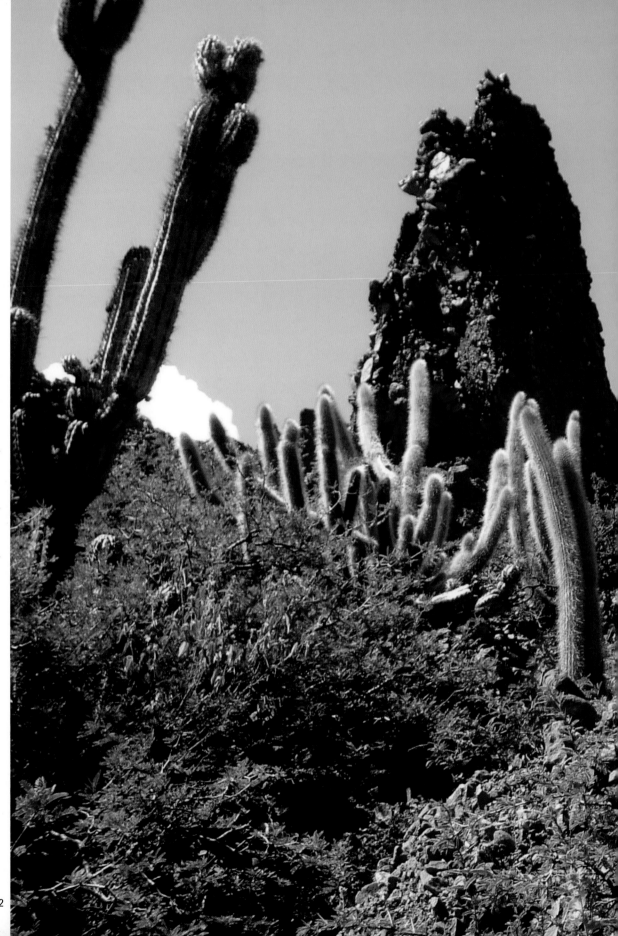

Echinopsis nothohyalacantha. Tupiza, Bolivia, 2007 (AM/GA)

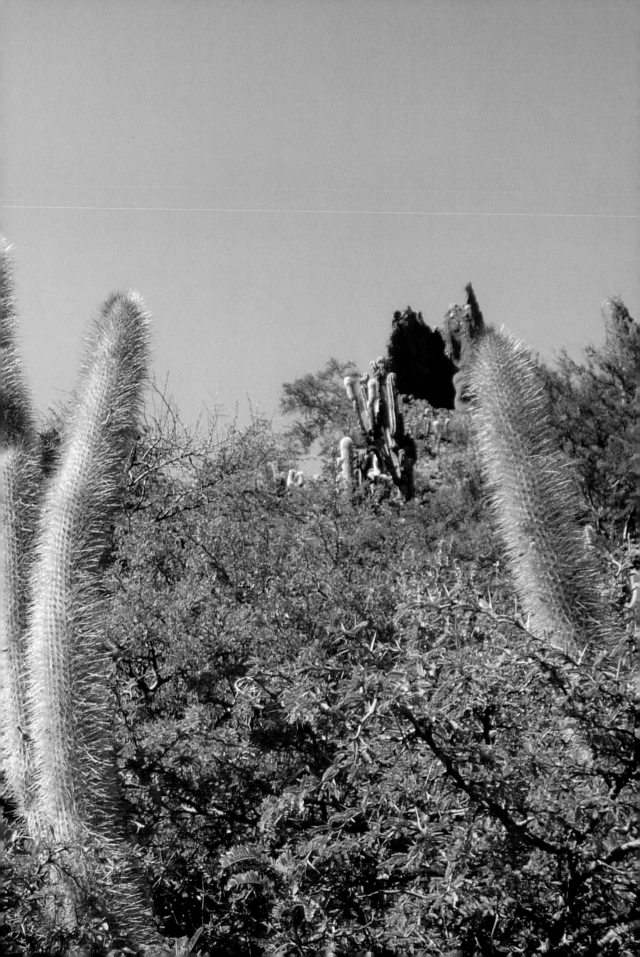

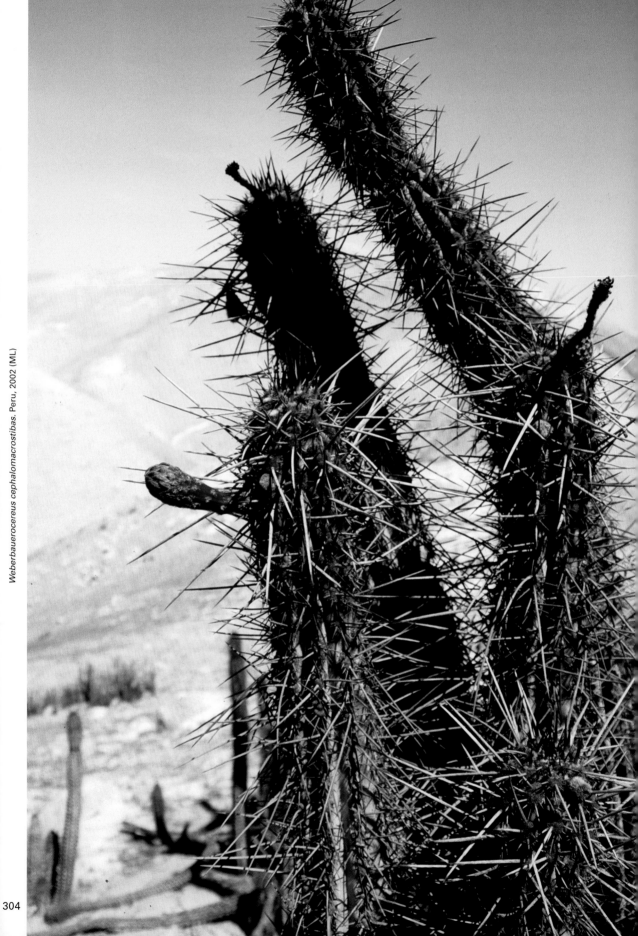

Weberbauerocereus cephalomacrostibas. Peru, 2002 (ML)

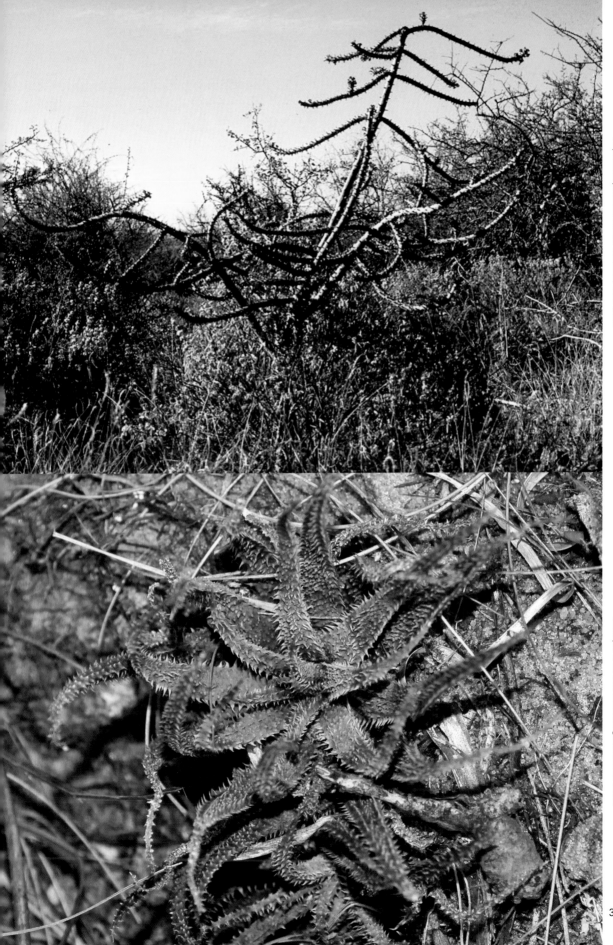

Euphorbia pseudostellata, Somalia, 1969 (JJL)

Aloe parvula, Central Madagascar, 2013 (WM)

305

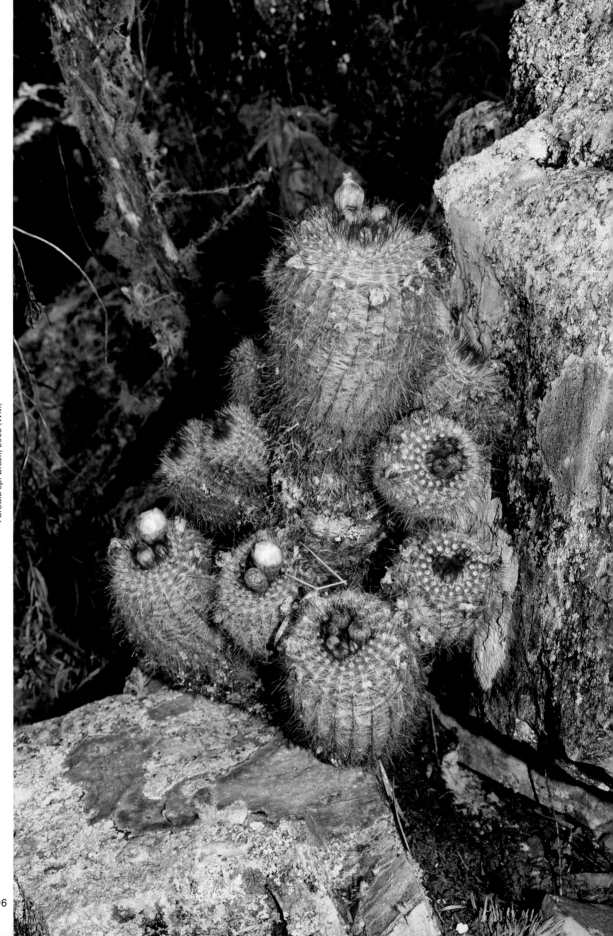

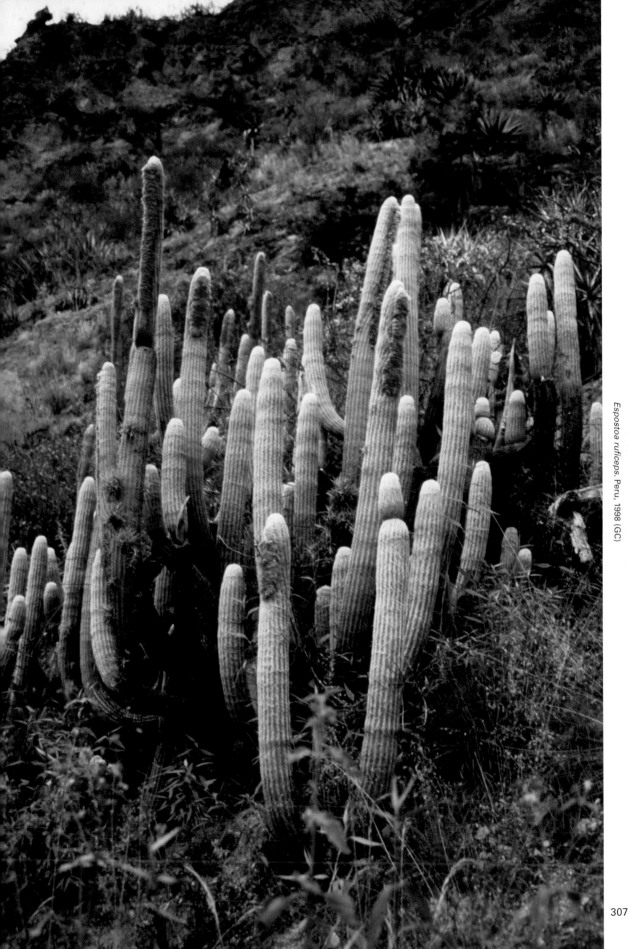

Espostoa ruficeps. Peru, 1998 (GC)

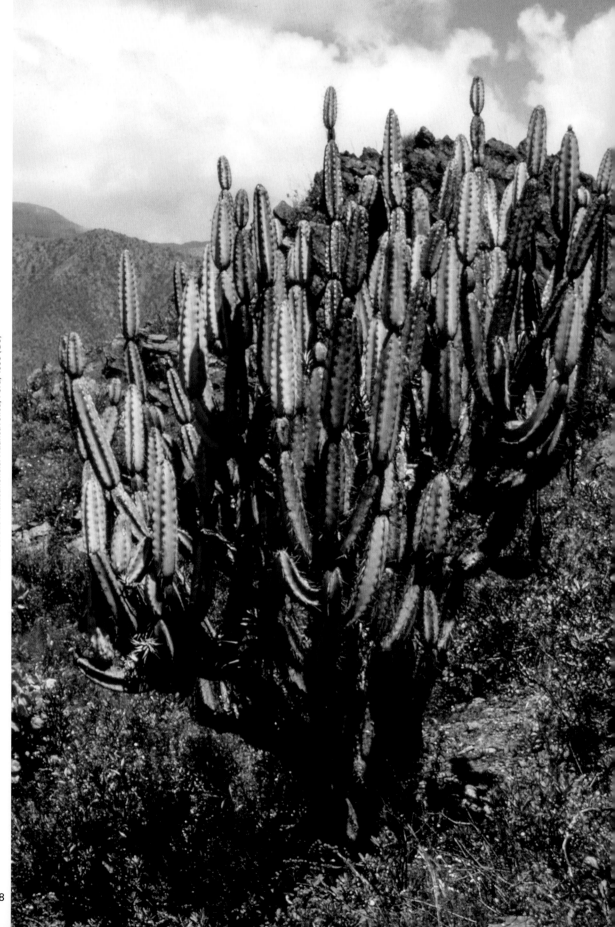

Armatocereus matucanensis. Huancavelica, Peru, 1998 (GC)

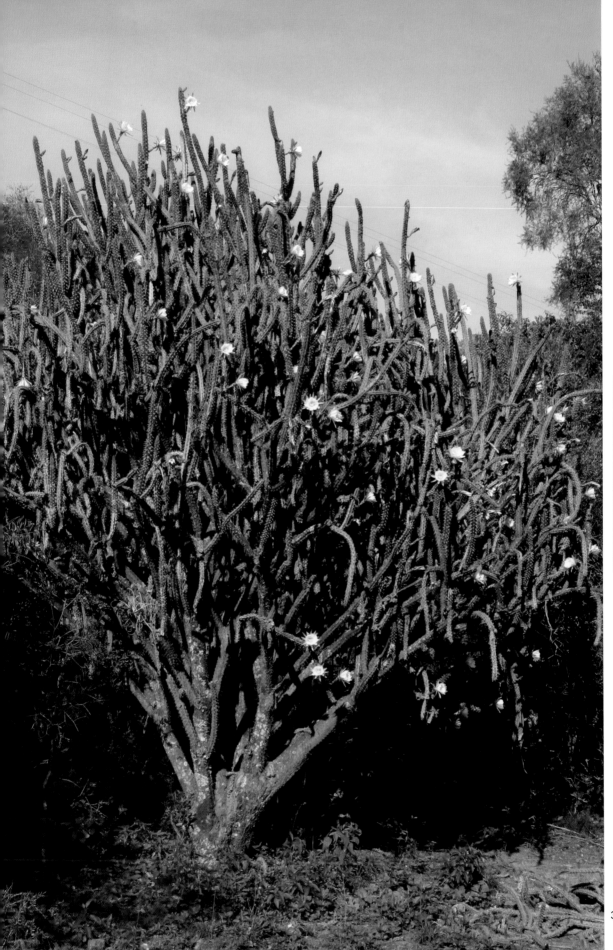

Harrisia tetracantha, Bolivia, date unknown (NT)

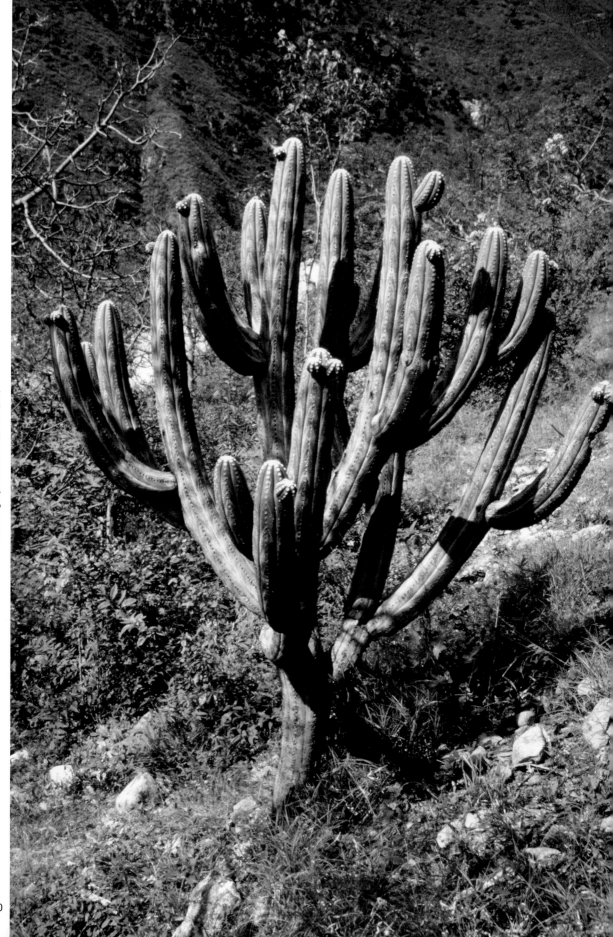

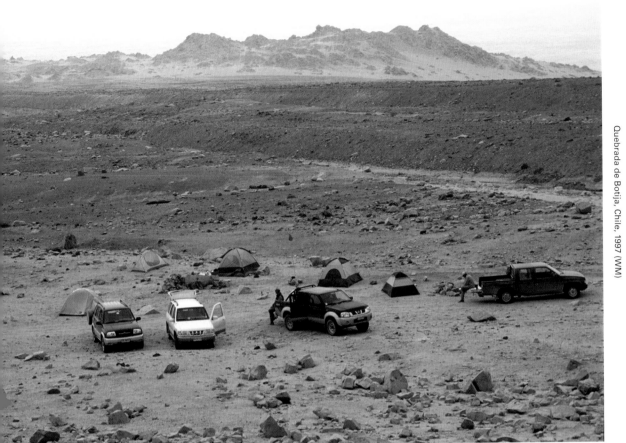

Quebrada de Botija, Chile, 1997 (WM)

Cinthia knizei, Bolivia, 2006 (MT)

311

Espostoa hylaea. Peru, 2002 (GC)

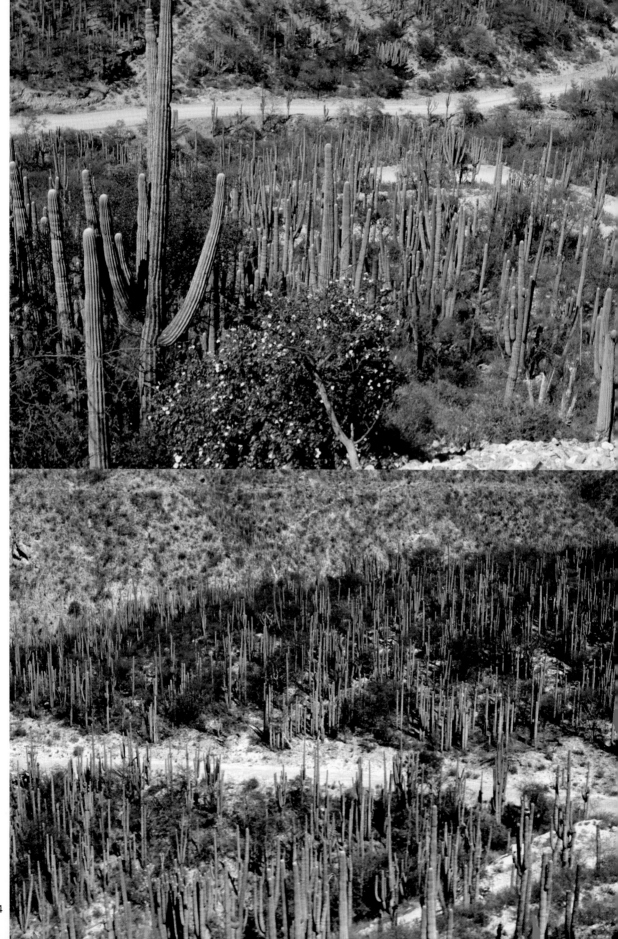

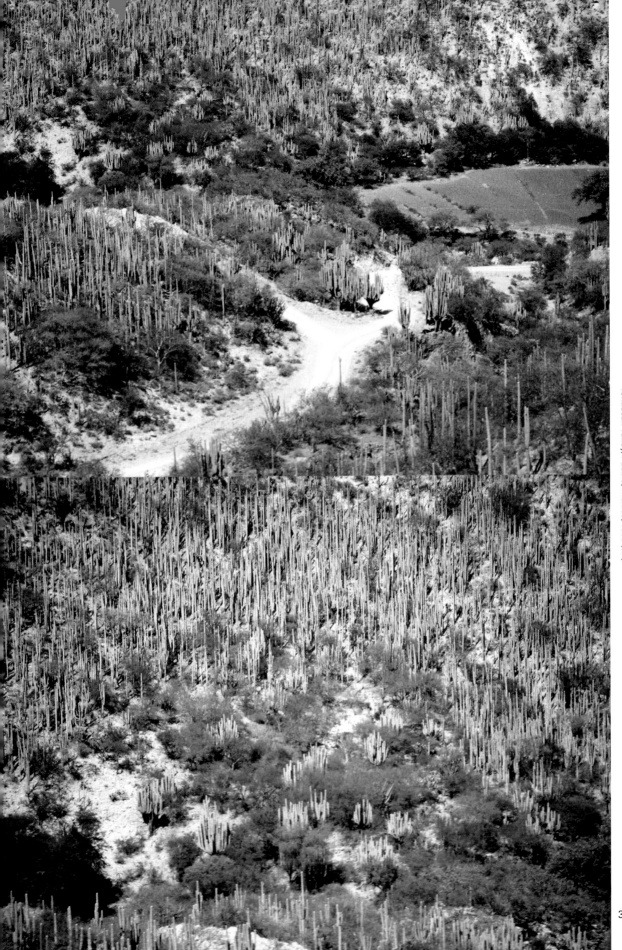

Tehuacan Valley, Puebla, Mexico, 1998 (JR)

315

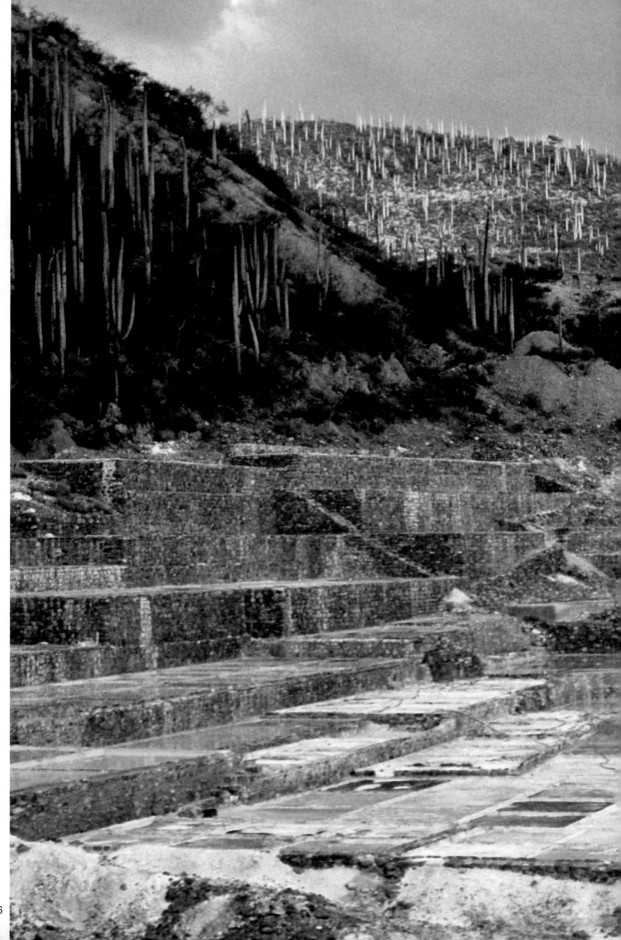

Puebla, Mexico, 1997 (JR)

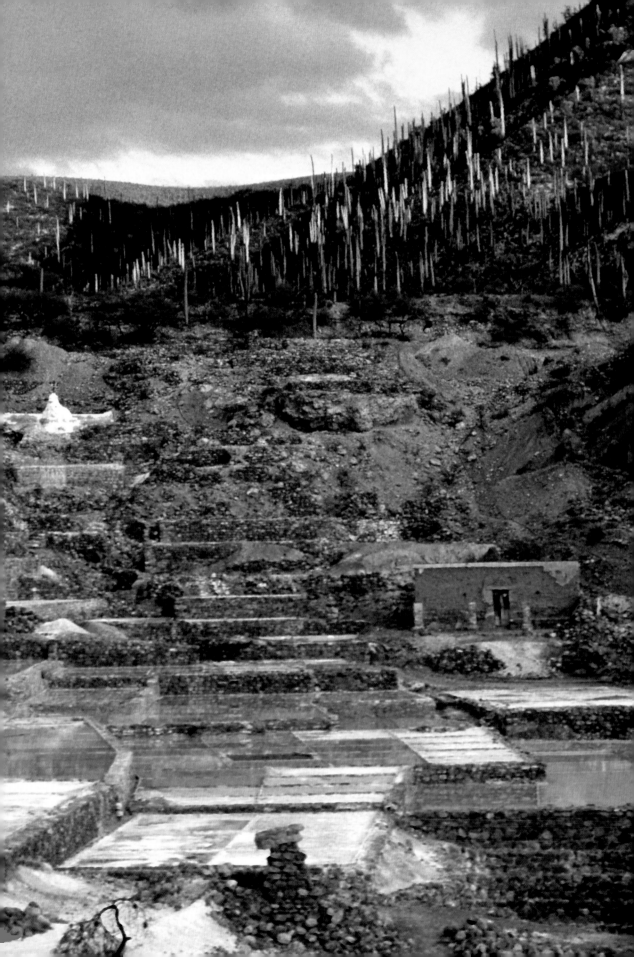

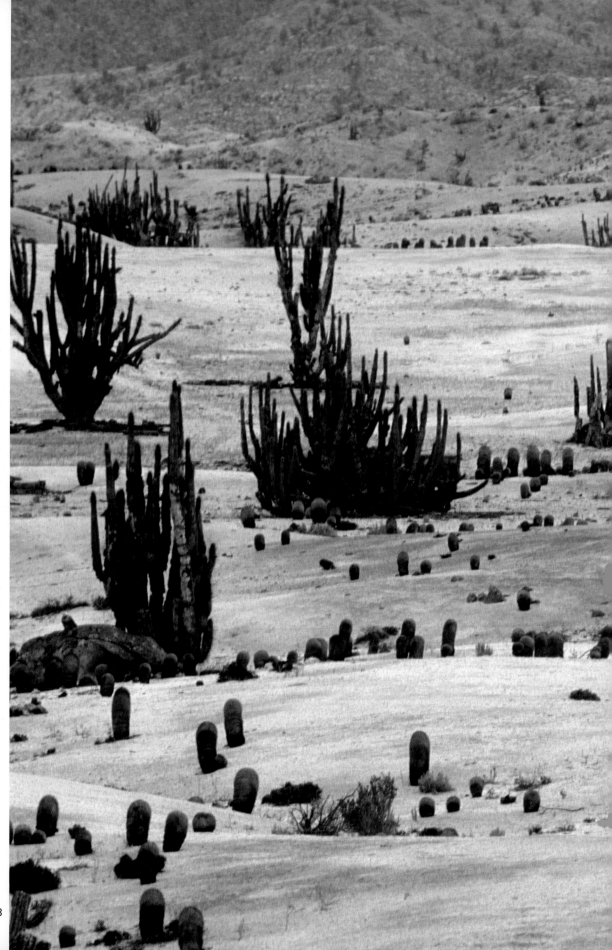

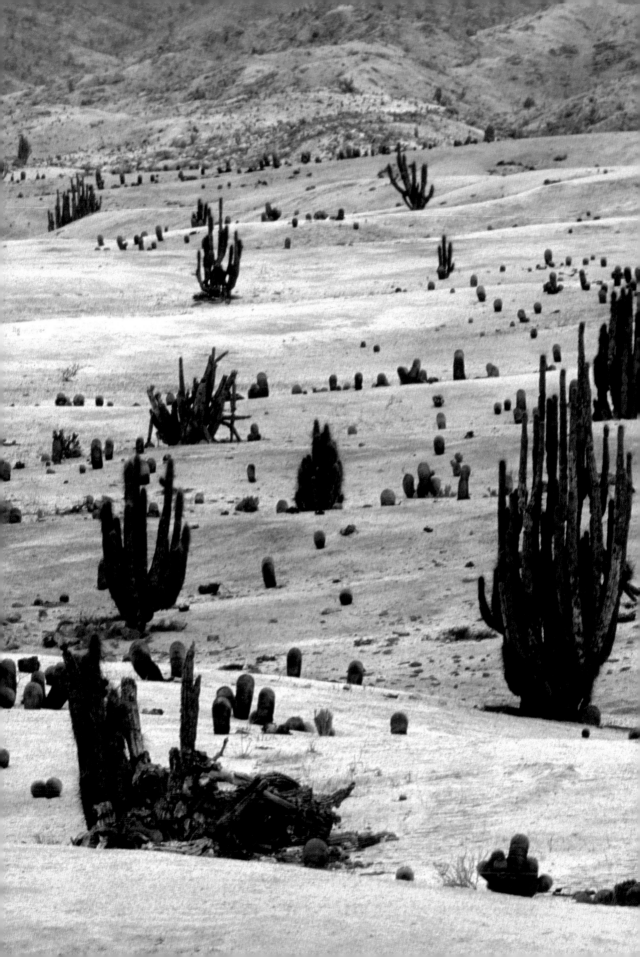

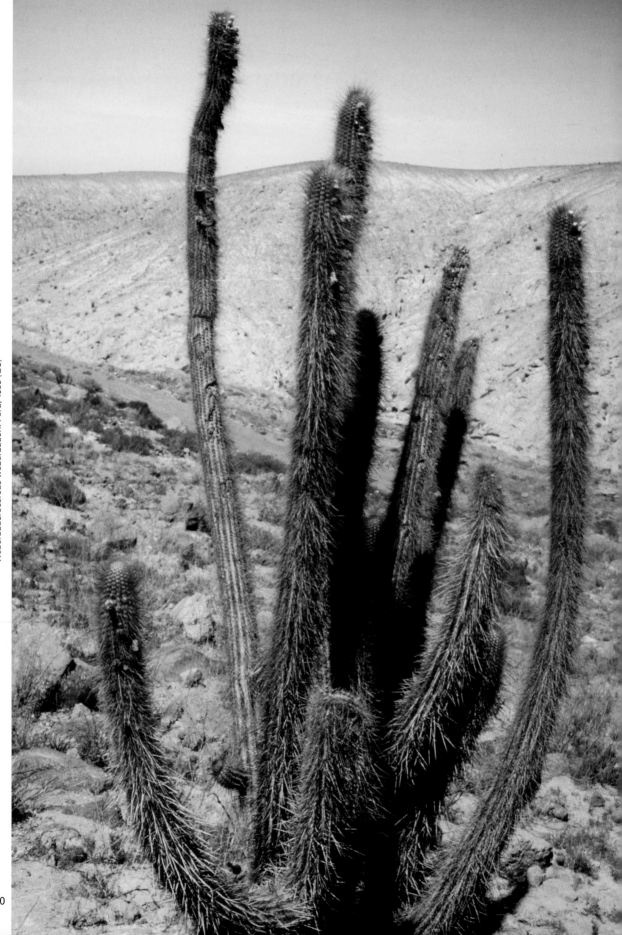

Weberbauerocereus weberbaueri. Peru, 1999 (GC)

Notes on the Photographs

17 *Copiapoa columna-alba*. With jet-black spines against its heavily glaucous gray stem, this striking taxon is what most people think of when they hear the word *Copiapoa*. These diminutive columnars are phototropic, which means that they tilt toward the sun when solar radiation is most intense to receive a maximum amount of radiation at the apex while minimizing it on the sides.

18–19 *Copiapoa cinerea*. A large population of north-facing cactus tilt their wooly apices toward the sun, while reducing side-stem exposure to high solar irradiance. Minnich labeled this species *cinerea* due to the location of its habitat but admits that it shares features with *copiapoa columna-alba*, suggesting it might be an intermediate species between *cinerea* and *columna-alba*.

20–21 *Austrocylindropuntia floccosa*. One of the few cactus found at high altitude in the Peruvian Andes. Here, an extensive population at 13,123 feet (4,000 m), near Andahuaylas, Peru.

22 *Cleistocactus laniceps*. In this lesser known species of *Cleistocactus*, from Bolivia, a thick, yellow central spine grows from each wooly areole.

23 *Cleistocactus buchtienii*. Previously known as *C. ayopayanus*, this form is known to have the longest flower in the genus.

24 *Vatricania guentheri*. Growing in a valley near the Rio Grande in Bolivia, this species' red cephalium is a unique attribute among cactus.

25 *Pilosocereus densiareolatus*. This candelabriform columnar cactus is known for its felted areoles and hairy pseudocephalium (*Pilosocereus* means "hairy cereus"). The yellowish tips on the plant pictured demonstrate how much new growth it's achieved in a single season, a visual representation for how slow xeric plants can be when living in habitats where resources are scarce.

26 *Armatocereus laetus*. The location where this plant once grew is now occupied by a gas station.

27 *Austrocylindropuntia floccosa*. A small detail of a much larger cluster.

28 (top) *Pediocactus simpsonii*. Throughout the mountains of the Western United States, this tiny, cold-tolerant cactus grows between 4,500 feet (1,371 m) and 11,500 feet (3,505 m) above sea level, often hiding in the shade of rocks and other plants.

28 (bottom) *Oreocereus pseudofossulatus*. This columnar cactus from the Andes Mountains wears a wooly toupee to protect its upper stems from the cold and the intense solar irradiance of high altitudes.

29 *Browningia columnaris*. This photograph is the first to be taken of this cactus since it was discovered in 1965.

30 (top) *Neoraimondia herzogiana*. This plant is sometimes called baseball bat cactus, because when young, it grows a single stem that tapers at the bottom like a baseball bat. As it matures, it loses this club-like form and takes on a more candelabra-like branching appearance.

30 (bottom) *Copiapoa dealbata*. Known for its long, black spines and bluish epidermis, *C. dealbata* resides in a liminal zone, where the world's most arid desert beach meets one of Earth's most productive marine ecosystems (the Humboldt Current), in the subduction zone wherein two continents collide, painting a backdrop of startling geological variation bedecked with lichenized life.

31 *Neoraimondia roseiflora*. This plant develops a grayish-white waxy layer on the older parts of its stem (this specimen is more than 9 feet [2.7 m] tall).

32–33 *Ferocactus diguetii*. Endemic to various islands in the Gulf of California, *F. diguetii* is a classic example of island gigantism, where like the giant tortoise of the Galápagos, an island species will grow larger than its mainland counterparts. It can reach 13 feet (4 m) in height at maturity.

34–35 *Ferocactus histrix*. This cactus had been one of the most populous species of its genus in Mexico. Today its numbers are greatly diminished by human extraction for making the cactus candies *dulce de acitrón* and habitat degradation resulting from urban expansion.

36–37 *Melocactus pachyacanthus*. A limestone clearing in the forest creates an ideal habitat for this population.

38 *Melocactus andinus* subsp. *andinus*. Mature *Melocactus* develop a dense mass of spines that form a bristly cap, or cephalium, at the top of the stem.

39 *Melocactus mazelianus*. Flowers and fruits grow inside the white wool and bristle–coated cephalium on the apex of the plant, which protects them from the heat and sun. Eventually, the fruits emerge ripe and ready to be munched by the closest grazing herbivore.

40 *Melocactus pachyacanthus*. Once the stem of a *Melocactus* is done growing, it develops its cephalium. Some cephalia have been known to reach 3 feet (91 cm) in height.

41 *Melocactus* sp. See notes for page 73.

42–43 *Cylindropuntia santamaria*. This very rare species occurs on only two islands in the Mexican state of Baja California Sur and has never been photographed in full flower.

44 (top) *Cylindropuntia bigelovii*. This species of *Cylindropuntia*, sometimes called teddy bear cholla, is arguably the most iconic of its genus, with spines that give it a fuzzy, almost cuddly appearance—but make no mistake, if you get too close, you will bleed!

44 (bottom) *Cylindropuntia alcahes*. Plants in the *Cylindropuntia* genus, also known as cholla cactus, have cylindrical, segmented stems and sadistic barbed spines that easily attach to flesh like Velcro. In the landscape, stands of cholla are formidable chevaux-de-frise and are often difficult to maneuver around, such as this one from Baja California, Mexico.

45 (top) *Stenocereus gummosus*. From the Baja Peninsula and on most of the Gulf Islands, as well as in Punta Sargento in the upper Sea of Cortez region, Mexico, this cactus bears fruits that were famously eaten by Colonial Spanish explorers for scurvy prevention.

45 (bottom) *Gymnocalycium pflanzii* subsp. *argentinense*. This ever-so-shy species grows cryptically—semi-buried in sand and partially obscured by shrubs.

46 (top) *Cumulopuntia ignescens*. From Peru, Chile, and Bolivia, this cactus grows in sizeable mounds of semi-prostrate, ovoid, tapered stem segments. It prefers the extreme habitat of the Andes Mountains, usually on north-facing slopes.

46 (bottom) *Copiapoa cinerea* var. *albispina*. From the beaches of San Ramon, Chile, this variety of *C. cinerea* has white (*albi*) spines (*spina*) and often a salmon-pink lower stem.

47 (top) *Stenocereus gummosus*. See notes for page 45.

47 (bottom) *Echinocereus pectinatus.* Sometimes referred to as rainbow cactus, *E. pectinatus* features stunning spine color variations, including whitish yellow, pinkish purple, and brown, sometimes expressing the full range of color variation on a single plant. It grows prolifically in Mexico and in the Southwestern United States.

48 (top) *Copiapoa tenebrosa.* On the summit of Mt. Perales, Chile, clumps of the rare and endangered *C. tenebrosa* look down upon the fog-blanketed lowlands.

48 (bottom) *Copiapoa cinerea.* This highly variable species enjoys a life of poverty in a habitat where little else can grow. It stands out for its heavily oxidized, blackened lower stems that almost look dead, in contrast to its brilliant, whitish, chalky apex, where it concentrates most of its resources to stay alive.

49 (top) Woody Minnich camping.

49 (bottom) *Copiapoa cinerea* var. *albispina.* See notes for page 46 (bottom).

50–51 *Copiapoa columna-alba.* This juvenile is perhaps half a century old. Also see notes for page 17.

52–53 *Copiapoa columna-alba.* An odd trifurcating (three-branched) growth pattern. Also see notes for page 17.

54–55 *Escobaria abdita.* Growing in vast mudflats, this quarter-sized species is known as a belly plant, as you have to be on your stomach to find them.

56 *Neochilenia tenebrica.* In dry times, this geophytic species sinks below ground level to conserve water.

57 (top) *Ariocarpus kotschoubeyanus.* Endemic to northeastern Mexico, this remarkable little cactus is the smallest in its genus. Like so many cactus in Mexico, this plant is threatened by habitat loss and poaching.

57 (bottom) *Ariocarpus fissuratus.* This extremely slow-growing and long-lived cactus is from the Mexican states of Chihuahua, Coahuila, Durango, and Zacatecas, with some populations found in Texas. Its hardened and fissured texture creates an impression of something ancient and wise.

58 *Lithops gracilidelineata.* Growing among and almost buried in quartz-strewn gravel, the wrinkled, pinkish brown, translucent top surfaces, or leaf windows, of these little plants enable light to enter the interiors of the leaves for photosynthesis.

59 Héctor Hernández doing fieldwork near the Zimapán Dam in Hidalgo state, Mexico. Taxonomic identification requires examination of microscopic details.

60 *Ferocactus diguetii.* George Lindsay pictured. See notes for pages 32–33.

61 *Ferocactus diguetii.* See notes for pages 32–33.

62 *Arrojadoa marylanae.* Violet flowers bloom only at the joints of this plant. This species is the largest member of the genus.

63 *Cipocereus bradei.* Endemic to the state of Minas Gerais, Brazil, this stunning blue-green columnar cactus grows on crystalline rocks in small populations of fifty to two hundred, in six known localities. Its stunning blue nocturnal flower buds are white within. Black spines disappear with age.

64–65 *Discocactus placentiformis.* One of the largest of the genus, this is a very desirable plant for the cactus cultivator because of its sweet-scented nocturnal flowers.

66 *Didierea trollii.* This rare and threatened succulent, endemic to Madagascar, is one of only two species in the genus. Whereas its totem-like sibling, *D. madagascariensis*, grows vertically, *D. trollii* grows prostrate for many years until it forms upright shoots up to 10 feet (3 m) in height.

67 *Didierea trollii.* See notes for page 66.

68 *Aloe* sp. Some of the world's most spectacular aloes are found in the Namib Desert, including this timeworn specimen, possibly *A. khamiesensis.*

69 *Adenium boehmianum.* This deciduous succulent shrub from Namibia and Southern Angola has the largest leaves of its genus, with striking, trumpet-shaped flowers that range in color from white and pink to blood red with dark purple throats. Commonly known as bushman's poison, its cardiotoxic root sap is traditionally used as arrow poison for hunting large game.

70 *Blossfeldia liliputana.* Named for the fictional island nation of Lilliput in Jonathan Swift's *Gulliver's Travels*, this Andean monotype (the only species of its genus) is the world's smallest cactus, up to 0.5 inches (13 mm). It lives on mudstone cliffs in the hairline fissures between rocks in northwestern Argentina and southern Bolivia. *Blossfeldia* is believed to have a poikilohydric cuticle, which means that it can endure high levels of desiccation—the plant can lose up to 80 percent of its weight and can rehydrate its cells after a single rain event. Well-known examples of poikilohydric plants are the resurrection plant, *Selaginella lepidophylla*, and the North African rose of Jericho, *Anastatica hierochuntica.*

71 *Ferocactus glaucescens.* In eastern Central Mexico, this barrel cactus grows in dry forests and on rocky slopes among junipers. It is admired for its powdery blue epidermis and sun-yellow spines.

72 (top) *Ferocactus peninsulae.* Because of poaching, habitat destruction, urbanization, and cattle grazing, the future of this barrel cactus in Mexico's Baja California Peninsula does not look good.

72 (bottom) *Ferocactus* sp. Most plants in the *Ferocactus* genus are barrel shaped, hence the name barrel cactus. They are widely represented throughout the Western United States and in Mexico, with apical flowers that range from white to yellow, orange, pink, red, or purple, even sometimes expressing two colors in a single bloom.

73 (top) *Melocactus* sp. Mature plants in this genus are easily recognizable by their cephalia, the wooly and bristly structures at the apex of the plants that contain masses of areoles from which flowers and fruits grow.

73 (bottom) *Melocactus zehntneri.* A lizard rests atop the seed-filled cephalium of this *Melocactus.* The fruits of this species sometimes stay embedded in the cephalium, waiting for the main plant to die and provide a bit of organic matter in which they will germinate.

74 (top) *Aztekium hintonii.* This bright-pink–flowering geophyte, narrowly endemic to a restricted region in Galeana, Nuevo León, Mexico, is known for its slow growth. Plants in this genus grow so slowly from seed that it can take years before growth is even detectible—a real ego-killer for even the most patient horticulturalist. *Aztekium hintonii* takes root in the fissures of sheer rock cliffs; its survival is threatened by poachers for the ornamental plant trade.

74 (bottom) *Astrophytum coahuilense.* This sculptural stunner hails from the Mexican states of Durango and Coahuila and is one of many cactus species now in decline because of habitat loss and poaching. When mature, *A. coahuilense* resembles a thing finely carved in white marble.

75 (top) *Avonia albissima.* From South Africa, Namibia, Bushmanland, and Griqualand, this tiny whitish cactus forms a tuft of thin, cylindrical branches that some say resemble bird droppings.

75 (bottom) *Ferocactus cylindraceus.* This highly variable, colorful species grows throughout the Southwestern United States and into Mexico in a variety of arid terrains, usually in gravelly or rocky foothills, canyon walls, and wash margins.

76 *Lophocereus schottii.* Dense hairs and bristly spines grow on the pseudocephalium along the stem of this plant, where flowers and fruits develop.

77 *Oreocereus celsianus.* Ripe fruits await consumption.

78 *Pilosocereus* sp. Known for their very hairy areoles, plants in the genus *Pilosocereus* (Latin for "hairy cereus") are sometimes referred to as tree cactus for their tall growth and multiple, sprawling branches.

79 (top) *Gymnocalycium spegazzinii.* This altitude-loving stunner from Argentina is admired for the variation and length of its spines and its brown to sage-colored stems. Its blooms are heart-arresting, pink-throated, velveteen white petals with creamy yellow stamens.

79 (bottom) *Echinocereus fitchii* subsp. *albertii.* The black lace cactus occurs in coastal grasslands, scrublands, and woodlands, and in saline soils on the Texas Gulf Coast.

80 (top) *Frailea phaeodisca.* From Brazil and Uruguay, this little dumpling-shaped cactus grows semi-cryptically in the South American Pampas grasslands. During the past two decades, an estimated 40 percent of its population has disappeared due to cattle grazing, agriculture, eucalyptus forestry, invasive plant species, and fire.

80 (bottom) *Haworthia viscosa.* From the Western Cape and Eastern Cape Provinces of South Africa, this succulent is known for its stacked-pagoda leaf arrangement.

81 (top) *Discocactus bahiensis* subsp. *gracilis.* Endemic to the state of Bahia in Brazil, this *Discocactus* species faces threat of extinction resulting from habitat loss and over-collection for the ornamental plant trade. Despite the fact that this remarkably adaptive cactus can withstand extreme environmental conditions, it suffers primarily from human encroachment of its habitat.

81 (bottom) *Epithelantha bokei.* This edaphic (relating to soil rather than climate) specialist from the Chihuahuan Desert grows in exacting soils and rock strata specific to altitudes between 2,000 and 5,000 feet (610 m and 1,524 m) above sea level.

82 *Dasylirion wheeleri.* New leaves emerge on this evergreen semi-succulent after surviving a wildfire.

83 *Ferocactus cylindraceus.* Hares have eaten into the root of this barrel cactus.

84 *Ferocactus townsendianus.* The spines of this Mexican *Ferocactus* species are usually reddish in color and hooked. It can be found in Baja California, Mexico, including the Magdalena Plain and the islands of Santa Margarita and Magdalena.

85 *Ferocactus gracilis.* From Baja California Norte, this Mexican barrel cactus typically grows red spines (see photo on page 188). It shares its habitat with an all-star cast of xeric heavyweights: *Fouquieria columnaris* (the Boojum tree), *Lophocereus schottii* (totem pole cactus), the spiny devil *Stenocereus gummosus*, and *Pachycereus pringlei* (the Mexican giant cardon).

86 *Ferocactus diguetii.* See notes for pages 32–33.

87 Miguel Dominguez Leon with *Pachycereus pringlei* (bottom) and *Ferocactus diguetii* (top), the largest species known.

88 *Haageocereus acranthus* subsp. *olowinskianus.* The dense coastal fog in this area is responsible for the yellow lichen growth on this plant.

89 *Haageocereus acranthus* subsp. *olowinskianus.* See notes for page 88.

90 (top) *Ferocactus diguetii* and *Pachycereus pringlei.* See notes for pages 32–33 and 202.

91 Collecting plant specimens atop Coronado Island (aka Smith Island).

92–93 *Copiapoa tenebrosa* and *Euphorbia lactiflua.* The view from Mt. Perales to Taltal below.

94 *Cylindropuntia fulgida.* This stunning arborescent species is sometimes called chain fruit cholla for its hanging chains of fruit. It is also called jumping cholla, because it is said to leap out and attack unsuspecting hikers (with even the merest brush by, bits of the cactus will cling to the clothes of passersby).

95 (top) *Cylindropuntia fulgida.* See notes for page 94.

95 (bottom) *Cylindropuntia bigelovii.* See notes for page 44 (top).

96 *Cleistocactus luribayensis.* This golden-thorned columnar hails from Luribay, a municipality in La Paz, Bolivia, which gives the species its name.

97 (top) *Haageocereus* sp. This genus is endemic to the lower elevations of coastal Peru and northern Chile, with fourteen possible species and eight subspecies. It is highly variable in form, from prostrate and crawling, to tentacular, to ascending and erect. Its cylindrical, often-branching stems boast up to twenty-six ribs, with relatively large, close-set areoles and numerous spines that in most cases completely cover the epidermis.

97 (bottom) *Grusonia bradtiana.* From the plains of Coahuila, Mexico, *G. bradtiana* grows in thickets of spiny, segmented columns that resemble insect larva.

98 *Fouquieria columnaris.* This plant, which hails from the Valle de los Cirios in the southern part of Baja California, Mexico, is known as the Boojum tree. The Boojum tree, named after a fictional animal from Lewis Carroll's nonsense poem *The Hunting of the Snark.* The poem describes a hunting party that encounters a particularly dangerous stripe of Snark, the dreaded Boojum, which has the ability to vanish its predators.

They hunted till darkness came on, but they found / Not a button, or feather, or mark, / By which they could tell that they stood on the ground / Where the Baker had met with the Snark. / In the midst of the word he was trying to say, / In the midst of his laughter and glee, He had softly and suddenly vanished away— / For the Snark was a Boojum, you see.

Because Carroll foregoes description of the Boojum in his poem, and because Henri Holiday, who illustrated the poem, famously depicted every character except for the Boojum, the word has at times been used for things that elude simple description, such as the boojum geometric pattern on the surface of one of the phases of superfluid helium-3 (plural booja).

99 *Fouquieria columnaris.* See notes for page 98.

100 *Fouquieria columnaris.* See notes for page 98.

101 *Fouquieria columnaris.* See notes for page 98.

102–3 *Brachycereus nesioticus.* Commonly known as lava cactus, this monotypic species is endemic to the barren lava fields of the Galápagos Islands.

104–5 *Brachycereus nesioticus.* See notes for pages 102–3.

106 (top) *Cylindropuntia alcahes.* See notes for page 44 (bottom).

106 (bottom) *Opuntia pycnantha.* This fat-padded stunner from Baja California, Mexico, stands out for its sprawling lateral growth form, with robust chaining pads that often seem to hover just above the ground. Its dark greenish epidermis is hoary with thick yellow to rust-colored whisker spines (not glochids) that, like grandpa's three-day beard, make you want to touch them (though I would advise against it).

107 *Cylindropuntia alcahes* subsp. *gigantensis.* See notes for page 44 (bottom).

107 *Opuntia pycnantha.* See notes for page 106 (bottom).

108 (top) *Coleocephalocereus purpureus.* This species has a very limited habitat range of about 3 square miles (7.8 sq km) in Brazilian Caatinga (an ecoregion in northeastern Brazil) upon gneissic outcrops and rocks. With fewer than one thousand individuals, *C. purpureus* faces threat of extinction from rock quarrying, among other issues. Its stubby stems and dense cephalium, a wool and bristle-coated structure at the apex of the plant, make it truly sui generis, without parallel in the cactus family.

108 (bottom) *Echinopsis nothochilensis.* The long toothpick spines on this Chilean columnar somewhat resemble the spines of *Eulychnia acida,* also from Chile.

109 *Borzicactus xylorhizus.* Only eighteen locations in habitat of this rare and threatened species are known.

110–11 *Gymnocalycium schickendantzii.* Endemic to northwestern Argentina, this species grows in flat, silty places, often in the shade of other plants.

112 *Ferocactus rectispinus* (crested). This solitary barrel species grows in central Baja California, Mexico, high on coastal cliffs. The species epithet *rectispinus* refers to having a very pronounced central spine per each areole. This photo shows an exceptionally large, cresting example of the species. "Cresting" is a mutation that occurs when the growing tip of a plant grows linearly instead of radially, giving the plant a coral-like appearance.

113 *Ferocactus rectispinus.* Detail of the cresting apex.

114 *Copiapoa columna-alba.* As this species matures, it sheds its lower spines, exposing an extremely dense bark that becomes a habitat for lichen (see example on page 179).

115 *Copiapoa columna-alba.* This plant could easily be more than five hundred years old, making it a juvenile at the time of Christopher Columbus.

116–17 *Echinopsis deserticola.* This population of plants grows in the fog zone overlooking the South Pacific, an area that is paradoxically starved of water.

118 (top) *Ferocactus "aquaticus."* The species epithet *aquaticus* is not recognized. This photograph shows a cactus that was possibly named by the photographer, likely to describe its proximity to water (presumably ocean water from its salt-encrusted spines). A halophytic (salt-tolerant) *Ferocactus*? I'd like to know more about this curious saline being.

118 (bottom) *Ferocactus* sp. See notes for page 72 (bottom).

119 *Echinopsis tacaquirensis.* This bright green, basally branched, archetypal columnar cactus grows in western Argentina and Bolivia.

120 *Astrophytum ornatum.* Like many other Mexican cactus species, *A. ornatum* is threatened by illegal collecting and overgrazing.

121 *Astrophytum capricorne.* This species is sometimes referred to as goat's horn cactus for its curly, horn-like spines that emerge from its apex. This solitary northern Chihuahuan Desert cactus grows very slowly, taking decades to reach maturity, up to 3.9 feet (1.2 m) in height.

122 (top) *Sulcorebutia rauschii.* Among the gentry of black-spined geophytes, this species is admired for its pectinate spines (small comb-like spines that grow flattened against the stem) and for its stem color variations, from very light green to a deep, velvety magenta.

122 (bottom) *Neochilenia napina.* Like all cactus from the coastal Atacama Desert area, this tiny, solitary, tap-rooted geophyte subsists on the meager water vapor provided by fog, with a few extra drops of annual rain, in the world's most arid desert habitat.

123 *Lophophora williamsii.* The peyote cactus grows in the Chihuahuan Desert in Mexico and north into southern Texas. This tap-rooted, spineless button cactus contains psychoactive alkaloids—known to induce extraordinary states of consciousness, including hallucinations, time-dilation effects, euphoria, depersonalization, and anxiety. The psychoactive properties of this entheogenic cactus make it undesirable foodstuff for animals, except perhaps for human animals, who have over-harvested the plant to the point of its endangerment.

124 (top) *Lobivia minutiflora.* From southern Bolivia and northern Argentina, this cactus has many geographical and morphological forms. Diminutive flowers open to 1 inch (2.5 cm) wide, hence the species name derived from the Latin *minutus* (little) and *flora* (flower).

124 (bottom) *Ferocactus alamosanus.* From the southeastern Sonoran Desert in Mexico, this rare species of *Ferocactus* lives in tropical, deciduous pine-oak forests.

125 (top) *Gymnocalycium spegazzinii.* See notes for page 79 (top).

125 (bottom) *Ferocactus rectispinus.* See notes for page 112.

126–27 *Ferocactus glaucescens.* The plant shown in the foreground on page 127 appears to be a *Ferocactus glaucescens.* See notes for page 71.

128 *Mammillaria cerralboa.* This densely spined, solitary, diminutive columnar cactus grows in rocky, hilly terrains at low altitudes in Baja California Sur, Mexico. True to its genus, its flowers grow in a halo formation around the stem. Their papery white petals, bright yellow stamens, and conspicuous magenta stigmas, are a sight to behold.

129 *Lasiocereus rupicola.* This tree-like candelabra-forming cactus from Peru is sometimes called wooly candle for its pseudocephalium, a hairy structure on the side of the plant near the apex, where flowers and fruits are produced. It is pollinated by bats.

130 *Pachycereus pringlei.* José Zuniga sits near a giant cardon that was hundreds of years old and more than 70 feet (21 m) tall. The cactus is no longer standing.

131 *Pilosocereus lanuginosus.* Endemic to Lagunillas, Mérida state, Venezuela, this plant grows on flatlands and slopes in the inter-Andean dry valleys, relying on bats to pollinate its flowers and on birds to distribute its seeds. Because of its limited extent of occurrence, just 163 square miles (422 sq km), and because its habitat is under pressure from urban development and farming, it is listed as endangered.

132–33 *Opuntia azurea* var. *discolor.* From Mexico to southwest Texas, this long-spined prickly pear grows in technicolor, with remarkable blue, green, and purple stems and red-throated flowers that alternate between yellow and magenta. Unfortunately, this seductive species is also irresistible to *Cactoblastis cactorum,* a cactus-eating moth with an insatiable appetite for wiping out entire *Opuntia* populations.

134 (bottom) *Astrophytum coahuilense.* See notes for page 74 (bottom).

135 *Vatricania guentheri.* The woolly cephalium on this cactus provides protection from the harsh elements for developing flowers and fruits.

136 *Pachypodium namaquanum.* Growing on a pure quartz outcrop, this plant's obscure habitat has never again been located.

137 *Pachypodium namaquanum.* Known as the halfmens tree, this plant grows in Namaqualand and the Richtersveld in South Africa and southern Namibia, in a region known for having the largest variety of succulent plants on Earth. In Afrikaans, *halfmens* means "semi-human"; according to legend, the gods turned some of the Nama people into trees as they were

driven south from their ancestral home, to forever gaze north toward their place of origin. Likewise, all *P. namaquanum* plants in habitat tilt toward the north.

138 *Browningia candelaris.* This species is named for its unique candelabra branching form.

139 *Browningia candelaris.* The virtually spineless branches of *B. candelaris* sit atop densely spined trunks that protect them from desperate herbivores—an ideal location for birds' nests.

140 *Eulychnia ritteri.* Plants in the *Eulychnia* genus are usually the most conspicuous lifeforms in the surrounding landscape, where they grow to remarkable heights, up to 23 feet (7 m), in an area where scarcely a weed can survive. Standing among these stoic candelabra cactus can be a deeply moving experience.

141 *Cylindropuntia alcahes.* Dr. Ira Wiggins pictured. See notes for page 44 (bottom).

142 *Cylindropuntia alcahes* subsp. *mcgillii.* This rare subspecies of *C. alcahes* occurs only in the Mediterranean region of northwestern Baja California, Mexico.

143 *Pilosocereus gounellei* subsp. *zehntneri.* Occurring only on Bambuí limestone in eastern Brazil, this cactus grows in a habitat that is unsuspectingly dangerous owing to extremely deep, sharp crevices.

144 (top) *Rebutia schatzliana.* This tiny, orange-and-red-flowered hermit lives cryptically in the mountains of Bolivia.

144 (bottom) *Eriosyce odieri.* This species grows cryptically in low coastal flats and on slopes in Chile's Atacama Desert. "Crypsis" for *E. odieri* means growing either partially buried, or totally flush to the ground. This helps to both keep it cool in the summer and warm during winter, with the added advantage of concealing it from wandering herbivores—desperate to eke out an existence in the driest desert on Earth.

145 (top) *Neochilenia napina.* See notes for page 122 (bottom).

145 (bottom) *Rebutia pygmaea.* This mountain cactus grows on rocky outcrops in the puna grasslands in Jujuy and Salta, Argentina, and in Chuquisaca, Oruro, Potosí, and Tarija, Bolivia, in rarefied (low oxygen) air, at 9,678 to 14,107 feet (2,950 to 4,300 m) above sea level.

146 (top) *Mammillaria phitauiana.* Though this species usually tops out at 12 inches (30 cm), the plants pictured here appear to be two to three times that length, likely due to their cascading growth down the face of a cliff.

146 (bottom) *Blossfeldia liliputana.* See notes for page 70.

147 *Arrojadoa rhodantha.* This plant's magenta flowers are like catnip for pollinators—hummingbirds, bees, flies, and butterflies. One such butterfly, *Phoebis philea*, is known as a "nectar robber" and "pollen thief," feeding on the plant's flowers through holes bitten in the petals, thereby bypassing contact with floral reproductive structures and undermining pollination. *Arrojadoa rhodantha* is fairly variable and the plant pictured is believed to be a subspecies.

148–49 *Cylindropuntia imbricata.* The cane cholla is widely represented throughout the Southwestern United States (Arizona, Colorado, Nevada, New Mexico, Oklahoma, and Texas), including some regions that are far too cold for most cactus to survive. It also occurs in Mexico (Durango, San Luis Potosí, and Zacatecas). Its wide range of occurrence is testament to its impressive adaptive versatility.

150 (top) *Mammillaria estebanensis.* This cactus is from San Esteban, a desert island in the Gulf of California that is known for its peculiar wildlife, including roaming cats, pigs, rats, rabbits, and the giant, speckled San Esteban chuckwalla.

150 (bottom) *Echinocereus grandis.* In terms of stem mass, this Mexican cactus is the largest of its genus, as its species name suggests. It is endemic to several islands in the Sea of Cortez.

151 (top) *Ferocactus cylindraceus* subsp. *tortulospinus.* This highly variable (from spheroid to cylindrical, solitary to clumping) species grows throughout the Southwestern United States, south to Sonora and Baja California, Mexico, in a variety of terrains, but usually in rocky substrate.

151 (bottom) *Ferocactus wislizenii.* This fishhook-spined barrel cactus, pictured behind the bicycle, grows alongside some of the most iconic cactus of the southwestern United States: ocotillos, opuntias, saguaros, and tree yuccas. It occurs throughout Arizona, Texas, Mexico, and occasionally in Wile E. Coyote cartoons.

152 (top) *Opuntia lagunae.* This bluestemmed, white-spined prickly pear is restricted to the highest parts of the Sierra de la Laguna mountain range of Baja California Sur, Mexico.

152 (bottom) *Opuntia gosseliniana.* Native to Pima County, Arizona, and the Mexican states of Baja California, Chihuahua, and Sonora, *O. gosseliniana* is commonly known as the violet prickly pear for having pads that turn purple when exposed to environmental stress.

153 (top) *Opuntia clarkiorum.* This plant was discovered and described in 2015 by John Rebman (see page 330), a botanist and cactus explorer who specializes in the opuntias and cylindropuntias of Baja, California. He found it growing southeast of El Rosario on Highway 1, 11 miles (18 km) north of the road to Los Mártires.

153 (bottom) *Opuntia pycnantha.* See notes for page 106 (bottom).

154 *Lophocereus schottii* (monstrose; syn. *Pachycereus schottii*). Sometimes called totem pole cactus because it resembles a thing hewn by hands, this plant comes from a small area northeast of El Arco on the Baja California Peninsula, Mexico. It thrives on rocky hillsides and on alluvial plains in riparian environments.

155 *Lophocereus schottii* (monstrose). See notes for page 154.

156–57 *Lophocereus schottii* (monstrose). See notes for page 154.

158 *Euphorbia viguieri* var. *vilanandrensis.* This variety of *E. viguieri* is admired for its angular green stem and apical floral display. It grows in the coastal forests of Madagascar, in the fissures of rocks, usually in half-shaded locales.

159 (top) *Arrojadoa marylanae.* From northern Brazil, plants in the genus *Arrojadoa* are often found growing on rocky outcroppings in tandem with shrubs that help support their delicate stems.

159 (bottom) *Arrojadoa rhodantha.* See notes for page 147.

160 *Parodia warasii.* This species can grow in rock fissures, suspended hundreds of feet above the ground.

161 *Echinopsis schickendantzii* (syn. *Trichocereus schickendantzii*). This cactus from northwestern Argentina and Bolivia is said to have the most striking flower of its genus. The cup-shaped white flowers, which bloom in spring and summer, are about 8 inches (20 cm) long.

162 *Parodia succinea.* A clump of blooming *P. succinea* happily grow in a moist region of the Rio Grande do Sul, Brazil.

163 (top) *Parodia horstii.* This modest, solitary to clustering floriferous cactus from Rio Grande do Sul, Brazil, is known for its flower variation across several varieties and subspecies, in colors including purple, purplish pink, coral-red, peachy orange, and creamy yellow.

163 (bottom) *Parodia mammulosus.* From Rio Grande do Sul, Brazil, and Uruguay and northern Argentina, this cactus generally grows abundantly where it occurs, but a few subpopulations in Brazil are in decline due to cattle grazing, agriculture, and forestry.

164 *Austrocylindropuntia pachypus.* A very slow grower, this plant has reoriented itself toward the sun after being knocked over. Also see notes for page 165.

165 *Austrocylindropuntia pachypus.* Endemic to central Peru, this elusive and rather peculiar candelabrum-like opuntioid prefers growing in shrubby, rocky terrains. It propagates clones of itself vegetatively by sending out roots from dropped and often seedless fruits to form new plants.

166–67 *Eulychnia acida.* Endemic to western Chile, these large, branching columnar cactus grow in the world's driest nonpolar desert, the Atacama, but in a coastal zone daily blanketed in fog. Plants in this region survive by harvesting the ambient moisture. *Eulychnia acida* is recognized by its long toothpick spines and is known for its not delicious, but edible fruit. In Latin, the word *acida* means "sour."

168–69 *Copiapoa dealbata.* A lack of rain in the Atacama Desert has led to the death of this cactus, whose remains may stay intact for hundreds of years. Also see notes for page 30 (bottom).

170 (top) *Copiapoa tenebrosa.* A perilous drive up the crumbling scree mining roads of Mt. Perales in Chile leads to the foggy mountain perch whereupon this monkish cactus resides.

170 (bottom) *Eulychnia iquiquensis.* This columnar cactus grows in one of the harshest climates on Earth, in Chile's parched Atacama Desert. Many *Eulychnia iquiquensis* in habitat are either dead or slowly dying, with scarcely any new seed germinating. This suggests a plant that is in terminal decline.

171 *Copiapoa cinerea* var. *albispina.* See notes for page 46 (bottom).

173 The Sierra La Asamblea, a mountain in Baja California, Mexico, is in the central desert region of the Baja Peninsula and experiences frequent fog.

174–75 *Stenocereus eruca.* This cactus, commonly known as creeping devil, is one of the few cactus with prostrate growth. Its adventitious roots enable it to "creep" along the soil, as it grows at one end and slowly dies at the other.

176–77 *Pilosocereus tuberculatus.* Though its flowers are visited by a host of animals during the day—butterflies, hummingbirds, and bees (bees being the predominant pollinator for plants in the *Pilosocereus* genus)—fruit formation on *P. tuberculatus* mostly depends on night visits from bats, suggesting a co-evolution between this plant and its bat partners (a condition known as "bat-pollination syndrome").

178 *Eulychnia* sp. This *Eulychnia* is covered in lichen, growing in the extreme fog zone 1,000 feet (305 m) above sea level.

179 *Copiapoa columna-alba.* Lichen-covered *Copiapoa* in a very high-altitude habitat above Guanillos, Chile. Also see notes for page 17.

180–81 (bottom) The desiccated remains of ancient columnar cactus in the *Eulychnia* genus, throughout the north Chilean coastal Atacama, look like ashes from last night's campfire. Also see notes for pages 140, 166–67, 170, and 178.

181 (top) Remains of *Copiapoa longistaminea.*

182–83 *Trichocereus atacamensis* subsp. *pasacana* (syn. *Echinopsis atacamensis* subsp. *pasacana*). *Trichocereus* growing among gravestones.

184 *Pilosocereus fulvilanatus.* On one of the most spectacular species of this large genus, note the thick, orange wool in the new areoles.

185 *Fouquieria columnaris.* This *Fouquieria* is growing through the middle of a cardon cactus.

186 (top) *Tephrocactus articulatus.* This species from Argentina expresses a multitude of physical forms. Cladode (segment) shapes include medium-sized and egg-shaped, sausage-shaped, minimally segmented and worm-like, and pinecone-shaped. Cladodes range in form from tiny, stacking, and spherical to comparatively large football shapes that are compacted into a mass of balls. Similar large-stemmed variants grow either as a single column stack or as a column stack with one or two delicate, branching, stacked arms, all of them maxing out at three to five cladodes high. Some have white, flattened, funnel-shaped, paper-thin spines (their common name is paper spine cactus); some have brown, thick, flattened fingernail-thick spines; and others have flat, black spines of various thicknesses. Some have no spines at all, while others have only a sparse few that emerge from the space between cladodes. Their colors include dark, waxy greens; grayish, glaucous blues; deep purples; flat, colorless grays; reds and pinks; and sometimes light-green and yellow with hints of red. The paper spines are most likely an adaptation for collecting dew and funneling it toward the stem of the plant.

186 (bottom) *Tephrocactus alexanderi.* From the provinces of La Rioja and Salta, Argentina, *T. alexanderi* is a low-clumping, obovoid opuntioid that thrives where little else can survive.

187 (top) *Fouquieria columnaris.* See notes for page 98.

187 (bottom) *Stenocereus gummosus.* See notes for page 45 (top).

188–89 *Ferocactus gracilis* and *Fouquieria columnaris.* See notes for pages 85 and 98.

190–91 *Mammillaria guerreronis.* From Guerrero, Mexico, this *Mammillaria* species grows in clusters of cylindrical stems, each up to 24 inches (61 cm) tall, with a halo of red apical flowers.

192 *Fouquieria purpusii.* Mining operations have destroyed the habitat of this rare species.

193 *Fouquieria purpusii.* See notes for page 192.

194–95 *Melocactus azureus.* This species is highly coveted for its blue coloration. The small red flowers on its terminal cephalium are pollinated by hummingbirds.

196 *Espostoa mirabilis.* This cactus occurs mostly in the Peruvian regions of Amazonas and La Libertad and around the city of Cajamarca in the Andes Mountains, with some populations occurring in southern Ecuador. Plants in this genus are known for their cephalia, the hairy structures that surround and protect their delicate flowers from the harsh elements. Recent evidence suggests that cephalia also facilitate the echolocation of it bat pollinators by creating a sound-absorbent area around the flowers, resulting in more pronounced flower echoes.

197 *Backebergia militaris.* This rare columnar cactus occurs in fragmented populations throughout Mexico, where it grows in inhospitable places that are prone to extreme aridity and abundant seasonal hurricanes. For instance, in one location where *Backebergia* occurs, rainfall is typically between 15 and 45 inches (38 and 114 cm) per year, while evaporation from the heat and wind can reach upward of 80 inches (203 cm). From a distance, these monotypic monsters look like giant cotton swabs covered in earwax.

198 (top) *Lobivia minutiflora* (crested). See notes for page 124.

198 (bottom) *Epithelantha micromeris* (crested). This tiny, globular, densely white-spined cactus is referred to as false peyote by the Tarahumara people of Chihuahua and the Huichol of northern Mexico. Ingesting this plant is said to aid one in communication with sorcerers, to prolong

life, and to drive evil people insane, causing them to jump from cliffs. It is also consumed as a stimulant and protector by the Tarahumara foot-runners.

199 (top) *Opuntia pycnantha* (crested). See notes for page 106 (bottom).

199 (bottom) *Mammillaria dioica* (crested). This very spiny cactus, also called the strawberry cactus, California fishhook cactus, strawberry pincushion, and nipple cactus, is shown exhibiting abnormal growth (cresting) that forms as a result of cell mutation.

200 *Opuntia galapageia*. Some members of this species have been known to reach 20 feet (6 m) in height. First collected by English naturalist Charles Darwin, this gigantic arborescent *Opuntia* species is found only on the Galápagos Islands.

201 *Opuntia galapageia*. See notes for page 200.

202 *Pachycereus pringlei*. Native to northwestern Mexico, the giant cardon is an arborescent columnar, famous for being one of the world's tallest cactus, growing to 63 feet (19 m) at maturity. It lives in symbiosis with arbuscular mycorrhizal fungi and with other soil microbiota that help it fix nitrogen from the air and release nutrients from the rocky substrate—enabling it to grow in rather challenging circumstances, sometimes even without soil on pure rock. Flowers of this species are known to have three sexual states in some populations: male, female, and bisexual.

203 *Trichocereus poco*. This monolithic columnar from the highlands of Argentina and Bolivia bears an extraordinary bonnet of flowers, in colors of red, orange, pink, peach, beige, and sometimes green.

204 *Stenocereus gummosus* (spiralis). "Spiralis" is sometimes used to describe plants with this particular spiraling mutation. It is common for photographers to gravitate toward plants like this with differences, mutations, and anomalies. See also notes for page 45 (top).

205 *Ferocactus diguetii*. See notes for pages 32–33.

206 *Lophocereus schottii*. See notes for page 76.

207 *Lophocereus schottii*. See notes for page 76.

208–9 *Oreocereus leucotrichus*. This small, shrubby columnar cactus forms dense, broad clumps covered in spines.

212 (top) *Gymnocalycium spegazzinii*. See notes for page 79 (top).

212 (bottom) *Astrophytum capricorne* var. *aureum*. This variety of *A. capricorne* grows a yellow spine. In Latin, *aureum* means "golden." Also see notes for page 121.

213 *Tephrocactus articulatus*. See notes for page 186 (top).

214 (top) *Tephrocactus recurvatus*. This photo was labeled *Tephrocactus recurvatus*, though we've seen this plant identified by multiple synonyms, including *Maihueniopsis recurvata*, *Cumulopuntia recurvata*, and *Cumulopuntia boliviana* subsp. *boliviana*. It grows in the central Andes Mountains of South America, in the puna ecoregion.

214 (bottom) *Uebelmannia pectinifera*. Because of the over-extraction of this cactus in habitat for the ornamental plant trade, it is now endangered. It has the dubious distinction of being more common in private collections than in the wild.

215 *Sulcorebutia patriciae*. With its long white hair, this may be a "hippie" form of *S. hertusii*.

216 *Copiapoa calderana*. A wind-eroded granite boulder frames a juvenile plant. Year after year, this and other *Copiapoa* species that grow in the coastal deserts of Chile suffer long periods of moisture deprivation, usually eight to twelve months without rain, when they rely solely on ambient moisture from coastal fog to stave off utter desiccation.

217 *Echinocereus brandegeei*. This heavily armed *Echinocereus* species from Baja California, Mexico, grows alongside devil cholla, *Opuntia invicta*; the two so closely resemble each other that the untrained eye may have trouble differentiating them.

218–19 *Copiapoa dealbata*. See notes for page 30 (bottom).

220 *Pachycereus pringlei* (crested). A heavily crested arm points north.

221 *Stenocereus thurberi*. The fruits of the organ pipe cactus are delicious, a delicacy for both humans and bats.

222–23 *Stenocereus thurberi*. Much of this once immense forest has been cleared for pasture or agriculture during the past thirty years.

224–25 *Pachycereus pringlei*. The whitewashed, guano-covered slopes on this island highlight the many cardon cactus that grow here.

226–27 *Copiapoa tenebrosa*. Above the clouds of Mt. Perales in Chile, clumps of *C. tenebrosa* look down upon the fog-blanketed lowlands.

228 *Fouquieria columnaris*. Succulent wood, like the remnants of this plant, can be very ornate and is sometimes used in building decorative interiors.

229 *Fouquieria columnaris*. Dr. Reid Moran investigates the epiphytic *Opuntia* growing on this Boojum tree.

230 *Facheiroa ulei*. Mature stems of this cactus have a long area for flower production down one side, called a lateral cephalium.

231 (top) *Echinopsis pampana*. This species of *Echinopsis* is found in Peru. Its flowers are reminiscent of solar flares.

231 (bottom) *Ariocarpus retusus*. This botanical rock star is sometimes called star rock for its star-like appearance, with hardened tubercles that blend in with its rocky limestone domain.

232 (top) *Caralluma russeliana*. From Djibouti, Eritrea, Ethiopia, Kenya, Saudi Arabia, Somalia, Uganda, and Yemen, this asclepiad bears flowers with large terminal clusters of Star Trekkie, umbel-like inflorescences.

232 (bottom) *Oxalis gigantea*. First described in 1845, this shrubby succulent is from the Chilean regions of Antofagasta, Atacama, and Coquimbo. Its bright yellow flowers are pollinated by hummingbirds.

233 (top) *Boswellia frereana*. In Somalia, where this species of frankincense occurs, it is revered for its aroma and for its use in treating joint pain.

233 (bottom) *Euphorbia ramiglans* (crested). This dwarf species grows in colonies in rocky coastal soils and dunes—often almost entirely buried in sand—in Little Namaqualand, South Africa.

234 *Peniocereus greggii*. This tuber-forming cactus, a night-blooming cereus, usually resembles dead twigs until one anticipated night every June or July, when all of its many giant, white, vanilla-scented flowers bloom.

235 *Ariocarpus kotschoubeyanus*. This remarkable little cactus is the smallest of its genus. With each tiny tubercle roughly 0.125 inches (0.3175 cm) long, mature plants can reach 9 inches (23 cm) in diameter after many decades. Like many geophytic cactus in Mexico, its populations are being depleted due to habitat loss and poaching.

236 *Euphorbia fianarantsoae*. Endemic to Madagascar, *E. fianarantsoae* grows on rocky outcrops and inselbergs in dense thickets. This species is threatened by habitat degradation and by the extraction of wild plants for the ornamental plant trade.

237 *Haageocereus* sp. See notes for page 97 (top).

238 (top) *Echinopsis camarguensis*. This Bolivian columnar stands out for its spectacular golden spines.

238 (bottom) *Oreocereus celsianus*. The old man of the mountain is native to the Andean Highlands. Its common name reflects its fluffy white hair, which helps protect it from the intense sunlight and extreme temperatures at high elevations.

239 *Punotia lagopus*. This species grows at 14,500 feet (4,420 m) in one of the highest, driest, and coldest places in the Andes.

240–41 *Cistanthe guadalupensis*. Accessible only by helicopter, the top of this islet off the west coast of the Baja California Peninsula had never before been visited by humans.

242–43 *Echinopsis maximiliana*. Aided by its hemispherical shape, this plant stays warm enough to flower even at 14,500 feet (4,420 m) and 39°F (4°C).

244 (top) *Echinocereus coccineus* subsp. *transpecosensis*. Hides in grass. Eye-popping flowers.

244 (bottom) *Pachypodium brevicaule*. From south-central Madagascar, this *Pachypodium* is, without a doubt, the strangest looking member of the genus, commonly growing to the size and shape of a cow pie, while producing the occasional flower and leaf. Older specimens of *P. brevicaule* can sometimes grow to be quite large, to about 3 feet (91 cm) in diameter, and can take on an almost liquid-metallic, blob-like appearance.

245 (top) *Cumulopuntia rossiana*. Growing in clumps helps *C. rossiana* ease the burdens of an existence taxed by extreme heat, aridity, and year-round frosts. It grows in the mountains of Bolivia and Argentina.

245 (bottom) *Echinocereus lauii*. This Mexican cutie is known for its prolific flower display.

246–47 *Mammillaria fraileana*. Larger shrubs and trees can serve as nurse plants that create microhabitats below them that are favored by certain cactus.

248 *Uebelmannia gummifera*. This *Uebelmannia* (shown at ground level) grows exclusively in white-quartz sand, here in a grove of taller *Vellozia auriculata*.

249 *Uebelmannia meninensis*. A film canister and an aquarium air tube make a perfect vacuum for seed collecting.

250 (top) *Lophocereus gatesii*. This mostly low-branching, sprawling columnar from Baja California, Mexico, resembles the prototypical form of *L. schottii*, but with more ribs.

250 (bottom) *Yucca schidigera*. Spanish dagger is a magnificent tree-forming yucca ubiquitous throughout the Mojave, Chihuahuan, and Sonoran Deserts of southeastern California, Baja California, New Mexico, southern Nevada, and Arizona. Unfortunately, wild populations of *Y. schidigera* have been thoroughly exploited by a panoply of industries for a staggering number of consumer products, including its use as an additive in pet foods for waste odor control; as an herbal remedy for gout, irritable bowel syndrome, arthritis, high cholesterol, and a host of other human ailments; and as a foaming agent used in beer and in cocktail mixes.

251 *Harrisia adscendens*. The roots of the species are used in Brazilian folk medicine as a treatment for toothache and heartburn.

252 *Cipocereus bradei*. See notes for page 63.

253 (top) *Euphorbia handiensis*. Endemic to Fuerteventura Island in the Canary Islands archipelago, this species bears a striking resemblance to *E. officinarum*.

253 (bottom) *Euphorbia horwoodii*. Although relatively common in cultivation, this *Euphorbia* species from northeastern Somalia is believed to be extinct in habitat.

254 *Yucca capensis*. What's not to love about a grizzly tree yucca expressing survival in its merciless habitat? This mountain dweller is endemic to the far southern tip of the Baja California Peninsula.

255 (top) *Hechtia* sp. In the family Bromeliaceae (the bromeliads), *Hechtia* is the only genus in the subfamily Hechtioideae, which includes seventy-five species. *Hechtia* are native to Mexico, Central America, and Texas.

255 (bottom) *Welwitschia mirabilis*. This two-leaved Angolan/Namibian monotype is sometimes called "the living fossil" because its life can span millennia. (In this photo, the two leaves have shredded and split over time.) To thrive in the hyperarid Namib Desert, *W. mirabilis* grows a very long tap root to reach deep groundwater, while also harvesting ambient moisture from desert fog with its leaves. *Mirabilis* in Latin means "amazing." When first discovered by the Austrian botanist Friedrich Welwitsch in 1859, he reported that he "could do nothing but kneel down and gaze at it, half in fear lest a touch should prove it a figment of the imagination."

256–57 *Haageocereus repens*. Like the fictional sandworms from Frank Herbert's novel *Dune* (1965), this semi-prostrate columnar resembles worms breaching the sandy desert surface. Unfortunately, unlike the near-indestructible sandworm, this highly threatened organism is suffering from habitat loss due to asparagus farming in the area wherein it occurs. It is endemic to a limited zone south of Trujillo, Region La Libertad, Peru.

258 *Haageocereus tenuis*. The habitat of this rare species comprises only a few clusters of about three hundred plants growing in pure sand, 100 yards (91 m) off the highway near Lima, Peru. Windblown chicken feathers are often found attached to the spines of this species as it shares its minuscule habitat with neighboring chicken farms.

259 *Haageocereus tenuis*. See notes for page 258.

260–61 *Strombocactus disciformis*. Like so many plants in the cactus family, this extremely slow-growing, long-lived cliff dweller from the states of Quetaro, Hidalgo, and Guanajuato, Mexico, is currently in decline due to the illegal over-collection of specimen plants for the ornamental plant trade.

262 *Ariocarpus fissuratus*. One of the largest known clusters of this species is located in Big Bend National Park in Texas.

263 *Parodia alacriportana* subsp. *brevihamata*. This little pin cushion from Rio Grande do Sul, Brazil, is a subspecies of *P. alacriportana*, which has so much spine variation from one population to the next that some suspect these variants may actually be discreet species. As of this printing, all variants are lumped into the single taxon *P. alacriportana*.

264 *Pachypodium lamerei*. This tree-forming stem succulent, the Madagascar palm, has a thorny, pachycaul (extra thick), bottle-shaped stem and a leafy apex. Some say it resembles the trees featured in children's books written and illustrated by Dr. Seuss. Its flowers closely resemble those of the plumeria.

265 *Didierea madagascariensis*. The octopus tree hails from the spiny thicket ecoregion of southern Madagascar, where an astounding 95 percent of plant species are endemic. The long spines on this bizarre xeric shrub are believed to be an anachronistic adaptation against four now-extinct browsing herbivores: the giant lemur, the prehistoric elephant bird, a pygmy hippopotamus, and the giant Madagascan tortoise.

266–67 *Cereus* sp. Ceroid cactus imported from South America are here being used as a clothesline.

268 *Euphorbia stellispina*. From Cape Province, South Africa, *E. stellispina* is known for its star-shaped (*stelli*) spine (*spina*).

269 *Cereus jamacaru* subsp. *calcirupicola*. This subspecies of the prolific Brazilian columnar bears delicious

fruits, if you can catch them before the birds do.

270 *Ferocactus viridescens.* Having survived a wildfire, this barrel cactus is growing new spines at its tip.

271 (top) *Ferocactus johnstonianus.* This species is endemic to Ángel de la Guarda Island in Baja California, Mexico.

271 (bottom) *Sulcorebutia heliosoides.* The pectinate spines (comb-like spines that grow flattened against the stem) on this miniscule cactus resemble hundreds of tiny white spiders. It lives a solitary life in the mountains of Bolivia, where the sun is bright and the weather is cool.

272 (top) *Gymnocalycium ferrari.* Like most species of *Gymnocalycium,* this diminutive geophyte from the Argentine provinces of Catamarca and La Rioja lives a solitary life. It possesses several of the hallmark attributes of the genus, including velvety brown stems and conspicuous (usually pink) blooms.

272 (bottom) *Epithelantha micromeris.* See notes for page 198 (bottom).

273 (top) *Blossfeldia liliputana.* See notes for page 70 (bottom).

273 (bottom) *Eriosyce odieri* subsp. *krausii.* Hiding in plain sight, this cryptic little cactus is expertly camouflaged in its surroundings—its only defense against grazing desert herbivores.

274 (top) *Ferocactus gracilis* subsp. *coloratus.* This plant is commonly known as the fire barrel cactus because of its intensely red spines, bright red flowers, and radiant yellow fruit. Spine color can veer toward pinkish, similar to in the plant pictured, probably because of hybridizing with *F. peninsulae* in the field. This subspecies is limited to an area between Punta Prieta and Miller's Landing, in western Baja California, Mexico, where it grows on rocky hillsides among the Boojums.

274 (bottom) *Ferocactus gracilis* subsp. *tortulispinus.* Though this photo was labeled *Ferocactus gracilis* subsp. *tortulispinus,* the subspecies name is likely incorrect. Unfortunately, *Ferocactus* species can be difficult to identify visually with accuracy.

275 *Copiapoa krainziana.* The dense spination on this cactus is thought to help collect water.

276 (top) *Opuntia pycnantha.* See notes for page 106 (bottom).

276 (bottom) *Cereus saxicola.* Distributed in Argentina, Brazil, Bolivia, and Paraguay, this somewhat languid columnar is often found in colonies, crawling along the ground like herds of very slow

worms. Like most plants in the *Cereus* genus, the dazzling white flowers on *C. saxicola* will knock your socks off.

277 *Opuntia pycnantha.* See notes for page 106 (bottom).

277 *Stenocereus gummosus.* See notes for page 45 (top).

278–79 *Pachycereus pringlei.* The density of these *Pachycereus* is probably owing to the absence of rodents and other herbivores on the island.

280–81 *Browningia pilleifera* and *Armatocereus rauhii.* These plants survive rapacious predation by goats.

282–83 *Cleistocactus strausii* and *Echinopsis schickendantzii.* One of the largest populations of *C. strausii* is now endangered by an expansion of the local highway. See notes for page 161.

284–85 *Echinopsis nothochilensis.* See notes for page 108 (bottom).

286 *Parodia leninghausii.* Growing on a cliff face 200 feet (61 m) above the canyon floor, these cactus are accessible only by careful rappelling.

287 (top) *Mammillaria* sp. This epiphytic cactus is an unknown species of *Mammillaria.* Is it *M. polythele* or *M. magnimamma?* Maybe it's *M. sempervivi?* What do you think?

287 (bottom) *Lepismium ianthothele.* Contrary to most people's impression of cactus as plants that prefer rocky desert substrates and harsh desert conditions, plants in the *Lepismium* genus reside in tropical areas in South America, and mostly grow on trees.

288 *Echinocereus pectinatus.* See notes for page 47 (bottom).

289 (top) *Eriosyce odieri* subsp. *krausii.* Endemic to a limited coastal area from Caldera, Atacama, north to Cifuncho, Antofagasta, Chile, this botanical phantom grows on a solitary mountain by the sea.

290 (top) *Ariocarpus trigonus.* Endemic to Mexico, *A. trigonus* is distinguished by its long tubercles (triangular stem protrusions), the longest in any species of its genus, and its conspicuous yellow flowers.

290 (bottom) *Adenia ballyi.* This peculiar Somalian succulent shrub grows a large, above-ground, tuberous, spheroidal, warty, boulder-like caudex (a water storage organ that helps the plant endure drought) that can reach up to 3 feet (91 cm) in diameter, out of which grows a tangle of thorny, flexuous, curly shoots of up to 6.5 feet (2 m) tall. It grows in open ground or wedged between rocks and boulders in subdesert steppe.

291 (top) *Agave cerulata* subsp. *cerulata.* Like many agaves, this one prefers heavily textured terrains, often on the slopes of hills with high granitic and volcanic content. It hails from the Baja California Peninsula, where it grows alongside some equally stunning desert tree species, including *Pachycormus discolor, Fouquieria columnaris,* and *Yucca valida.*

291 (bottom) *Aeonium tabuliforme.* The epithet *tabuliforme* means "flat," referring to the flattened gumdrop appearance of this strange, non-branching, monocarpic succulent. Endemic to Tenerife in the Canary Islands, this bright green, rubbery cliff-dweller seems distinctively alien, especially when its flowers begin to spike.

292 *Espostoopsis dybowskii.* This species, known to exist in only a few disjunct populations in eastern Brazil, is the only one in the genus.

293 (top) *Cistanthe guadalupensis.* A member of the Portulacaceae family, *C. guadalupensis* is found on a volcanic outer islet south of Guadalupe Island, in Baja California, Mexico. It grows on the pumice floor of a volcanic crater with other crater floor–specific plants.

293 *Agave sebastiana.* On the islands of West San Benito, Natividad Island, and Cedros Island, off the Vizcaino Peninsula in Baja California, Mexico, grows this stunning leathery succulent that resembles a giant blue artichoke. From seed, *A. sebastiana* is solitary. Over time however, it suckers from the base to produce a clustered colony.

294 *Ferocactus rectispinus.* See notes for page 112.

295 *Stenocereus gummosus.* This young stem of a *S. gummosus* shows stress as it adjusts to solar exposure. A common misunderstanding about cactus is that they prefer maximum solar irradiance and prolonged drought conditions. It would be more accurate to say that they can tolerate periods of solar intensity and drought if they have to, but they are not invulnerable.

296 *Neoraimondia arequipensis.* This columnar cactus from the Peruvian Andes is an ingredient in the intoxicating concoction *cimora* (or *timora*), a traditional medicinal brew used for treatment of illnesses and for ceremonies. *Cimora* also includes *Trichocereus pachanoi,* a cactus that is rich in the psychedelic protoalkaloid mescaline. Extended areoles along the ribs of this cactus grow larger after each year's flowering.

297 *Neoraimondia arequipensis.* See notes for page 296.

298 *Echinopsis tarijensis.* This girthy columnar from Argentina and Bolivia shares its mountain habitat with some of our favorite desert plant species—*Blossfeldia liliputana, Opuntia sulphurea,* and *Deuterocohnia brevifolia.*

299 *Carnegiea gigantea.* Also known as saguaro cactus, *C. gigantea* is the largest North American cactus. It is often used in cinema to represent the machismo and rugged individualism of the American West. Saguaros usually top out at 40 feet (12 m) but have been known to exceed 70 feet (21 m) in height. Most plants live in excess of two hundred years. Its first flower appears only after the plant is at least thirty-five years from seed, and it takes fifty to seventy years before it grows its first branch. Saguaros are most abundant in Arizona, with some smaller, lesser-known populations occurring in California and in Mexico.

300 *Trichocereus poco.* See notes for page 203.

301 *Echinopsis tarijensis* subsp. *bertramiana.* Growing in high-altitude grasslands in Argentina and Bolivia, from 10,500 feet (3,200 m) to 13,780 feet (4,200 m) above sea level, this monolithic mountain dweller prefers the company of boulders, grasses, bromeliad cushions, and two of our favorite cactus species, *Blossfeldia liliputana* and *Opuntia sulphurea.* In this plant's habitat, the climate is dry and winter frosts are cold and reliably rainless, which helps it endure until the warm season when rains come.

302–3 *Echinopsis nothohyalacantha.* With locale names such as Puerta del Diablo (Devil's Door) and Canon del Duende (Canyon of the Goblin), Tupiza, Bolivia, is known for its unbearable shadeless heat, low precipitation, and dramatic rock-scapes. Here you will also find *E. nothohyalacantha* living with stoic indifference to its inhospitable surrounds. When hiking through this habitat, be advised to carry with you rocks and sticks for fending off wild hungry dogs, a known nuisance for travelers, but a non-issue when you're a plant covered from basal-stem to apex in 3-inch (7.62 cm) golden spines.

304 *Weberbauerocereus cephalomacros-tibas.* This species grows on coastal hills of nearly pure white sand.

305 (top) *Euphorbia pseudostellata* (syn. *Monadenium stellatum*). Insurance broker and botanist John Jacob Lavranos took this grainy photo in dense bush between Bulo Burti and El Bur, in south-central Somalia. He labeled the photo *Monadenium stellatum,* though what's pictured doesn't seem to fit what little we know about this plant. Lavranos has since passed away, and we are unable to get more information.

305 (bottom) *Aloe parvula.* This charismatic dwarf aloe hails from the mountains of central Madagascar, where it grows in the fissures of rocks, hiding among grasses and sedges. When in flower, *A. parvula* bears a 12-inch (30 cm) stalk with coral-red blooms. As of this writing, the species is considered endangered.

306 *Parodia* sp. This genus of South American cactus includes fifty known species. The tallest of the group, *P. leninghausii,* maxes out at 3 feet (91 cm), while the vast majority of plants are 12 inches (30 cm) or less in height. *Parodia* cactus are known for their often yellow-and-white, hair-like spines and for their usually yellow flower display.

307 *Espostoa ruficeps.* This close relative of *E. lanata* grows a trumpet-shaped, albeit silent, nocturnal white flower.

308 *Armatocereus matucanensis.* Plants in the genus *Armatocereus* grow in segments, with each year's annual growth creating "pinch points" on the cylindrical stem. Although not coming through very well in this photo from 1998, *Armatocereus matucanensis* stands apart from other plants in the genus for its powder-blue stems.

309 *Harrisia tetracantha.* A shade-tolerant, shrubby cactus from South America, Greater Antilles, The Bahamas, and Florida, *H. tetracantha* is known for its spectacularly fragrant night-blooming flowers and for its fruit, a delicacy to lizards, mice, coatis, foxes, tapirs, birds, bats, and humans.

310 *Browningia pilleifera.* This spineless state is a sign of maturity in this species.

311 (bottom) *Cintia knizei.* This dwarf mountain cactus from Bolivia enjoys a solitary life in the puna ecoregion of the central Andes Mountains, where it exists cryptically, expertly camouflaged in its craggy mountain domain.

312–13 *Espostoa hylaea.* This species, known to exist in only a small area near the Rio Marañón in Peru, has the thinnest stems of any *Espostoa.*

316–17 *Neobuxbaumia* sp. This archaeological site in the Tehuacán Valley in central Mexico is surrounded by large populations of *Neobuxbaumia* columnar cactus.

318–19 *Copiapoa columna-alba* and *Eulychnia* sp. See notes for pages 140, 166–67, 170, and 178.

320 *Weberbauerocereus weberbaueri.* This plant stands alone, marking the farthest southern edge of its habitat.

Interviews

Woody Minnich

Wendell "Woody" Minnich grew up in the Mojave Desert, and has spent the past forty-five years exploring the far-flung cactus habitats of the world. He is well known in the cactus community for his presentations on these expeditions. An accomplished grower, he runs his nursery, Cactus Data Plants, from his home in New Mexico.

Xerophile: Do you feel like in some ways your purpose in life has been to explore the desert?

Woody Minnich: There's no question that my purpose is about nature. The statement I use, a derivative of what some Native American tribes use, is that I believe we are all a part of the whole. What we do to any one part of the whole, we do to ourselves. That's where I'm at. You know—you've been to my house. I won't kill a spider. It's all valuable. It's all precious.

X: You've always been around the desert, but how did you get started with cactus?

WM: When I was in college, I would drive home from school through Simi Valley, past this house with a cactus garden in the front yard. I finally got up the courage and knocked on the door. It was the house of Bill and Ellen Lowe. They gave me a few plants—in retrospect, I'm sure they could tell I was ripe for getting hooked—and that's how it started. They invited me to Baja for the first time, and it was there that I met some other very serious cactophiles, the ones who got me into taxonomy, morphology, and really loving succulent plants. I was the young guy—they were all thirty years older than I was—but I had already developed a sharp eye.

After a while, Werner Rauh noticed my passion. He was a brilliant field man, the real deal. He was in charge of the Botanischer Garten, the Heidelberg botanical garden, and after a number of expeditions together, he invited me to visit him in Germany. I finally saved up some money and went, and the day I showed up, I found out that he had died the night before. I was devastated, but you know what? I think it was a sort of passing of the torch. His colleague gave me a tour, and I was allowed to take any plant of my choosing, as those were Werner's wishes. I took a *Euphorbia francoisii*.

X: Do you still have it?

WM: No, actually, I didn't keep it. I lent it to a friend who I knew had a better touch with that specific plant. At that time, I had a real thing for mammillarias and had become quite serious about them. You have my field collection list, don't you?

X: No.

WM: You have to see it. It was me, Alfred Lau, and a bunch of Mamcrazies. I think I went down to Mexico about eighty times. I'd spend my two Christmas weeks in the field, probably two months out of the summer, and the whole spring break. I met a guy early on—he would order from me, because I had some real hard-to-find *Mammillaria* and he loved the Mams. He was a big music guy, big '60s-rock guy, and he was brilliant. We got to talking, and he told me he used to put on shows in Southern California. I told him I'd been in a band called the Humane Society, and he was like, "What? You were in that band? I've seen you guys!" We'd toured with all the big bands of the time: Starship, The Byrds, Buffalo Springfield, and many others. His mind was blown. Then he said, "I've been doing some fieldwork on the genus *Crotalus*"—sort of testing me to see if I knew that he was talking about rattlesnakes—"I've been working in the Transvolcanic Belt, and I've noticed the cactus around there but don't know much about them." So I asked him if he wanted to do some fieldwork with me, and he ended up doing fieldwork with me for the next twenty years.

X: So he became your partner?

WM: Yes. We were the perfect team; he was awesome. We'd just put things together, bam-bam-bam. I'd take him to all these places I'd been in Mexico. We'd be in, let's say, Tomellín, which is north of Oaxaca, overlooking a valley, and I'd say, "OK, this is where *Mammillaria crucigera* grows. Where are you gonna find it?" Just playing with him, you know, the teacher in me. And he'd say, "Right there on those cliffs to the right." He'd be dead-on every time. He had an intuitive sense; he was my ideal partner. I could express things and he would understand—about the field, about speciation.

X: We consider you a true example of a cactus explorer—an obsessive. What do you think makes you so well suited to this type of work?

WM: My dad was one of the top rocket scientists in the country, but he was also an outdoorsman. His father was part of the last American cavalry in Fort Yellowstone, and he was a hunter, a fisherman, and an explorer. My dad was really raised outdoors, and, starting when I was small, he'd take me to the especially desolate parts of the Mojave Desert. He gave me the explorer mentality, the hunter mentality. I am a hunter, really, just not with a gun.

My mom, though. She was an amazing artist, a true creative spirit, and when she was young she was an incredible ballet dancer. In the late 1930s, she became a part of Ted Shawn Ballet, and she was their number-one ballerina. She blew out her knee before a tour of Russia, and it crushed her.

My parents moved to California so my dad could work on the development of the Sidewinder missile, and my mom took up painting and became a well-known California painter. We lived in the desert, and she'd go out to paint landscapes and take me with her; she'd be on the side of a hill near Walker Pass, or out along the Sierras, painting, and I'd be trying to catch lizards, and she'd be calling to me, "Woody, get over here!"

X: You have German heritage, which seems to factor into your meticulousness and cataloging. Your background as a teacher connects to your quest for knowledge. Do you think your Native American heritage plays a part when it comes to your intuition in the field?

Woody in habitat.

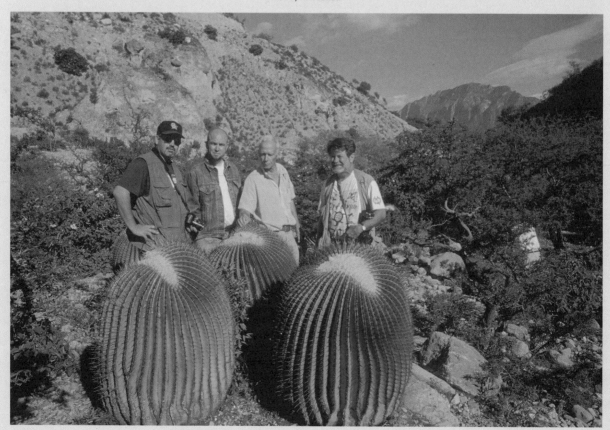

Woody (right) and friends with a family of *Echinocactus platyacanthus*.

WM: No question. There's a magic that has been passed on in Native American communities for a long time. And the more something is passed on—a philosophy, an approach to life—the more it becomes embedded in the genetic tissue of the people. There's no question in my mind that this is partly why I love the outdoors so much, why I appreciate and love all plants and animals so much. My Native American spirituality is who I am, really, even though I'm only 1/64 Sac and Fox.

Every summer I'd go to my grandparents' farm, in Oklahoma. I'd spend my time there connecting with the land, chasing butterflies and lizards. They were so abundant. They aren't anymore, and it breaks my heart! Some of these habitats are so fragile. When I was a kid, my dad said, "My father used to tell me that there were things he'd seen that I would never get to see, because they were gone. And, Woody, there are things I've seen that you will never get to see, because they, too, are now gone." That hit me right in the heart. Can you imagine telling your kids that there was once a creature in northern Africa and India that had a big long trunk and was called an elephant?

X: Can you talk about your favorite three genera?

WM: Boys, I'm an old-fashioned purist. *Astrophytum. Ariocarpus. Copiapoa.* Those three are symbolic of almost the entire cactus world. When you look at *Astrophytum myriostigma*—a sculptural beauty, all the little trichomes creating these delicate white spots—you're looking at something that is as fine a piece of art as any that can be created. But you look at *Ariocarpus*, and if you're a novice you say, "Why would anybody grow this? It looks like a dead agave." Then you realize how slow and special they are. And of course they flower in the fall, which is a real turn-on. Then you get to *Copiapoa*, which is a genus made up of ancient, ancient plants. Some of the clumps are hundreds, if not thousands of years old. They, too, are sculpturally fantastic. *Copiapoa* have beautiful, often gray bodies. They have incredibly strong and powerful black spines, and just the stance of them. . . . When you see *Copiapoa* in the Atacama Desert, in Chile—*Copiapoa columnari*, for example, many of which are at least five hundred years old—and they are leaning toward the sun coming up from the north, it's spiritual.

X: Can you tell us what a night in the Atacama feels like?

WM: Well, just imagine, we're camping right up against the ocean, and there's not a soul around. You're in the desert, but you're breathing the ocean air. Our camp is right in the middle of these fields of *Copiapoa*, some of which are almost a thousand years old. You're sitting out there, and the campfire is flickering on everyone's faces and on some of these ancient cactus. A little desert fox will run up and sit a few feet away, looking right at you, because the wildlife in the Atacama is not accustomed to humans. You're sitting there staring at the heavens above, so to speak. You can see all the constellations, the [aurora australis]. Then the fog starts rolling in, and it gets very, very moist and cold. The fog covers absolutely everything, and you go to sleep in the fog. You wake up in the morning, and you can barely see a few feet in front of you. And then the fog starts to clear, and slowly the mighty Atacama Desert appears in front of you.

Joël Lodé

Joël Lodé, an author and adventurer, has traversed many of the world's deserts on bicycle in search of cactus. He lives in Spain.

Joël Lodé: Hello, sorry, I just got back from a conference.

Xerophile: What kind of conference?

JL: I was telling the story of how I rode around the world on my bicycle in 1975.

X: We've heard a little bit about that. It sounds absolutely insane. Why did you do it?

JL: I grew up in the same town Jules Verne was from, and when you grow up in the same small town as a famous person, you want to be just like him.

X: Were you looking for cactus on this trip?

JL: No, but they certainly found me. I was in the Mojave Desert and I ran over a cholla—it popped my tires. I thought, What a horribly ugly plant!

But it got my attention. I wanted to know why these cactus existed—why were they here? I very quickly became obsessed and developed a strange desire to see them all.

X: Would you travel alone on these adventures?

JL: In the beginning I was always alone, but later on I got married—adventurers shouldn't get married, but sometimes it happens—and then she would come with me. She was valiant, but eventually she vowed never to join me again. We're not together anymore. I mean, the trips were very hard, I'm not going to lie.

X: Were there times you almost died looking for cactus?

JL: Yes, many times.

X: Can you tell us about it?

JL: The majority of the times I almost died were in California, in the Mojave. It's truly savage, that desert. The first time was in 1984. I'd arrived in the middle of summer, and very quickly my body started to unravel. I was hit with severe heatstroke—which is when your body starts to shut down, organ by organ—but I didn't really know it. I took some salt pills to retain water, but they had no effect. So I left my bike on the side of the road with my diary open next to it, and I wrote across two pages, in very crude pencil, the word "HELP." Then I dragged myself to the shade of a large boulder, lay down, and went almost instantly to sleep.

A man driving by saw my sign, and he went to investigate. He found me almost unconscious under the rock, and pulled me to his car. I think he was an ex-military man. He drove to the nearest gas station—being in the Mojave, this was not at all close—bought all the ice he could, and laid the bags on top of me in the back seat, to bring down my body temperature. He took me back to Lake Havasu, which is where he lived, and I ended up staying with him for about a week. He was a pilot, so we went around in his plane a few times.

X: Holy shit, that's insane.

JL: I almost died from the sun three times on that trip. Another was in New Mexico, which is actually quite a curious story about hospitality.

X: What happened?

JL: Well, I was biking through White Sands National Park, and some rangers were kind enough to give me a special pass to sleep there overnight. But it was the middle of August, so even at night it was very, very hot.

I got up early the next morning, and headed toward Texas. On that particular route, there's what feels like an endless incline. I was about halfway up, when I felt that I could no longer ride, so I got off my bike and began to walk, carrying the bike like a mule. When I reached the top, I suddenly began to feel quite ill. I saw a house in the distance, and knew that I had to ask for help. I approached the house, which was all alone—very strange, nothing else around—and I knocked on the door. A beautiful woman answered, and I told her that I was unwell and needed a place to rest, and asked if I might be able to camp on the property. She was very curious and agreed. I went to the back of the property and began to set up my tent, at which point I passed out and fell into a patch of chollas. I came to a few minutes later, and stumbled to the front door of the house, and that's all I remember.

I awoke sometime later, being fed salads and cold fruit drinks. I was still very hazy, and for the few days I was there I saw only beautiful women. I thought I was hallucinating; it was so surreal, this very dark house in the middle of the desert with only beautiful women. And then, ah-ha! I realized what kind of house I was in! What a shame! [Laughs]

In reality, though, the worst times are when you're alone. When I was in Baja, climbing the Cuesta del Infiernillo to the peak of Las Tres Virgenes, the three virgins, I was caught with heatstroke and no help. I hid from the heat under some rocks, where I stayed for a few nights, hoping it would pass. I lost fifteen kilos [33 pounds] on that trip.

X: What's the farthest you would go for a photo?

JL: I went to Yemen at the height of the civil war to photograph a plant. I was the only tourist—there was not a single other person on the flight or in the airport. I'd been able to get in through the Yemeni Embassy, because I had written books on the plants of Socotra.

I stayed for about two weeks, and when I wanted to return to the airport, no one would take me. I finally found a crazy taxi driver who agreed to drive me, and as we headed back into the city, I knew I was in a bad place—there were snipers all along the road. After I got to the airport it was barricaded, and I was trapped inside. I could hear artillery fire everywhere; all the lights had gone off, and I was alone—like, literally, the only foreigner in the airport—and there

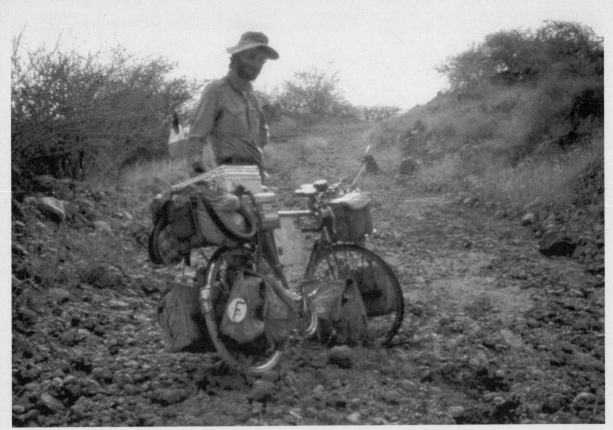

Jöel on a rocky road in Kenya while traversing the globe on bicycle.

Jöel serenades a large cluster of *Euphorbia canariensis* on the Canary Islands with the traditional Breton bagpipes.

was no way to leave. I eventually encountered an Air Egypt employee who helped me, but I had to stay until the airport was open to traffic again, at which point I flew out of there.

X: Oof.

JL: Yeah, that's what happens sometimes trying to find these plants.

X: There seem to have been a lot of people who helped you on these journeys. Have there been others who opposed you or don't understand your mission?

JL: Yes, in my family my mother was the only person who understood me. My father thought that I was doing nothing with my life, but my mother would help me in secret.

When you have a vision, you either open it up to the judgment of other people—and internalize their belief that you're crazy—or you tell yourself that *they* are crazy, and follow it through. As I see it, it's quite simple: since you're the only one who has this vision, you're the only one who can realize it. Of course other people can't see it—it's your vision! Dreams are like a current in water—if you follow them, you won't need to exert yourself too much.

Most people won't support an idea if you suggest it. But, conversely, if it's clear that you're going to embark on your mission regardless, people will help. You can tell someone that you're going to the moon, and they'll tell you when the next ferry leaves.

I used to work in a bank. When I told people there that I was going around the world on my bike, they would laugh. They thought I was crazy. When I started, very few people were paying attention, but by the end of it, when I was in the *LA Times*, the people who'd said, "You shouldn't" were saying, "Oh, my God. He's doing it." What's hilarious is that when I was signing my first book at a library in town, a lot of the people who'd told me not to go were waiting in line to have their books signed. And when they approached me they would put a hand on my shoulder and say, "I always knew you could do it. I believed in you the whole time." I wouldn't say anything. I'd just smile.

X: What do you think unifies people who search for cactus?

JL: In some ways, you could say that someone who's obsessed with cactus is not so different from someone who's obsessed with begonias. But I do think there's something special about the cactus-obsessed because of where these things come from—the harshest desert—and because they can be so hard to find, and to identify. I think the fascination comes from something inexplicable. I'm not sure, actually. But what I do know is that we're all crazy. That's what I do know. That, and the fact that it's deeply weird to be obsessed with something that has so many damn spines!

X: I remember seeing a picture of you on the back of a mule looking for plants.

JL: Oh, yes, that was in Brazil. I was looking for the elusive *Uebelmannia*. It took us about a day to get up the side of this mountain, and when we arrived at the top there it was, just like people had said it would be. Fantastic. I was so happy, because I'd finally found what I was looking for in that era. That was in 1986.

I'd been there for a few months, looking for that plant. Sometimes I was on a bike, sometimes I was on foot, and sometimes on a mule. I used a lot of riverboats, too. I'll take any transportation.

X: What's your favorite mode of transportation to see cactus these days?

JL: A car with four-wheel drive.
[Laughs]

Giovanna Anceschi & Alberto Magli

Giovanna Anceschi and Alberto Magli run cactusinhabitat.org, an ever-growing resource for the documentation and classification of cactus populations throughout South America. They live in Italy.

Xerophile: What inspired you two to start exploring the world of cactus?

Giovanna Anceschi: We've always been fascinated by the look of cactus, and by their modes of survival. In 2004, we were going through a difficult time, and we were both sitting at our dining room table. I was looking through a magazine, and saw a picture of a very stark landscape—lagoons in Chile, forty-two hundred meters [13,779 feet] above sea level. I said, "We should go there to see it with our own eyes." So in 2005 we started to travel to research plants. Then it was like a drug.

Alberto Magli: So I guess we've been doing it for twelve years, and of that time we've spent five full years with plants in their habitats. When we started, we didn't know what we were embarking on, or, rather, what it would become: an incredibly precise program of classification. At the beginning, we weren't thinking about taxonomy—we only wanted to learn how these plants lived in their natural environments.

GA: We weren't satisfied with the information out there. In 2005, it was mostly in books. There wasn't that much online. But there weren't many books, and those that did exist had very few images, usually of a little plant in a pot. Nothing to do with habitat. So when we took our first trip, it was extremely emotional.

AM: It was a revelation and a revolution. Like Giovanna said, lexicons try to give you an idea of a species through one or two photos, which is impossible.

GA: We used those books as a base, but when we were out in the field, looking for the plants, some things seemed a little peculiar. Sometimes they didn't exactly correspond with what we'd read.

AM: We eventually realized that many of the species you see in books don't exist. In other words, many plants that are categorized as distinct species are in fact all the same plant.

X: So it's just environmental differences in the habitats that make these plants appear to be different species?

GA: Yes. A natural species, or a dominant species in a Darwinian sense, is made up of many populations, which will change form throughout a geographical range. But returning to your original question: we started, very earnestly, trying to find these plants that were described in books. We looked and looked. On the first trip we had a few questions, and on the second trip even more, and so on. There were many things that didn't add up.

AM: We discovered that a lot—not all, but a lot—of the work that was done to classify these plants was done by people who would come to the habitat for a short time. They'd take a seed, or a plant, and off they'd go. When they returned home, they'd take that little plant or that seed and put it in a little pot. And at that point they'd study how it grew, and how it lived. But now this little plant has nothing to do with its habitat—it doesn't have the same pollinators and seed dispensers, the same climate, or any of the plants and animals that live around it in the wild.

X: How do you guys find cactus?

GA: There are many different methods, and we use them all. These days, there are large databases that list field collection numbers, with varying degrees of detail about location. They're huge public databases, and many people contribute to them. We do, too, but we're pretty vague about the details, because they're often used for poaching.

AM: We're unusual in this sense—since we're not collectors, our A&M numbers [numbers used to catalog the plants identified in habitat] refer only to field observations.

X: Really? You don't have a collection at your house?

AM: No. We have very, very few plants, all of which were gifts.

X: That's quite an anomaly. We usually find that collecting is what leads to an interest in plants.

GA: I just don't have the desire to possess. All the plants I've encountered in the field are my plants.

AM: For me, there's nothing further from nature than a greenhouse. People put plants next to each other that would never, ever be seen together in nature. That's fine for a fan, but not for a researcher, and I would venture to say that it's part of the reason people continue to have confused ideas about the taxonomy of these plants.

GA: A desire to own a lot of plants will inevitably influence the way that you classify your plants. Let's say you're a collector, and you have a hundred plants with different qualities, and you have the power to name them. Are you going to say that most of them are the same, and name only fifty new plants? Or are you going to give each one a different name? Naturally, as a collector, it's in your own self-interest, whether conscious or not, to name based on differences rather than on similarities.

AM: Species in a habitat want to survive, and to survive they sometimes need to join with other species. So often the boundaries between species are not so rigid, not so solid and clear. Naming a species is often nothing more than a concept.

GA: Yes, like good humans we need to classify to make sense of things.

AM: But we think a natural species is something much more varied than the books say.

GA: Or, put another way, much more simple.

X: Do you run into a lot of opposition to your scientific theories?

GA: Yes, of course. Older botanists generally prefer to maintain the status quo, but there is a new generation of researchers, and some of them are adopting our methods. In Peru, for example, there are some youngsters at the National Agrarian University, in Lima, who are using our theories.

Alberto and Giovanna with *Parodia claviceps* in Argentina.

X: Do you have idols in the science world?

AM: Willi Hennig, Ernst Mayr, and Elliott Sober. But, above all, we are Darwinists. You can't speak about biology—you can't really speak about anything—without being in accordance with Charles Darwin.

X: Do you consider yourself activists?

AM: In general, we're scientists and explorers. We're always testing theories as we explore, and applying a theory isn't always easy—there's a lot of baggage that comes with the history of these plants. Trust me, I love *Cleistocactus* and *Haageocereus*, but they're only names. If we want to be truly faithful to scientific evidence, we have to be ready to call them *Echinopsis*. For years, molecular analysis has been proving that floral characters don't have anything to do with identifying or separating genus or species. Yet in every modern cactus book you see species, and even some genera, divided by their flowering characteristics.

X: This seems like a lot of work.

GA: It's an incredible amount of work. For example, in 2011 we went on an eleven-month expedition. I took fourteen thousand photos, and Alberto has written up field notes on many of them, as well as details about the morphology of all the taxa we saw.

X: How do you support this passion? Do you have other jobs?

GA: No, we devote our lives to the research, and we live very, very humbly. We share one basic cell phone, we have no car, no TV. It's a wonderful life!

X: You're married and you're obviously very invested in these theories. Do you have to exert some self-control to not talk about cactus all the time?

GA: Um, sometimes *[laughs]*. Our life is a nonstop debate—Niels Bohr would say that we're complementary.

X: Speaking of thinking about plants all the time: Some people believe that plants have consciousness—do you agree?

GA: Yes.

AM: I am certain.

Jon Rebman

Jon Rebman, the curator of botany at the San Diego Natural History Museum, has been exploring and studying the flora of Baja California, Mexico, for the past twenty-five years.

Xerophile: What sparked your interest in cactus in general, and in Baja in particular?

Jon Rebman: I grew up in a very rural part of Illinois, but I did have some cactus as a kid. The first one that I remember is *Backebergia militaris*; it had an incredible cephalium.

X: That was your first cactus!?

JR: Yes. You'd never seen anything like it in Illinois.

X: You started with some high-class stuff. We don't even have that in our collection! Most people don't.

JR: Well, somebody brought it back from Texas, or somewhere like that, and gave it to me, and I kept it growing on a windowsill. That was my introduction to cactus, but when people ask how I really got into cactus as a career the answer is "academic coercion."

X: Who coerced you?

JR: My PhD advisor. I did my bachelor's degree in Illinois, my master's in Missouri, and a PhD at Arizona State. At Arizona, I wanted to stay very classical with alpha taxonomy; I wanted to work on aquatic plants, actually, but I ended up coming in under Dr. Donald Pinkava, a very well-known cactus taxonomist, a specialist in Opuntioideae, and he got me interested in working on cactus. He had a cholla project in Baja California that he wanted me to consider, so I went on a trip there early on in my doctoral days.

X: What year was this?

JR: It would have been '91 or so. I fell in love with Baja California on that first trip. Pinkava wanted me to work on this one hybrid complex of chollas, and as I got into it, I said, "The hell with that—I'm going to do all the chollas of Baja California!" Of course, all that fieldwork was quite a big job, which is why it took me seven years to get my PhD after my master's.

X: What was your PhD in?

JR: It was in chollas—in *Cylindropuntia* of Baja. People ask me, Why Baja? And I have to say that, early on, when I'd just started taking trips to Baja, I would stop in Cataviña to camp, and I would look around that landscape—you have giant Boojum trees and elephant trees and cardons, and everything is to the max as far as big, charismatic plants. And, coming from the flat country of Illinois, it was as if a UFO had picked me up and dropped me off—I could have been on another planet, it's so different from where I grew up. I was fascinated with it.

During my cholla work, I'd started doing general collections, and I became increasingly captivated by the flora of the area. Just before I finished my PhD, I got a Fulbright to live in Ensenada, in Baja. I moved down there for ten months, and did a ton of fieldwork with Mexican scientists and Mexican students. At that point I was all in, hook, line, and sinker.

X: What was Baja like back then?

JR: Early on, I was generally far from any human influence other than that of cattle and ranchers and the like. I was always visiting remote populations, collecting and documenting like a madman. One of the taxonomy problems with cactus is the lack of good collections to study, so it took me many years to get a handle on the species in the field—to have enough of a collection to document distribution and variation, all that kind of stuff.

X: Was it difficult to access a lot of the areas where you were collecting?

JR: An amazing thing about the peninsula is that there still aren't a huge number of roads; big tracts of it are hard to get to, really remote. Despite four-wheel drives and new highways, some areas are more difficult to access now than they were in the 1800s. Last year, I lived in La Paz for ten months—I moved the whole family down there—working to rediscover lost plant species, trying to explore areas where specimens were collected in the 1880s and that no one has been back to since.

Often the only way to get to these remote areas is on mule or on horseback. I'm adamant about the fact that we should use local guides whenever possible. I take a lot of trips that require animals, and they can handle the animals. They know where the trails are, where the water is. They just know their territory extremely well. So using vaqueros is definitely the way to go, but it's becoming harder and harder to do. A lot of people have moved to the cities, and the trails aren't kept up. Many ranches have been abandoned, and the ranchers that are still there are older, and they no longer have the animals or are unable to lead trips.

When we do have locals on the team, I try to get as much ethno-botanical information from them as I can. When I'm pressing a plant, I always ask, "What do you call this?" and "Do you use it for anything?" I record the answer and put it on the label, so that it's connected to the scientific specimen. This information will eventually be lost if we don't record it.

X: How many days do you spend on a mule or a horse to get to some of these locations?

JR: A week, at least. A good example is the Sierra de la Libertad, which is about halfway down the peninsula. We found some people who were able to get enough animals, and who knew the region. We took many multi-day expeditions there. A couple of years ago, I named and described seven new cactus—one of them is from there, and I called it *Cylindropuntia libertadensis*. I found it in only one canyon. We hiked in the canyon for a day and a half, and it was all over, it dominated throughout that area.

X: Do you believe that there are still a lot of undiscovered succulent species in Baja?

JR: Oh, yeah, definitely. Prickly pears, for instance. I've been working on the prickly pears of the region for a long time. There are certainly new taxa there, probably at least five. But I'm having trouble delineating the differences among some of the species,

Jon on a mule, one of the main sources of transportation on many expeditions.

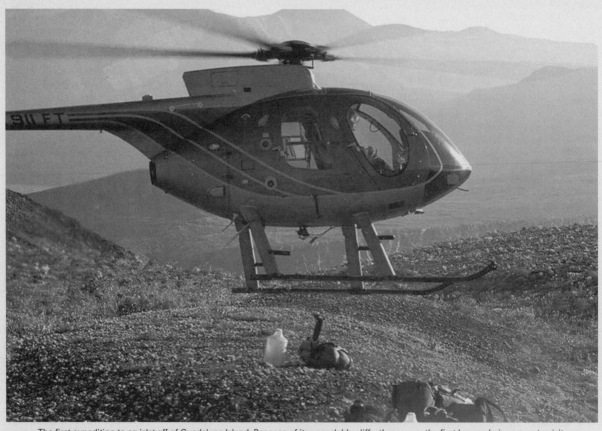

The first expedition to an islet off of Guadalupe Island. Because of its unscalable cliffs, these were the first human beings ever to visit.

since they're so plastic and so variable. There are definitely new opuntioids on the peninsula. And *Mammillaria* species—I'm sure that we'll find new mammillarias as well. There are areas that we just haven't been able to access, and areas where we haven't collected or documented the plants' distribution very well. If somebody dove into the *Mammillaria* taxonomy of the peninsula, which I think is crap at the moment, to be honest, new taxa would emerge for sure.

X: What's the relationship between the community of scientists who are focused on cactus and the community of, I guess you would call them enthusiasts? People who are also out there exploring, collecting, discovering, and even naming plants.

JR: That's an excellent question *[laughs]*. You know, as academics, we've bitched and complained a lot about the enthusiasts, because they've named *bazillions* of things, not realizing that whether something has three spines or yellow spines has no real relevance, evolutionarily. For a group like cactus, where there are just two or three thousand species, there are around twelve thousand species binomials!

X: Wow.

JR: Some enthusiasts have gotten so heavily involved that they've named a lot. And don't get me wrong—enthusiasts have their place in discovery. They find some amazing things, and they're extremely knowledgeable. They've played a very important role in cactus discovery, but it's gone too far in some popular groups. We just don't have that many academics scientifically studying cactus.

Europeans, too, have historically been very involved in cactus, and often their plants are grown only under glass, in greenhouses. They have one collection, so they don't even know the plant's natural variations. You've got to spend time in the field with these cactus to really understand the variation that occurs within them. We've ended up with a lot of things named based on specimens grown in Europe. We just need more field studies of a lot of these groups to better understand them.

X: How big is the community of academics who focus on cactus?

JR: It's a tiny field. We're way behind in molecular work for cactus, and some of the early molecular work was not that good. We need more people involved academically, people who have studied these plants in detail. They're just not easy to study. Look at opuntioids, my chollas—I mean, they're so freaking promiscuous! They hybridize left and right *[laughs]*. Try to do sequencing on that! You're gonna get a disaster! We've got a long way to go before we have the taxonomy worked out for a lot of these cactus groups.

X: What's the process of trying to determine taxonomy? Are you doing work on the molecular level?

JR: I'm really an alpha taxonomist, so I'm someone who uses mostly morphology to understand and describe a species. I don't necessarily use DNA sequencing to say, "This is a different species," because we just don't have enough of that data available yet. People who, like me, do general morphology and understand the variations in the plants, from spending years and years in the field, they use more advanced techniques, too. For chollas and for prickly pears we use cytogenetics—chromosome numbers—a lot. That's been quite informative in those genera.

X: What do you see happening with the taxonomy of Baja?

JR: For Baja, I think we'll see more splitting than lumping. Especially in groups that have never been looked at closely—the opuntioids are a good example. They're dominant in our landscape, but enthusiasts have never really gotten into them, and academics have never really gotten into them either.

X: We've always thought that was the weirdest thing. Almost none of the collectors we know are into opuntias. We're always looking for interesting opuntias, and basically no one grows them. It's so strange. We think they're just amazing and beautiful.

JR: I know—they're so impressive. And they're our widest spread group of cactus; they grow from Canada to Patagonia. I don't know why they

aren't more popular. Maybe partly because of glochids? People don't like glochids.

X: Maybe they just aren't phallic enough?

JR: I think you're right *[laughs]*.

X: We'd love to hear a little about your relationship to the previous generation of explorers in Baja. Do you feel like you're following in some of their footsteps?

JR: Well, literally, yes, because I've been trying to trace a lot of Townshend Brandegee's old routes. He and his wife, Katherine, were some of the first cactus explorers in Baja. I'm following his routes to find species that were in his collection but have never again been seen in the field in Baja.

George Lindsay and Reid Moran were big influences for me as well; I know you're including quite a few photos from them in your book.

X: Did you know them?

JR: In graduate school, most of the collections I was using to study the chollas for my doctorate were made by George and Reid sometime between 1940 and the end of the '80s. I remember meeting them for the first time: it was at a Huntington Gardens succulent symposium, and I was still a graduate student. It was maybe 1990. They're both tall, really large men. They gave a talk about their early expeditions, and it was completely fascinating. They would be out traveling in the backcountry for months at a time. They were just so intimidating, too, like they could beat the shit out of me *[laughs]*. I'm almost 6'3", and they were much taller than I was. In Baja, they called George "El Gringon."

George was the director at the San Diego Natural History Museum for a time, and he hired Reid to be the curator of botany, which is now my job. George was so excited when I started working here after I graduated. He said, "I'm retiring, and I want you to come get all my cactus files, my photos, everything." And so I did. I still haven't gone through everything, but I have all of his cactus-oriented notes.

One day, out of the blue, I got a package in the mail from George. It had a letter in it that said, "This is not for the museum, this is for you. Anyone studying Baja California should have this." I opened it up. It was an original map based on Fernando Consag's journey of Baja—almost three hundred years old.

After that, I lived for a while in a remote ranch, up near Alpine, California, and we got burned out by the Cedar Fire in 2003. Fortunately, I was able to run into the house and grab that map and some of my important specimens—like the type for the very rare *Grusonia robertsii*—before they were destroyed.

X: So when your house was on fire, that map was one of the first things you grabbed?

JR: It was.

X: That's amazing.

JR: You know, George and Reid were such interesting people, and I feel so privileged to be the torchbearer of their work. They both deeply respected Baja, and those of us who work at the museum now are still building on that.

One thing I've tried to revitalize at the museum is the tradition of multi-disciplinary and bi-national expeditions. If you study only botany, or only cactus, your view can become very limited and rather narrow. Every few years, we organize a natural history expedition that brings scientists from a bunch of different disciplines into the field together, collecting together, working together. With this kind of collaboration, you become much better as a naturalist, because you start to see all sorts of new connections.

X: And this practice used to be more common?

JR: Yes, and then it died out. In the past, it was always a bunch of Americans, or other gringos, going in and raping and pillaging the land in Mexico. But that's changed. There are great Mexican scientists and graduate students, so now we all work together—that's my thing. It puts us all on the same page. We do a lot of collaborations, joint publications,

stuff like that. I think a huge part of the past twenty years has been pulling in Mexican collaborators and learning from them.

X: Are there any particularly iconic plants in Baja? The biggest or the strangest, something that you revisit?

JR: There is a cardon in the Catalina boulder fields that I visit each time I'm in the area. It's between sixty and seventy feet tall, just massive [p. 130]. I've never seen one quite like it. It takes your breath away to stand under this cactus.

However, what I'm about to say is really sad: it died. It must have been at least five or six hundred years old. And a few years ago it just up and died.

X: No way. . . . I guess everything does die eventually.

JR: At first I thought, Oh, my God, did someone do something to it? But it seemed like a natural death.

X: How did you find it? Did you see a slow decay?

JR: I hadn't been there for a year or two. I went back, and it was starting to rot. It's a fascinating ecology, when something that large starts to die. All the water and yeast and bacteria build up, and it becomes a haven for a whole other succession of life, including insects. It was just dripping with water and resources.

It's sad to see, though, at the same time.

X: It's like a decomposing whale.

JR: Exactly. And now it's no more. There's hardly any of it left standing. It took about a year or so, and then it was gone.

Martin Lowry

Martin Lowry is a retired British biochemist and cancer researcher who has taken dozens of trips to South America, focusing mainly on the cactus of Bolivia.

Xerophile: Where in England are you?

Martin Lowry: In the northwest, just southeast of Manchester.

X: Are you a Manchester fan?

ML: Not particularly. I don't follow football [soccer]. I follow cactus.

X: Are you growing cactus in England?

ML: Yes. I have a collection of around three thousand plants.

X: Had you studied plants before you started collecting?

ML: Oh, no. It was quite separate from my work and my career—it was really a distraction from work. Something to keep me sane.

X: What's your career outside of plants?

ML: Now I'm retired, but I used to work in medicine. I was a biochemist working on cancer research using MRIs.

X: What inspired you to go cactus exploring?

ML: Well, I'd been collecting lobivias for about twelve years, and I decided to go see them in habitat. See where they lived, see their country. I wanted to connect what I had on the bench with what was growing in the wild. After going to Bolivia twice, it became a sort of addiction. You can't not go back. Now I have to return and see more plants each year.

X: When was your first trip?

ML: My first real expedition was to Bolivia, in 1996.

X: How did you end up finding the plants that you were looking for?

ML: To be honest, it's not very difficult in Bolivia. If you travel south from La Paz, through Oruro and Cochabamba, you don't have to go more than a hundred meters [328 feet] from the main road to see plants; it's really about where you stop. You look in the literature and see that you want to go to this village or that town—this particular plant comes from there. But in 1996, even the main road from Cochabamba to Sucre was a dirt road. There were only a few hundred kilometers of tarmac in the whole country. Now all those roads are tarmac. Roads that were only eight feet [2.4 m] wide are now two-lane highways.

It was just so different from driving around, say, Arizona. The main difference was the level of hygiene and sanitation, and the poor quality of the food in places, and the difficulty in getting food, good food, in the areas where we wanted to stay. No haute cuisine at all, it was a big shock.

X: Not like Arizona. . . .

ML: *[Laughs]* I probably lost more than fifteen pounds [6.8 kg] on my first trip. Stomach bug, of course. Since then I've been to Bolivia ten times, so I know the ropes a lot better. We've found good restaurants, good places to stay.

X: Do you ever visit the same habitat twice?

ML: Multiple times, yes. In some cases, to see how the plants coped with changes to their environment. The city of Cochabamba, for example, has expanded, I would say, threefold in twenty years. So habitats I saw on the outskirts of that city in 1996 have totally disappeared under big housing developments, or have become surrounded, or just don't exist anymore. With other plants, it's just nice to check back in with them.

X: An old friend.

ML: Yeah, that's right. I do that quite frequently with a *Cleistocactus winteri*. In 1996 we thought that the habitat for this *Cleistocactus winteri*, on a cliff at the edge of a dirt road, would disappear when they widened the road and put tarmac down. But it's still there, along with the very same other plants, twenty years later, hanging off the cliff, so it's good to go back and see it.

X: Why is it that certain people are connected to certain plants? Why do you have an affinity for a particular species?

ML: I started trying to grow *Eriosyce* in the mid-80s, and I struggled. Then I acquired some lobivias, and they grew great for me and flowered wonderfully, so I stuck with them.

X: Did you ever meet anyone who acted as a guide?

ML: No, but in Bolivia I was put in touch with students at the various herbaria and universities, and I actually took *them* around and told them about the cactus of their country.

X: Do you think that people often don't see the plants that are in front of them, or take them for granted?

ML: I think it's a bit of both. Bolivia is becoming far more affluent, and the people in the big cities are starting to become interested in the plants for the plants' sake. The people in the countryside just take them for granted, though. They're too busy trying to keep themselves alive. It's subsistence living in a lot of places where these plants grow—it's hand to mouth every day. So they don't see the plants aesthetically. They see them perhaps as a nuisance. The plants take up space, so they chop them down. Or maybe they see one or two as having good fruit for eating, things like that.

X: It's like how in the 1960s people in flea markets in Mexico would make glue out of *Ariocarpus*.

ML: *[Laughs]* Yeah, I think the situation in other places—places like Brazil and Chile and Argentina—is very different. They're far more affluent countries, and people there have more leisure time. They look at the plants a bit more carefully.

X: Do you ever get a response from local people like, "What the hell are you looking for?"

ML: Oh, all the time. Then, eventually, they want to go dig up the plants and present them to you. At that point,

Martin with *Echinopsis rossii* in Bolivia, 2012.

we get in our vehicle and drive away, because we don't want that. We're there to photograph, not to take the plants.

X: So they literally dig up the plants and try to offer them to you for sale?

ML: That's what happened with *Geohintonia*, in Rayones, in Mexico, isn't it? And with the *Aztekium hintonii*. They became valuable to the locals, who ripped up the hillside gathering them.

X: I know there are some people— poachers—who go into habitats and leave with the plants. Do you have to totally suspend the collector side of yourself to avoid the desire to do that?

ML: Definitely. You just have to say to yourself, "No, all I need is the photograph."

X: Do you have the same feeling toward your photographs that you have toward the plants in your collection? Something like, I have *this*

plant photographed somewhere in my collection.

ML: You know, I've got a database of seventeen thousand photographs. It's an interesting hobby in that way— you see a plant in the greenhouse, and it connects you immediately to the hillside where it grows.

X: Were you interested in photography before you started doing this?

ML: Just like any person with an amateur camera, you know, nothing special. I'm not a professional. It's just something to record where you've been.

X: It's interesting that you say that, because your photographs are very much in line with what we were looking for for this book. Some people's cactus photographs are super stylized, almost more about the photograph than about the plant or the situation.

ML: No, the photograph is all about the plant and its situation, its habitat.

I like the photograph to tell you something about the plant.

X: Your approach does feel very natural, almost like a snapshot. It's not a snapshot, of course, but it doesn't seem immediately composed—it just feels like documentation.

ML: Which it is, a lot of the time. Obviously you try to compose it a little bit, you don't want distracting backgrounds, things like that. You want to get rid of the litter, or at least try to make sure that it doesn't enter the photo. There is a lot of litter in some of these places in South America. Plastic bags blow hundreds of miles across the altiplano.

X: So you've picked up a lot of trash.

ML: More avoided it than picked it up.

X: Have you ever had the feeling— you know, sometimes when it's an early summer morning, and you've had to water your greenhouse every other day—of just, like, why am I doing this?

ML: No.

X: Is there a plant that you've never been able to find?

ML: Oh, yes, the one everybody's looking for in Bolivia—*Rebutia perplexa*. The little green one. Nobody has found it since it was discovered, and many people have given up on it at this point. I've looked many times in the area where one person told me it would be; I've looked in the places where people think it *really* should be. We've just never been able to find it. We devote a day to it every time we are in the region, go down a different road and have a look.

X: Where do you think your connection to cactus comes from? Some people identify with their resilience and against-all-odds quality. Other people identify with them aesthetically, their form. What do you think it is for you?

ML: I guess it was really just finding something that I could grow. And, yes, it is their shape and their unusual form and the unusual places where they grow—it's certainly broadened my view of the world to travel and see the plants. You know, I was given my first cactus as a present on my seventh birthday, so I was branded as a kid, you might say. The plant was fantastic to me. It grew and grew, and it did what it was supposed to do, and I thoroughly enjoyed it.

X: Do you still have that cactus?

ML: I do. *Cleistocactus hyalacanthus.* It's four feet [1.2 m] tall now, with five stems and two to three hundred flowers each year. It's a lovely plant.

X: Who gave it to you?

ML: One of my aunts.

X: Was she a cactus collector?

ML: No, she just worked in a local plant nursery and thought it would be a nice birthday present for her nephew.

X: So you've moved everywhere with that plant?

ML: It's been looked after by family, when I was in university, and by friends, when I was in other countries. But it's always stayed with me.

X: Did anyone ever almost kill it?

ML: Oh, yes, several times. They got told off. It's looking fine at the moment. Actually, it's in flower today.

John Jacob Lavranos

John Jacob Lavranos was a Greek botanist whose pioneering work on the succulents of Africa and Arabia resulted in the descriptions of close to one hundred and fifty new species. He lived in Portugal at the time of this interview in 2017.

Xerophile: Hello, John. It's Carlos and Max.

John Jacob Lavranos: Yes, I knew it would be you.

X: It's an honor to be speaking with you.

JJL: Oh, no honor at all. Perhaps a pleasure.

X: It's a pleasure, then. You're in your nineties now, is that correct?

JJL: Yes, I'm ninety-one years old, incredibly.

X: And how did you get involved with succulents?

JJL: Well, they're peculiar, aren't they? They capture one's imagination. It wasn't until after the Second World War that my interest in plants really took hold. I collected plants in the mountains in Greece when they finally became accessible, in 1949. Before that, the mountains were out of bounds because of the Communist insurrection.

In my travels, I selected succulents because they keep better. If you find a nice daisy, or a nice shrub, what do you take with you if you're in the middle of nowhere? But a little *Euphorbia* stuck in your bag lasts for a long time, and that's why I brought back more succulents than I perhaps would have liked.

X: Did you have any mentors to guide you?

JJL: When I got to South Africa, in 1952, at the age of twenty-six, I saw all these peculiar things! Plants I had never heard of—these weird conophytums, euphorbias, and so many others—and I became very, very interested. I was living with my first wife in Johannesburg, and I took a trip to the Botanical Research Institute in Pretoria. The director there, Dr. Dyer, gave me the push I needed. I owe it to him, really, for getting me on the road and helping me become truly serious about plants. Later,

with Douglas Goode, I named a new species of cycad, *Encephalartos dyerianus*, in his honor.

X: Your explorations and your work have had so much to do with cactus and succulents. What is it about these plants and their environments that attract you?

JJL: I like deserts. I don't know why. Mireille, my wife, who died three years ago, would say, "What on Earth does a man from the Mediterranean like in these ghastly, desolate places?" Well, they have something to them—a particular energy. It repels some people, but it attracts me to no end.

X: What do you think it is?

JJL: I have no idea. I would need a psychologist to dig it out of the primitive part of my mind.

X: We can arrange that. . . .

JJL: *[Laughs and sighs].*

X: Are there any plants or environments that stand out to you as having a particularly strong energy?

JJL: Well, as a youngster, I wanted to go to Arabia because I liked the word "Hadhramaut," which I'd read in an atlas. I'd heard there was a South African architect, Clyde C. Meintjes, who was working in Aden and was interested in plants, so I wrote to him. And it was through him that I was able to get a visa to enter the Aden protectorate, which at the time was almost impossible to do—they were afraid of incitement, you know, the same old story. When I arrived, I made a point to meet all the officials. I used charm and conviction with them, and, after that, we went everywhere with no problem. Once you're in, you're in! Somalia was the same, a place where you supposedly couldn't go, but which I felt I had to visit, so I did.

X: How did that happen?

JJL: It started on a trip to Socotra in 1967. I collected everything: snails, insects, plants, hibiscus and other seeds, you name it. When I got home to South Africa, I opened a paper bag, and there were some dead insects inside. They were just insects, but, at that time, I said to myself, "Insects from Socotra? You can't just throw these away!" The location was so remote and so little explored at the time. So I went to the National Museum in Pretoria, and they were able to put me in touch with Dr. Charles Koch, an entomologist and, at the time, the director of the Namib Desert Research Station, who had been to Somalia in the mid-50s. We met, and I started talking about Somalia. I said it was such a pity that one couldn't travel there, and he said, "Who told you that?" Aha! So he put me in touch with the chief of police in Somalia, and off I went—in the midst of apartheid, no less. And so began my time in Somalia, thanks to four or five little dead insects. That first trip, in 1968, began in Mogadishu and ended in Djibouti, which was a French protectorate at the time, and that's where I met Mireille, my third wife, who was working there.

X: Wow. What was it like to explore in Somalia then?

JJL: It was absolutely fascinating. The first few times I went, it was perfectly all right, no real problems. Then, after the president was assassinated, in 1969, things got harder. You needed papers to go anywhere.

X: So how did you get around?

JJL: I often traveled in a police car, except when leading institutionally supported parties.

X: You rented a police car?

JJL: No, since I'd got into the country via the police chief to begin with, it became a tradition that I was taken around by police car. Every visit from 1968 to 1973. I really talked my way into a lot of things. I'm a good bullshitter, you see.

X: Where did you sleep during these expeditions?

JJL: Sometimes I stayed in government rest houses, but often I slept outside.

John and company en route to Abd al-Kuri Island.

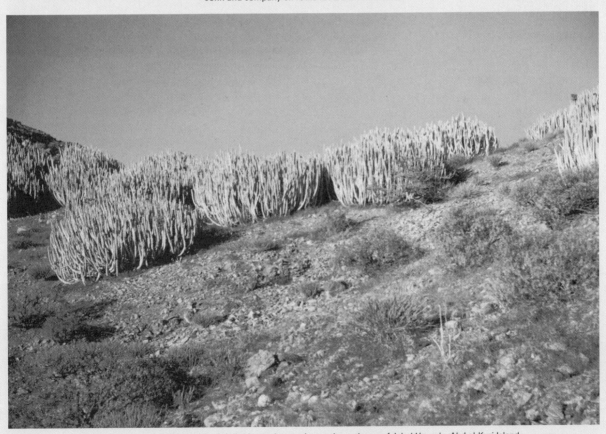

The extremely toxic *Euphorbia abdelkuri*, growing on the northern slopes of Jabal Hassala, Abd al-Kuri Island.

X: In a tent?

JJL: No, just on the ground, under an emergency blanket.

X: Did you ever feel like: Why am I doing this?

JJL: Oh, no. It was terribly exciting. You have no idea how exciting it was.

X: Did the locals think you were crazy?

JJL: In Somalia, like everywhere else, there is an elite, and they get the cream of everything. Most of the people in Somalia have nothing besides a few camels and the odd donkey. I know—I lived with these people for a long time, eating spaghetti or fried camel's liver in the early morning. Of course they were curious, and they were suspicious, like, "What the hell is this bastard doing here?" Some rumors began to circulate that I was looking for gold. Of course I couldn't be looking for gold! These areas are sedimentary—marine sedimentary! So they could never contain any gold [laughs].

X: You're one of the only botanists to visit Euphorbia abdelkuri in person, correct? Can you tell us a bit about that expedition?

JJL: Oh, my. I wanted that plant dearly. It was originally described to me as groups of tall green candles, like nothing else. I had to see it, and no one had it in cultivation. It was first collected by Forbes and Ogilvie-Grant, in 1903, but probably no one else, other than the handful of natives on the island, had seen it since. I was able to make its acquaintance in 1967. It hasn't been visited really at all since then; those waters are now the waters of Somali pirates.

Anyway, when we were in Socotra in 1967, we managed to hitch a ride on a British Navy ship with another botanist, Alan Smith. We were there under the auspices of the British Middle East command—that's how we were able to go to the little island of Abd al-Kuri.

X: Is that the image you sent of a group of men in a small zodiac boat?

JJL: Yes. We were ferried in from the warship. There were ten of us, mostly military. We were dumped ashore and then fetched two days later. We went up the mountain, and that's where we found it. It was quite some distance from the spot where we camped, so we didn't see it at first. But we went in a particular direction, because it was obvious that if it still existed, it would be there.

X: Why was that?

JJL: Well, because one develops a nose and smells things, so to speak. And so we knew it could be nowhere else.

X: What was that first sight like for you?

JJL: It was one of the highlights of my life. I'll never forget it—coming up over the mountain and seeing these tall green candles, which, of course, were euphorbias that were centuries old. There were two hundred or so, in the middle of the mountain, on limestone outcrops and granite slopes, where they form open thickets. The island gets an inch and a half of rain a year on a good year. Euphorbias grow painfully slowly, so you can imagine how long it takes to get green glowing candles that are six feet [1.8 m] tall. They were bigger than I was.

X: Did you collect plants on the trip?

JJL: Yes, of course. Every single Euphorbia abdelkuri that's in circulation came from this trip.

X: Did you ever shed a tear at the sight of a plant?

JJL: At the beginning of my adventures, I was often overcome with excitement. I'll never forget when I found two specimens of Whitesloanea. It's a four-angled cube, about seven inches [18 cm] tall, totally spineless. When I found it, I literally almost fell over. I was on my way to take a crap, if I may be excused, in the early morning. Suddenly I was confronted with this incredible plant! I wasn't looking for it; I was looking for a place to lay an egg.

X: How do you reflect on your life in the field with these plants?

JJL: I can tell you one thing: it's been an absolutely marvelous life. You interact with these things, and, after so many years—we're talking sixty years—you feel at one with them.

Paul Hoxey

Paul Hoxey has been growing and collecting cactus since his teens, and exploring and studying the plants in habitat since 1996, where he has focused on the cactus of South America. He lives in England.

Xerophile: Paul, you've visited the very small, very obscure population of *Haageocereus tenuis* more than anyone else. Can you tell us a bit about them?

Paul Hoxey: Many *Haageocereus* live on the coast of Peru, where the landscape is essentially vast, sprawling sand dunes. There's a coastal mist that comes off the ocean—much like in the Camanchaca, in Chile—which sustains the very little life that lives here. There's *Haageocereus decumbens*, which is found in southern Peru, and then, three hundred miles [483 km] north, there is the tiny population of *Haageocereus tenuis*. It seems related to the southern population, but it's very strangely out on its own.

X: How did you find this habitat?

PH: I was in Peru, in 2002, with Alfred Lau. Someone—I think it was Carlos Ostolaza, who has written a few books on the cactus of Peru—had published its location in a journal. I believe it was at kilometer 118 off the Pan-American Highway.

X: It's right off the highway?

PH: Oh, yes. You wouldn't believe it. We took the main highway from Lima, got to kilometer 118, turned off the road, and there they were. Anyone can find it if they know the magic number, 118. It's simultaneously dreadfully remote and very easy to get to. It's just that no one ever stops there.

X: What's the habitat like?

PH: It's basically a few clusters of plants a few hundred yards apart, growing in pure sand. The habitat is tiny—it's reported to be less than one square mile [2.6 sq km]. People have found a few stragglers growing in the hills above this location, but that's basically it.

X: Some people say that *Haageocereus tenuis* is the most rare cactus on Earth.

PH: I can't say for sure, but it is very rare, and of limited distribution in the wild.

X: Can you explain how these plants survive in what seems to be pure sand, with zero organic material? Sand is generally one of the least hospitable environments—rarely do you see a beach littered with plants. Where do these cactus find their nutrients?

PH: Well, the water is one thing. Coastal mist is absolutely necessary. The cactus have a pretty extensive network of roots, so they can consume the small amount of sea moisture that settles on top of the sand. And they have adapted to find minerals in the slowly decomposing sand itself. But there is an interesting catch-22: the few nutrients that do exist tend to stick around because of the extreme dryness. If there were just a hair more water, all those nutrients would wash right through the sand, and the plants' survival would be, well, more impossible than it already is.

X: These plants snake across the sand in all different directions; they really appear to be crawling. What do you think about this very particular movement?

PH: I personally believe that each individual clump of *Haageocereus tenuis* originated from a single plant that constantly regenerates itself. It appears as separated bits because the plant roots along the bottom of the stems. As it grows, the tips are rooting and setting up their own life support, while the back of the plant is slowly dying. I think this is related to a survival tactic—if a bit of the plant gets covered in sand, it will eventually die because it can't photosynthesize, but the part that makes it out can keep going. So the cactus is indeed constantly crawling out of the sand.

X: *Haageocereus tenuis*, in the pictures you've taken, seem almost pathetic—little flaccid phallic monsters surrounded by trash and cigarette butts. But to think that they

have been there, unmoved, for centuries is remarkable.

PH: Yes, it's striking, isn't it? Especially with these ancient plants. When you see a nice habitat, you realize it's because humans haven't touched it. If people came in and destroyed this, it would take many years to recover, because of the slow pace of regeneration in arid habitats. It's not like a plant in a wetter environment, which could come back much faster.

X: People say that this plant shares its habitat with a chicken farm, and that most of the plants are covered in chicken feathers. True or false?

PH: Sort of true. *Pollo a la brasa* (grilled chicken) is a very popular dish in Peru, as you've probably heard. All over the country, there are giant sheds filled with chickens. Many of them are in the desert, because you can't do anything else with that land. But the desert is pretty windy, so the chicken feathers—or any rubbish, for that matter—blow across the vacant region into this tiny habitat. The spines of the cactus can catch the feathers quite easily.

X: There's kind of a melancholy feeling to these plants, almost like they were marooned by some cruel mishap of Mother Nature.

PH: I see what you're getting at. When you find them on this little island in the sand, you definitely ask them, "Why are you here? How did you get here?" There's something special about this place. The cactus are surrounded by awful, bleak desert. And they're very far away from any relatives.

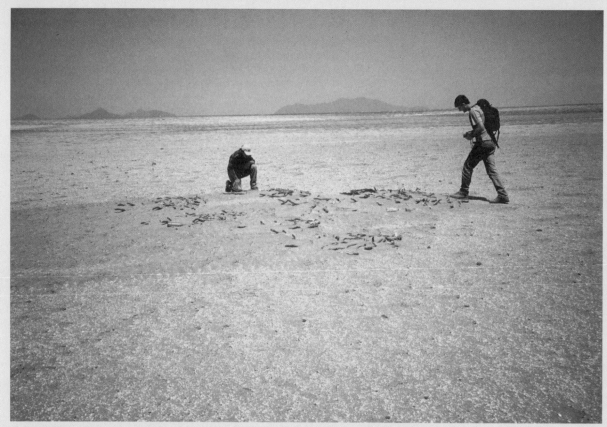

Paul Hoxey (right) and Job Rosales in the miniscule habitat of *Haageocereus tenuis*.

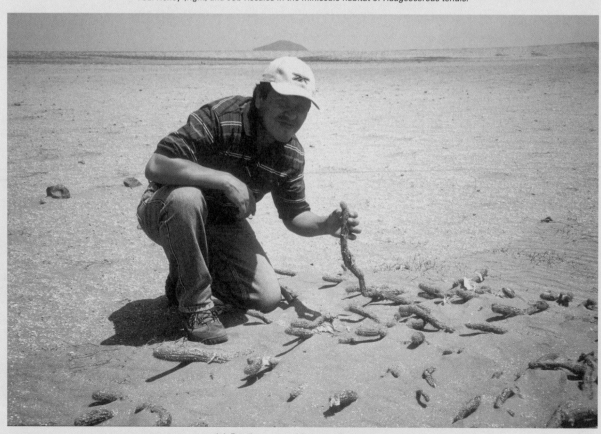

Job Rosales poses with the snake-like plant.

Index of Plants

Acknowledgments

This book is dedicated first and foremost to the contributors. They opened their doors and their photo archives to us with trust and graciousness. This book exists as a testament to their incredible work.

In particular, Woody Minnich provided unwavering generosity, knowledge, mentorship, and friendship. The five days that we spent with Woody and Kathy, sleeping on their trundle beds and looking through thirty years' worth of documentation of their expeditions, made us feel certain that we were on the right track.

April Whisenand, Tyler Bougoise, Han Wang, and Eric Van Zanten all jumped in headfirst to assist with the vast amount of research and organization that went into putting the book together. It would not exist without their work.

Many thanks to Eleanor "Eagle Eye" Martin for editing the many hours of dialogue and countless pages of unformed ideas that we sent her way.

Artie Chavez has vouched for us in the cactus world since day one, for which we are forever grateful.

For the first edition, we want to thank Emma Reeves for connecting us to Hat & Beard Press; J. C. Gabel, for taking the initial risk; Brian Roettinger and Taylor Giali, for their expertise; Jessica Hundley, for her support; Sybil Perez for her attention to detail; and Lisa Bechtold, for making it all happen.

For this second revised edition, we are immensely grateful to Lisa Regul, Isabelle Gioffredi, Dan Myers, and the whole team at Ten Speed Press for believing in the book and helping us get it back into print and onto shelves, in even stronger form than before.

Thanks also to Jeff Kaplon, John Morera, Nick Walker, Sofia Londoño, Gabriella Zecchetto, Liz Lee, Lauren Mahon, Bea Valls, Gordon Rowley, Roman Alonso, and Nena Zinovieff. To the CSSA; Copy Tech and Associates; the Gates Cactus and Succulent Society; the Montessori School, for its old printer; and Renato Rodriguez and the San Diego Natural History Museum, for their incredible online archive dedicated to the flora of Baja California, bajaflora.org.

A deep and special thank you to Maury Martin, Susan Miller, Kerry Kaplon, Patricia Kaplon, Tony Morera, and Haydee Campos, for their encouragement, support, and love.

And, last but not least, we are indebted to Xerophiles the world over, living and dead, who, through their obsession, travel, documentation, and cultivation, have brought us all into contact with some truly remarkable plants.

Originally published in somewhat different form by Hat & Beard Press, Los Angeles, in 2017.

For photo credits, see page 15. Each photographer retains copyright to their photos and they are reprinted here by permission. Additional permissions noted below.

Grateful acknowledgment is made to the San Diego Society of Natural History for permission to reprint the photographs by Kenneth Fink (KF), George Lindsay (GL), Tim Means (TM), Reid Moran (RM), Jon Rebman (JR), Laurie Roberts (LR), and Norman Roberts (NR), copyright © San Diego Society of Natural History, all rights reserved, www.sdnhm.org.

Howard Gates letter courtesy of the CSSA.

Paul Hoxey interview photographs courtesy of Clarke Brunt.

Library of Congress Control Number: 2021936015

Trade Paperback ISBN: 978-1-9848-5934-1
eBook ISBN: 978-1-9848-5935-8

Printed in China

Cover photographs: Woody Minnich (front), George Lindsay (back)

For original Hat & Beard edition
Editors: Cactus Store
Design: Cactus Store
Copy editing: Eleanor Martin and Sybil Perez
Proofreading: Lara Schoorl, Clark Allen, and Lisa Bechtold
Translation: Carlos Morera and Bea Valls
Research: April Whisenand, Tyler Bougoise, and Lauren Mahon
Layout assistant: Han Wang
Text: Carlos Morera, Max Martin, Tyler Bougoise, Gabriella Zecchetto, and Christian Cummings

For this Ten Speed Press edition
Editors: Cactus Store and Lisa Regul
Designer: Cactus Store and Isabelle Gioffredi
Art director: Elizabeth Stromberg
Production designers: Mari Gill and Faith Hague
Production manager: Dan Myers
Copyeditor: Lisa Theobald
Proofreader: Jean Blomquist
Publicist: Feliz Cruz | Marketer: Andrea Portanova

Cactus Store is owned by Carlos Morera, Max Martin, and Christian Cummings.
Cactus Store
3209 Fletcher Drive
Los Angeles, California 90065
www.hotcactus.la

10 9 8 7 6 5 4 3 2 1

2021 Ten Speed Press Edition